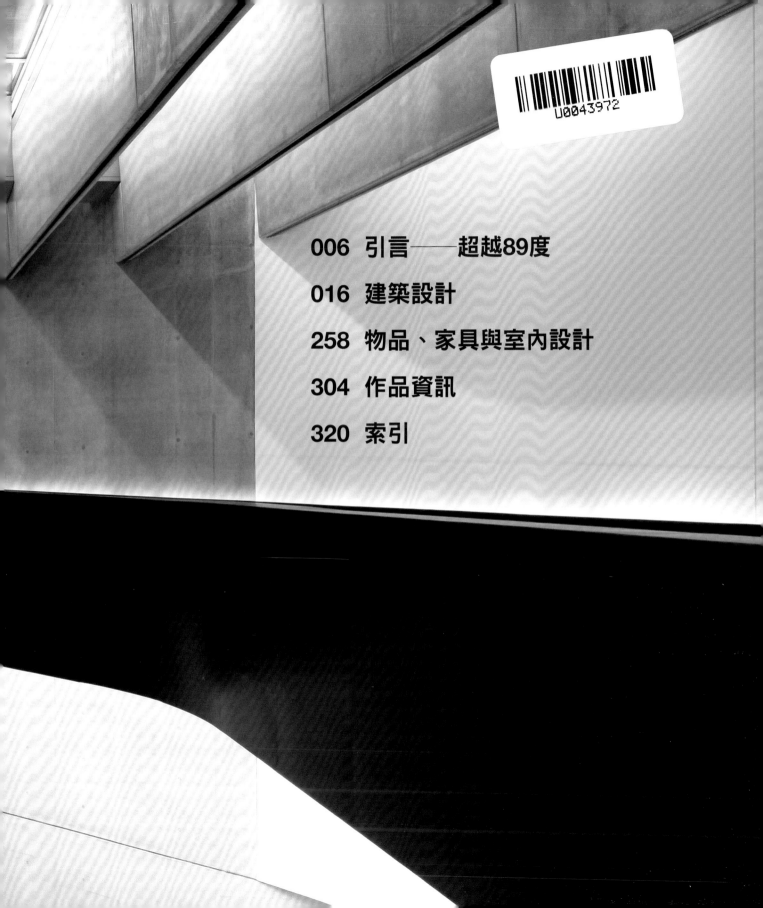

電影，一方面使我們對於主導著人們生活的必然事理有進一步的領會；另一方面，電影設法讓我們相信，有一個浩瀚並超乎想像的活動場域。我們的小酒館和大街小巷，我們的辦公室和陳設的房間，我們的火車站和工廠，似乎將我們絕望地囚禁起來。然後，電影以十分之一秒的瞬間炸藥，將這個有如監獄般的世界轟炸得支離破碎，所以此刻，我們在電影一望無際的廢墟瓦礫中，泰然且冒險地踏上旅途。透過特寫、空間擴張；隨著慢動作，活動延長。放大的瞬間畫面並非單純地以更精確的方式，呈現一切不明顯但卻可見的事物：它顯露的是拍攝主體嶄新的結構組成。因此同樣的，慢動作不僅呈現了我們所熟悉的運動特質，還揭露出運動特質中全然未知的面貌，「它們看起來遠遠不像被延遲的快速運動，而是被賦予滑行、飄浮、超自然等奇特的運動效果。」顯然地，肉眼所見和攝影機所拍攝的事物，有著截然不同的性質──那是因為無意識瀰漫的空間取代了人們有意識探索的空間。[1]

引爆十分之一秒的瞬間

札哈・哈蒂（Zaha Hadid）是傑出的電影攝影家。她的目光就像一台攝影機。她用慢動作、平移、高速靠近和特寫鏡頭、跳接和敘事節奏來感受城市。當她描繪圍繞在她身旁的世界時，她刻畫出那些未知的空間。她發掘了潛藏在我們現代世界的事物，並繪製成烏托邦的分鏡腳本。她大膽探索，時而放慢、時而加快日常生活的節奏，並將她的環境透過建築的精準曝光作為一種再現的形式。她建造了有如十分之一秒爆炸的瞬間。

這並非意味著她不是一位建築師。一直以來哈蒂都將目標放在建造，而她的圖面，（早期畫作以及她將結構化身為建築姿態和奪目造型的手法），更是她進一步邁向構築的推手。然而，她從沒打算過將獨立的物件置入空白基地中。相反地，她的建築是導致空間擴張的高密度聚合體，她壓縮了所有形成建築的能量，從機能到技術服務設施。她的建築可以從這種密度下自由擴展，創造出天馬行空的空間。在那曾經（可能有）私人活動、牆和管線的地方，現在則是劃過地景的碎片和面，打開了一個我們從未想像過的空間。

哈蒂以類似的方式打造她的建築職業之路。她將幼時編織地毯上的回憶，混合進倫敦的建築聯盟學院（Architectural Association）學習歷程裡。她用二十世紀初藝術家所創作的形式作為構築元素，來從中豎立她抽象記憶中的宮殿。她擷取都市的能量和深刻的地景輪廓，像披風那樣圍繞著她，然後，將這股力量化作探索的出發點，邁向她多角形式的未知領域。

或許有人會說，札哈・哈蒂是現代主義者，她對創新宣示的方式，是設計出與科技核心緊密結合的開放空間（lofts）[2]。札哈・哈蒂沒有類型、使用次序、預設立場或是地心引力的包袱；她深信我們可以且應當建立一個更美好的世界，一個標榜著以自由至上的世界。我們將自過去中解放，從社會常規的限制中、物理法則中和我們的身體中擺脫。建築，對於像哈蒂這樣的現代主義者，總是在局部構築著這樣的自由世界。

現代主義的三種狀態

傳統上，這樣的現代主義有三種層面。首先，其追隨者相信新的結構。一個好的現代主義者認為，運用科技，我們得以更有效地利用我們的資源（包含我們自身）創造出最大量的盈餘，無論是空間上的還是價值上的。這樣的「過剩」是那永遠的新、未來與烏托邦的史詩般實現。它無形並且是在形體最極簡時才會產生。第二，現代主義者相信新的觀看方式。或許世界已然全新，只是我們沒有認知到這樣的世界。我們慣用被訓練過的方式去察覺我們所見。如果我們能夠用新穎的方法觀看，僅僅透過這樣的行動，我們便可以改變世界。我們必須對我們存在的現實世界打開雙眼、耳朵與心思。於是，我們將能夠得到那已然存在的自由。第三，現代主義者希望再現現代性的真實。融合上述兩個層面，現代主義者將我們新的感知，轉化成我們所創造形式的再現。這樣的形式是真實的原型，其中事物已被重新排列和溶解，這一刻，除了嶄新之外的事物消失無蹤。以新的方式表現新事物，只要用我們的眼光，就可以建構一個新世界，並居住其中。

現代主義的第三個層面正是札哈・哈蒂作品的特徵。她沒有發明新形態的構法或技術；而是用顛覆的方式呈現給我們一個新的世界。她在主體和客體的溶解中找到現代主義的根源，並把它們帶到現代地景的舞台上，這個被她重新塑造成一個可以任我們恣意漫遊的地方。這種現代主義的典範至少可以追溯到巴洛克時代，當主體和客體第一次失去他們無庸置疑的權威時。人的身體，不再是罪惡世界中站在神面前的肉身，而只是真實地連續性進入到自身的皺褶：

INTRODUCTION: BEYOND 89 DEGREES

Aaron Betsky

1　華特・班雅明（Walter Benjamin），〈機械複製時代的藝術作品〉（The Work of Art in the Age of Mechanical Reproduction），in *Illuminations*, trans. Harry Zorn（New York: Schocken Books, 1969），p. 236.

2　"The loft"是現代主義最卓越的空間，因它是一個工業化的，具開放和功能性的空間，使我們不受到機能、私密與公共、和裝飾的限制。它不僅是哈蒂作品中的建造單元，還出現在其他晚期的現代主義者作品中，如藍天組事務所（Coop Himmelb(l)au）。作者在（倫敦：Architectural Review Press，1998）中更詳盡地討論了"loft"對於Coop Himmelb(l)au的重要性。

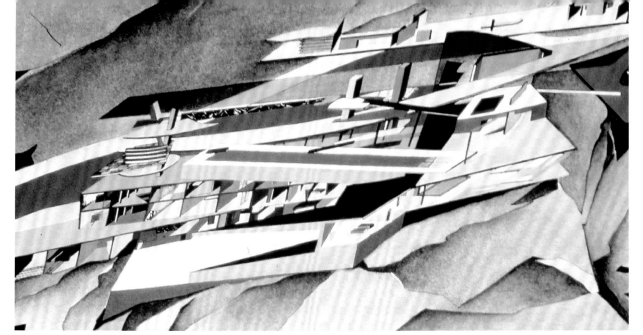

因此物質提供一種無限多的孔隙、海綿狀、或凹陷但不空洞的質地，孔洞無止盡地包含更多其他孔洞：無論再小的個體，每個都具有著被不規則的軌跡所刺穿的世界，並且被不斷增加的飄渺流體所圍繞和滲透，整個宇宙就像是「存在著不同流轉與波動的一池物質[3]。」

建築試圖去呈現這種能量的流轉，在其無數的形式中捕捉它：

> 巴洛克時代創造了無限的作品或過程。問題不在於如何完成一個皺褶，而是如何延續它，讓它能穿越天花板，如何將它帶向無止盡……（皺褶，the fold）決定並具體化形式。它產生一種表達的方式，一種「造形」（Gestaltung），一種基因元素或曲折的無盡線形，一種具有獨特變化的曲線[4]。

工業革命，想當然爾地，建造了這般渾沌的世界，剝奪了每一個物或人的意義或價值，並將其攪拌進資本的洪流之中。結果，越來越多的建築消溶在玻璃、鋼鐵和混凝土的場域裡，流淌在形式的最後身影周圍，埋藏在成堆的消耗商品背後。而札哈‧哈蒂建造了這樣的流動。

引外入內

然而，哈蒂的作品並不僅擁有伴隨西方根源而來的現代性。出生於伊拉克的她，談及年少時對波斯地毯的著迷，複雜的圖騰打破理解，體現了結合手藝，將真實世界轉化成感性的織面，將簡單的空間帶入生機。值得一提的是，這也無獨有偶地是女性的創作。[5]

我們也可將哈蒂作品的敘事展開，與中國和日本的捲軸畫做比較。現代主義提出從不斷累積的日常活動中，建構能持續改變我們理解真實的感知，而非將特定的秩序固定在事物上。這是一種捲軸畫繪者深諳的創作方式。他們在作品中來回穿梭，專注於微小的細節，從不同的角度將場景多次的展現，將許多分離的元素串連成地景。一波又一波回聲般的線條，混合進創作者的想像之中，在那世界裡改變並回傳，轉化後再送回給觀者。

上述這些傳統觀念皆為二十世紀初藝術家所運用，他們的藝術為哈蒂的圖像式構築元素提供線索。無論是在立體主義、表現主義亦或是超現實主義中，抽象的片段被組合成敘事結構。這些藝術家為他們的世界投下震撼彈 ——杜象的《下樓的裸女》[6]有如札哈‧哈蒂的母系始祖（grandmother）。

3 吉爾‧德勒茲（Gilles Deleuze），《皺褶：萊普尼茲和巴洛克》（*The Fold: Leibniz and the Baroque*），trans. Tom Conley (Minneapolis: University of Minnesota Press, 1993), p. 5.

4 同上，pp. 34–35。

5 與創作者的對話，1997年12月14日。

6 譯註：1912年杜象顛覆當時藝術界的油畫作品，收藏於費城藝術博物館。作品中人物在畫布上以垂直方向重覆呈現直立的動態，從左上到右下的對角線降階。

哈蒂最直系的建築血統，可說是位於倫敦的建築聯盟學院。她在那裡學習時，這所學校正處在全球建築實驗中心的巔峰位置。承接建築電訊（Archigram）[7]的腳步，彼得‧庫克（Peter Cook）[8]、雷姆‧庫哈斯（Rem Koolhaas）[9]、伯納德‧屈米（Bernard Tschumi）[10]和奈傑爾‧寇茲（Nigel Coates）[11]等學生和老師們，將現代世界的

恍惚動盪編寫成為作品的主題和形式。無所畏懼地再次主張成為現代主義者，藉由不斷講述他們的故事，來試圖捕捉一切源自於我們活動變換中的能量，並為形塑現代性的嘗試增添敘事觀點。

無論作品是軼事與晦澀的（屈米〔Tschumi〕），還是表現了神話般拼貼的（庫哈斯〔Koolhaas〕）又或者是宣言的（庫克〔Cook〕），他們都將多重的觀點、具席捲力和表現性的形式、以及技術面的架構一起整合進畫面中，表現的方法則是透過描述而非精確定義。

倫敦特拉法加廣場 主建築
Grand Buildings, Trafalgar Square

凝聚的拼貼

正是在這樣的背景下，讓札哈‧哈蒂的創作有了雛形。她第一個備受矚目的提案，是她為泰晤士河上的橋樑「馬列維奇的構造」（Malevich's Tektonik, 1976–77; p.18）所做的論文設計，無疑地有賴於她與雷姆‧庫哈斯的協作（她與OMA大都會建築事務所合作了三年），作品運用將幾何形狀減少到其精髓的手法，來凸顯重要性，直接地喚起了馬列維奇的絕對主義[12]創作。她所描繪的橋，看起來像馬列維奇飛行器，或許也可以是雕塑品又或者是房屋。畫面的中立是刻意的，因為她將建築視為「凝聚社會的機器」（social condenser），一種當時在AA建築學院相當流行的用語。建築本身是一個現代主義的開放平面，反過來帶入不同的功能元素（她實際上沒有說明）拉近彼此之間的聯繫。不過，令觀者感到驚艷的，不是這個設計在功能上的抱負，也不是對於過去的引用，而是畫面本身：以對「新」堅定的表述，使它成為眾所矚目的焦點。

在畢業後的幾個設計案中，哈蒂持續將她的敘事觀點更完整地發展為空間語言。她為胞兄的公寓伊頓街59號（59 Eaton Place [1981–82; p. 21]）所設計的形式，直接喚起了曾經發生在附近的愛爾蘭共和軍炸彈爆炸事件[13]。這幅畫本身就是一場爆破，畫面上的元素，是能量以最現代的方式宣洩所產生的碎片。物件凝結與城市的形式轉變成家具，成為哈蒂建築的中心思想。隨後這些室內作品回頭取代普普藝術元素的位置，一個為重新佔領現代城市所準備的舞台。哈蒂更進一步發展了伊頓街59號的圖面，並使其成為哈爾金街（Halkin Place [1985; p.28]）這個設計的想法。從屋頂上方看，觀者用彼得‧潘的視角，翱翔在城市排屋的屋簷之上，俯瞰一個城市徹底崩解，這個觀看角度，得以讓哈蒂現代主義烏托邦的碎片重新回歸它們的歷史樣貌。

哈蒂的愛爾蘭總理新官邸提案（Irish Prime Minister's Residence[1979–80; p. 20]），將拼貼運用

在她的作品之中。具象的元素（片狀，球狀，塊狀）充斥在一個簡單的空間立方，並隨著一道長的曲牆切開它，以展開設計的敘述。哈蒂喚起了這個官邸的國際性本質，而不是對我們述說關於功能或基地的種種；她設置了場景，而不是給我們劇情。在倫敦特拉法加廣場主建築的提案中（Grand Buildings, Trafalgar Square [1985; pp. 25–27]），集結了她的多項成就，並展現了她重新想像都市景觀的能力。這件作品是一幅雙聯畫，至少從五種角度來刻畫建築。它同時展示這城市在直立著且以由下而上的角度自我剝離，藉此創造出畫面中何為反射、何為主要地平面的動盪效果。結合艾薛爾（Escher）[14]繪畫的巧思與構成主義（Constructivist）[15]組構的意念，哈蒂將城市分層撥開。

哈蒂對於這種表現的方法有她的設計準則：主建築這個設計案會將特拉法加廣場的活動和形式密集地組合在一起，釋放出多層級的開放空間，讓城市得以進入建築，同時其侵略性的造型也轉移到都市地貌之中。我們所經歷的真實、與新投射的幻想或建築相遇在擁擠滿載至臨界點的城市，成為她畫作中不斷出現的主題。在這案例中，她用畫面完成了這件事，將特拉法加廣場遺留在過度觀光的真實，把未實現的建築奇想置於烏托邦的國度中。

這些早期的作品可以歸納為兩種主要形式。第一種是以一幅畫表現了當時她所有的設計方案，《世界（89度）》（The World〔89 Degrees〕[1983; p. 24]）。在這幅畫中，哈蒂將我們在地球上的真實想像作為她設計的集合，因為我們或許會從直升機上或射入太空時的火箭上看見它們。當這個世界翻轉，地景升起變成新的幾何碎片。真實世界成為哈蒂樂園，在那裡重力消失，透視扭曲，線條匯集，尺度或活動的定義不再。這不是一個功能和形式的特定場景；而是像一個有著各種可能組合的星座，整體形成一片真實的地景：將空間親手打造成我們實際生活環境的人造描繪。

第二個形式總結使哈蒂聲名大噪。她贏得香港山頂（The Peak）競圖的作品[1982–83; pp. 22–23]，向成千上萬的建築師和設計學生（包括本文作者）證明，她所建立的設計方法是一種嶄新的建築形式。座落在當時殖民地的制高點，這個設計本身就是對這個基地和所有機能的總結，用偏好享樂的形式集合來屏棄現存的世俗需求。這建築是一個用看似可被社會接受的形式來愉悅和訓練身體的設施。

哈蒂在這個設計中，將管狀結構堆疊在一起，像木樑堆放在工地裡那樣，將機能和基地透過建築具體表現出來。它們以懸挑和層疊的空間增加基地的垂直向度。形式間的縫隙凸顯了山頂的功能，作為一個活動匯集的社交俱樂部。而樑的走向似乎在捕捉並固化身體運動的軌跡。這是一座讓人和山匯聚在一起相互試探的建築。它不僅是「為山頂加冕」（crown the brow），它更將最「山頂」的部分抽離出來，讓我們如現代泰坦巨人（Titans）般可與之決鬥。

哈蒂將這樣的想像揮灑在一組巨型畫作中，似乎渴望表現出「山頂」本身的尺度。雖然建築師強調了她構築的理性本質，但她的繪圖卻將局部和構件分開檢視，爆破了基地和機能。在其中一幅繪畫中，哈蒂描繪了山頂俱樂部的元素成為香港鬧區的一部分，而下方的都會摩天大樓則成為抽象的平面，其旋轉、飛行並實際成為建構山頂的量體單元。在這些情況下，哈蒂提出了一種建築，它能以抽象幾何形式的組構來表達這個城市或任何大都會的人造地景。而這些破舊立新的碎片指向一個更為開放、強烈和不穩定的空間佈局。

在形式的汪洋中啟航

在接下來的十年之中，哈蒂將這些主題擴大分佈於世界各地的建築、設計和提案，許多是在德國。包括她迄今最雄心勃勃的兩個設計，柏林的IBA集合住宅（IBA-Block 2 [1986–93; p. 33]）和位在萊茵河畔威爾的維特拉消防站（Vitra Fire Station [1990–94; pp. 52–55]）。前者運用了在特拉法加廣場主建築設計案中的基本形式，而後者指出了她作品的新里程。

14 譯註：荷蘭版畫家，1898-1972，作品運用精準的線條、對比顏色與重複排列的圖形元素，呈現空間的錯置。

15 譯註：1920年代早期構成主義這個詞開始被使用，相信藝術應直接反映現代工業化社會，發起人為塔特林（Vladimir Tatlin）。1923年其追隨者們於Lef 雜誌上發表宣言，認為構成主義是純粹的掌控技術與材質的組構。這個藝術運動對二十世紀藝術、人文、設計與社會有廣大的影響。

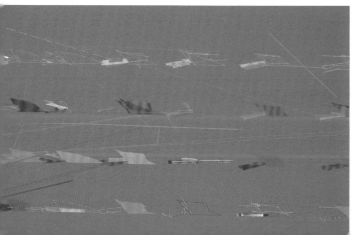

維特拉消防站 Vitra Fire Station

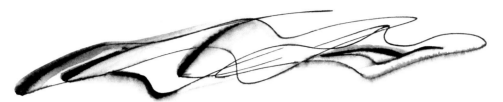

伊斯蘭藝術博物館
Museum of Islamic Arts

在柏林的維多利亞城區（Victoria City Areal [1988; pp. 40–41]）、漢堡的海港街開發案（Hafenstraße Development [1989; pp. 44–45]）以及杜塞道夫萊茵河岸的佐爾霍夫三號媒體園區（Zollhof 3 Media Park [1989–93; pp. 50–51]），現在也因為哈蒂標誌性的船首造型、圍繞偏心的開放平面型空間[16]、將公共空間引入建築內的同時，把建築物體向外延伸至都市中，而有了設計上的共通點。多年來，這些形式扮演了造型上重要的角色，但它們的特色也在改變。它們變得更輕、更透明、並且更有層次。在某種程度上，這是由於更大型，或多數情況下，更普遍的機能所導致的。這些辦公大樓和公寓街廓幾乎沒有混合元素（hybrid elements），所以可能不易發展它們的故事性設計表現。

我們同時也可感覺到設計焦點的移轉。哈蒂早期的建築是由不同的元素所組合成的拼貼，但現在（這個時期）她的形式似乎演變出獨特的姿態造型。對於哈蒂來說，這是由於她將作品視為一種地景形式，或是形塑土地所造成的結果。正當維多利亞城區仍然遵循哈蒂最早於特拉加廣場主建築計劃所提出聚集和擠壓成型的設計方法時，在杜塞道夫和萊茵河畔威爾大型綜合方案的設計，卻像是現代主義冰山的碎片，它們的裂縫讓邊緣形成開口。而這些裂縫揭示了每座建築物的局部性質。

在杜塞道夫設計案中，複合園區的各種機能積累成相似的形式，它們被剪裁成橋樑、步道和公共建築群，它們在空間的自由探索中合而為一。無論是在公共領域還是在辦公大樓，一切都屬於同一個形式的世界。

哈蒂所使用的色彩也開始改變。繼大都會（Metropolis [1988; p. 38]）的炙熱畫面，以及兩棟位在柏林的建築物仍然出現依色彩區分的碎片之後，其他在德國的設計，在顏色表現上卻非比尋常的柔和。有一部分是因為玻璃在此時站上了主導地位，又或許也是因為德國城市相對較為灰色調的環境。然而，它似乎也代表著哈蒂趨向冷靜的設計風格：色澤與調性、連續形式的折疊與模矩化的量體，取代了碎片的拼貼。

這些發展最終成就了維特拉消防站。當人們從法蘭克・蓋瑞（Frank Gehry）著名的全白色博物館（維特拉設計博物館）看見消防站時，最能發現它的船首狀造型。在現實中（哈蒂的繪畫使這更顯清晰）消防站在概念上是從旁邊工廠的量體所削切下

來，並沿著能引導回博物館和園區周遭的彎曲步道發射出去。這是在此處的一場爆發，將工廠牆面的沈默無聲凍結成傾斜的圍牆。建築物沿著消防站的高低起伏打開視野，而非緊靠著。這種地貌成形持續在內部發生著，給消防車使用的較大空間逐漸彎曲成淋浴間和休息區，而樓梯隨著量體抬高朝向二樓。

哈蒂以維特拉消防站（和後來在斯特拉斯堡外的公車轉運站）證明了她可以建造地景。雖然這些形式或許看來熟悉，但是已經遠離她早期作品那種構築的聚合形式了。不再強調直接蓋在土地上、開拓新空間、和置入高聳並對於周遭環境帶有挑釁意味的形式，她現在從基地擷取建築形式的構想、從功能塑造形式、並運用空間邏輯來創造紀念性的構築景況。她的建築讓人回想起，田野如何覆蓋山坡和洞穴，如何在下方鑿開，河川如何流過起伏的地景以及山峰又是如何能夠提供方向感。也許哈蒂理解到，「十分之一秒的爆炸」揭露既存環境的本質多過於人類心靈的構成，這是因為既存環境是遵循著一種類似無機規則所形成的人類居住沈澱[17]。她發現自由的空間並不存在於烏托邦的片段裡，而是存在於對真實世界的探索。

螺旋在握

繼維特拉消防站之後，螺旋開始在哈蒂的作品中出現，在伯明罕的1995年建材展中，用來圍塑Interbuild 95藍圖展示館（Blueprint Pavilion for Interbuild 95 [1995; p. 78]）的金屬摺板，以及在卡地夫灣歌劇院（Cardiff Bay Opera House [1994–96; pp. 70–73]）捲曲而上的「城市寶石」，和維多利亞與艾伯特博物館的鍋爐室增建案（Victoria & Albert Museum's Boilerhouse Extension [1996; p. 82]）中緊密的空間序列。在悠游於地景之後，哈蒂似乎希望藉由對機能的包覆，並再以周圍環境來遮蔽或包含空間，使建築能創造自身的地景。在 V&A博物館提案中，展覽空間高過屋頂的方式與哈蒂金街（Halkin Place）設計手法相同。在卡地夫灣歌劇院，螺旋包覆主大廳的中央空間；在藍圖雜誌展示館，他們為展場攤位創造了一個小型祭壇式的樣貌。

雖然她在晚期絕大部分的作品都是大型建築案，但哈蒂卻持續地將它們描繪成透明量體。不再是有份量感的板塊構造，這時的她認為藉由幾何與結構的操控，可以將空間從禁錮中釋放出來。而她以連續性地景做為開放空間延伸與室內量體的想法，

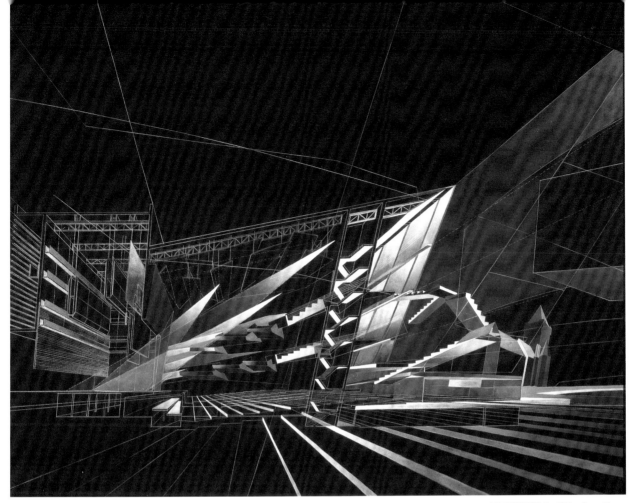

卡地夫灣歌劇院 Cardiff Bay Opera House

也重塑了她一直以來的設計思考。與這些設計有關的許多繪圖，都是白色線條畫在黑色表面上，就好像只是用來嘗試可能性的草圖，開放詮釋。她早期作品中，繪圖的確定性已經讓位給有如動態素描般探索的抽象開放性。

這種半透明的、如寶石般的質感，在哈蒂所提出的倫敦哈克尼帝國劇場（Hackney Empire theatre）和在辛辛那提的羅森塔當代藝術中心（Lois & Richard Rosenthal Center for Contemporary Art [1997- 2003; pp. 97-99]）到達了巔峰。在這裡，皮層逐漸溶解消失，只剩下作為都市能量與室內能量之間介面的功能。這些力道開始越來越集中施展於坡道和螺旋量體上。透過折疊和相互卡接，正的形式（牆體，地板和天花板）和負的空間（可居住空間）轉變為有如鰻魚般緊密貼著彼此滑行，但空間組織仍全然清晰。

同時，她早期設計中的管狀形式也變成顯著的特徵。它們被束在一起構成維也納的斯匹特勞高架橋（Spittelau Viaducts [1994-2005; pp. 74-77]）和在倫敦的屋橋（Habitable Bridge [1996; pp. 84-85]）形式。雖然在某種程度上，樑狀量體令人回憶起香港「山頂」設計的板塊量體，但此時的聚集更為密實緊湊，動線和可用空間幾乎無法區分。

此外它們也對空間的水平走向強調多過於形式的垂直堆疊。而在德國的1999園藝展覽館（Landesgartenschau 1999 [1996-99; pp. 88-91]）方案中，形式上更結合了哈蒂先前透過建造地景來創造大型曲面的喜好。

邁向新地景

有一段時間，地景成為了哈蒂作品中居於主導地位的設計思維。如果她設計的量體越來越流線，那麼它們的室外也會是如

16 譯註：形容哈蒂的形式處理，與傳統平面垂直疊加上去的方式有所不同，哈蒂運用不同樓層平面產生的變化，形成多變的造型。
17 見曼紐・德・蘭達（Manuel De Landa），〈非有機形態〉（Nonorganic Form），in *Zone 6: Incorporations* （New York: Zone Press, 1992），pp. 128–67.

此。就像在卡達的伊斯蘭藝術博物館（Museum of Islamic Arts [1997; pp. 92–93]）的提案中，建築恰如其分地成為基地的漣漪波動，向上去涵蓋空間，然後再消沉回到地面下。而庭院的狹縫能將空間編織成如波斯地毯般的密實，但也像河川或湖泊，在大地來回流動。如同衣服上的波紋或她所喜愛的維諾·潘頓（Verner Panton）[18]椅子造型，這些建築本是形隨機能，並且只是為了滿足使用需求而建造，但後來卻展露了那存在於動態中的建築本體之美。

然而，在這個新世界裡，卻存在著一個不同的真實世界。這也是哈蒂在設計中最為充分探索的一件事，例如她在倫敦千禧巨蛋的心靈地帶展覽（The Mind Zone exhibit [1998–2000; p. 100]）中提出的方案。空間和形式的複雜交織，被地景般的皮層撫平了，但是隨著一道牆的翻面，卻使得地景的輪廓變成如懸挑的船首背脊。

哈蒂在二十一世紀初大部分的設計，都是以螺旋和管來取代板、船首脊、和塊體。動態和姿態取代了形式，成為設計的主導元素，並且作品變得更加實驗和抒情。打開都市地景，展開現代都會的能量，並創造一個富有遠見的世界，哈蒂用擁有自己類型、結構與（甚至大膽地說）風格屬性的造型，去探索這一類建築的空間可能性。

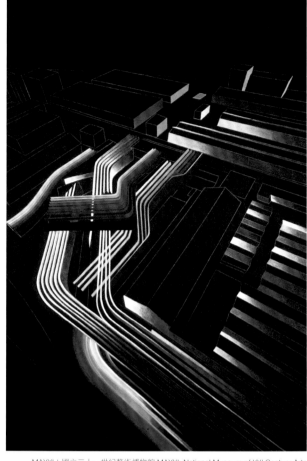

MAXXI：國立二十一世紀藝術博物館 MAXXI: National Museum of XXI Century Arts

她表現作品的方式與作品的設計意圖開始同步。經過多年，哈蒂越來越少地親自動手繪畫和製圖。隨著公司和案量的增長，她更喜歡像文藝復興時期的大師一樣工作，擔任工作坊的負責人。她速寫並勾畫出「所有的精確線條」以表達她的設計目標[19]；然後同事們將創作渲染成更大的尺度，並填補她手勢揮舞之間的空間。同時她作品中的細節越來越少，差異減少，顏色也用得更少。她從多彩和費工的拼貼式繪畫，轉移到以單色洗禮的畫面，做出許多黑紙上只有白線的畫作，彷彿見到未來城市的一抹幻象。

螢幕上的寶石

讓哈蒂將繪畫實力轉變為具國際影響力的實踐，並創作出大尺度建築的契機，是由於她採用了（在她的合作夥伴派屈克·舒馬赫〔Patrik Schumacher〕力薦下）電腦設計和溝通技術。軟體技術的進步使其開始與建造方式直接鏈結，這讓現在的她，有能力展開（unfold）既存的地景，透過平移、搖擺、驟轉、裁切、減慢和加速，以一種她過往只能在畫中提議的巨大尺度與複雜層次運作著。基於演算法和參數運算（algorithms and parametric calculations）（哈蒂合作人舒馬赫詳盡發展出來的理論），這些數位形式也使她的建築物逐漸減少了非常個人的設計探索，展現她所想像的是對現代性固有的多義與歧義（複雜與矛盾）的真實反應。這也意味著她的公司可以從小型設計工坊，發展成能將設計到施工流程掌控得天衣無縫的高效率基地，並具備在全球建造許多大型建築的能力。因此，她在公司的功能已經成為扮演主要的發想者、評論家和銷售人員，她從飛機和建築基地中領導公司團隊的時間和在倫敦總部一樣多。

哈蒂並不是唯一意識到數位潛力的人。在許多方面，電腦實現了華特·班雅明（Walter Benjamin）所預見的前景，特別是當介於感知、再現與實作之間的邊界逐漸溶解。電腦能視覺化太過抽象而不易被看見的力量，並且也讓我們能夠形塑與再形塑那些我們所選擇的資訊，然後將這些關鍵的資訊再現，量化為可以建造的品質。因此這種「新」來自於對既存資訊再現後的數位操作。

當哈蒂在1983年將她的世界和我們的世界結合在一起時，她相信自己的畫有足夠的力量，將我們現實生活中各種不同的片段，重新組成一個新世界。而在千禧年之際，哈蒂正在超越以地景為主要發想的設計，進入一種新型態的空間。既密集又開放、既準

確又模糊、既真實又虛擬，越過89度、越過直角和偏斜的幾何、並且越過了「事件視界」（event horizon）[20]，在那裡，人們的活動固化為空間形式。

建造流體形式

在2004年，哈蒂獲頒被許多人認為是建築專業最高榮譽的普利茲克建築獎。她的臉孔出現在時尚雜誌，以及更專業的建築出版品上，讓數以百萬計的人開始認識她。這樣的認識並非無足輕重。這意味著她可以推銷自己和她的作品：以她為標誌的建築計劃提高了大眾的關注和客戶的聲望，公寓或辦公空間的銷量或出租量也因而提升。這個地位的轉變為她帶來了許多案量。在這過程中，她越來越多的作品發展出了如簽名般的設計特質。

在某些案例中，可以很直接的辨識出她採用簽名式設計。有人或許會在她最後十年的一些作品中認出「z」這個字母，那也可以被解讀為她一些早期如蛇滑過般形式的合理發展。爾後在這裡演變成在侷限的環境中，一種更緊密定義空間的設計方法。在羅馬被稱作MAXXI的國家二十一世紀藝術博物館（National Museum of XXI Century Arts in Rome [1998–2009; pp. 106–9]），以及萊比錫的BMW汽車廠辦中心（BMW Plant in Leipzig [2001–5; pp. 132–35]），皆是透過基地侷限形成了蛇形的蜿蜒。在羅馬，這些包含了經哈蒂修復的既存歷史建築群，是要作為歐洲大陸最大的現代美術館整體園區的一部分。形狀最顯眼的是巨型長量體，呈鋸齒狀（zig-zag）般地從開口投向室內中庭，通過有點驚人的歷史建築物，並一直進到後方未來將作為增建的區域。在這強烈的形式之下，展覽室向上對著傾瀉而下的光打開，哈蒂透過屋頂結構之間，將光引入室內。空間沿著階梯式的展覽區擴張，而動線則在彎折的角落循環。上下樓梯和手扶梯、與透過簡單設計動作所產生的複雜空間安排，全都幫助營造了無止境發展的感受，總是有更多的房間等待著在下一個轉彎處展開。將這一切聯繫在一起的是屋頂，它確實地讓一切事情發生，並同時涵蓋了新的空間。結構的連續性產生了空間的連續性，但兩件事並不對等，而是因這兩者間的對比讓美術館的特質浮現。

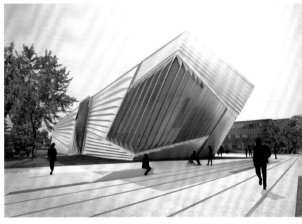

伊萊與伊迪絲・布羅德美術館
Eli & Edythe Broad Art Museum

鋸齒形狀在萊比錫的設計案中更加清晰，在那裡，哈蒂必須要在別人設計的巨型汽車製造廠之間的基地做設計。她的課題是創造公共場所與辦公空間以及對外展示汽車的製成和工作人員的供膳設施，而她將上述各種空間機能詮釋為同一項任務。形式的軌跡在這裡同時遮蔽和定義了入口，並緩緩穿過大眾接待區和員工辦公隔間坐落的階梯式平臺，逐漸上升的平臺下方，同時也提供了餐廳的空間，到後方的區域則以健身房和一般性的設施填充了造型最尾端的角落。屋頂的桁架在這裡再次透過連繫所有元素創造了空間的連續性。在這個案例中，它們是一群組的超高強度混凝土樑，具有大跨距，讓下方的空間彼此開放。相較於這個大尺度的建築手法，局部組裝和塗裝的汽車半成品，透過輸送帶從一個製造廠移動到下一個（製造廠）的展示過程，似乎變得微不足道，儘管以輸送帶移動並展示，確實能在機能上和宣傳上帶來效益，但除此以外可能就只剩下作為一種建築姿態。

以上所述的這些空間是宏偉壯麗的，但從因斯布魯克的伯吉瑟爾滑雪跳台（Bergisel Ski Jump [1999–2002; pp. 114–15]）這個提案看來，其垂直性和具象的設計，也看似是哈蒂的作品中，最後幾種從傳統建築設計中發展出來的幾何形式之一。不過以「對角」為主題的形式，再次出現在格拉斯哥的河濱博物館（Riverside Museum [2004–11; pp. 170–71]）。除了強調對角的造型與配置，它也成為立面構成的元素，例如在蒙佩利耶的活石大樓（Pierres Vives building [2002–12; pp. 146–48]）和密西根州立大學的伊萊與伊迪絲・布羅德美術館（Eli & Edythe Broad Art Museum [2007–12; pp. 226–27]）等設計中，「對角」的立面元素將原本建築巨大且封閉的量體切出開口，並且在視覺上透過分割來縮小建築的尺度。

18 譯註：潘頓椅是家具設計史上的經典作品，1967年潘頓與Vitra合作開發生產。
19 與創作者的對話，1997年12月16日。
20 譯註：圍繞在黑洞周圍的邊界。

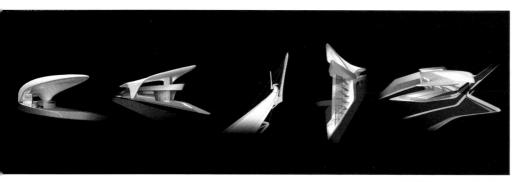

北山纜車 Nordpark Cable Railway

讓哈蒂證明了她展開和再編織真實的想像確實可以達成。然而，有人可能會附上不同的看法，因為這當中有許多設計也存在於沒有涵構的地景（tabula rasa landscapes），所以在其中它們所展開的一切都只是新的建設和設施，而不是作為揭露潛在真實的存在。

在蛇形屋頂和彎曲的形狀之外，哈蒂還發展出輕繫地面、向外鼓出、結構似乎比空氣還輕的建築形式。最有詩意的是在因斯布魯克的北山纜車（Nordpark Cable Railway [2004–7; pp. 166–69]）。它僅是一個棚蓋，並由於鋼構的複雜網狀結構使它得以實現，但是所有人看到的都是一個閃閃發光的白色雲狀金屬板量體，繫在沿著電扶梯和樓梯周圍的幾個端點。這個建築不用任何詮釋上或空間上的限制，就能將地景表態和開放、定義和揭露。 在倫敦水上運動中心的設計（London Aquatics Centre [2005–11; pp. 180–85]），這些雲團澎漲到巨大的高度，並且成為空間的容器，輕而易舉地橫過游泳池並遮蔽數以萬計的觀眾。在她生命的最後十年中，哈蒂開始把彎曲扭轉的流動性伸向天際，試圖將封閉且往往被視為雄風象徵的權柄打開，化身為著迷於天空的蛇，進入被她喻為開花的形狀與那用前庭和大型開口切開的流體建築，打開周遭的環境發掘那原本與世隔絕、用室內空調、和高度保全下的建築。

在尺度光譜的另一端，哈蒂為「後物件」（post-object）的世界發展了建築單元。她所設計的傢俱，在設計時擁有許多結構與形式上的自由，削切扭曲的塊體被逐漸溶解成網狀，再連接進入空間中並剛好能容納人的身體。對比之下，她的都市設計變成了一大群的圓形，共同創造了一個整體的佈局模式。在為伊斯坦堡的卡爾塔爾－朋迪克（Kartal-Pendik [2006–; pp. 194–95]）、畢爾包的佐羅祖雷（Zorrozaurre [2003–; pp. 150–51]）、與新加坡的緯壹科技城（One-North [2002; p. 131]）所做的整體計劃中，她提出的觀點是，設計的地景（designed landscape）應該是由一群元素所構成的集合，某些元素具有空間性，另一些則只是在景觀或街道上的波動起伏，它們必須匯合以創造一種世界，讓人們可以居住其中並超越結構、功能或基地的限制。浮現於電腦生成的人工地皮首先只是地景的起伏，就像在大型城市的規劃，尤其是卡爾塔爾－朋迪克整體規劃的方案中一樣。地景隨後發展成一像是會自行生長的重寫本（palimpsest）[21]，傾向於在基礎設施交會處所產生的高強度片刻。當線條在垂直方向彼此互相串接並且延伸至地景之中時，它們變成了空間的容器，無論像是在杜拜的高樓還是萊比錫或羅馬的管狀結構。對於哈蒂和她的公司團隊來說，這些結晶是

在後來的設計中，建築不再發展成蛇形空間的多重堆疊，而是轉變成以流體造型（bulbous forms）聚積而成的丘狀量體，以中國的廣州歌劇院（Guangzhou Opera House [2003–10; pp. 156–61]）為例，就像是座人造山丘，由較小卵石狀的建築提供其入口及服務功能。 此外歌劇院和其他相關的設計提案，都依靠空間框架與外牆皮層，包覆一種似乎要把建築侷限爆開的空間複雜性。而這樣的設計也展現出工作團隊越來越依賴電腦去創造複合型與大尺度的建築，並且讓哈蒂終於能實現「結構與空間相互交織」，這個她從學生時代就夢寐以求的想像。

廣州歌劇院是第一個在技術層面上來說完全被實現的流體建築，它以多面向的立面凸出於公共機能空間的上方。主建築是一個披上金色外皮的洞穴，以狹縫空間從四面八方彎曲圍繞著。 這效果是一種傳統劇院類型的抽象化，可以追溯到1875年由查爾斯‧加尼葉（Charles Garnier）設計的巴黎歌劇院（Paris Opera House）。在這個設計中，哈蒂主要的成就是她運用科技和從數位工具上奪取而來的空間流動性，來創造出不斷開展、游移於觀眾四周、並隨觀者移動而變化的空間。從外觀上來看，歌劇院仍是具有神祕感與紀念性的文化建築，瀰漫著一種無從定義的特質，但卻如錨定般重要。只是粗糙的施工有時會讓人在壯麗的建築中分神。

哈蒂開始更完全地依靠電腦的能力，由起伏的結構面下方穿過去展開連續的空間，有時結構面會升起形成流體液塊（bulbous masses）或高塔。像在阿布達比表演藝術中心（Abu Dhabi Performing Arts Centre [2008–; pp. 232–33]）這個設計，蛇的形式再次現身，並在彼此周圍盤繞。然後它們在眾「蛇頭」聚集處，結成一團結構和動線元素，透過這個由許多斜坡道、樑、與房間所構成的網，圍繞著一個流體的核心空間。這樣的設計讓建築不但可以作為一個完整實體的存在，也可以讓人探究其間隙的複雜性。這些建築呈現一種幾乎不可能的流體狀態，但是藉由最先進的電腦建模設備，它們

建築經過抽象、打開、重塑，然後以流體的形式凝固在它們所運作的世界。

在北京和首爾兩個亞洲城市裡，哈蒂的提案成為這些城市設計宣言的凝聚：首爾東大門設計廣場（Dongdaemun Design Plaza [2007–14; pp. 200–5]）和北京銀河Soho（Galaxy Soho [2009–12; pp. 250–51]），它們在尺度上大過於單棟建築，但又小於城市，這些商業和文化的凝聚體使人想起最原始的動物：巨型尺度的阿米巴原蟲（amoebas），滲流到基地的周圍；它們像水母用觸手纏繞，並延伸到街道和地鐵；或像魷魚流體狀的頭形建築內含有塊狀機能量體。這樣的意象或許可以説是因為參數式設計原本獨特的有機造型本質，但這也讓我們聯想到許多藝術家和建築師，都傾向在他們創作生涯的後期，變得越來越傾心於這種流體形狀。東大門的廣場設計案也比從前任一個作品都更能夠將基地和建築融合在一起：它涵蓋了一個地鐵站和一座公園、一系列的遺址和歷史古蹟，空間和平面浮現或衍生出博物館、會展中心、購物區、以及其他機能性的元素，使廣場成為重度使用的大型都市構造。並駕齊驅的是北京的銀河Soho，這是第一個在大型建築方案上，哈蒂和她的團隊驗證他們可以高度控制這些形式的建造與執行，將廣州歌劇院粗糙的銜接面和管線外露的過去，遠遠地拋在身後。

哈蒂對於形式的期望似乎越來越高，她追尋一種形式力量的漸強，一個歡騰的瞬間。以她為阿布達比表演藝術中心所作的設計為例，它逐漸上升至巨大尺度來涵蓋一座表演空間，同時將自己面對大海敞開。而在這些構造中最顯著成功的是在巴庫的阿利耶夫文化中心（Heydar Aliyev Centre [2007–12; pp. 216–17]），其中的線條更像是她早期的平行條紋，但此時在如此險峻的角度或翻騰躍起、或蜻蜓點水，與她之前相對狹長的空間形式相比，更具有豐富的多樣性。這樣的空間所帶來的後續效應，帶入到東京奧林匹克水上運動中心（Aquatics Centre in the Tokyo Olympic Stadium）變成更為奪目的壯麗（若有被建造出來的話），而現在也將會顯現在她持續進行中的卡達足球場（Qatar Soccer Stadium）。

哈蒂持續鍾情於管狀形式的類型，然而，她許多在後期更成功的作品，包括倫敦的伊芙琳葛蕾絲中學（Evelyn Grace Academy [2006–10; pp. 198–99]），和高棲在中阿爾卑斯山脈上的梅斯納爾山脈博物館科羅尼斯分館（Messner Mountain Museum Corones [2013–15; pp. 208–9]），都是她管狀群體的變化型，但現在配上更有棱有角的切斷端作為觀景平台。這些較簡單的構造，並非巧合地，似乎也是最常出現在當基地或預算，又或者兩者皆受到限制的時候。因此當這種情形出現時，她並不強求以全面流體的概念，提出具顛覆性的創新地景設計，而是透過建築讓緊湊的空間和形狀更為複雜，使它們盤根錯節，沿著邊緣一路軟化它們，過程同時打開空間和形式，使它們流出，直到機能、資金或空間耗盡時，愕然而止，好讓我們從盡頭的玻璃看清外面的世界，此刻觀者得以欣賞它們的形狀，彷彿切口是為了我們探索而打開。

在成為哈蒂公司團隊主要收入來源的大樓設計案中，分叉、管狀和起伏成為她主要的立面操作手法。它們在大樓基座處成為空間的前導，再伸展出去將公共大廳打開，並在大樓的頂部對天空展現姿態，同時又隱藏機械設備。由於哈蒂很少能在這類的大樓設計案中，從空間機能或基地涵構裡找到她可以將建築打開或回應的機會，因此她通常會利用基地的特殊性（角度或景色），或結構的性質來引導出特殊的設計方向。

在過去十年之中，哈蒂和她的公司團隊，確實開發出一種不同於以往的設計模式——以岩石或人造山為主要設計發想。她將這樣的設計發想應用在香港的賽馬會創新樓（Jockey Club Innovation Tower [2007–14; pp. 220–23]）並取得很大的效果。這個設計是一個先朝向地面傾斜，再隨著大樓上升反向操作的條紋量體，在高度上升的同時，它的角度變化扭轉，並回旋於環繞其四周的垂直板與管。在建築內部，哈蒂把這些水晶洞（geodes）切開，創造出狹窄且具角度的空間，透過橋、樓梯和電梯穿梭於挑空之中，創造出的壯麗感受幾乎是她之前所有作品所無法比擬的。在安特衛普的港口大樓（Port House [2009–16; pp. 238–41]），她將這塊人工地質凝聚成一塊巨石，平衡地安置在主港口行政大樓頂部，彷彿要將其航向遠方，同時又提醒著我們它不可思議的份量。

哈蒂離開的太快，但已經成就了大量的作品，並透過她的製圖、繪畫和設計改變了建築世界。她受封為女爵士，她的設計從水龍頭、遊艇、摩天大樓、一直到遍佈世界的城市規劃。她獲獎無數並引起效仿風潮的事實，更廣泛地説明了她的重要性。她是世界上最傑出的建築師之一，引爆十分之一秒的瞬間化了乘載、歌頌和世代流傳的文化構造。革命性的潮流將想像從電腦內匯出，並覆蓋了建築基地，從哈薩克（Kazakhstan）到馬賽（Marseilles）。蛇形般滑動，突出延伸，會飛的平面、不斷滾動開展的地毯，哈蒂持續突破設計的里程碑，一直走到最後，她的建築，仍有許多持續興建中或即將問世的作品，而她的影響，也將持續啟發和開展，沒有終點。

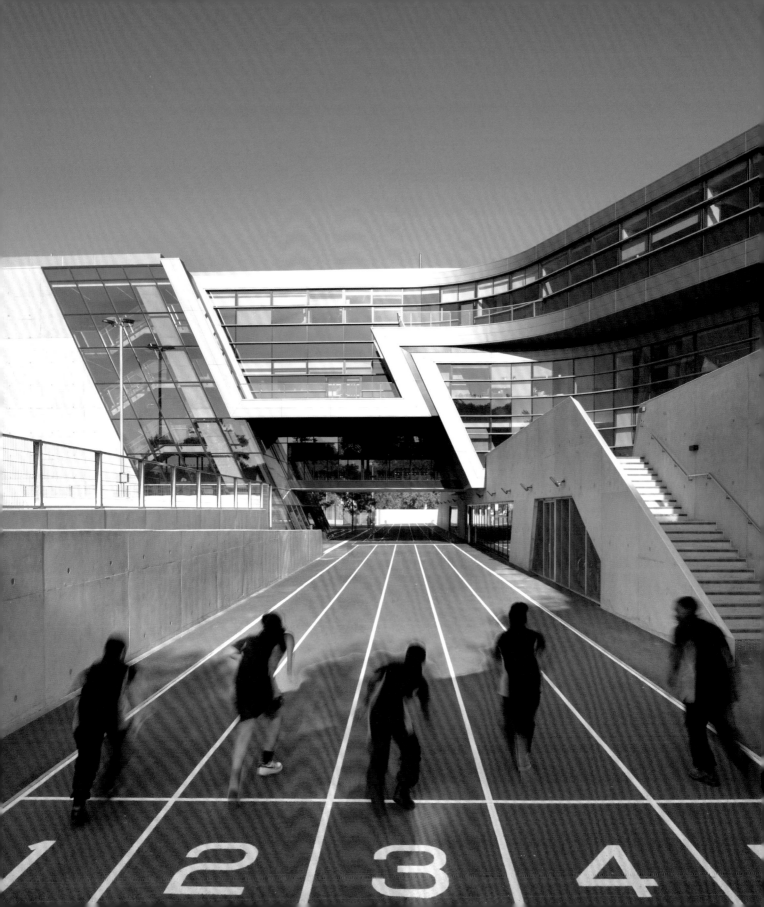

建築經過抽象、打開、重塑，然後以流體的形式凝固在它們所運作的世界。

在北京和首爾兩個亞洲城市裡，哈蒂的提案成為這些城市設計宣言的凝聚：首爾東大門設計廣場（Dongdaemun Design Plaza [2007–14; pp. 200–5]）和北京銀河Soho（Galaxy Soho [2009–12; pp. 250–51]），它們在尺度上大過於單棟建築，但又小於城市，這些商業和文化的凝聚體使人想起最原始的動物：巨型尺度的阿米巴原蟲（amoebas），滲流到基地的周圍；它們像水母用觸手纏繞，並延伸到街道和地鐵；或像魷魚流體狀的頭形建築內含有塊狀機能量體。這樣的意象或許可以說是因為參數式設計原本獨特的有機造型本質，但這也讓我們聯想到許多藝術家和建築師，都傾向在他們創作生涯的後期，變得越來越傾心於這種流體形式。東大門的廣場設計案也比從前任一個作品都更能夠將基地和建築融合在一起：它涵蓋了一個地鐵站和一座公園、一系列的遺址和歷史古蹟，空間和平面浮現或衍生出博物館、會展中心、購物區、以及其他機能性的元素，使廣場成為重度使用的大型都市構造。並駕齊驅的是北京的銀河Soho，這是第一個在大型建築方案上，哈蒂和她的團隊驗證他們可以高度控制這些形式的建造與執行，將廣州歌劇院粗糙的銜接面和管線外露的過去，遠遠地拋在身後。

哈蒂對於形式的期望似乎越來越高，她追尋一種形式力量的漸強，一個歡騰的瞬間。以她為阿布達比表演藝術中心所作的設計為例，它逐漸上升至巨大尺度來涵蓋一座表演空間，同時將自己面對大海敞開。而在這些構造中最顯著成功的是在巴庫的阿利耶夫文化中心（Heydar Aliyev Centre [2007–12; pp. 216 17]），其中的線條更像是她早期的平行條紋，但此時在如此險峻的角度或翻騰躍起、或蜻蜓點水，與她之前相對狹長的空間形式相比，更具有豐富的多樣性。這樣的空間所帶來的後續效應，帶入到東京奧林匹克水上運動中心（Aquatics Centre in the Tokyo Olympic Stadium）變成更為奪目的壯麗（若有被建造出來的話），而現在也將會顯現在她持續進行中的卡達足球場（Qatar Soccer Stadium）。

哈蒂持續鍾情於管狀形式的類型，然而，她許多在後期更成功的作品，包括倫敦的伊芙琳葛蕾絲中學（Evelyn Grace Academy [2006–10; pp. 198–99]），和高棲在中阿爾卑斯山脈上的梅斯納爾山脈博物館科羅尼斯分館（Messner Mountain Museum Corones [2013–15; pp. 208–9]），都是她管狀群體的變化型，但現在配上更有棱有角的切斷端作為觀景平台。這些較簡單的構造，並非巧合地，似乎也是最常出現在當基地或預算、又或者兩者都受到限制的時候。因此當這種情形出現時，她並不強求以全面流體的概念，提出具顛覆性的創新地景設計，而是透過建築讓緊湊的空間和形狀更為複雜，使它們盤根錯節，沿著邊緣一路軟化它們，過程同時打開空間和形式，使它們流出，直到機能、資金或空間耗盡時，愕然而止，好讓我們能從盡頭的玻璃看清外面的世界，此刻觀者得以欣賞它們的形狀，彷彿切口是為了我們探索而打開。

在成為哈蒂公司團隊主要收入來源的大樓設計案中，分叉、管狀和起伏成為她主要的立面操作手法。它們在大樓基座處成為空間的前導，再伸展出去將公共大廳打開，並在大樓的頂部對天空展現姿態，同時又隱藏機械設備。由於哈蒂很少能在這類的大樓設計案中，從空間機能或基地涵構裡找到她可以將建築打開或回應的機會，因此她通常會利用基地的特殊性（角度或景色），或結構的性質來引導出特殊的設計方向。

在過去十年之中，哈蒂和她的公司團隊，確實開發出一種不同於以往的設計模式——以岩石或人造山為主要設計發想。她將這樣的設計發想應用在香港的賽馬會創新樓（Jockey Club Innovation Tower [2007–14; pp. 220–23]）並取得很大的效果。這個設計是一個先傾向地面傾斜，再隨著大樓上升反向操作的條紋量體，在高度上升的同時，它的角度變化扭轉，並回旋於環繞其四周的垂直板與管。在建築內部，哈蒂把這些水晶洞（geodes）切開，創造出狹窄且具角度的空間，透過橋、樓梯和電梯穿梭於挑空之中，創造出的壯麗感受幾乎是她之前所有作品所無法比擬的。在安特衛普的港口大樓（Port House [2009–16; pp. 238–41]），她將這塊人工地質凝聚成一塊巨石，平衡地安置在主港口行政大樓頂部，彷彿要將其航向遠方，同時又提醒著我們它不可思議的份量。

哈蒂離開的太快，但已經成就了大量的作品，並透過她的製圖、繪畫和設計改變了建築世界。她受封為女爵士，她的設計從水龍頭、遊艇、摩天大樓、一直到遍佈世界的城市規劃。她獲獎無數並引起效仿風潮的事實，更廣泛地說明了她的重要性。她是世界上最傑出的建築師之一，引爆十分之一秒的瞬間化成了乘載、歌頌和世代流傳的文化構造。革命性的潮流將想像從電腦內匯出，並覆蓋了建築基地，從哈薩克（Kazakhstan）到馬賽（Marseilles）。蛇形般滑動，突出延伸，會飛的平面、不斷滾動開展的地毯，哈蒂持續突破設計的里程碑，一直走到最後，她的建築，仍有許多持續興建中或即將問世的作品，而她的影響，也將持續啟發和開展，沒有終點。

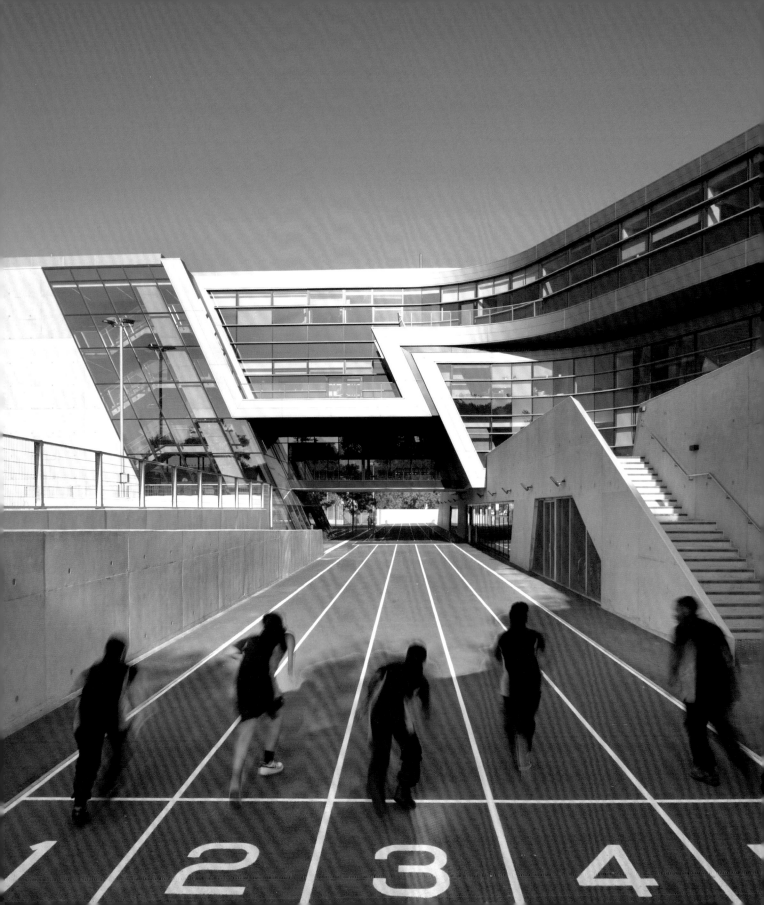

BUILDINGS AND PROJECTS

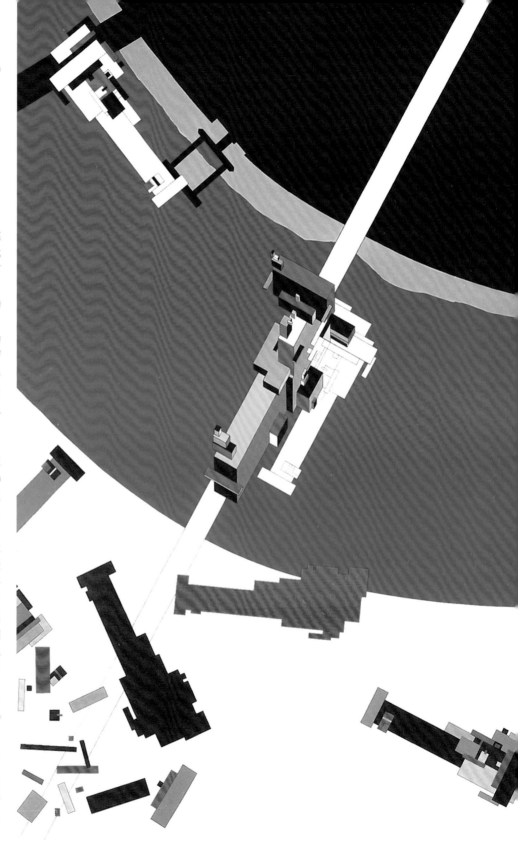

第16頁篇頭圖：伊芙琳葛蕾絲中學（Evelyn Grace Academy）

為了（日後）我在倫敦AA建築聯盟學院的畢業設計[1]，我想探討一個橫跨泰晤士河亨格佛橋（Hungerford Bridge）上的旅館，其功能需求上的「突變」（mutation）因子。在這個研究中，水平方向的「板塊構造」（tektonik）[2]依循且運用了絕對主義形式（Suprematist forms）中看似隨機的組構方式，以滿足功能和基地的需求。

這座橋將代表十九世紀倫敦這一側與另一端的南岸（South Bank）聯繫起來，南岸又以1950年代藝術聚落的野獸派建築著稱。十四層樓的結構，系統化地連接在水平板塊構造上，將所有可能的限制轉變成新的空間機會。這個設計特別與我後來的幾個設計有共同的迴響：一個是在紐約古根漢美術館的「大烏托邦」[p.63]展覽中，我得以實現一些板塊構造的具體樣貌；和另一個同樣是在泰晤士河上，「屋橋」[pp.84–85]設計中，也考慮了混合使用型開發案的可能性。[3]

譯註1：哈蒂在做畢業設計之前，於大四所做的設計探討。
譯註2：這個設計始於對馬列維奇雕塑的研究，因此這裡的板塊構造是哈蒂對絕對主義形式的建築詮釋。
譯註3：指多種機能如商業與住宅等同時發生在基地上。

在政治上分屬不同體系的荷蘭國會與政府，卻一同被安置在名為「內庭」（Binnenhof）的行政綜合中心，一個位於海牙中心的矩形「堡壘」。為了分開這兩個政治上權責對立的機關，當局取得了一塊新的三角形基地來做為國會設施增建的使用。因此新的增建在規劃需求上，必須考量到配合既存的建築結構，同時又要使國會在空間上具有獨立的自明性。設計透過在「內庭」中創造一道由兩塊板狀建築量體所形成的間距，來達成規劃上的目標。這兩塊板狀量體（slab）是由一個水平元素（由玻璃磚建造的平台式建築，具多種功能並可做為一個有屋頂的政治公共論壇，以及一個橢圓房間的微型高樓），與一個垂直元素（國會政黨與政策專業運作的空間）所組成。這兩個量體透過國會議事廳的橋接，將一般大眾和政府單位整合起來；而穿越垂直板狀量體的迴廊，則提供了串聯國會增建與既存建築之間的動線。

OMA：哈蒂、庫哈斯、增西利斯

荷蘭・海牙 1978-79

荷蘭國會增建

DUTCH PARLIAMENT EXTENSION

The Hague, Netherlands 1978-79

OMA: Zaha Hadid, Rem Koolhaas, Elia Zenghelis

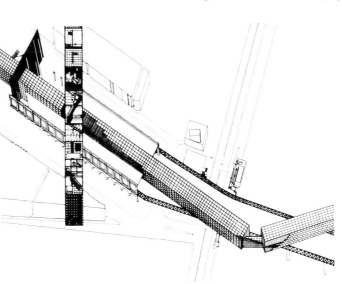

英國・倫敦 1977-78

十九世紀博物館

*MUSEUM OF
THE NINETEENTH CENTURY*

London, UK 1977-78

這是我最早關於意識形態與推論的幾個提案之一，其中我嘗試在二十世紀末的城市背景下，為建築所該扮演的角色制定原則。由於過去，我對於和歷史與文化相關背景的議題特別感興趣。因此，這個十九世紀博物館的創作原型有兩個探討的面向；透過對都市場所中精確社會景況的詳盡闡述，以及透過對符號敏感度的展現，這是在當時涵構主義（contextualist）建築師的作品中，似乎不存在的一種討論面向。[4]

譯註4：當時的涵構主義建築師在設計上，著重建築是否能在形式與空間回應周遭既存都市紋理與人文歷史，因此與哈蒂透過符號與展現社會景況的設計有所不同。

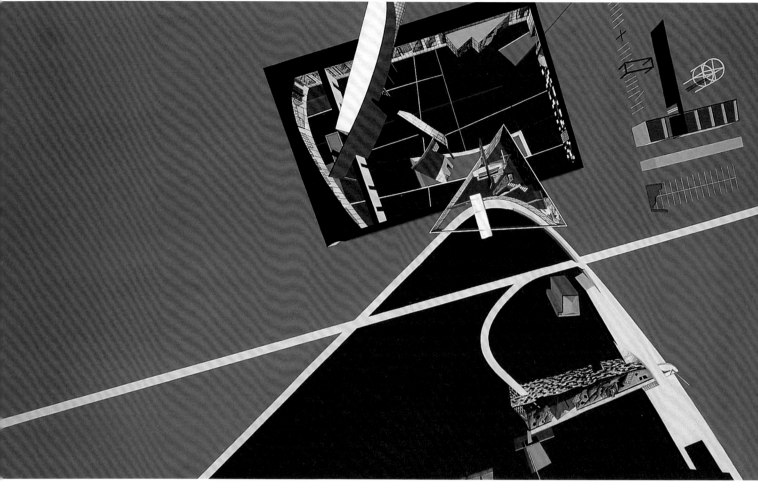

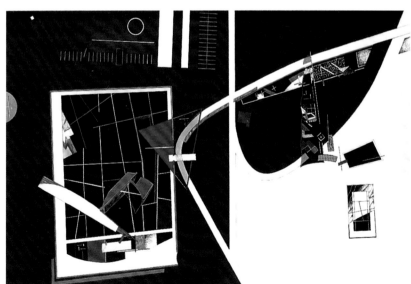

愛爾蘭總理官邸

IRISH PRIME
MINISTER'S RESIDENCE

Dublin, Ireland 1979–80

愛爾蘭總理（或稱Taoiseach）新官邸和
國家多功能會議廳是我的第一個主要建
築提案，設計目標是創造一種很輕的，
讓人能從公眾生活壓力中釋放的感覺。
新設計的兩棟建築，雖然以馬路和走道
相互連接，但同時也需要保有它們各自
的隱私。座落於一座擁有圍牆的既存花
園內，新的迎賓館與總理官邸之間以主
會客廳做為屏障。除了有如「漂浮」
（float）在花園上的會客區和主套房，迎
賓館的房間則沿著建築的邊界分布。

這個競圖是要為一座推廣科學的公園,設計平面和構成元素,基地位在巴黎市郊最熱門的地區,我們創造了可以移動穿越平坦基地的漂浮物件。綠色的臺地在場域裡形成一種新形態的花園:懸浮,而非掛在那裡。整體來看,這些漂浮物件的作用就像在地面書寫,由機械系統影響,被人的活動和自然所牽引,時而受控制時而又隨機。野餐區、快餐店、和資訊亭運行在自成的宇宙裡,與長形、單色調的「行星帶」(planetary strip)形成對比。為了讓這個提案更切合以未來為主的思考,我們以「發現樂園」(discovery garden),將公園所有的功能和景觀凝聚在一起。

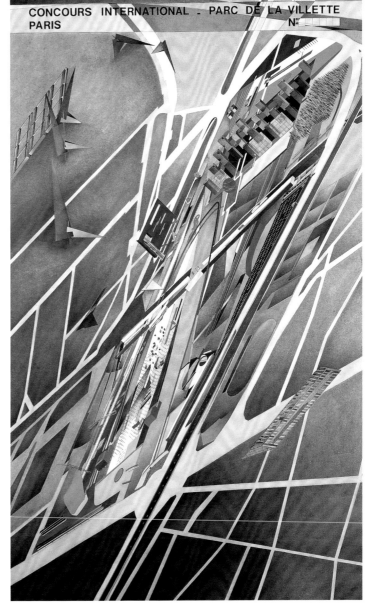

基地座落於伊頓街,是一條位於貝爾格拉維亞區(Belgravia)非常白淨的街道,而一場發生在38號的義大利領事館氣爆案,提供了我們翻修這建造於世紀之交的優雅連棟別墅(59號)主要的靈感來源。這間待翻修的公寓是內含在連棟別墅中的三個樓層,我們在概念上,將公寓由水平層疊反轉成三個垂直區域。透過在一樓和頂樓採用絲綢和石頭等材質,以及在大廳和用餐處置入一座新的樓梯,將公共領域向上打開至中間層,我們以設計介入空間,希望帶來一種嶄新的感受。

這個傲然於擁‧城市之上的山頂度假勝地，有著「絕對主義地質學」（Suprematist geology，物質會在垂直和水平方向受影響）[5]的特質。建築就像鋒利的刀劃過基地，切開傳統組構原理並建立新的原則，對抗自然同時又小心避免破壞它。

像山一樣，建築是分層的，每一層都定義了一個功能：第一層和第二層設有公寓，第三層是一個13公尺高作為俱樂部的虛空間，懸浮在第二層和頂層公寓之間。虛空間形成新的建築景觀，裡面諸如運動平台、小吃吧和圖書室等元素像星球般被懸掛在空中。第四和第五層包含了頂層公寓單元。

山頂的條狀建築和虛體空間提供並象徵高品味生活的巔峰，在堅固山體上溫和的撼動著。

譯註5：這是哈蒂在「山頂」一案，綜合絕對主義和構成主義所形成的設計方法，是她獨創的用詞。

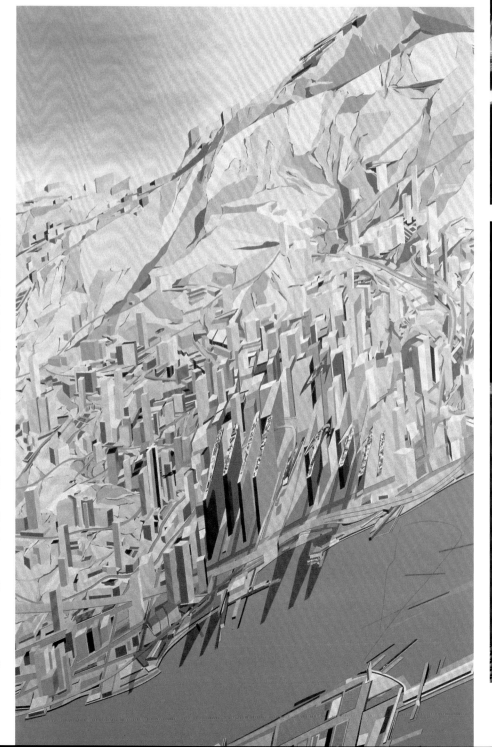

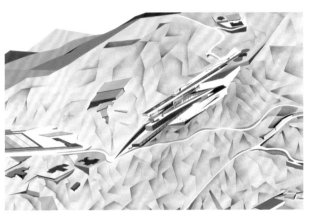

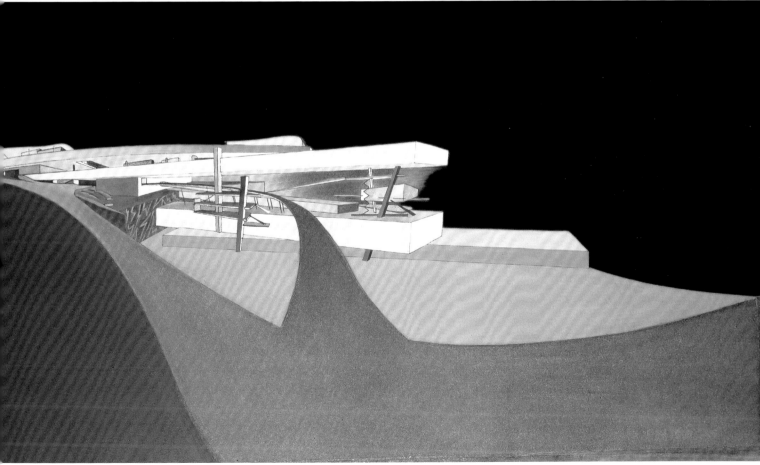

世界（89度）

1983

THE WORLD (89 DEGREES)

1983

這幅畫代表了我從建築聯盟學院的學生時期開始，為期七年對於建築未知領域探索的成果。科技的快速發展與我們不斷改變的生活方式，創造了本質上嶄新且令人振奮的構築背景，同時在這新世界的環境裡，我感到我們必須重新啟動那曾經中斷和未經測試的現代主義實驗[6]，這並非再次呈現，而是揭露構築的新領域。在這裡，過去七年來所進行過的設計提案被壓縮和放大一次呈現。

譯註6：現代主義初期的許多實驗中，仍然有很多未被直接引入建築設計，或曾經有但未能持續。特別是不同於所謂「國際式樣」的嘗試。推薦參考由柯寬恩（Alan Colquhoun）所著《Modern Architecture》一書。

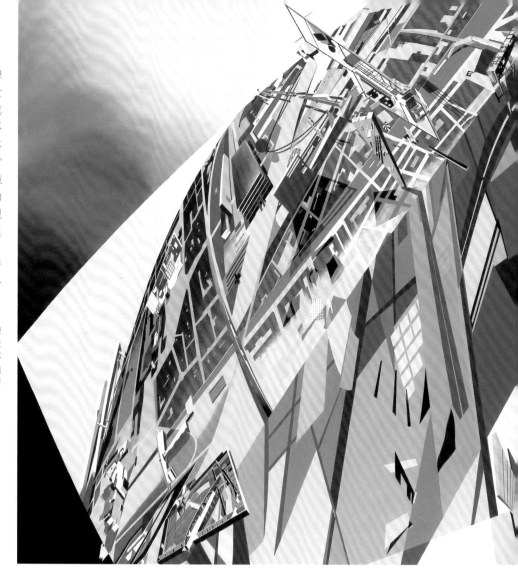

梅柏芮公寓

英國・倫敦 1985

MELBURY COURT

London, UK 1985

基地位於以特定用途建造的戰後小型公寓，而這個設計的目標，是將那些僵固公寓中的房間盒打開。兩道玻璃弧牆延伸穿越在既存的公寓中，偶爾重疊，以創造圍繞中央光井四周開闊的流動空間。家具被設置在軌道或轉軸上，使起居區域在空間上和功能上能靈活運用。

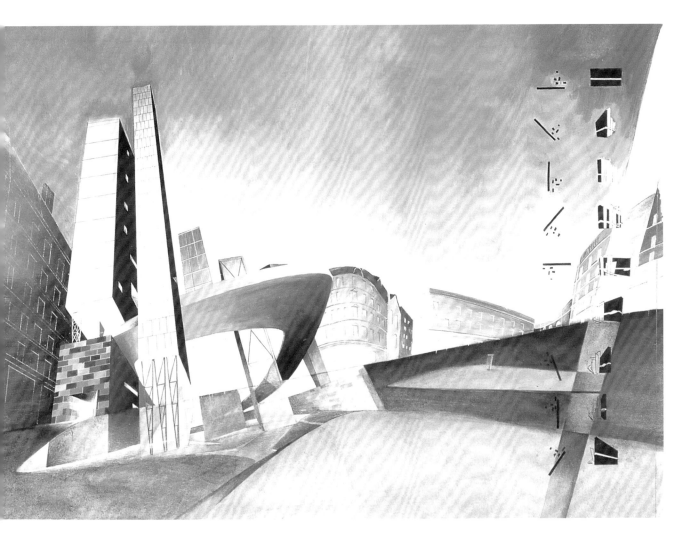

讓過去倫敦最著名的廣場重返榮景的計劃一直延續至今。抱持著過時的規劃限制有可能廢止的前提下，我們提出歌頌都市景觀中各種動態可能性的提案，透過將公共領域延伸到專業的辦公室，如此能將現代建築對都市生活品質的貢獻更向前推進。公共平台、板狀辦公樓和高樓是建築群的核心元素。在最高層設有頂樓公寓的高樓，其下方為地下大廳。一個購物廣場有如被掀起般，微微地彎曲圍繞基地四周，環繞出一個乘風直上屋頂的新公共領域，同時產生一個可俯視著下方車陣的公共露台。當人的眼光在廣場周遭移動，高樓群時而看似穿破廣場的碎片，時而又狀似一塊固實的量體。

從小尺度的住宅基地到大範圍的都市構想，這個研究探討了倫敦的各種層面。我們設想一個由許多屋頂所構成的都市景觀，它們將回應天空與周遭都市環境，有些屋頂可以居住，有些則不能。（這個想法為我們在鳳凰歌劇院[p. 86]的概念埋下伏筆）。在這一地難求、規劃限制又嚴峻的大都市裡，這些被架高的區域，透過將空間在垂直向度上區分出室內與室外範圍的概念，本身就可以被考慮成為新的建造基地。以哈爾金街這個提案的情形來說，頂層公寓的空間就被包夾在既存屋頂和新的屋頂之間。

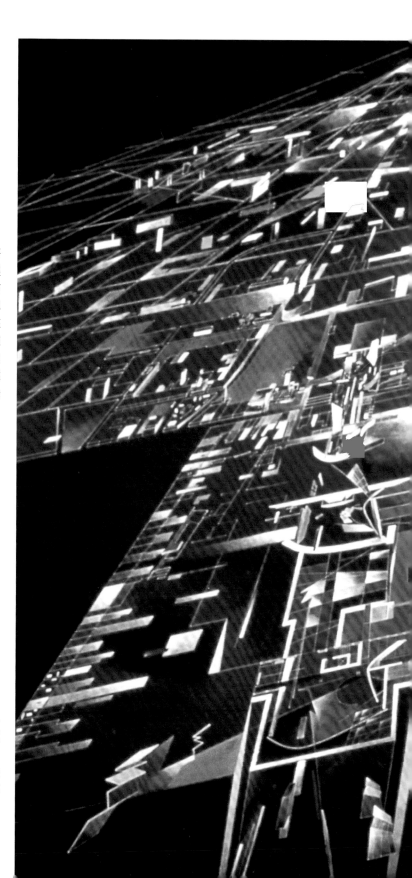

這個裝置的片段想法，於日後成就了卡斯卡特路24號設計案[對頁]，就如同大阪裝置[p. 48]作為後來運用在維特拉消防站[pp. 52-55]中設計原則的試金石。為了在非常侷限的涵構下，尋找新的方法來顯明空間，我們運用了弧形的牆去包覆或彎曲空間（如梅柏芮公寓[p. 24]），並利用遮棚來標明入口。

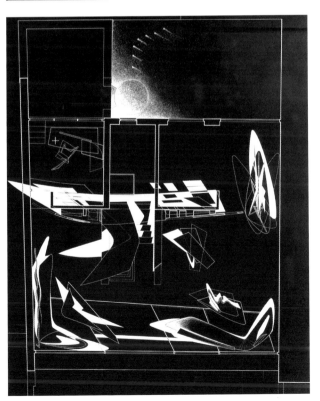

維多利亞時代帳篷的概念經常是反映當時室內的特點，而這次的展覽提供了我們機會，去創造一個與此概念對比的現代版提案。我們的方案是將造型結構置入既存的空間中。因設計主要是由上方來觀看，構造的平面以排除的方式來包含空間——使得這和維多利亞式的帳與幕所創造的圍蔽空間形成相反的效果。

這個國際式樣的住宅，提供了我的「絕對主義地質學」首次材質展示的背景，也是我在伊頓街59號[p. 21]探索的延伸。內裝組合包含了我們的比塔爾家具（Bitar furniture），能創造屬於自己的動態空間，而非僅是在中性的空間容器中扮演雕塑品。透過軸轉、滑動和旋轉，儲藏牆以其門和櫃的實際動態來讓空間更具活力。

1980年代後期，歐美有許多城市對於水岸地區的活化抱有強烈的興趣。在漢堡市舉辦，兩個探索水岸地區再利用機會的工作營中，我們受邀去思考這個城市的歷史港區，特別是從前為倉儲區的倉庫城（Speicherstadt），是否能透過都市的整體規劃以再生這個區域，並滿足各種不同的混合使用。

港岸的開放性和大尺度，以及與市中心的整合，浮現出幾個有趣的課題，而我們曾經於同樣在漢堡的海港街開發案（Hafenstraße Development [pp. 44–45]），以及科隆的萊茵港（Rheinauhafen project [pp. 66–67]）等設計案中，以各種方法處理過這些課題。藉由將都市環境帶入港區，用港口的視野、開放性和無時不在的水，替空間增添獨特色彩，我們為重新開發尋找新的幾何與分區，如此不僅能開創出新形態的都市生活，還能夠為城市網絡注入全新的活力。

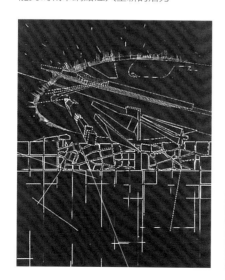

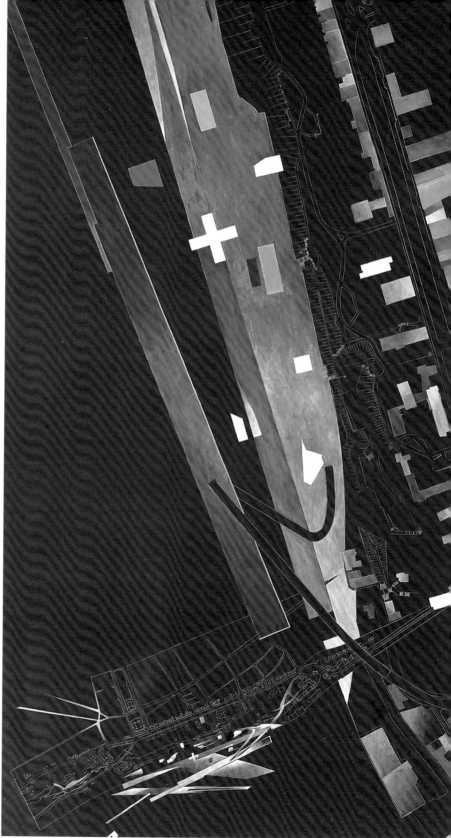

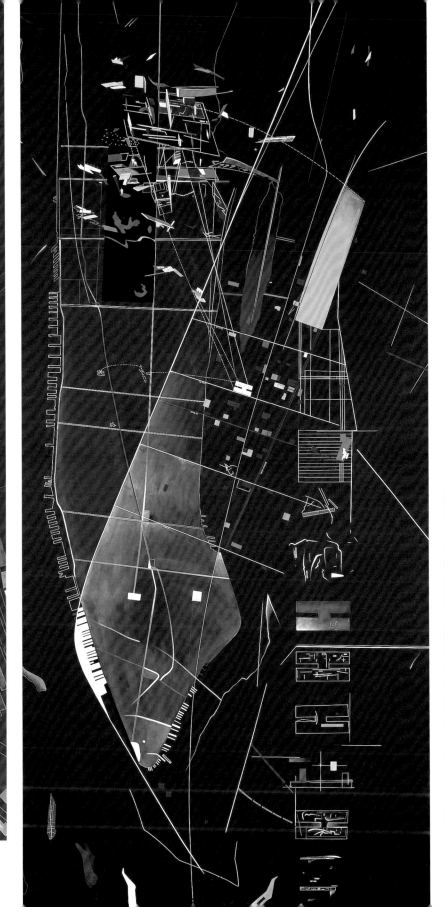

紐約 曼哈頓：新的平面書寫

與一個旅館的改建提案有關，這幅草圖勾勒出重新定義「旅館」與「都會生活」為一系列特定都市功能擁擠至臨界點所產生的機會與變化。從柯比意給曼哈頓的光輝城市（Ville Radieuse）提案[7]作為出發點，我相信這是從根本上誤判了紐約的都市狀況。因為曼哈頓是一個被都市密度強化下擁有許多層面的城區，建設的介入應該要像凝聚壓縮後的爆炸。然而柯比意的願景是要溶解城市，僅以鋪上一大片無特色的現代主義建築，來取代原有的城市。因此我所相信的是，不去侵蝕那維繫城市的網格（grid），但仍有機會去支撐住一個大都會的強度。

譯註7：柯比意是二十世紀極具影響力的建築師。光輝城市的概念在1924年首次發表，並於1933年出版，1935年柯比意造訪美國，以此想法為基礎對曼哈頓提出看法，他認為當時的建築太小並且過於緊湊，因此提出以均勻分布在街道網格上的高樓來取代既有建築，高樓包含居住、辦公與服務設施，故理想上都市將能擁有更多綠地和陽光。

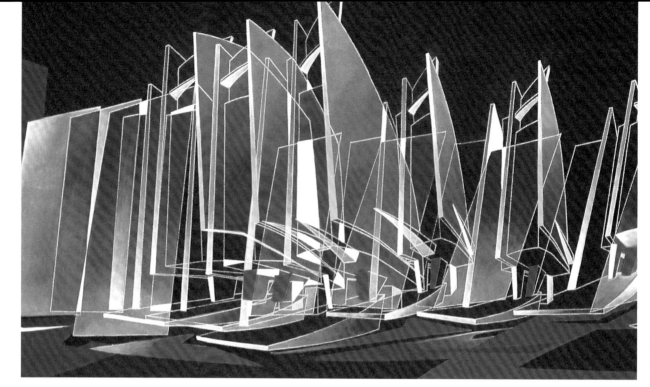

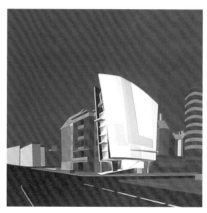

極為狹窄的基地限制（2.7公尺×16公尺），讓我們設計出一個壓縮、卻包含一系列面、空間與用途的「三明治」構造。這個如「三明治」般層層夾出的構築，其橫切面是樓層平面的基礎，它建立了與辦公空間分離的動線和移動方式。在垂直向度上，這個如「三明治」層疊的空間，區分了作為公共入口的地面層，與其上方懸挑的建築體——包含了辦公空間和頂樓雙層挑高的辦公室。大廳與入口抬高於地面，由斜坡道進入，因此讓建築平面可以獨立自主於地面，似乎向俄羅斯絕對主義（Russian Suprematists）的藝術家微微致意。上方建築體的結構由新的背牆拉出，其位於斜坡道上方的縫隙則揭示了主入口。

建築平面輕輕的弓曲，並朝著角落延伸；於是樓地板面積逐步變化，在頂樓達到最大值，而這樣變化所創造的力度，也使這個設計跳脫出一般辦公空間模組的不斷重複。長向的沿街立面，有著藉由鋁製帷幕結構從屋頂懸吊的透明皮層，讓建築成為一個明亮的玻璃盒子，室內的活動也因此可被覺察。

剖面序列[上圖]

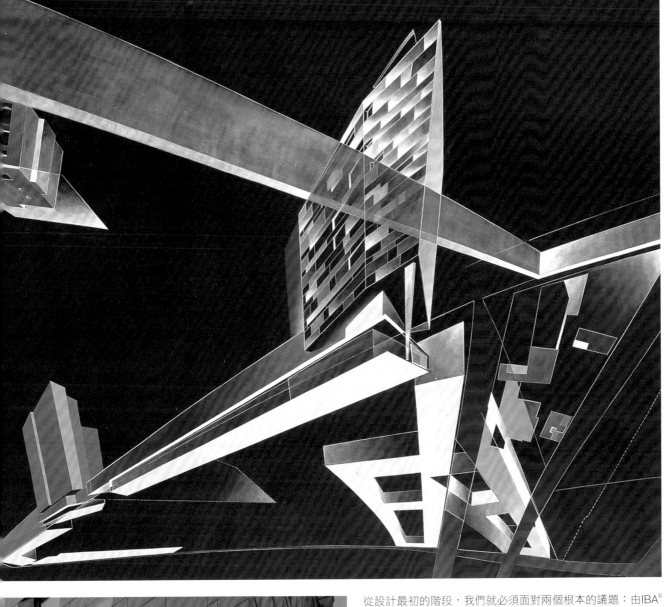

從設計最初的階段,我們就必須面對兩個根本的議題:由IBA[8]所制訂關於填入和修復都市的策略,以及與現代開放平面配置抵觸的嚴格社會住宅法規。除了這些限制,基地周圍的建築物也有著廣泛的類型並建造於不同時期。所以儘管規範明定,在這地區的新開發案必須為平均五層樓高,但是完全遵循規定所做的設計,似乎不太可能與這種不規則的都市涵構契合。

因此,我們詮釋五層樓設計限制的方法,是創造一長條三層樓的量體,並在街角以八層樓高的建築作為結束。較長量體的低樓層為商業空間,而上方則是標準的住宅;屋頂是一個包含了兒童遊樂場的花園。具有雕塑感的高樓以電鍍金屬板為立面,每個樓層含有三個楔型的開放型平面住宅單元。

譯註8:IBA 直譯為國際建築展,是一個大規模的柏林都市更新計劃,邀請了許多國際知名建築師設計社會住宅。

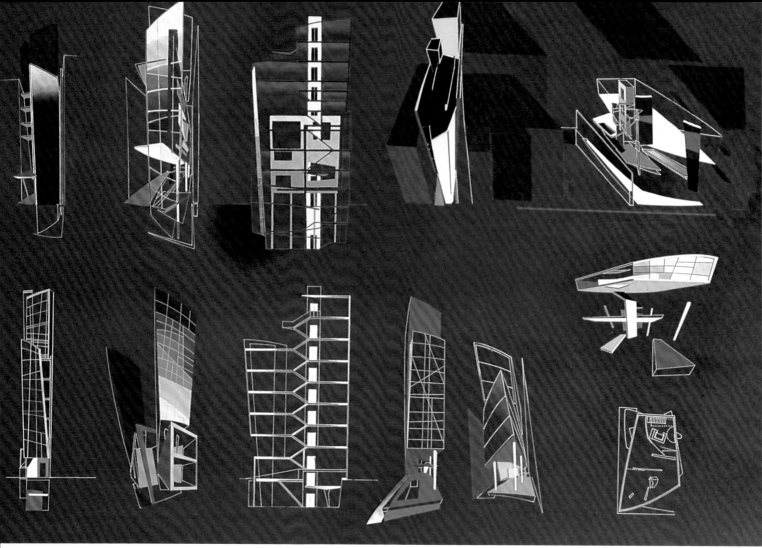

麻布十番和富谷的合併平面與剖面

藉由1986年庫達姆大街的設計經驗[p. 32]，我們理解到釋放空間的設計方法有很大的潛力。在東京（有如電影《銀翼殺手》中的世界）大部分的基地都超出了空間的界線，許多建築物都只是在強化這城市令人窒息的壅塞。

切開地景並下挖土地，在六本木附近許多任意建造的房子形成有如位於都市峽谷般的基地，而這棟建築誇大了其狹窄基地所造成的壓力。簡潔閃亮的玻璃構造被夾在金屬高牆和鋼筋混凝土牆之間，以寶石般的窗戶形成小的開口。在牆與牆之間是兩道帷幕牆——一個有著藍色玻璃，另一個則是透明的——傾斜而出，向上升到露台矮牆的高度。在內部，挑高三層的入口空間中，可以立刻感受到釋放空間所帶來的完整效果。垂直的樓梯從建築中央一路向上延伸到頂部，再有如爆炸般的展開以形成戲劇性的陽台。

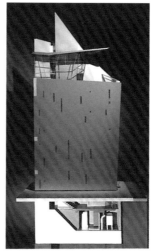
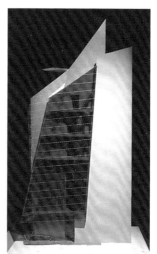

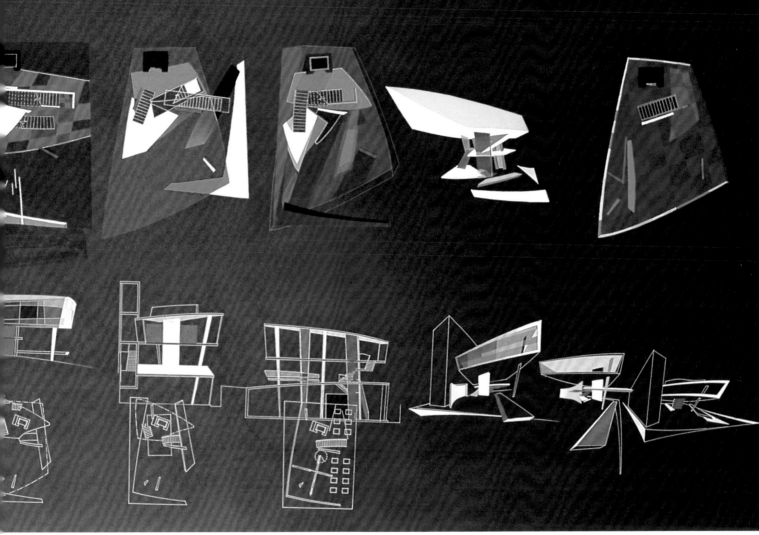

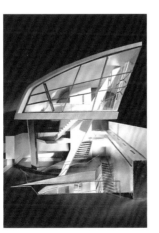

剖面

這個小型、混合使用的設計位於密集的住宅區內，雖然在許多方面上，都與麻布十番〔對頁〕的提案相關，但是設計概念卻是反轉的。建築由一系列懸浮的水平空間與垂直元素所構成，再以盤旋而上的樓梯和平台交互連接，和麻布十番那般將虛體壓縮後釋放出來有所不同，這是一棟化量體為虛體的建築。設計的核心是一個抬高的細緻玻璃盒，有三個面是透明的，懸挑在開放的地面之上。建築的大部分位於彎曲攏起的地面層之下，它從邊界往內拉並包含一道玻璃高牆，這使光線能夠進入到較低的地下空間，而其寬闊的空間比例能彈性支應零售與辦公活動的使用。

在這樣高密度的城市裡，採光和通風向來奇貨可居。我們必須將這些禁錮在基地的空間釋放出來，讓光與空氣得以進入都市的環境狀態。

在此設計裡幾個有趣的層面中，一個是關於相對年輕且進步的
都市區域，企圖在洛杉磯修補其複雜的都市架構中，找到自身
定位。另一個有趣的部分，則是該地區富饒的創意資源——
西好萊塢是美國室內和平面設計師密度最高的地方之一，由鄰
近的西薩・佩里（César Pelli）所設計的「太平洋設計中心」
（Pacific Design Centre）就可以看出，這被暱稱為「大藍鯨」
（Blue Whale）的設計中心，是該城市著名的建築地標之一。

在相對沒有涵構的環境下，這個設計成為我對於「建築作為地
景」最早的探索之一，而該地區平坦的地勢，讓我們能將基地
看作是幾何形狀的地形，這樣的設計方法，其實在之前的拉維
萊特公園[p. 21]等提案中已經出現徵兆。在這個有如城市幾何的
畫布上，物件以一種只在廣闊空間中才會發生的方式，飄浮與
互動。

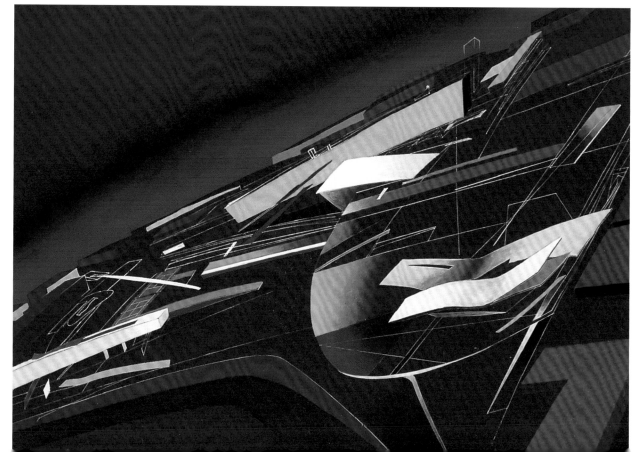

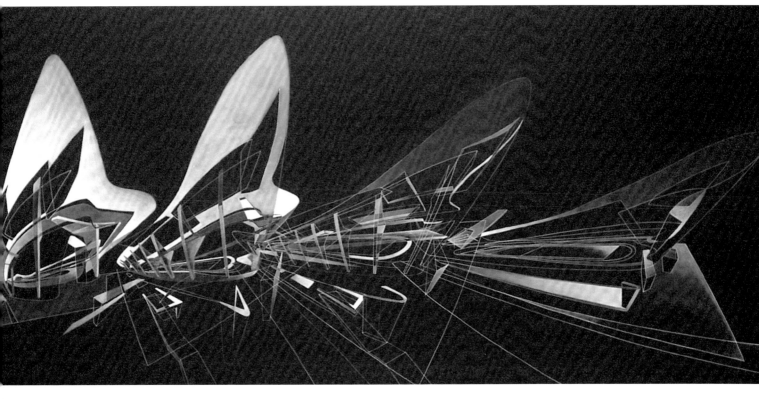

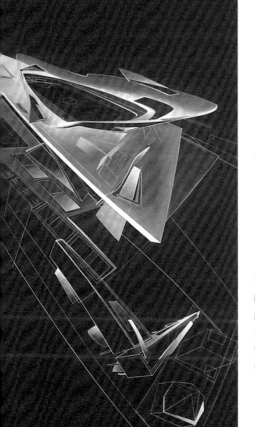

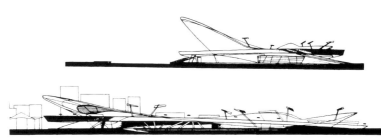

立面圖 [上圖]

阿拉伯聯合大公國・阿布達比 1988

阿爾華達運動中心

AL WAHDA SPORTS CENTRE
Abu Dhabi, UAE 1988

明顯對比於我們在柏林和東京[pp. 32-35]這樣高密度城市所做的設計,這個運動中心的環境,讓我們能夠向外拓展,而非壓縮。因此,這個構造物成為大尺度的地景浮雕,反映並落實到地貌。就某種程度上來說,這個提案代表了我們對於地景的早期探索。設計由三個主要元素所構成:一個平台,同時也被視為一個高架公園,提供進入體育館和觀景台的入口;新的地平面,從街道攀升上來並鑽入平台底下;與體育館,從富有變化的地平面和平台中升起,並可容納多樣的座位安排和使用目的。

這幅作品是受一個探討大都會
各個面向的展覽所委託，於
倫敦當代藝術學會（London's
Institute of Contemporary
Arts）展出，而畫裡有如吶喊
般的紅色，主要是表達一種對
都市失序蔓延的惱怒。某種層
面上，畫中呈現的倫敦是一個
由聚落拼湊出來的城市。 但
與其鼓勵這已經沿革數百年均
勻分佈的都市合併，我們更傾
向將城市描繪成多核心布局，
也就是將許多都市中心凝聚在
不同的焦點上。在這樣的背景
下，畫中的紅色象徵倫敦之
火，表達倫敦需要開發新的聚
落和新的都市核心，去汰換勞
碌疲憊的城市之心。

在1989年柏林圍牆倒塌前，我們受邀來想像關於這個城市的未來。做為整體計畫案的一部分，基地從梅林廣場（Mehringplatz）到腓特烈大街站（Bahnhof Friedrichstraße）軸線和布蘭登堡門（Brandenburger Tor）到亞歷山大廣場（Alexanderplatz）軸線之間，而圍牆的倒下為都市再生提供了新的可能性。我們同時思考著城市的發展與修復，包含從都市開發的廊道一直到「柏林圍牆區域」的建築規劃。

我們以亞歷山大廣場作為願景的重點。由於它表現了少數超越典型十九世紀都市主義的嘗試，所以我們決定捨棄均質的商業開發，因為那會破壞這曾經劃分柏林的敏感線條所形成的哀傷對比。一系列的說明圖，展現了這些新釋出土地可能的發展。廊道城市投射至地景之中，而新的幾何進駐在先前的「無人區」（見下圖），有時是正交狀的，但又與現有的都市秩序略為不同。在我們眼中，牆區可以成為一條線性公園。在這個曾經是帶狀水泥牆和禁區的地方，我們將打造一條以建築為裝飾的帶狀公園。

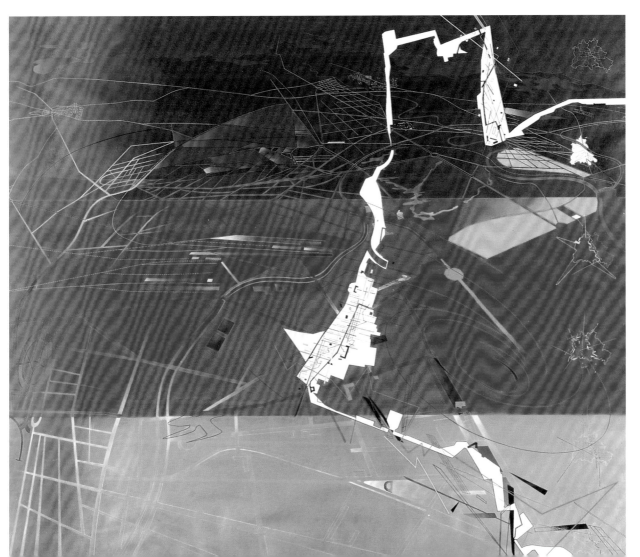

在柏林圍牆倒下之前，基地完美地呈現這個城市如同一座都市島嶼的狀態。雖然位於城市主要軸線的庫達姆大街上，但基地卻是完全的封閉，並且幾乎無法進入。要在如此隔離的環境下建造一座建築物，代表著我們應該要在水平方向上強化都市密度，因此基地被劃分為有著三個不同區域的新空中走廊，並包含了購物、辦公和旅館等三種主要機能。

十字型基地將會成為幾條交通樞紐（街道和鐵路）的新焦點，而新的購物區域則呈階梯狀，與沿著基地邊緣的商店，形成同心的關係。這個圍閉的空間具有玻璃地板，懸浮在更多的商店、旅館大廳、多功能會館、會議中心和餐廳等公共設施之上。疊加在購物設施上方的，是可持續延伸的線性辦公室系統，每一條都能保有獨特的企業辨識度。而在商場與辦公室之上，則飄浮著彎曲的板狀旅館。

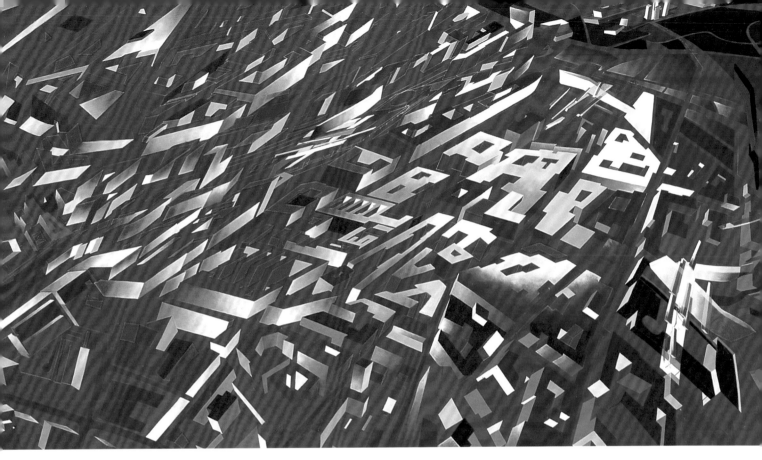

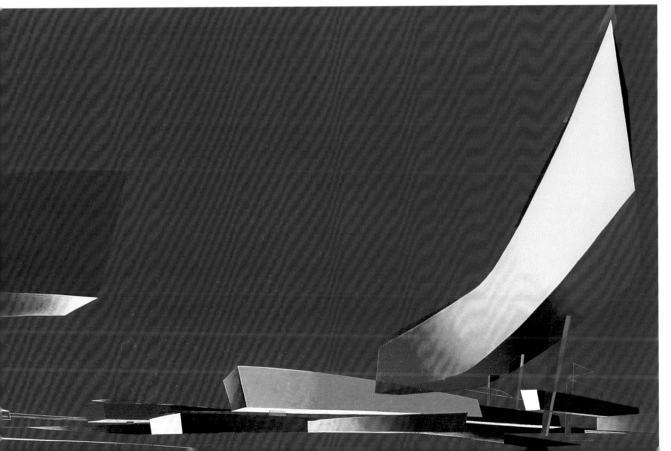

新巴塞隆納

在十九世紀時，塞爾達（Ildefons Cerdà）[9]為巴塞隆納的都市擴張所提出的對角軸線設計策略，是我們重構巴塞隆納的關鍵元素。新的都市幾何，是以些微扭曲塞爾達的對角軸線，來形成偏斜並互相交織的都市片段。當這樣的場域對角穿越都市時，會與富含地區特色的「彈性廊道」（elastic corridor）——不規則地（聚落）、棋盤式地（住宅區）、帶狀地（鐵道與水岸）不斷交匯，引發都市回應並豐富了各區的街道活動。

譯註9：著名的西班牙都市規劃工程師，於1859年提出巴塞隆納擴建區計劃，以整齊的八邊形都市街廓、不同階級混合、對角線大道與提出現代城市規劃中，關於日照、通風、交通等多項進步概念的都市原型為特色，為都市計畫史上寫下重要的一頁。

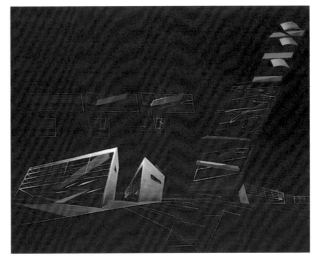

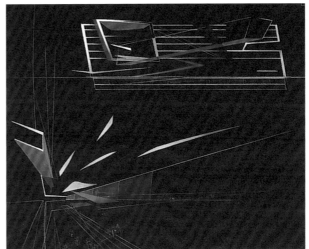

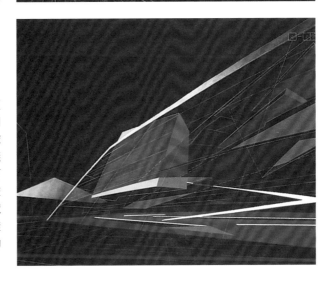

與我們在麻布十番[p. 34]、富谷[p. 35]設計案中所運用的原則類似，目標皆是在對抗東京的擁擠滿載。核心的形式是一個如同玻璃容器的虛體，裡面還有一些較小的虛體則是被更極端的挖空，作為這個建築物內發生文化與會議活動的區域。這些會議區域在空間緊密編排的迷宮裡（宛如龐貝城的平面），透過可變的隔間，既可以是簇群也可以獨立使用。在地面層，這些空間可以經由玻璃地板中劃開的縫隙被窺見。上層則包含了展覽空間、工作室、餐廳和公共區域。屋頂是一座景觀花園，並透過花園中一道斜對角線的切口，讓採光和通風得以進入較低的樓層。

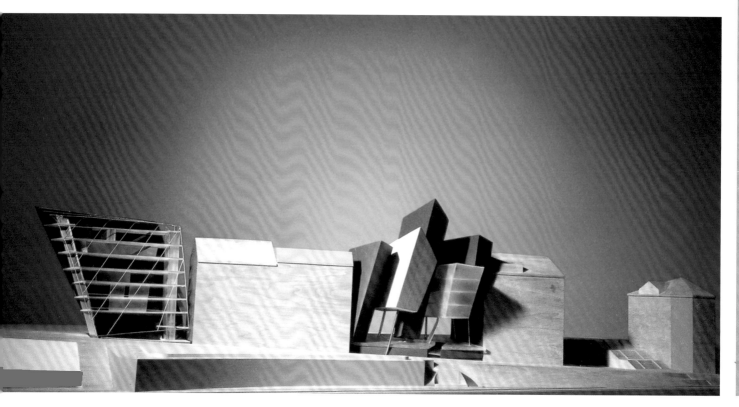

在有著傳統四、五層住宅的舊海港街上,有兩處基地(或者可以用縫隙來形容),即將展開新的開發。這街道和街屋,是一部分朝易北河(River Elbe)逐步下降的都市條紋,這一系列的都市條紋還包含了小公園、新的街道與堤岸。而我們的目標是創造上述平行都市條紋間的鏈結,並將堤岸轉化為休憩區域。

第一個基地位於銳利的轉角。是一個向前傾再往後扭轉的板狀建築,並朝向河岸打開。垂直方向是由一序列商業與住宅的層疊所構成,第一、二層則是公共空間。部分玻璃帷幕是可滑動打開的,這使得每個樓層都有局部區域能成為戶外露台。正對著河的立面則是一片連續的帷幕牆,其向上翻折包覆構成閣樓屋頂。

第二個基地則是位於十九世紀街廓中一道縫隙般的空間。我們提出了一系列壓縮板體(compressed slabs)[10]般的設計,因此,儘管是一個高密度的集合體,卻仍能保有一定程度的透明。當人行經過這個建築,可見構造之間的空隙打開與閉合,從而拒絕了扁平立面的意象。地面層包含零售空間;上方則為住宅單元,並有一些橫向連接板體的通道。這個設計的許多層面,後來成為佐爾霍夫三號媒體園區[pp.50-51]的基本設計原則。

譯註10:哈蒂在這時期的創作中,用於描述建築量體「形狀」的方式。

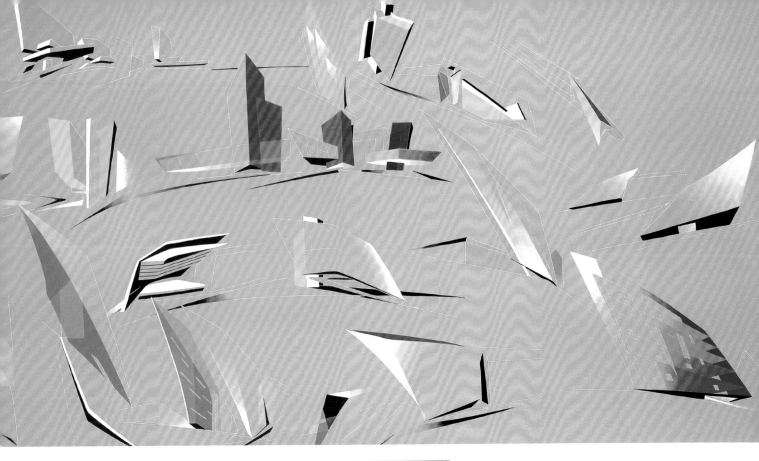

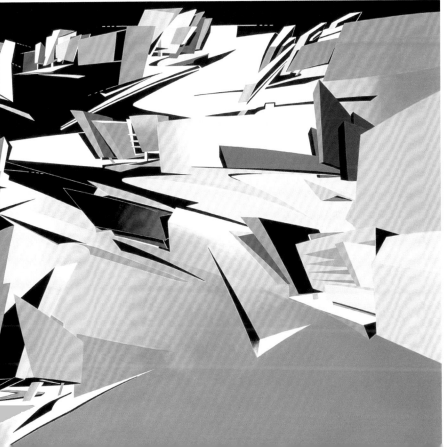

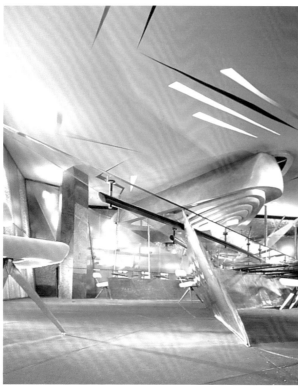

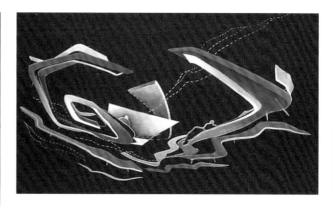

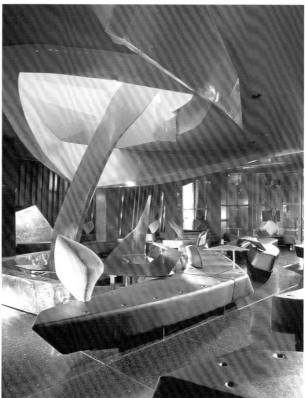

我們想創造一種氣氛上的對比，來同時滿足正式用餐和輕鬆交誼的雙重功能需求。結果設計出兩個既複合又奇異的世界：火與冰。受到札幌季節性冰屋的啟發，一樓的設計運用玻璃和金屬材質描繪冷冽的灰色。桌子宛如鋒利的冰塊碎片；抬升的地板像冰山般漂浮橫跨於空間之中。冰室上方迴旋著一爐火，散發出炙熱的紅色，耀眼的黃色和盎然的橙色。酒吧上方的一條螺懸撕開一樓天花板，捲曲到二樓的穹頂之下，就像個火熱的龍捲風，從壓力槽爆發而出。一條流動的有機形態沙發，藉由可無限重組配置的座椅形態，並搭配移動式托盤和插接式沙發椅背，滿足用餐和交誼的各種需求。

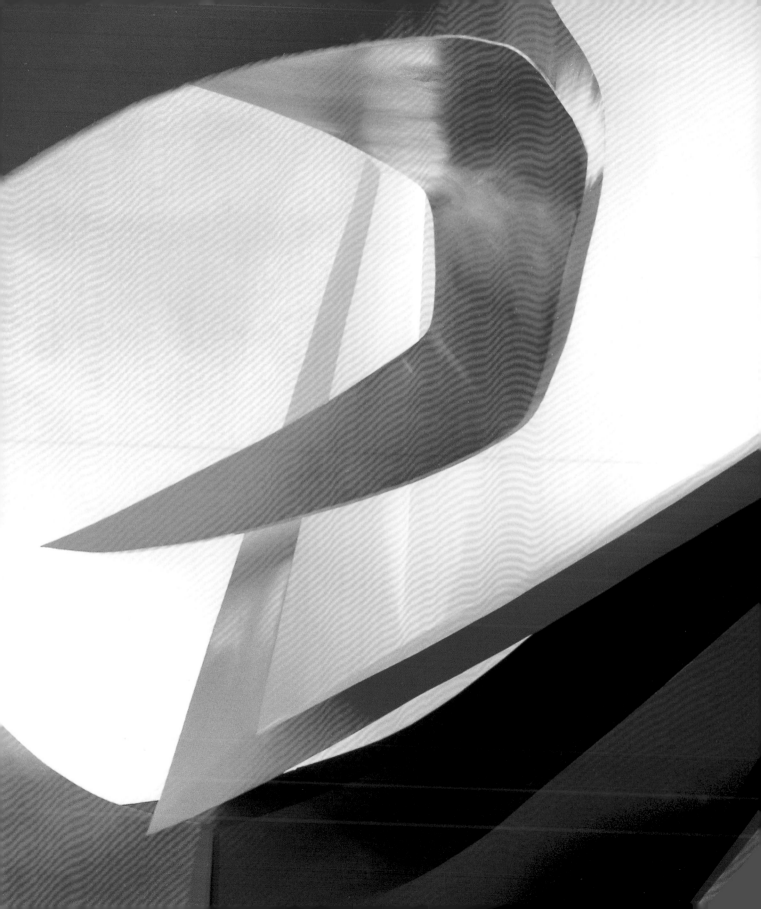

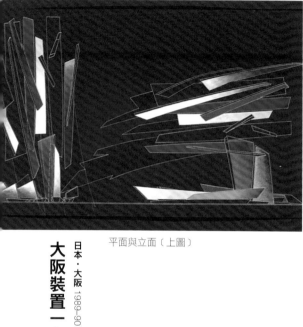

平面與立面〔上圖〕

大阪裝置一九九〇世界博覽會

OSAKA FOLLY, EXPO '90

Osaka, Japan 1989–90

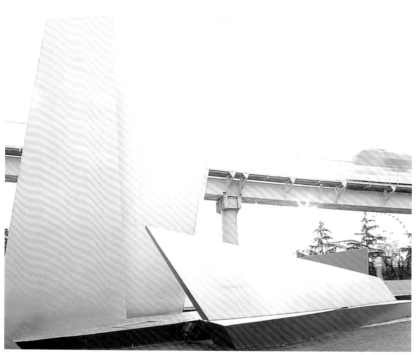

在大阪國際博覽會中，我們的基地位於由數條路徑所交匯的一個開放廣場上。這個設計透過一系列壓縮和融合的元素，在地景中延伸並改變行人的移動方向。從遠處看，兩道垂直矗立的面替這個作品向接近的參觀者示意，當靠近看，水平方向的面界定了構造的範圍，並創造一連串的峽谷空間。不同於飛躍的面，五個大小不同的坡道沿著地平面伸展開來。這些動態的水平和垂直元素，交織出許多意想不到的角落，提供參觀者在馬不停蹄的走訪中一個臨時的庇護所。

透過這些成群和扭曲的牆板，我們也可以將大阪這個案子視作維特拉消防站[pp. 52–55]縮小二分之一尺度的實驗裝置。

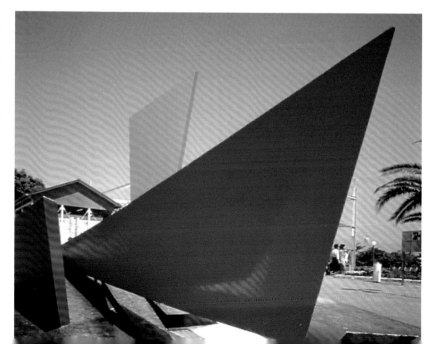

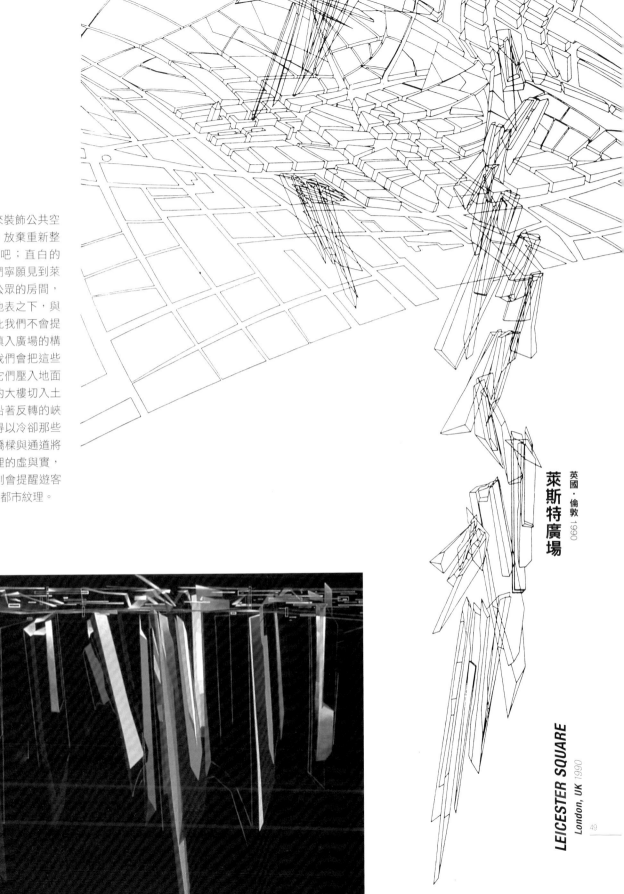

透過設計新的噴泉來裝飾公共空間的構想是多餘的。放棄重新整修既有廣場的期望吧；直白的說，廣場已死。我們寧願見到萊斯特廣場作為一個公眾的房間，可以居住並潛藏在地表之下，與城市命脈相連。因此我們不會提出用建築物或噴泉填入廣場的構想；而是相反地，我們會把這些構造反轉過來，將它們壓入地面之下。扎實和透明的大樓切入土地將會提供居所，沿著反轉的峽谷傾瀉而下的水，得以冷卻那些過度勞碌的心靈。橋樑與通道將穿越新地下都市紋理的虛與實，而縫隙透下的光，則會提醒遊客那盤旋在上方熟悉的都市紋理。

英國・倫敦 1990
萊斯特廣場

LEICESTER SQUARE

London, UK 1990

49

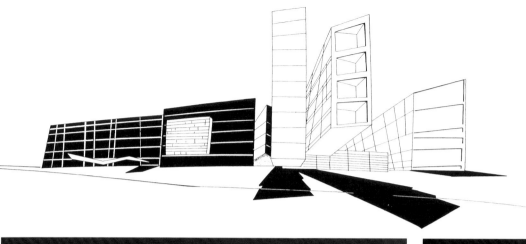

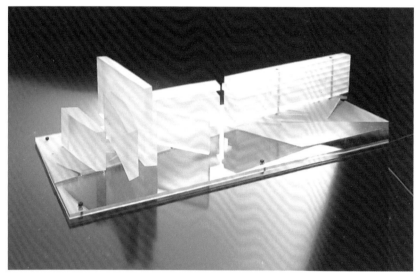

佐爾霍夫三號媒體園區

德國‧杜塞道夫 1989-93

ZOLLHOF 3 MEDIA PARK
Düsseldorf, Germany 1989-93

為了重新開發杜塞道夫（Düsseldorf）的著名港口，使其成為一個具有廣告公司、工作室、並穿插商店、餐廳和休閒設施的媒體產業園區，我們創造了一個面對河流的人造地景，它也成為水岸活動和功能的延伸。這個地景受到一個90公尺長如高牆般的建築保護著，建築內包含辦公室，同時也具有隔絕交通噪音的功能。從河流向園區看，一個巨大的金屬三角形切進基地，刺穿如牆般的建築形成一個入口坡道。相鄰的地平面有如裂縫般的開口，向北揭露了專業工作坊、商店和餐館。在地面下，一段技術服務功能的牆被壓縮，使得一部分的牆體抬升到地面之上，並彎曲圍塑出一個320人座的電影院。

高牆建築沿街的混凝土立面上，有許多小型線性切口；沿河的面，則以不同深度的出挑樓板（cantilever），來彰顯各層的變化。一個玻璃的「手指狀」建築是由一系列各自分離的板體組成，它們垂直於街道，就像是玻璃碎片破牆而出。而這些板體匯集處，有一個彷彿被挖掘出來的虛空間，是設置會議室和展覽的區域。入口大廳位於高牆和手指狀建築的交匯處，是個被一系列具有雕塑感的基座，與厚重的三角形結構所圍繞的簡約玻璃盒。同時這個玻璃入口大廳，也將街道與河景做了視覺串聯。一條大樓梯像緞帶般地由上懸吊而下，引導著人們穿越厚重的板體之下，向上前往會議區域。

50

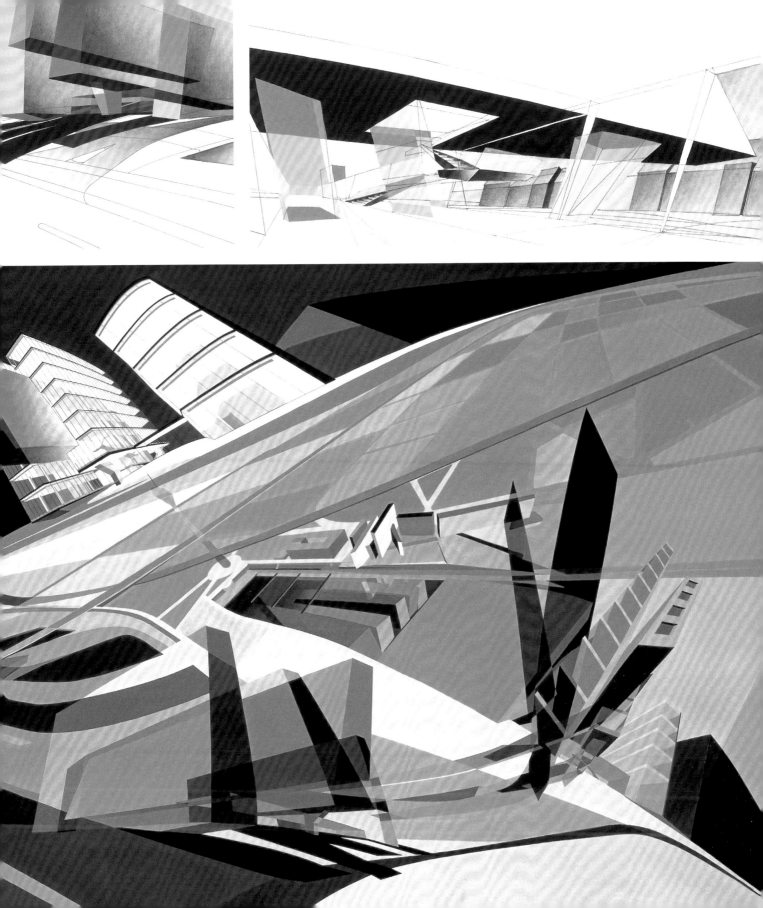

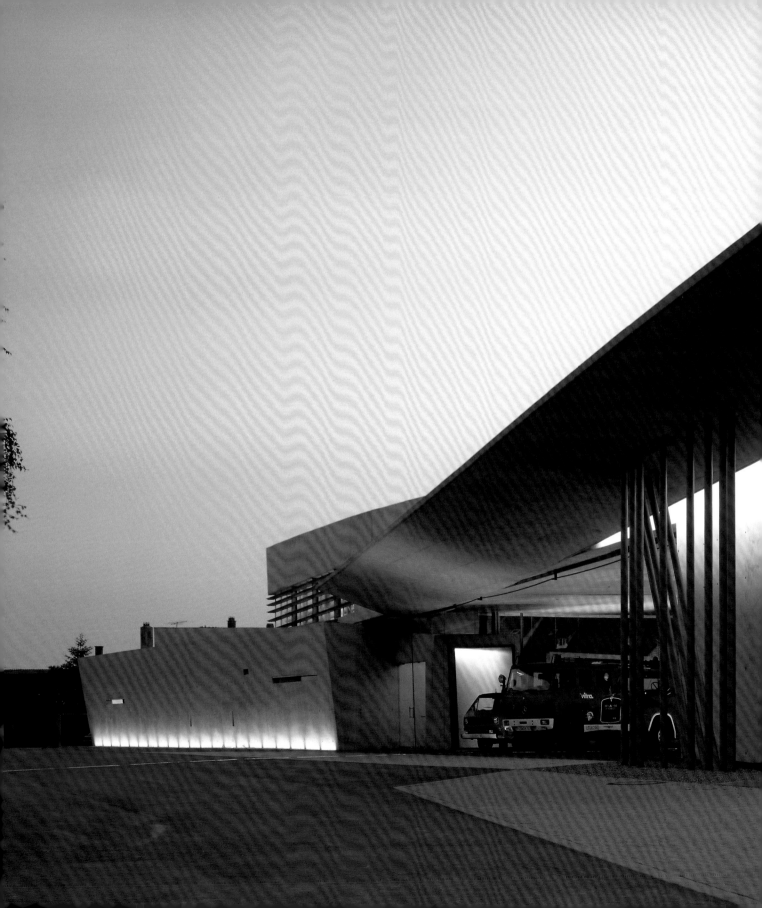

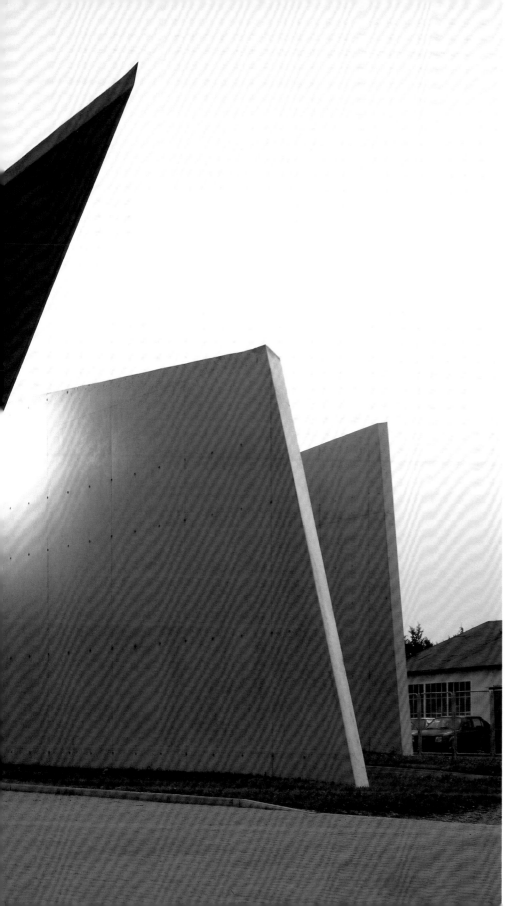

維特拉消防站

此一委託案原是在瑞士家具維特拉廠區（Vitra）東北部建造一個消防站，而後設計需求計畫擴及了圍牆、自行車棚及運動場。此新建築的空間定義功能決定了它的建築設計概念：一個線性的、層疊的牆壁系列，消防站即處於這些牆壁之間，並根據機能需要對這些牆進行開孔、傾斜和斷開。

現在作為活動和展覽之用，這棟建築物僅能從垂直的視角揭示其室內空間。當訪客穿過消防站的空間，可以瞥見大型的紅色消防車，它們的運動軌跡被刻入柏油路面之中，彷彿一系列的編舞記號。整個建築是運動與凍結，它表達了消防站處於隨時待命狀態的張力，以及隨時可能行動爆發的潛能。巨大的滑軌門形成會移動的牆壁，好似能夠滑過彼此。

該建築是由現場澆灌的清水混凝土構成，邊緣的銳利程度被特別地關注，同時也避免屋頂收邊和貼面（cladding）的細節，以免分散了稜柱形量體的簡單性。無框的玻璃，滑軌門和照明系統也同樣地不做細部，好讓光帶（lines of light）引導這些必須保持精準而快速的移動，穿過這棟建築物。

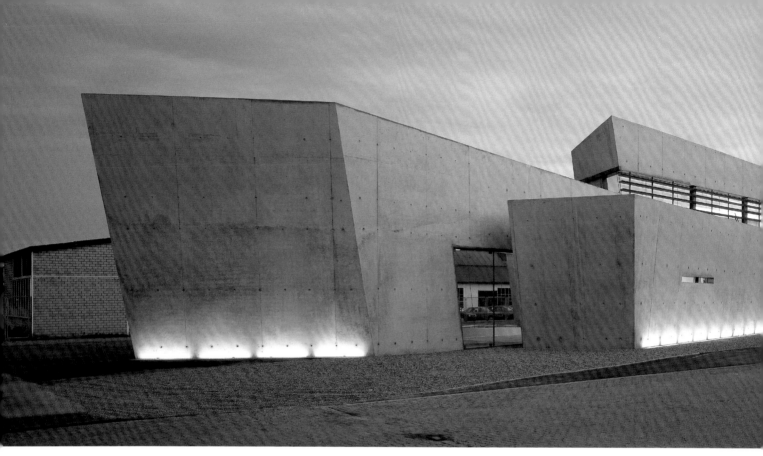

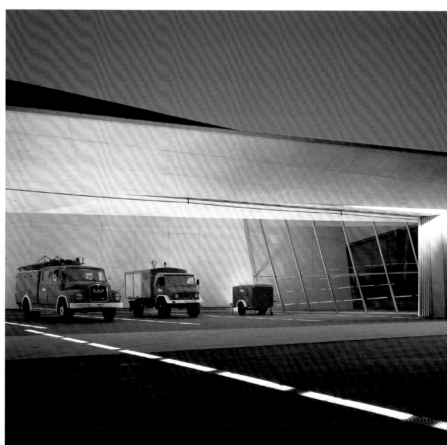

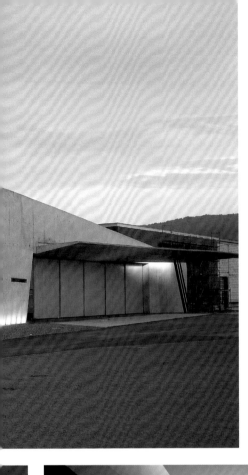

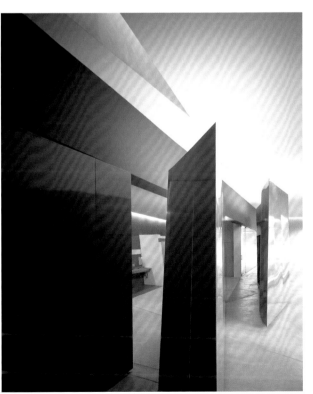

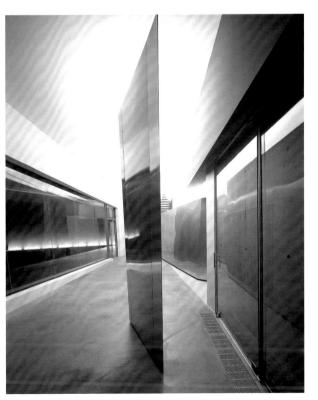

我們的音樂影視館的設計意圖，是在城市中此一對我而言最具挑戰性的位置──魚市場（Vismarkt）區中，具紀念性的阿教會（Aa-kerk）哥德式教堂和科特海納（Korenbeurs）新古典歷史建築之間，做出一個有趣好玩的地方。就像是紐約度假勝地火島（Fire Island）上一些如同「螢幕」一般，有著大窗且面海的板牆房屋，到了晚上顯露出高大的內部風景，這個館的設計也希望能提供一個對外世界的櫥窗，讓移動在影視意象之間的人們，成為櫥窗表演的一部分。

突擠到玻璃外殼內的甲板，被夾在兩個距離相隔一公尺牆壁之間，影像從上層甲板投影到中層甲板上、玻璃幕牆的半透明面板上，以及下方抬升的地面上。雖然製作短片花費大量的精力與經費，但單單影片仍是不足的。在此，我們想要讓影片製作者、表演者和製作人有一個可藉以進行實驗的框架結構。

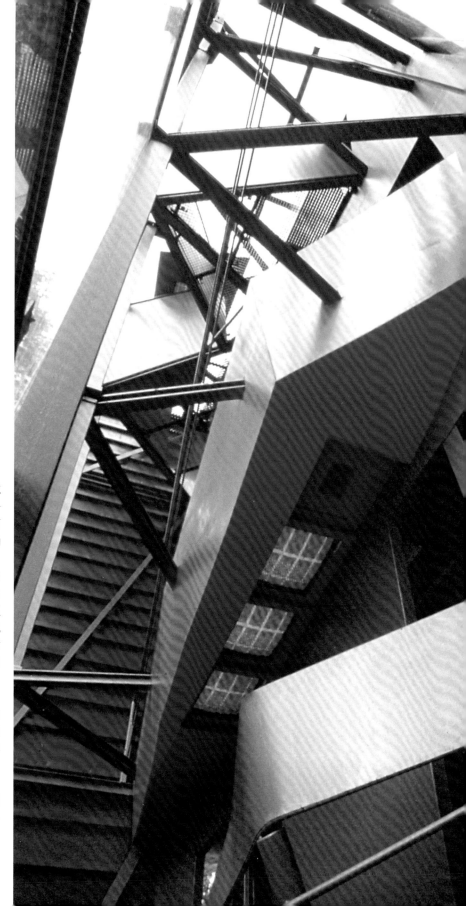

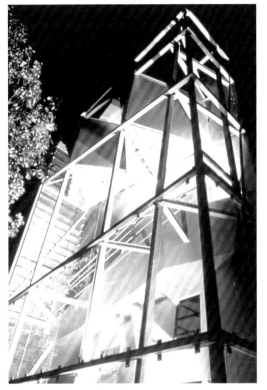

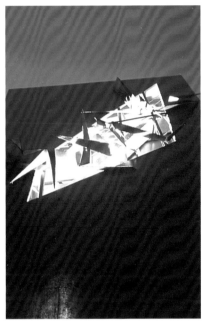

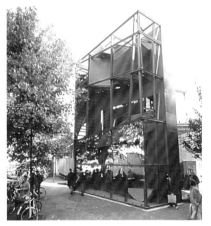

備選提案（alternative proposal）：平面、立面、剖面，及結構框架。[跨頁最左圖]

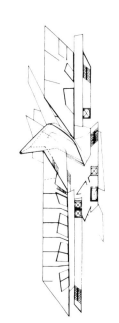
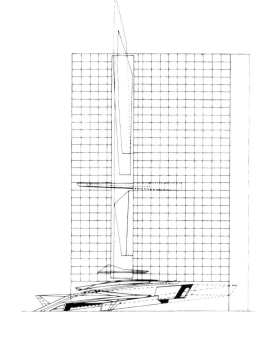

如同許多美國城市，阿布達比的城市也是建立在一個棋盤式的網格上。網格是個規律整齊的結構與建築的基礎，卻也成為特殊建築「事件」的阻礙。對於此一位於城市主要地點上的複合飯店，我們將這個水平向的城市網格翻轉成垂直面，於是出租公寓和飯店客房所構成的一個板狀量體，就成為了飯店中相關設施的背景牆，包括會議室、餐廳和健身房等。就在板狀量體裂開成兩棟之處，上述這些空間被懸掛在一個「垂直的中庭」之中。在地面層上，一個四層樓高、如同橫樑的量體切過基地，並穿過板狀量體，容納位於其頂部的辦公室與底部的商場。位於橫樑量體四樓的是飯店大廳，可俯瞰海灣風景。從基地一角蜿蜒而來的坡道，圍繞著板狀量體，並穿入垂直的中庭，通達飯店大廳。

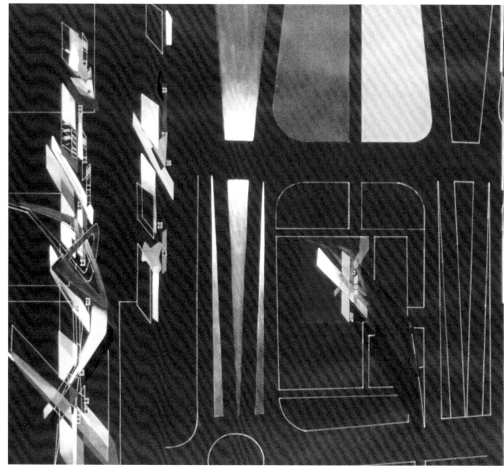

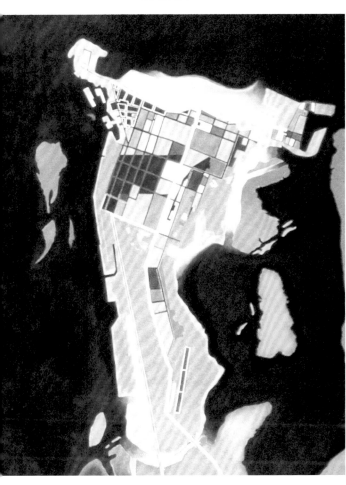

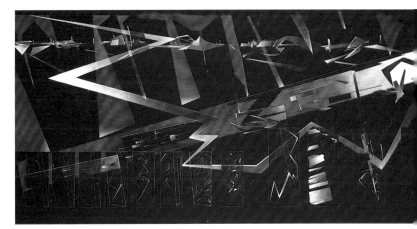

德國・Gluzendorf 1990

一九九一 國際家具零配件暨五金建材展

德國木材製造商要求我們創造一個展示架,以便在兩年一度的國際家具零配件暨五金建材展(Interzum)展示他們的產品。我們主要的設計企圖是創造一個能讓人以多個層面進行體驗的獨立環境。在大型而枯燥乏味的貿易展背景環境中,我們想在一個封閉的結構之中,誘發一個隔絕的景觀感。在裡頭,一條中央路徑像是一棵樹的樹幹,上頭有著展開的分枝,引領人們通達產品展示區和周邊環境。

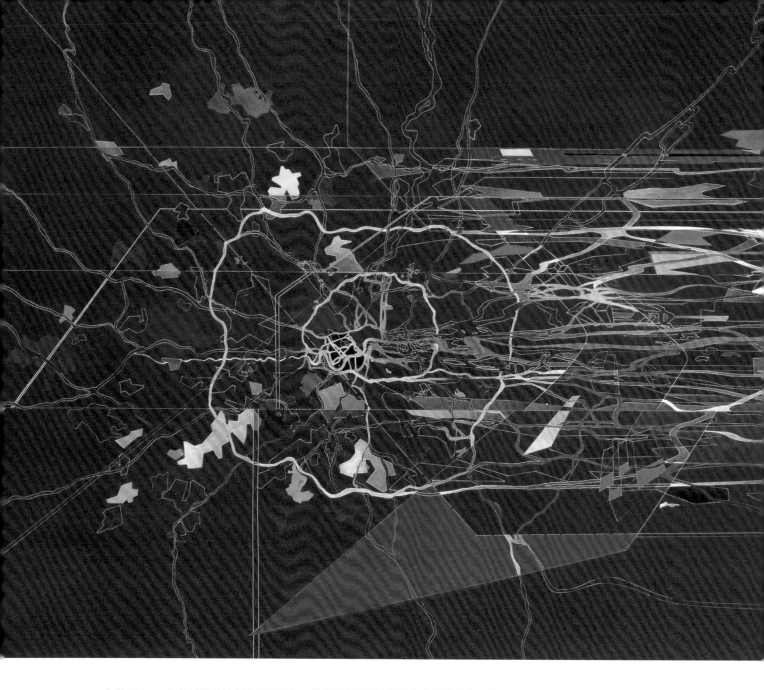

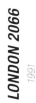

為英國Vogue雜誌繪製的這幅大尺度畫作，延續了我們對倫敦城市特徵的探索，其開始於「主建築」（Grand Buildings）[pp.25-27]，「大都會」（Metropolis）[p.38]和「萊斯特廣場」（Leicester Square）[p.49]計劃。這幅作品在一幅畫中以圖解和繪畫的方式呈現了我們對城市最激進的震盪 —— 而它本就應該以這樣的激進性來加以評判。我們研究了開放空間、鐵路、道路、水路、航路、行政區佈局，並且重新組織了整個計劃。隨著筆刷從西方刷過倫敦，產生縷縷線條的收斂、伸展，並向東延續，這些筆畫刻劃出空中和地面的區域劃分線。由於這些地點上的垂直結構與地面之間形成重要的交點，加上地面層公共活動在新的計畫中將被強化，我們相信這些區域將成為新興的建築基地。

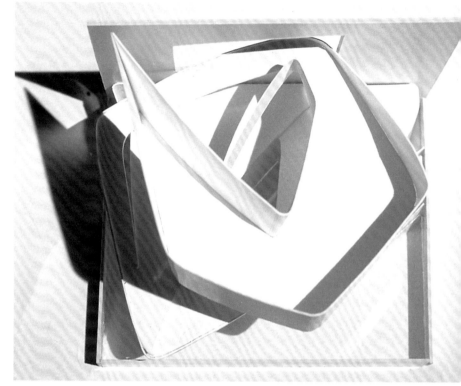

荷蘭 · 海牙 1991

海牙別墅

「十字形」住宅草圖[下圖左]；「螺旋」屋剖
面[下圖右]

在海牙住房節（Hague Housing Festival）期間，我們呈現了兩個設計，做為在城郊由八個別墅所構成「場域」的一部分，這些別墅對國內傳統的空間配置進行抽象（abstract）操作，以創造意料之外的空間互動和社會互動。第一個設計是一個「十字形」住宅，由一個地面層的墩座與兩個「樑」相交而成，容納大部分的居所。下方的「樑」被用來切挖地面層的墩座，「負的」空間形成了中庭。在上方的「樑」則是「正的」，裝入開放的起居室和工作室空間，漂浮在墩座上方，並跨過中庭。而「螺旋」屋在本質上則是一個立體，地板從入口平面向上旋繞，穿過這個立體，通過起居區後再轉進工作室，偶爾還會戳穿，跑到外部。玻璃外牆循著地板的螺旋形描述了一個旋轉動作，上頭間雜地出現厚實的、格柵的、半透明的以及最後的透明板片。外部立體和內部螺旋間的空際中，遺留下來的不連續空間呈現了令人驚訝的景觀，也提供了人際溝通與互動的管道。

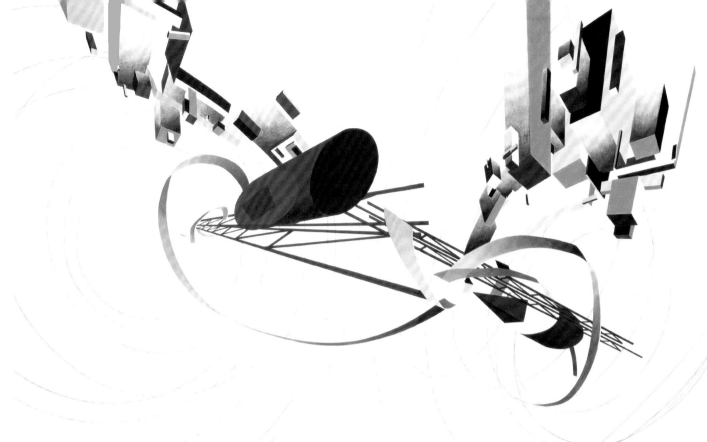

這個為紐約古根漢博物館的俄羅斯絕對主義和構成主義
（Constructivism）展覽所做的設計，提供一個機會，讓我重新
回顧了學生時期在《馬列維奇的構造》[p.18]這件作品中對三維
性的探索。我們的展覽提案有《塔特林塔》（Tatlin Tower）和
《馬列維奇的構造》兩個大型裝置，它們都以其自身的方式與
萊特（Frank Lloyd Wright）設計的螺旋形接合[11]，而後又再受到
空間影響所扭曲。這是《馬列維奇的構造》第一次成為可使用
（habitable）狀態：因為參觀者不得不通過它到達上層畫廊。

展場的設計使得馬列維奇的《紅色方塊》（Red Square）和弗
拉基米爾‧塔特林（Vladimir Tatlin）的《邊角浮雕》（Corner
Relief）在其中形成對比[12]。對於原出自1915年《0.10》的展覽
作品，馬列維奇的構圖在地板上伸拉開來；在《黑室》（Black
Room）中，展示了1921年《5×5 =25》中展過的作品[13]，展示
在透明壓克力上的畫作，看起來是非物質的，並飄浮在空中。

譯註11：指展場所在建築物——紐約古根漢博物館的螺旋體。
譯註12：哈蒂的創作受到俄國抽象藝術強烈影響，在這個展場設計中展現與
這些啟發她的藝術作品建立連結的高度企圖，展場空間不僅做為展示作品
客觀而中立的背景，更是主動地與藝術品進行互動與對話的展示空間。
譯註13：文章中提及的藝術作品，曾經分別在1915年《0.10》、1921年《5
×5 = 25》兩次抽象藝術展覽中展出，歷經多年，在這個由哈蒂所做的展覽
設計中重新組織後再次展出。

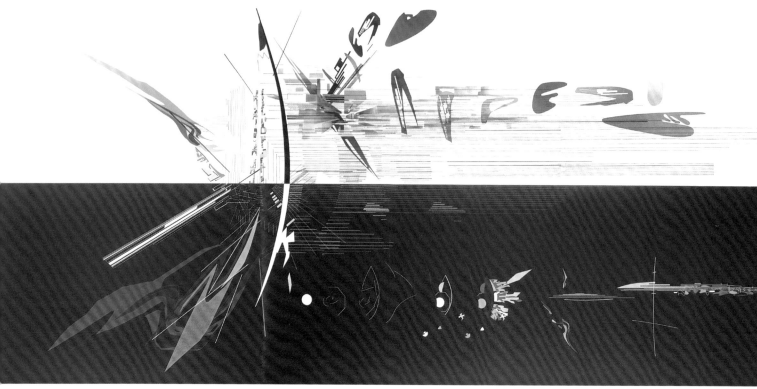

歷史上，馬德里的都市成長可被描述為宛如多重外殼的連續爆開：圓形的中世紀城市、加上十九世紀的網格、與當今二十世紀由橢圓形高速公路所定義的線性發展（linear development）。受到西邊曼薩納雷斯河（Rio Manzanares）的框限，馬德里目前的成長主要朝東邊擴張，在城郊的住宅區已快速成長到越過了M30高速公路，並即將吞噬附近的鄉村。我們的目標是防止這個城市的崩解失序，並對這種無政府狀態的發展加以引導和組織。為達到這個目標，我們提出四個特定區域的重建和再生計畫。在南部，過去城市中鐵道周邊的工業紋理將轉變為有生氣的公園和休閒景觀；新的商業發展將集中在通往機場的帶狀廊道；將新建築物置入既有的縫隙，或將公共空間置入開放的口袋空間，以強化南北軸線——卡斯蒂利亞大道（Paseo de la Castellana）；最後，郊區尚存的空地將會予以保留。

平面圖，第一層（星形），第二層（螺旋形）和第三層（十字形）[左到右]

這個藝術旅店增建案有一個有趣的脈絡：一個半木造結構的農舍與馬廄，業主想要一個有挑戰性的新結構，並具有雕塑性的表現。設計的核心是一個「液珠狀」（blobby）——在新舊建築之間進行調和的橢圓形空間。部分空間成為建築物基礎，同時，該空間也可用作表演或展覽。在這個活力十足的樞紐點上的塔樓，是一座基於十字形和星形的三層空間，每層皆自給自足，並有家具和內飾。第三個主題——螺旋，由其他兩個空間共用，並藉之連回主樓。在一個具有濃厚地方性格的鄉村中，這個設計形成了顯著對比，意圖鼓勵辯論和創造力。

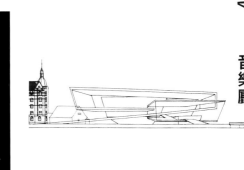

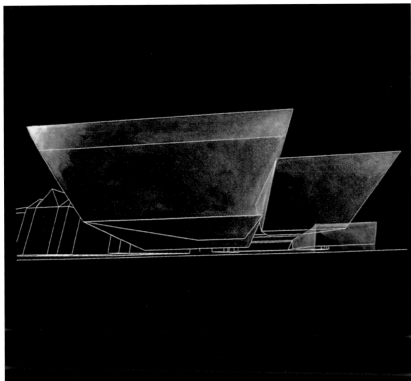

座落在緊湊的基地上，這個大尺度結構藉由在實（solid）的量體中，對光、陸地和水進行深邃的切削，獲致了空間的緊湊和開放。這些銳利的切削向天空打開，展現了大廳的完全釋放。一個彎曲對角線的削切劈開了公共廣場，將長廊慢慢地帶進建築物。此具有雕塑表現性的結構量體群，以不同顏色的花崗岩塑造其間的流暢性，量體之間形成空間壓縮。結構以現場灌鑄的鋼筋混凝土製成，以適應不規則形狀的樓板。

萊茵港區之再開發

為了將這個過去的工業區連接至城市，我們使用了三種不同的形體——梯形、楔形和螺旋形，來定義這個多用途場地，並使之適應其異質的環境。這些形狀是巨大的、不明確的實體，並以不同尺度介於建築物和地面之間。這些部分組合起來，包含了文化、休閒、居住和商業設施，形成了密集而和諧的區域，同時透過機能轉型和新結構置入將老建築融入。

梯形區域擁抱整個港口區，內有兩個碼頭建築，包含了船舶設施和船運旅客中心；北側區域則是一個會議中心。在梯形和楔形區域之間，升起傾斜的辦公大樓群。楔形部分自萊茵河畔切割出來，插入烏比夷環城路（Ubierring）地區，將河岸連接起西弗林（Severins）住宅區。集合住宅設計成狹長而水平的量體，有如過去的倉庫建築，立於椿上、底部懸空抬高，以便讓水岸景觀不受阻擋。螺旋體連起羅馬公園（Römerpark）與碼頭區，跨越著河畔道路的一部分。在整個基地中，新的文化中心被設想為散落的寶石，隨著季節更迭與河水流動映照出水光變化。

基地配置[下]

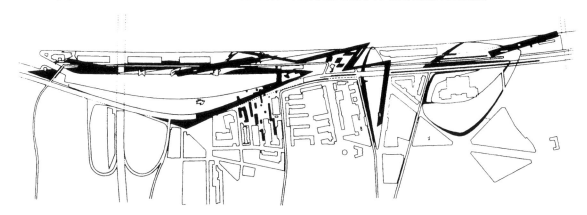

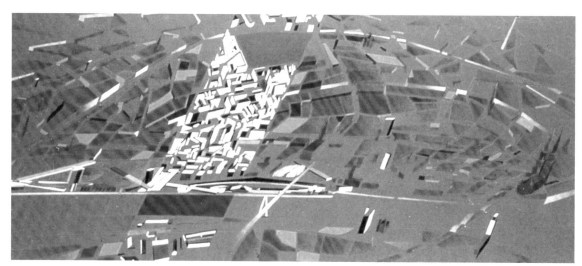

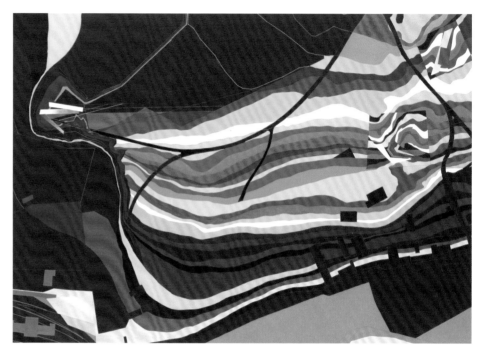

考古遺址的迷人之處，就在於人類文明遺產融入於地景，與自然融合。基於這個觀點，我們希望這個山腰上的文化公園建築——包含一個地質中心、戶外劇院、眺望台和博物館，能成為地景中又一次的人為延伸。這些建築物將是新文化的第一批考古碎片，隨著時間它們將逐漸棲居於周圍的採石場，這些碎片意味著一種反轉的考古學。

地質中心就位在山區的歷史之中，過去的採石活動，像刀刃般切開地層，露出的基岩就成為展覽的一部分。樓板相互傾斜，像是一些斷層面；一個嵌入山脈，另一個則順沿山坡。戶外劇院被設想如同沿著地形等高線而建的希臘露天劇場，彷彿是在採石場中的一個「偶遇的寶石」。在這個「負」的、被挖出的空間中，出現了一個「正」的投射，懸挑在斜坡之上，隨著時間的推移，逐漸從基地高原上結晶而出。博物館再現了在其他三個案子中探索的概念交集，地表爆發並將一些大尺度板塊推向空中，有如地質露頭一般。

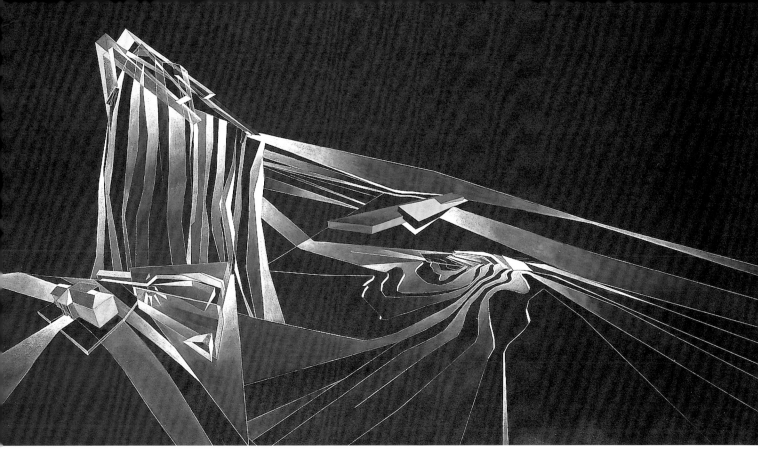

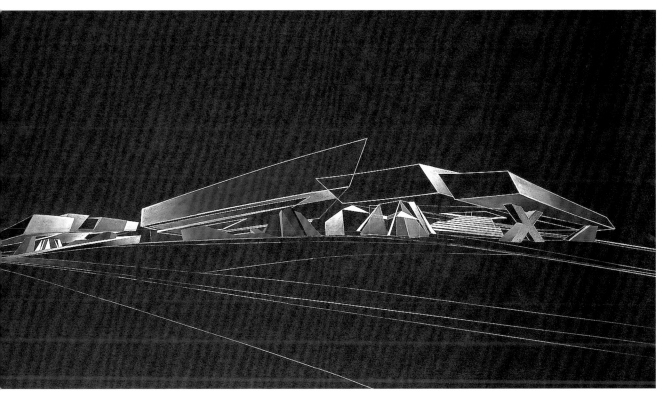

我們提出的設計企圖體現兩個經常互斥
的城市設計範型（paradigm）：「紀念
性」和「使用空間」。此案是形成歐瓦
貝森廣場（Oval Basin Piazza）的連續建
築量體的一部分，但其本身就是水岸邊
的強烈地標。在外部塑造較大型的城市
公共空間，同時包圍著一個僻靜的內部
空間，這種典型沿著基地週圍分佈量體
的二分法，在此被消溶於這兩種類型空
間之間的連續體中，透過三種互補手段
而得以實現：提高邊界高度；打開邊角
指向碼頭，以展現音樂廳量體做為基地
內的主要實體；最後，延續公共空間，
以一個平緩的斜坡將廣場延伸至基地，
在主要的門廳區建立新的地面層。

於是，這個設計提供了一個適合戶外表
演的抬高廣場，可以欣賞到內港和海灣
的景色。建築概念基於被服務與提供服
務之間的空間層次表現；音樂廳和其他
公共或半公共表演和排練空間，像是具
備理性對齊及結構支撐的一圈珠寶一般
地湧出。然後，這個圈環繞著基地的
周邊，像一條內外反轉的項鍊，所有的
「珠寶」都轉向彼此，創造出一個集中
的公共空間，可以讓觀眾從中心進入，
同時又可從周圍的背側進行服務。這個
中央空間也可從露天中庭或地下的前廳
空間而經歷。音樂廳和主要排練室穿透
了這個抬高的地面層。在這個平面上的
切口，標誌著由出入口而來並穿過空間
的兩條軸線，分別來自歐瓦貝森廣場的
行人入口，及皮埃爾街的大廳出入口。

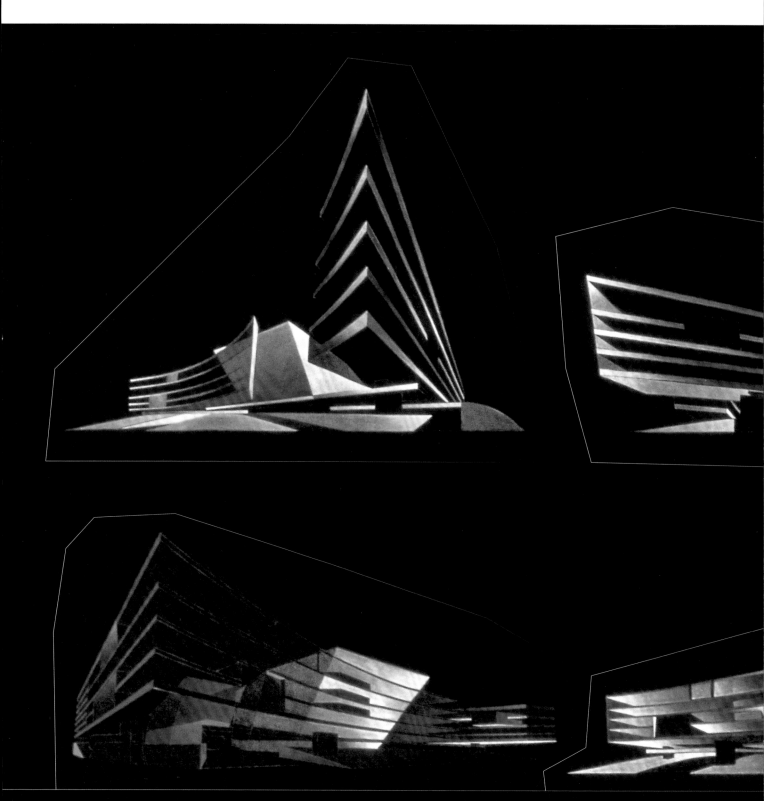

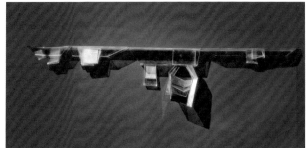

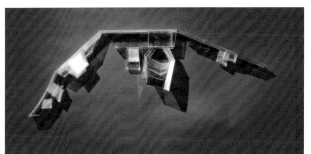

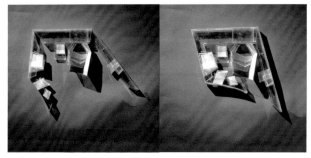

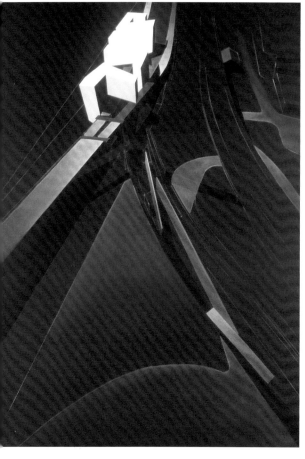

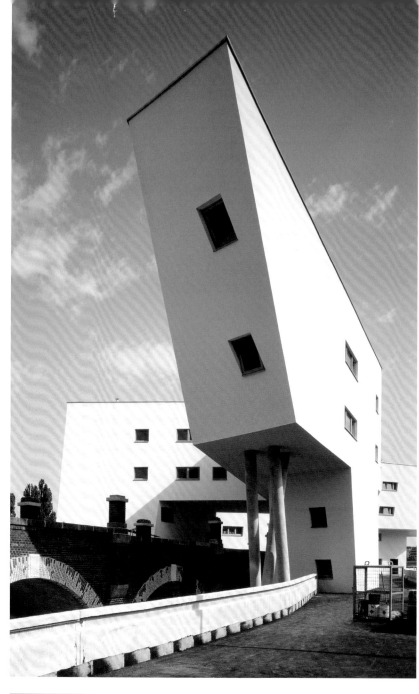

斯匹特勞高架橋

奧地利‧維也納 1994-2005

SPITTELAU VIADUCTS

Vienna, Austria 1994-2005

本案是維也納市為環城帶（Wiener Gurtel）——通過城市紋理的環形切片，所進行振興舉措的一部分，這個基地顯著的特徵是密集重疊的基礎建設，其中包括維也納最頻繁行駛的多瑙卡諾（Donaukanal）公路、沿著堤岸繁忙的自行車道，以及維也納鐵路系統中具歷史性的部分區段，特別是由奧托‧華格納（Otto Wagner）[14]所設計的一段已列入保護的高架橋。設計中一系列的公寓、辦公室和藝術家工作室的量體，如一條絲帶，嬉戲地穿梭、環繞或跨越著高架橋拱，互相交織，從而產生多變的室內及室外空間關係。屋頂是私人會所，為繁忙的運河沿線增添了視覺活動。

譯註14：1841－1918，奧地利知名建築師，維也納分離派的代表人物。

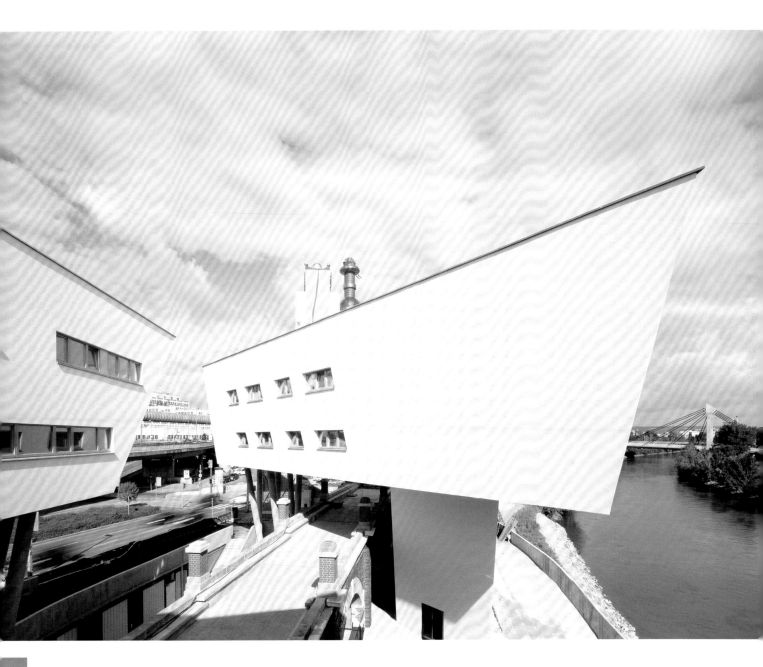

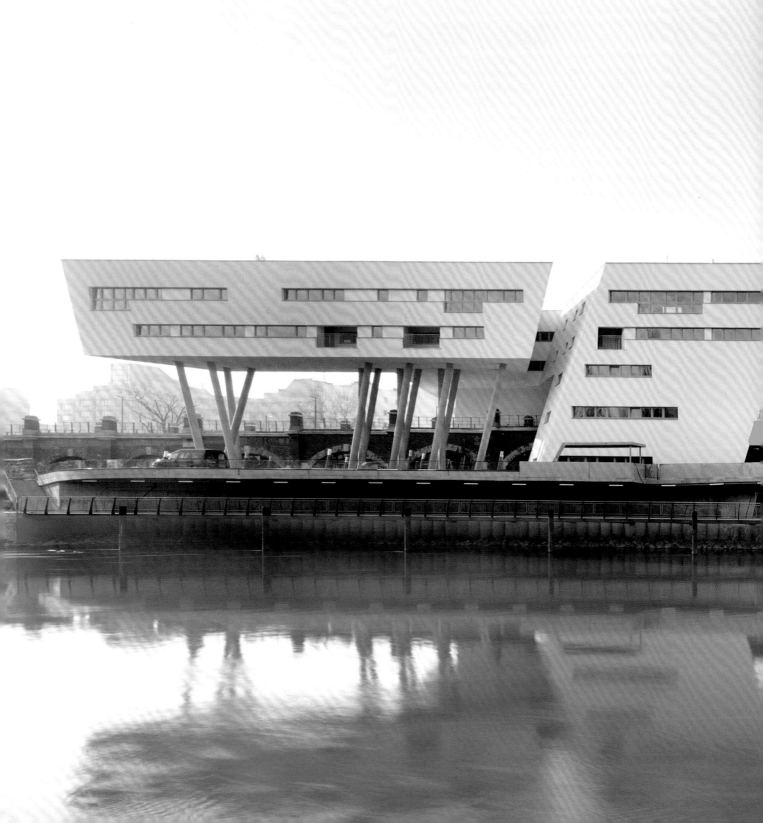

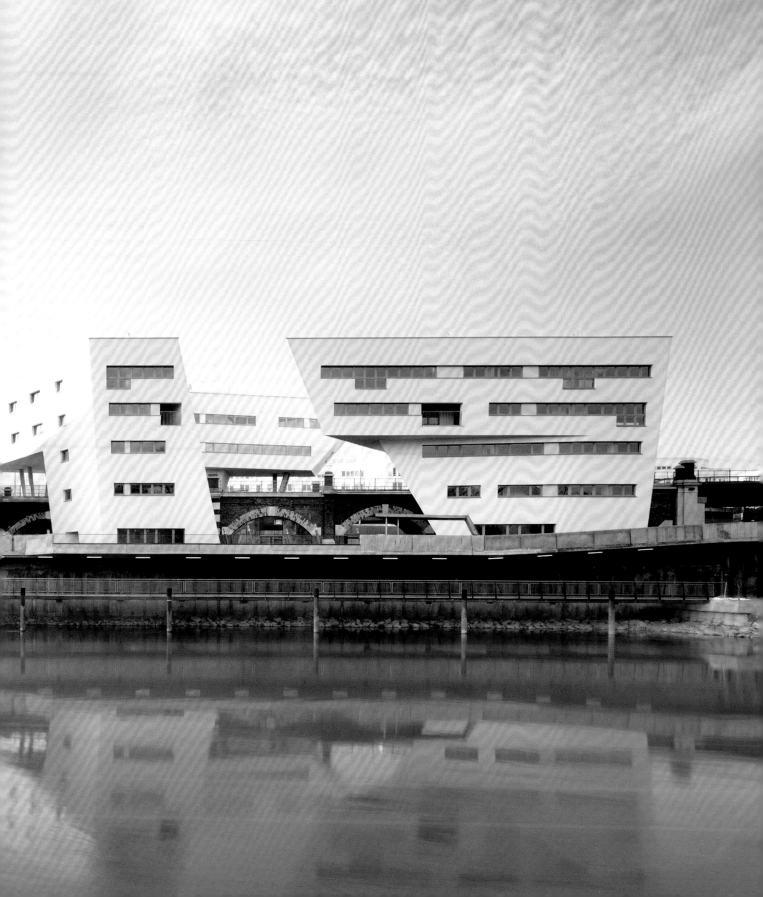

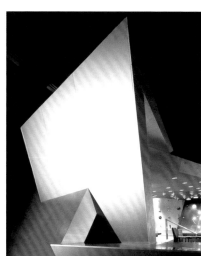

將展館設計成一個能夠表現參觀者動線、統一產品展出的連續空間。其結構由連續的板（plate）所定義，折疊到自身之上構成兩個相互交錯的樑，使得板的內部變成展示區域。該板包含一組鋼樑底盤，夾在外覆材（片狀鋁或工業壁板）和內覆材（mdf，工業地板或其他飾面）之間。某一完成面可以以這種方式不間斷地從地板流出或在牆壁周圍流動著。照明設備則嵌入板內，或是懸掛其上。作為一個整體，莫比烏斯環狀的板（Mobius strip-like plate）[15]扮演著全然整合展覽空間的功能，每個參展商在這個「物件」中都有特定的位置，而顯露出來的表面材料可以從一空間無縫地跨越移動到另一空間。

譯註15：莫比烏斯環（Mobius strip）是一種只有一個表面與一道邊緣的特殊拓撲幾何，該環的一端翻轉180度後再接合於另一端，因此在環上前進一圈後，即可不跨越邊緣而能夠到達出發點位置的另一面。莫比烏斯環強調移動的無限循環。

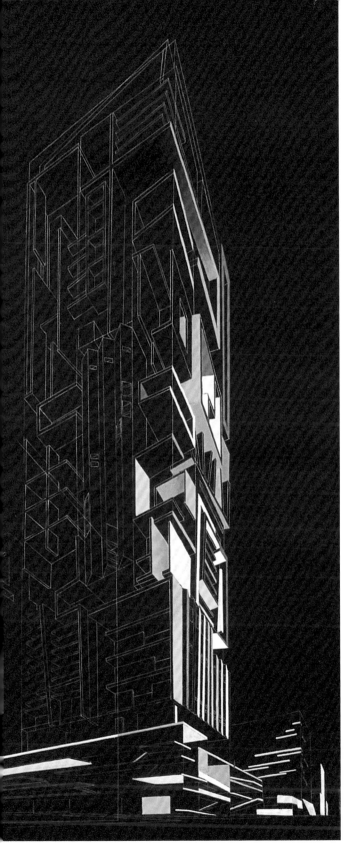

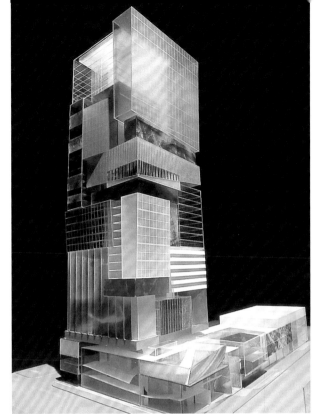

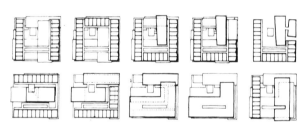

位於第八大道與第四十二街的旅館大樓設計，來自於創造一個城市縮影（microcosm of urbanity）的企圖，用以表現紐約這個全球城市的複雜和魔力。綜合提案中包括了兩個三層的商業群樓和兩棟旅館大樓，北側四十五層，南側二十二層。在其中，循環系統、動力標誌、照明方案以及相關娛樂和零售活動統整了這個複合建築體。飯店是一條垂直的街道——一個塔中塔（a tower of towers），其中有950間客房，通過主塔中心的虛空間被第二座塔的元素中斷。在旅館大樓連接商業群樓之處，垂直街道溢出地平面，形成零售商店、餐館和公共設施的網絡，將其自身整合於城市網絡中，並直下通達地下的地鐵大廳。

史匹妥市場

與派屈克・舒馬赫合作

德國・柏林 1995

SPITTALMARKT
Berlin, Germany 1995
In collaboration with Patrik Schumacher

前東柏林米特區（Mitte）的中心是歐洲最大和最繁忙的重建地區之一。我們受邀設計一個辦公大樓開發案，基地沿著該地區最繁忙的一條通道——萊比錫大街（Leipzigerstrase），並位在一個重要的交界處，類似我們在維多利亞城區域發展方案中呈現的情景[p. 40–41]。

該大樓將包含主要的金融機構總部和私人辦公空間。我們的設計試圖調和十九世紀與戰後缺乏特色的建築，這些是在柏林圍牆倒塌之前，支配著天際線的建築物。這個建築重複地使用相互碰撞編織的L型，由三個主要樓層構成。就像其所處的壅擠十字路口，這些獨立高大的結構體反映了周圍環境，並強化了來往車輛的動態感。

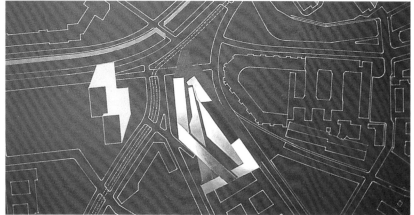

基地配置圖[上]

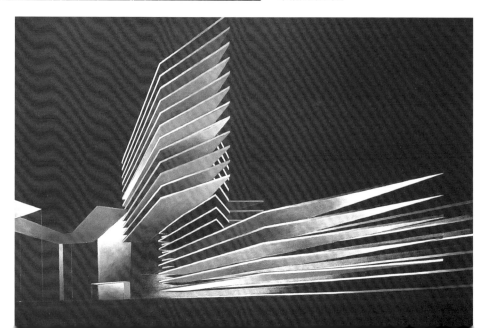

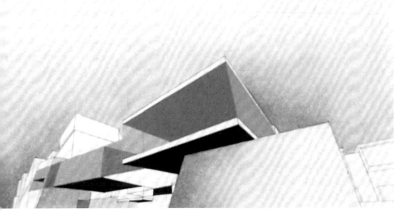

在南肯辛頓一所法國公立中學的業主需要一間警衛
室和門房宿舍,以彰顯這座既存且尺度不大的房子
及庭院入口。我們決定將傳統的直立大門加以旋
轉,使其可以在飄浮的水平面上與房子融為一體。
學生可以經由像森林一般的一個柱列系統自由地通
過這座建築,就像任何人穿過一座大門一般。然後
這被抬升的水平面被碎化如同拼圖碎片,都有各自
的柱、翼板和墩座的結構系統支撐,使地面轉化為
結構元素的遊戲場。除了容納門房及其眷屬的宿舍
外,該建築物還包含四間教室。

由於倫敦金融區的歷史背景,在一個緊
湊的基地上設計辦公大樓,面臨了許多
規劃上和建築上的限制。最切要的是,
地面層必須包括一個臨街的公共區域,
發揮一種如同室內公園的功能。我們透
過建立一棟建築物來圍繞一個區域,以
打造「室外空間」的方式,來克服這個
問題。在基地的准許範圍內,這「蛇」
一般的構造在室內與室外空間之間、以
及私人辦公室與公共廣場之間,建立了
平衡,同時引入了動態互動到這裡的城
市傳統建築中。

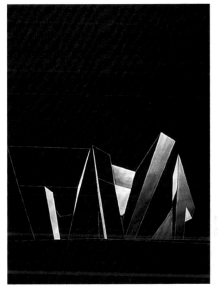

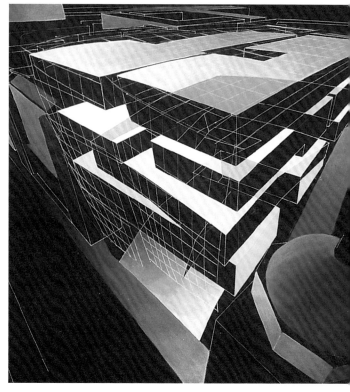

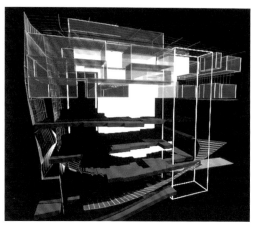

維多利亞與艾伯特博物館（Victoria & Albert Museum）[16]，經歷了過去一百五十年的演化，形成目前由眾多時代的建築拼湊起來的狀態。歷經一段向外擴張的過程之後，當局決定將目光轉向內部，並就其所剩的閒置空間加以利用。我們對舊鍋爐室的設計反映著V&A博物館作為建築風格演變的代理人角色，在各種尺度上，我們使用像素（pixel）作為配置的媒介，無論是顯示面板或是展示空間。最頂部的三層交錯量體設有行政機構、教育與管理中心和機房，並連接到博物館現有的側翼。在這些實體之間，虛體被切割成屋頂和立面以引入日光，並插入到現有立面和新建築之間的區域，好讓阿斯頓・韋伯（Aston Webb）[17]設計的立面不被遮擋。這個設計的立面是由兩個表皮組成，除了各自扮演特定功能，同時也編織在一起，有時還會相互合併成地板、牆壁和窗戶。起伏的外表皮是由玻璃和金屬平板所製成的抗風雨層；內表皮則結合抵擋陽光的百葉窗簾，於展覽時阻隔光線之用。

譯註16：1852年成立，世界上最大的設計、工藝美術及應用藝術的博物館。
譯註17：1849－1930，知名英國建築師與建築學者，最著名設計作品為白金漢宮新建立面設計與維多利亞與艾伯特博物館。

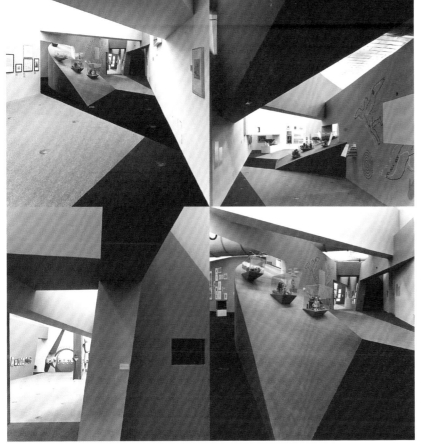

願望機器：世界發明展

建築中對於人類社會事實與虛構間糾纏的詮釋，無法化約為柏拉圖式的理想形式，沒有任何事物可視為先天必然。位於維也納藝術館（Kunsthalle）的這些展覽空間，就像束成一捆的幾道牆面所形成的曖昧透視效果。這些牆面倏地出現在入口空間，並穿過幾乎不能容納它們的盒子。這裡沒有規定的路線，隨處皆是擋不住的驚奇。

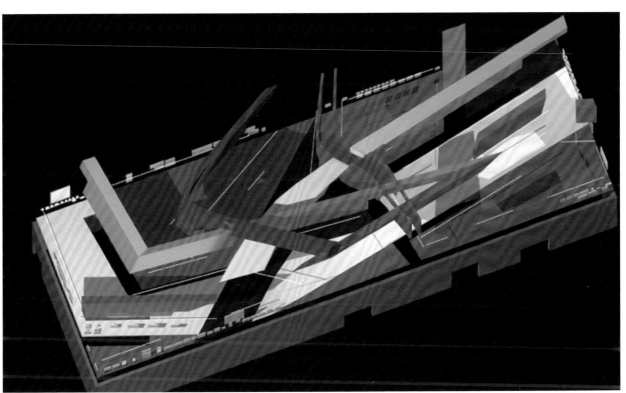

大師切面，威尼斯雙年展

義大利・威尼斯 1996

MASTER'S SECTION, VENICE BIENNALE
Venice, Italy 1996

在威尼斯格拉西宮（Palazzo Grassi）中的展示間包括一個橢圓形房間，和一個小型的相鄰露台。房間的四面都連接著主要動線，我們希望強調此一空間的體積，因此將展示用的牆面脫離地板，懸吊在兩公尺高之處，不致阻礙參觀者的來去。眾多繪畫、圖面、模型和淺浮雕在牆上組成的樣態，創造了一個「超級意象」。

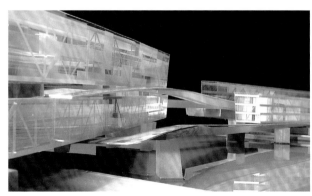

屋橋

英國・倫敦 1996

HABITABLE BRIDGE
London, UK 1996

基於可能成為城市景觀的支配性特徵，屋橋設計採用水平摩天大樓的形式。當描繪一個城市文化的多樣性時，一座橋樑也能將形形色色的零售、文化和娛樂活動與功能，交織成一個有生命的結構體。我們對於倫敦這座橋樑的提案特色是一組綑束在一起的樑，反映河岸邊的城市密度。這捆束的量體相遇一起又分散開來，形成一系列急轉向河岸的量體與路徑。橋身的斷口彰顯了此一分解，同時打開了東西向軸線的視角，可看見從西南的里奇蒙（Richmond）一路到東邊聖保羅教堂的遠景。以垂直的方式組織起機能計劃，較低樓層有自由流動且對外開放的「街道」──為商業和文化空間的混合體，量體高層則是私人的閣樓區域。空間和路徑的功能如同一個流動的整體，充分彰顯了河流的存在性。

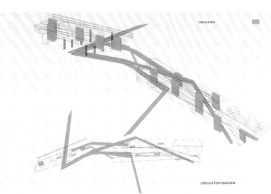

CIRCULATION DIAGRAM

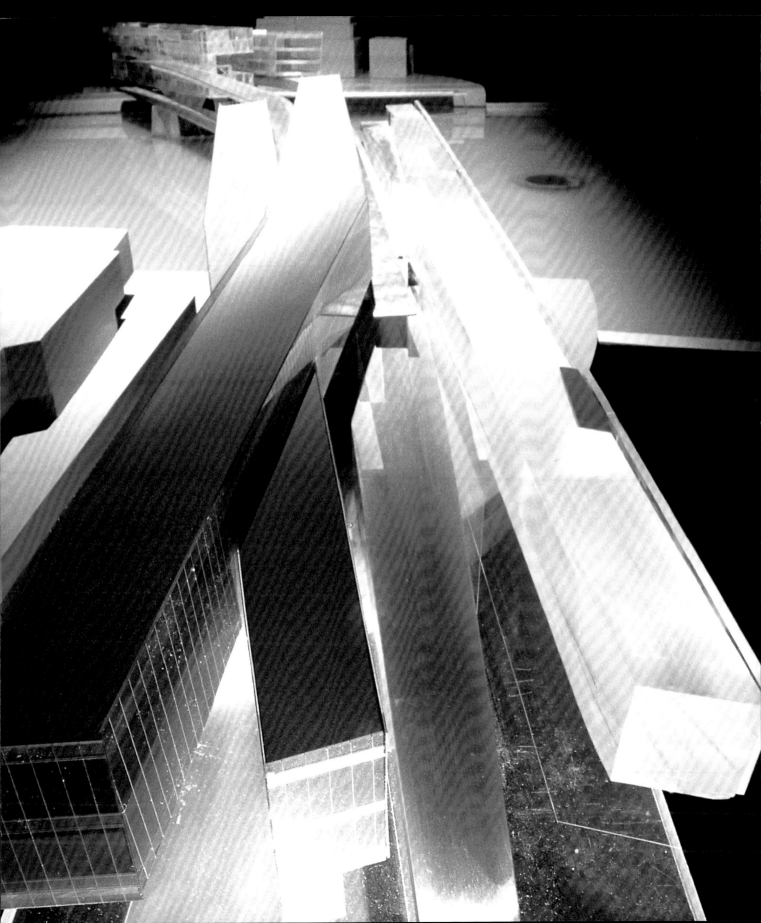

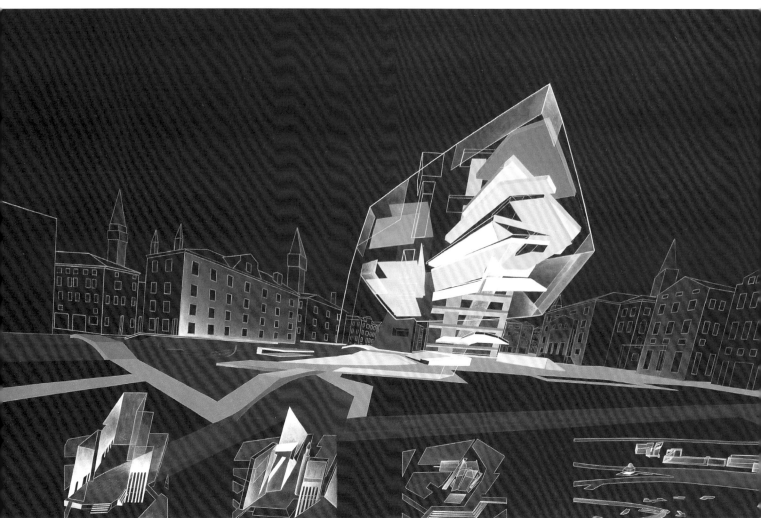

鳳凰歌劇院

義大利・威尼斯 1996

LA FENICE

Venice, Italy 1996

倫敦報紙《每日電訊》（*The Daily Telegraph*）委託我們對位在
義大利最受推崇之一的一間歌劇院提出一個對策，它在1996年
一月曾遭大火蹂躪。威尼斯是一個充滿高塔的城市，屋頂景觀
由錯落的煙囪和尖頂構成。我們提出一個高架歌劇院，希望有
助於這個紋理，同時融入城市的屋頂景觀。威尼斯本身就是一
間大劇場，所以我們將建築平面轉向，讓表演對外打開，創造
一個面向廣場和運河的戶外舞台和休息區，這個運河邊的空間
本身就變成一個舞台，而它後面的房子立面則變成投影屏幕。
一如我們在卡地夫灣歌劇院的設計[pp. 70–73]，在此能夠從劇
院的不同樓層前廳俯瞰下方廣場。人們也可以登上高牆上的戶
外平台，或往上到劇院內的平台，來獲得更好的俯瞰角度觀看
地面活動。

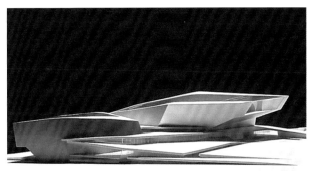

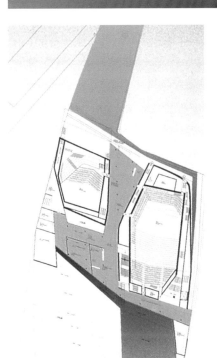

面向舊城區的陡峭山脈，激發
我們的靈感而驅動設計的概
念：地景。我們通過一系列的
分層、階梯狀或斜坡狀的樓
板、屋頂與樓層高度等，發展
出人造等高線基地的想法。在
這個「地景」中，湧現出氣勢
宏偉的主廳和室內音樂廳。觀
眾通過緩緩上升的坡道進入
前方大廳，以及上方平台與前
廳。這些斜坡和坡道就像一個
連續起伏的地景，搭配著一些
嵌於關鍵位置的中庭，給予地
面活動所需的光線。地景也擴
展至室內之中，地形等高線在
此定義了人行動線。

PHILHARMONIC HALL
Luxembourg 1997

In collaboration with Patrik Schumacher

87

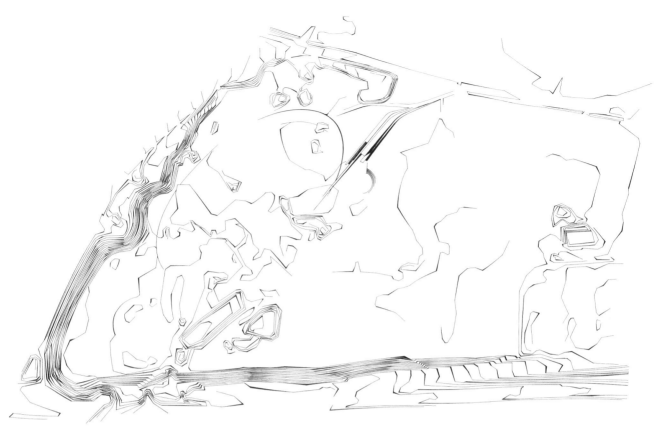

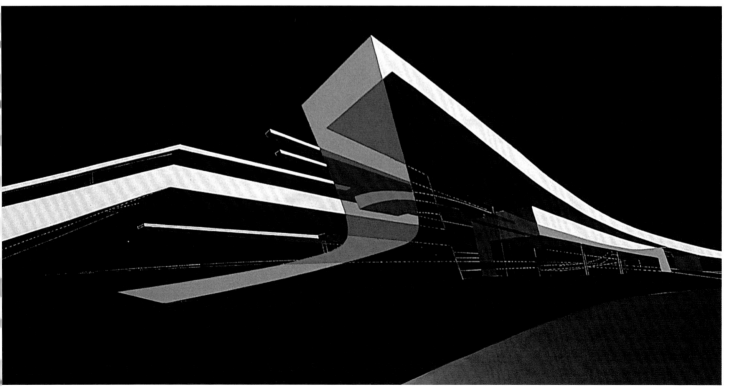

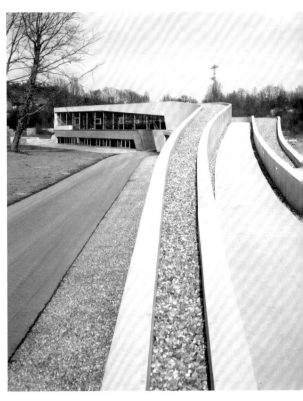

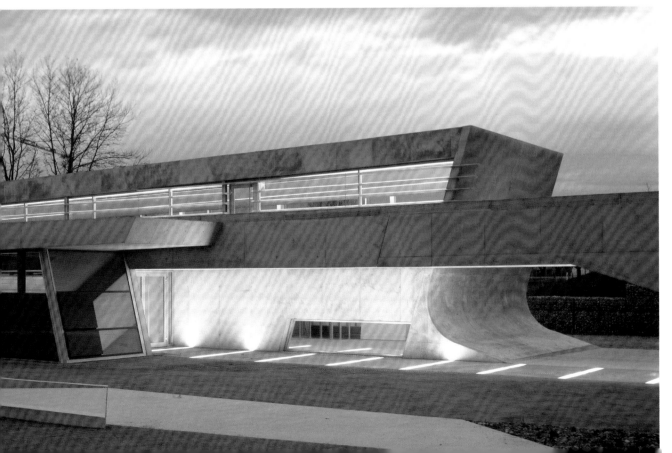

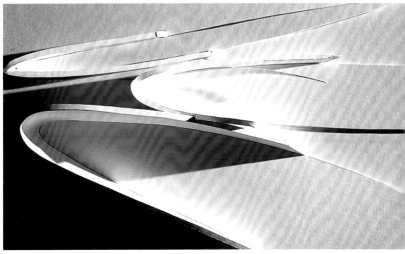

與派屈克·舒馬赫和伍迪·姚合作

卡達·多哈 1997

伊斯蘭藝術博物館

MUSEUM OF ISLAMIC ARTS

Doha, Qatar 1997

In collaboration with Patrik Schumacher and Woody Yao

在中東缺乏十九世紀風格博物館的出色前例,所以我們開發出一個原型,源自伊斯蘭藝術偏好的重複圖案,並加以差異化的間斷。建築整體是一個綱目化的「物體」容器,與展示空間中的一個想法相呼應:廣闊的水平露臺和傾斜樓板,以容納範圍廣泛的文物,從硬幣和手稿到玻璃器皿和地毯。地景在建築的概念中扮演關鍵角色,尤其是盡可能無縫地將環境脈絡與建築元素融合的嘗試。屋頂是一大特徵,將建築物表達為一個連續但有差異化的空間,同時在景觀、天空和展示室之間進行調合。嵌入室內的中庭提供了自然光,並因此與伊斯蘭建築和規劃中必然具備「中介空間」(al-fina)[18]的強烈傳統連繫起來。

譯註18:al-fina為伊斯蘭傳統建築中的露天中庭,或空間與空間之間的中介空間。

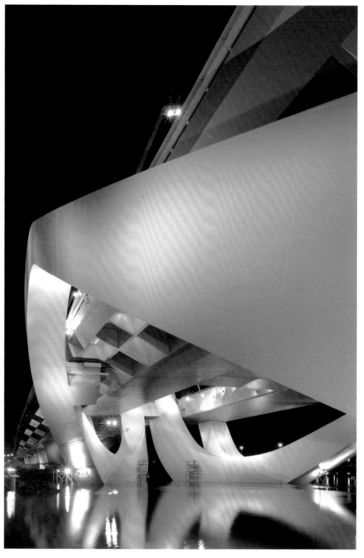

阿拉伯聯合大公國 · 阿布達比 1997–2010

謝赫·扎耶德大橋

SHEIKH ZAYED BRIDGE
Abu Dhabi, UAE 1997–2010

阿拉伯聯合大公國高度汽車化的社會需要一條波斯灣南岸的新路線，以連接七個酋長國。1967年一座鋼拱橋的完成，將阿布達比島連接到大陸[19]，而後在1970年代建成的第二座橋樑，連接了該島南側的下游。這個門戶橋（Gateway Crossing）的位置鄰近第一座橋樑，對公路系統的完成極度關鍵。在一個開放的環境中，橋樑自身就具有成為目的地的潛力，或成為阿布達比城市發展的催化劑。設計中一組聚攏在其中一側的結構線，在路徑全長上被抬升及「推進」，一個正弦波形提供了結構的輪廓。大陸仿若發射台，這個橋樑自地表浮現，朝道路射去。道路的甲板在主脊結構的兩側向外懸挑，鋼拱自位於其間的大型混凝土墩非對稱地舉起，彰顯大陸方向和通航水道。脊柱沿著中心的空隙位置從一個岸邊分開並伸展，在路面下方分叉到橋另一端的道路外側。橋樑主拱上升至水位60公尺高，道路高點位於平均水位20公尺高。

譯註19：阿布達比與阿拉伯半島之間有海水相隔，因此文中稱阿布達比為島，阿拉伯半島為大陸。

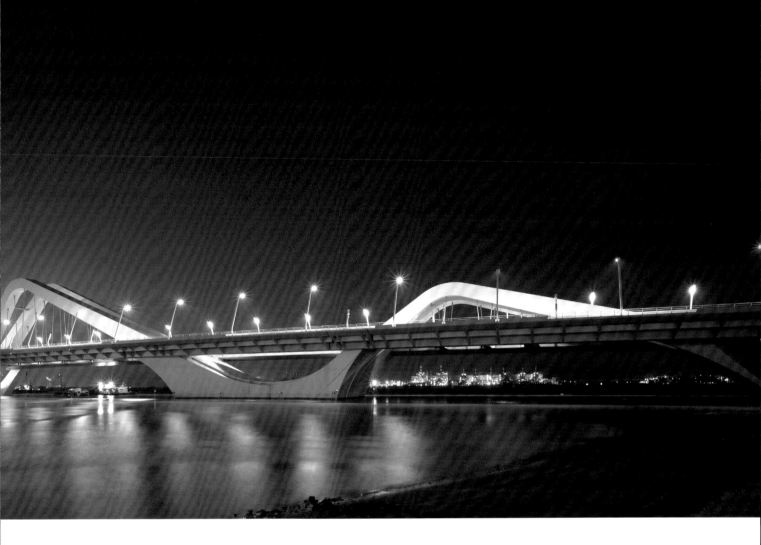

伊利諾理工學院校園中心

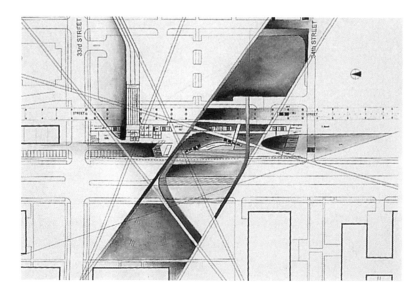

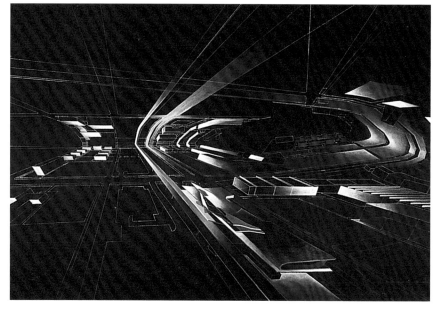

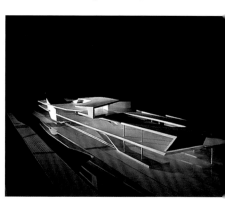

本案在密斯（Mies van der Rohe）[20]規劃的校園中置入一個學生中心，以回應大學內部社群的多元使用模式，和芝加哥本身的城市紋理。我們採用一個流動的組織系統，模糊了工作和休閒的區劃，並將橫向分佈的總體規劃在同一地點上並折疊起來，以確保構成校園的元素能夠聚集在一個緊湊而的多層的量體中。此建築透過一個漸變的地面和彎曲坡道，進入一個挑高兩層的前庭，引導訪客通往演講廳、餐廳和零售空間。二樓的一部分是從一樓剝離開來，樓梯坡道挖空樓板，留出向下瞥見的空隙。會議室是一套活動面板矩陣，根據學生組織的需要而推移。所有空間都沒有明確的邊界，用以鼓勵交流活動；這透過檔面式的模矩系統而增強，產生了這令人驚奇的配置。

譯註20：1886-1969，德國建築師，現代主義建築大師之一，提出「少即是多」等論述，對全球現代建築影響深遠。曾任德國包浩斯學院院長，1937年起受聘為新成立的美國伊利諾工學院的建築學院院長，同時一手擘劃該學院的校園空間與建築設計。

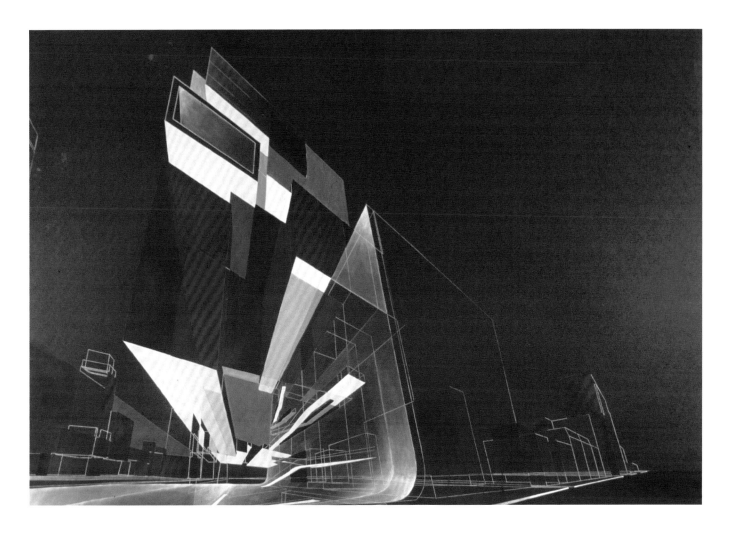

博物館成立於1939年，是美國第一所致力於當代視覺藝術的機構之一。新建築的設計目標是將行人引入，創造一個充滿活力的公共空間。從第六大街和核桃街（Walnut Streets）的轉角開始，地表線進入建築物時慢慢向上，而後上升成為一道如同「都市地毯」的背牆，吸引參觀者走進入口和大廳，並引領他們走上懸吊半空並穿過全長大廳的坡道。大廳在白天作為一個開放的日光「地景」或人造公園。

與都市地毯及其一系列光滑、起伏的表面形成鮮明對比的是，這些展覽室看來彷彿是從整塊混凝土中雕刻出來，飄浮於大廳上方。展覽空間的大小和形狀各不相同，以符合當代藝術中各種尺度和材質。樓梯坡道以 Z 字形向上穿過建築物後方的狹縫，從動線系統步入展覽室時，令人驚奇的景象映入眼簾。這些不同的展覽室互相鎖扣在一起，有如虛實組構的三維立體拼圖。建築物轉角導致了兩個方向的立面相異但互補的發展。沿著第六街的南向立面，形成半透明的皮膚，路人可見中心內部的活動。沿核桃街的東向立面則如同浮雕，是來自展覽室內部空間在外部形成的反面印痕。

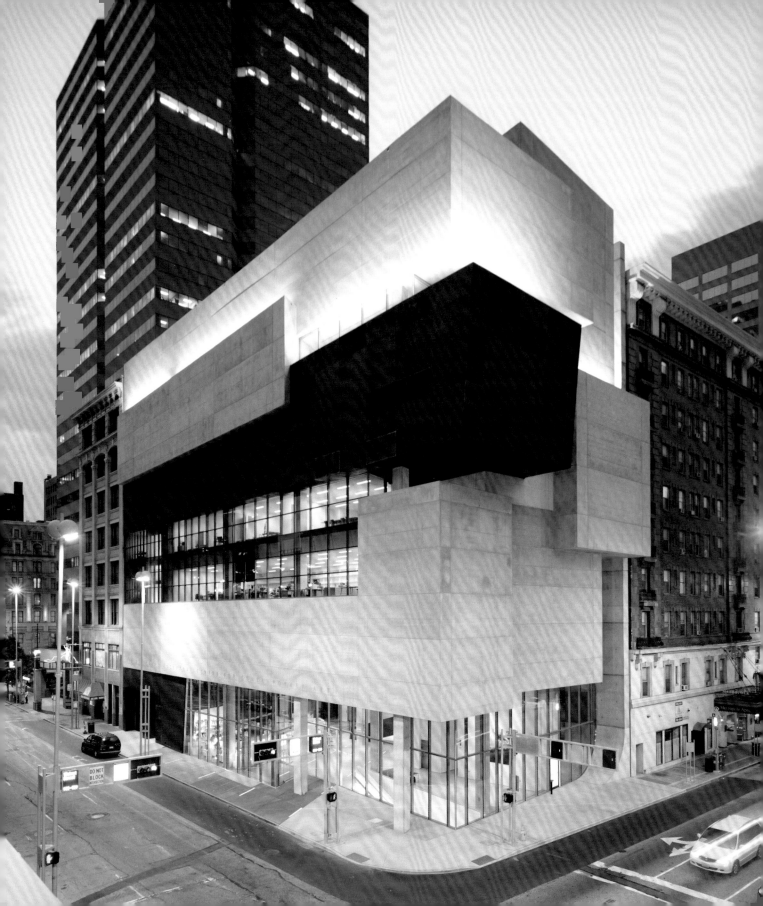

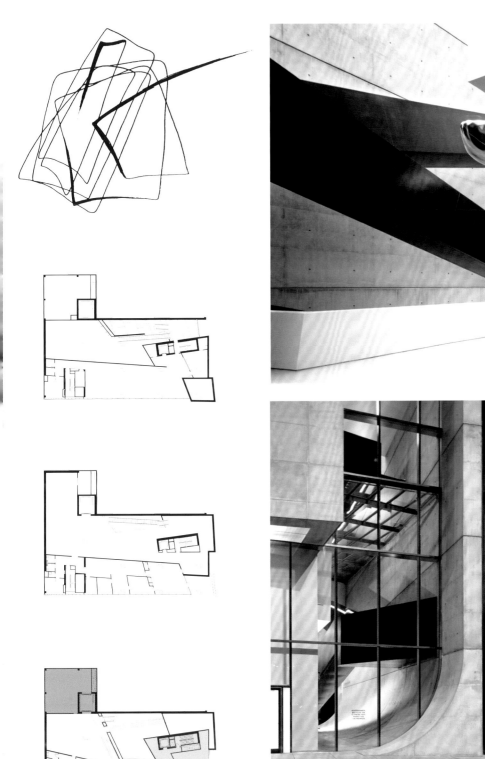

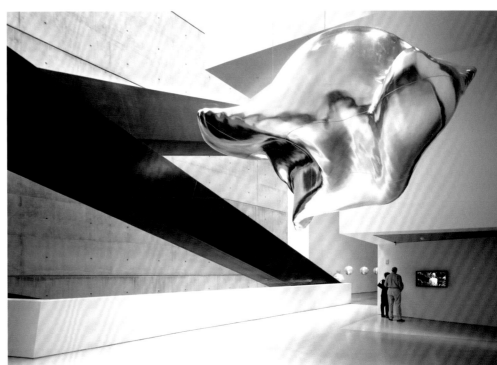

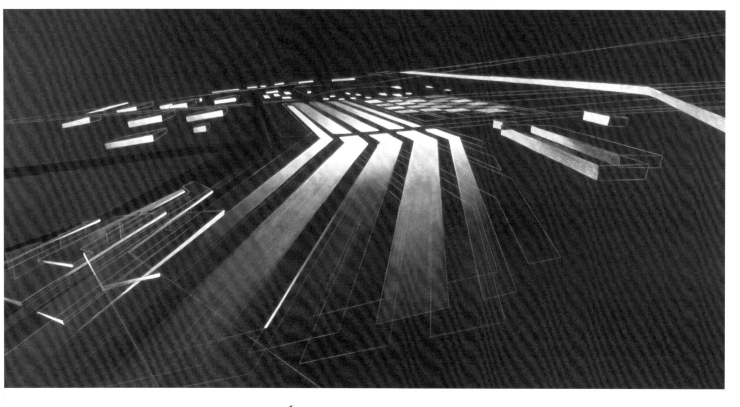

法國·史特拉斯堡 1998-2001

奧奈姆-北車站

CAR PARK AND TERMINUS
HOENHEIM-NORD
Strasbourg, France 1998–2001

為了克服市中心日益增加的交通壅塞和污染，而發展出新的電車運輸服務，以鼓勵駕駛人將車輛停在特地設計的停車場，搭乘電車進城。這個位於路線北端點、七百多格停車位及車站的概念是一堆重疊在一起的「場」（field）和線段，彼此編織在一起而形成一個不斷變化的整體。由汽車，電車，自行車和行人所創造的每一種移動的場都具有軌道和痕跡，不同運輸方式之間的轉變＝通勤者在不同運具之間的轉換，設計將此展現在空間的轉換之中。

三維向量的感知在空間處理上被強化：線條的操作於是成為地板上的光帶、家具或天花板上的條形燈。在平面上可見到，所有的「線」匯流在一起，創造出一個同步的整體。汽車作為基地上不斷變化的元素概念，體現在黑色柏油路面上劃上白線的「磁場」形式，每個白線都劃定一個停車位，從基地最低處以南北向出發，然後隨著基地邊界的曲率稍稍地旋轉。這一群燈桿的長度與地面斜坡的傾斜度結合，在每個位置上都維持在測量基準面上一致的高度（constant datum height）[22]。

如同一場合奏，電車站和停車場創造了地板、光和空間之間的化學反應。藉由開放式景觀到公共室內空間之間的過渡瞬間的詮釋，一個「人造自然」的新概念被提出，它模糊了自然與人造環境之間的邊界，增進了史特拉斯堡通勤者的市民生活。

譯註22：依據地面坡度的高低，調整每個燈桿的自身長度，使燈桿頂點位置對齊於同一個水平高度，因此相對於某個測量基準面是同高的。

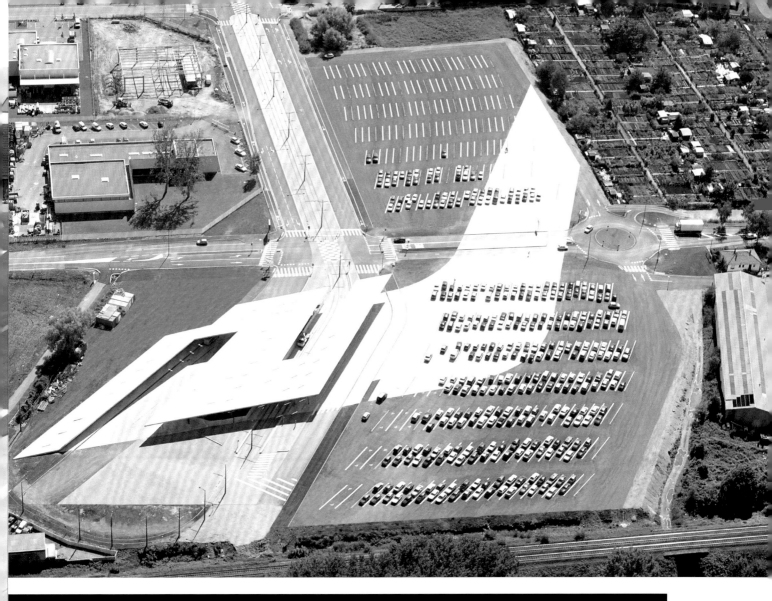

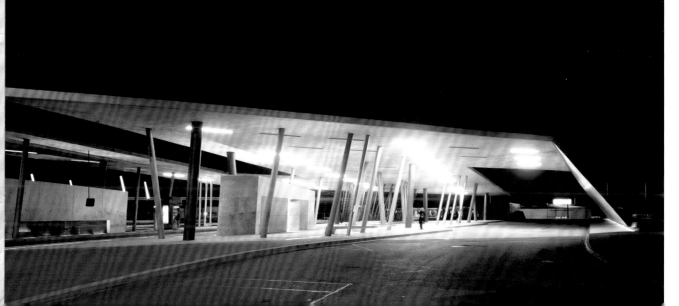

與派屈克・舒馬赫合作
義大利・羅馬 1998-2009

MAXXI：國立二十一世紀藝術博物館

MAXXI: NATIONAL MUSEUM OF XXI CENTURY ARTS
Rome, Italy 1998-2009
In collaboration with Patrik Schumacher

這設計並非只是一個拓撲性拼貼（topological pastiche）[23]的嘗試，而是對週邊低層都市紋理的延續以及對高層街廓的抵抗，使博物館成為「城市中的新芽」（urban graft），或第二層皮膚（second skin）[24]。該建築連接著台伯河與圭多雷尼路（Via Guido Reni），它創造了包含內部的和外部的、既有的和所期望的多種移動模式。通過將動線與都市紋理相互交織、卷鬚狀路徑與開放空間疊合，這棟建築賦予城市一個公共的維度。除了動線循環關係之外，諸多建築元素也在幾何上對齊於在此地交接的都市網格。

此設計提出一個「類都市場」（quasi-urban field），非在定向游移的基礎上組織和引導出來的建築物。它是以密度分佈，而非來自關鍵節點，這反映了博物館的整體性質：多孔、沉浸感的一個場域空間，垂直和傾斜的動線元素位於匯流、干擾和紊流的區域。在理解建築與內部藝術品之間關係，從「物體」變成「力場」的此一移轉是極度關鍵的；該設計鼓勵停止沿用「物件」導向的畫廊空間，代之以「漂移」概念的體現。此一「漂移」既是建築上的概念，也是在博物館中經驗式巡行的一種方式，這路徑將博物館從一個「物件式的」轉為「多重關聯場域式的」，可預期必然的改變。

譯註23：拓撲學（topology）研究拓撲幾何，認為在連續變化（如拉伸或彎曲，但不包括撕開或黏合）下，其幾何性質維持不變。
譯註24：非常緊實的外衣，如同真正的皮膚。

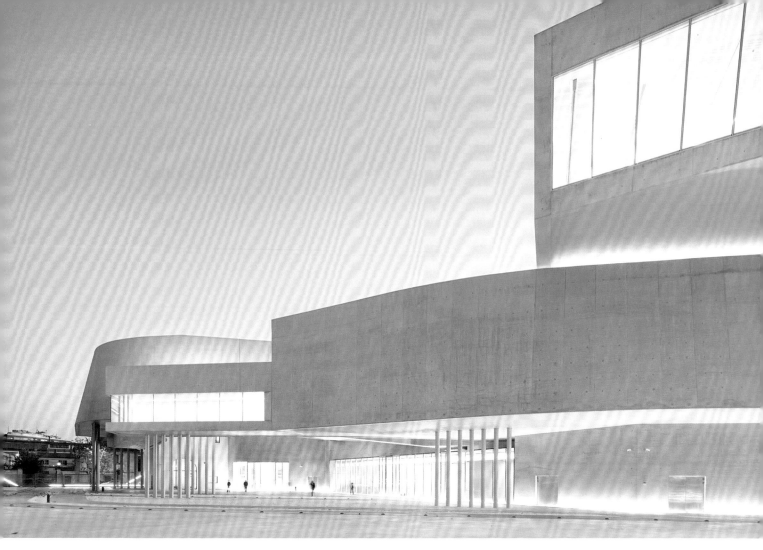

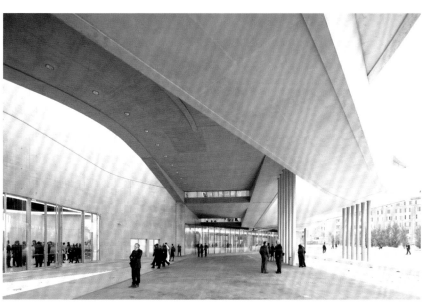

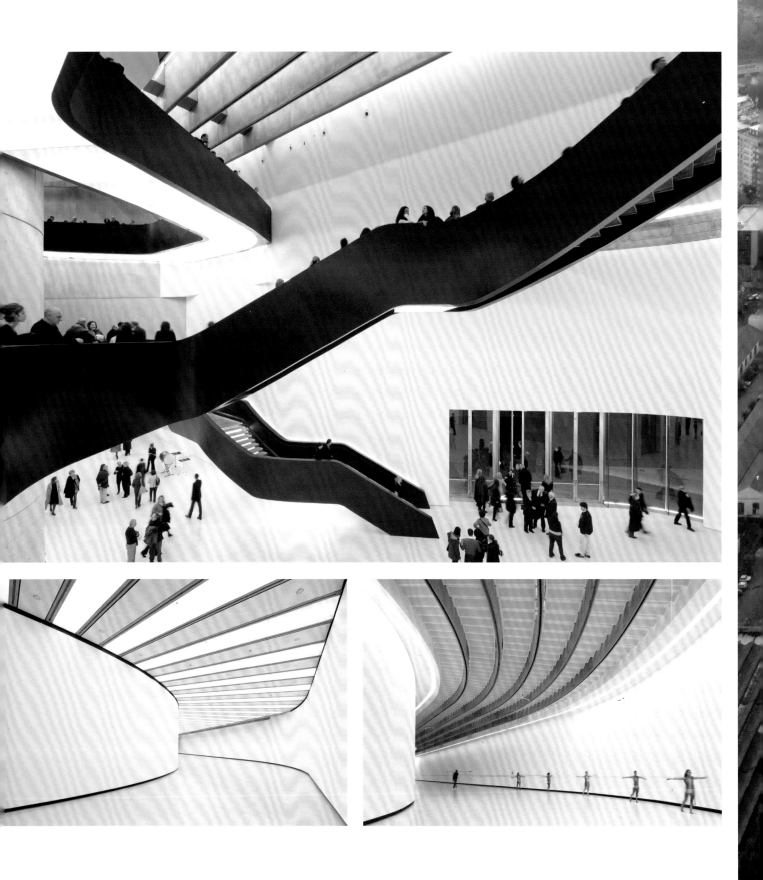

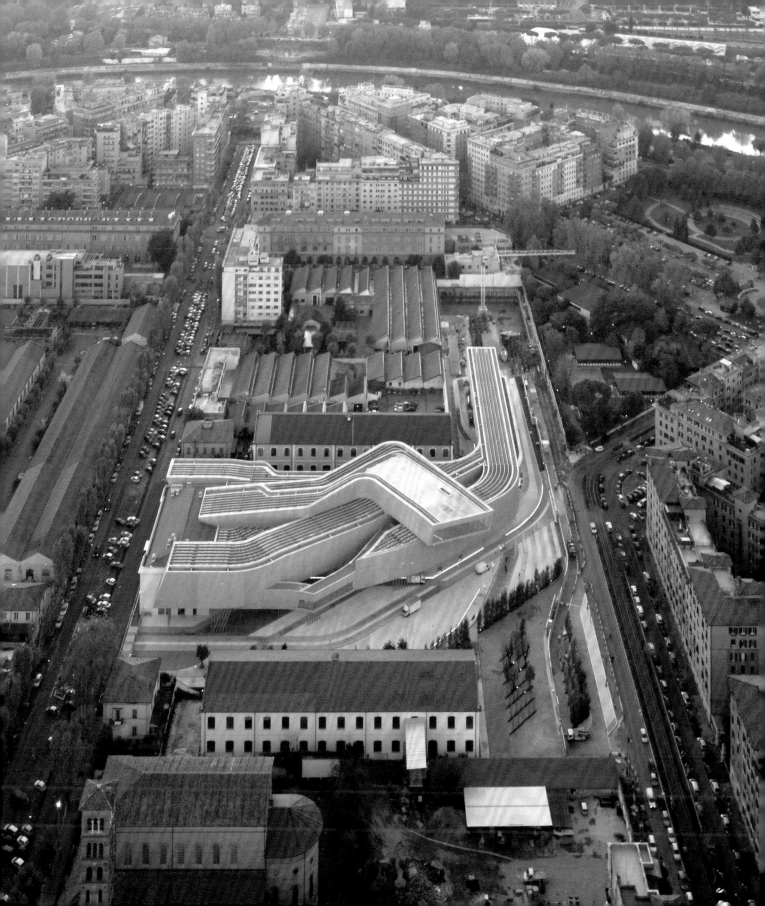

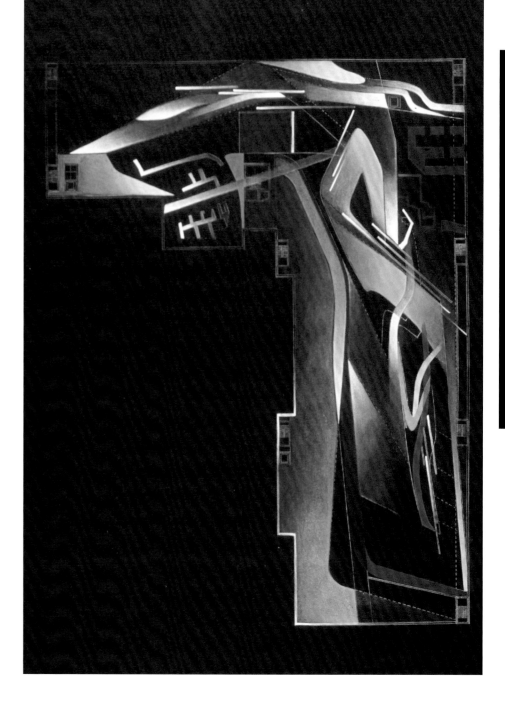

位於馬德里的這座新建博物館的建築語言啟發自侵蝕形態（morphology of erosion），所有形狀都是「負」的或包圍起來的虛體，而非「實」的形。提案中的基地位在皇宮和大教堂之間，隱藏在地下，只能通過廣場上的細長切口和其表面輕微的彎曲而顯露。內部空間由一個掃掠（sweeping）、三向度闡述（three-dimensionally articulated）的牆所構成，兩個空間中的環帶相互交織並穿過這個量體。可用的空間量體並非以樓層分隔，而是在這個畫廊中保持著整體狀態，兩條蜿蜒的動線在視覺上相互交錯，同時又保持嚴謹的序列線性。垂直向的空間運動實現於一系列階梯狀的露臺，同時提供出寬廣的水平樓板面。這些露臺沿著中央的挑空轉變成平滑的坡道，成為穿越空間的動線。

與派屈克‧舒馬赫合作

西班牙‧馬德里 1999

索菲婭王后博物館擴建

我們的主要目的是為博物館創建一個可即刻辨識、具生動特徵的建築，這棟建築的靈活性為關鍵目標之一。一個可立即識別的路線相互聯繫這些畫廊，創造出獨特的步行路程，並最大程度地利用每個空間。透過層層交織的伸展和裂開，充分地在建築中運用自然頂光。做為大眾出入的東立面，將建築物清楚地劃分為公共和私人區域，西立面則作為貨物進出口。

REINA SOFÍA MUSEUM EXTENSION

Madrid, Spain 1999

In collaboration with Patrik Schumacher

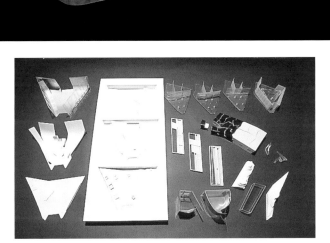

英國‧倫敦 1999

羅斯柴爾德銀行總部和家具

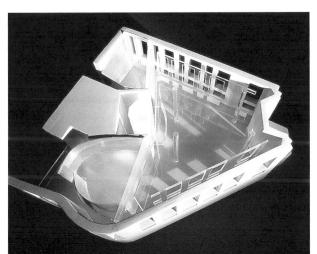

倫敦羅斯柴爾德（N. M. Rothschild）銀行新總部的入口大廳設計──包含接待櫃台和展示櫃。以三種不同的方式切入，第一是將入口視為一個房間內的一個玻璃房，獨立於周遭環境；第二將空間形塑成牆面地板之間無差異的連續表面；第三是將空間視為室內地景，家具將從中浮現。地景研究被發展成特定的家具設計，每個都是一個「地景反轉」，它們可以和彼此或和背景相互附著和分離。地景反轉作品──桌子和櫥櫃，由木材層疊並搭配玻璃盒子構成，如同拼圖一般，桌子和椅子單元可以打開並組成不同配置。

ROTHSCHILD BANK HEADQUARTERS AND FURNITURE

London, UK 1999

瑞士·盧加諾 1999

瑞士皇宮飯店及賭場

ROYAL PALACE HOTEL AND CASINO
Lugano, Switzerland 1999

盧加諾（Lugano）的冰川地形創造了一個光滑、波狀輪廓的地景，成為城市生長之處。基地上的景觀從山頂傾瀉而來，形成了一個熔岩流，在它下降盧加諾湖時，部分被飯店門面擷獲。量體龐大的熔岩流容納了飯店和娛樂設施，它的坑坑洞洞又為外部景觀和中庭提供了光線和空氣。飯店被放置在現有立面內，而娛樂場則被安置於距離之外的山腳處，以維持歷史悠久的立面景觀。

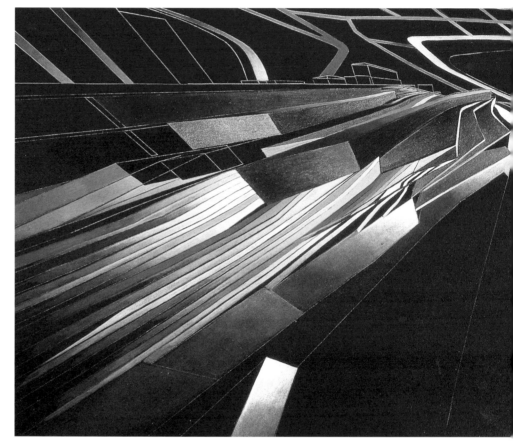

比利時·盧加諾 1999

後大都會，夏勒華舞團

METAPOLIS, CHARLEROI/DANSES
Charleroi, Belgium 1999

弗雷德里克·弗拉曼德（Frederic Flamand）在夏勒華舞團（Charleroi / Danses）的舞蹈作品喚起了城市的節奏。各種材料以不同層次的地形編織成優美的結構景觀，創造出與舞者動作相吻合的流動混合空間。弗拉曼德的編舞遵循並激發了空間的形態轉換，舞者們被裹入了空間複雜性，在其中，他們被捕捉，同時也被釋放，該結構通過壓縮和釋放過程不斷轉換。三座10公尺跨距的半透明橋，在舞者穿戴下成為各種姿態。服裝就像中介多重層次，靈活的結構將舞蹈延伸成4D圖案。

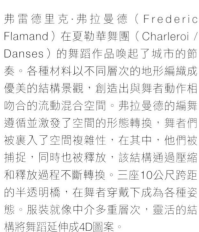

112

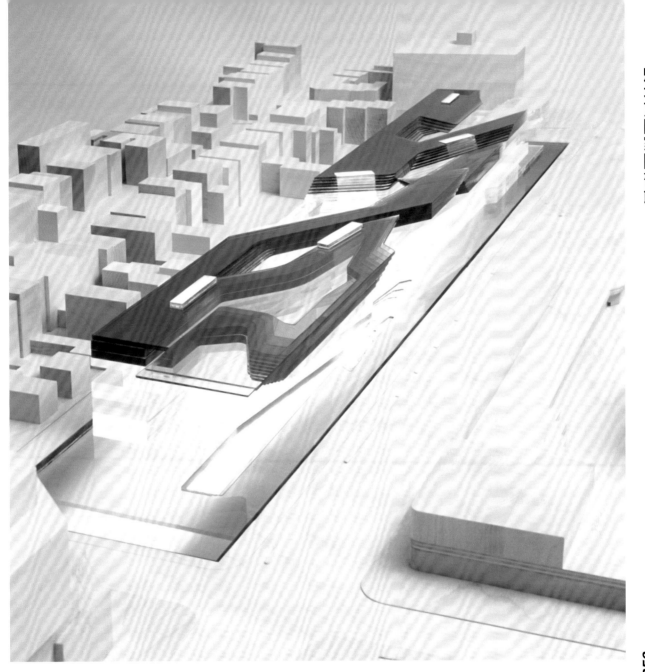

魁北克國家圖書館

這個新圖書館的機能是多樣的，涵蓋從珍稀手稿的處理到二十四小時開放區。此設計為這些活動創建了自給自足的環境，這些環境也與其他部分前後相連。通過這些「地方」的差異化，消除了大型公共建築所產生的體制異化感（the sense of institutional alienation）[25]。主要的建築設計概念依據學科劃分邏輯──知識樹（the tree of knowledge）的連續導引空間為基礎，如同葉脈狀侵蝕建築實體一般。參觀者可以沿著葉脈分枝向上移動，而後選擇路徑通達館藏區或閱覽室。主要的館藏室如梯田狀的山谷，書籍分佈於週邊，環繞著中心的閱覽區。

譯註25：異化（alienation）是社會學的相關概念，用來描述社會關係中，個人之間或個人與所屬群體或組織之間的距離或孤立程度。體制異化（institutional alienation）指的是個人與社會體制之間的疏離。

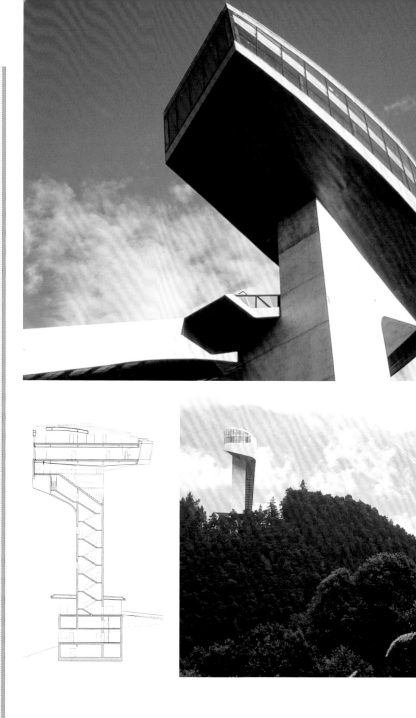

BERGISEL SKI JUMP
Innsbruck, Austria 1999-2002

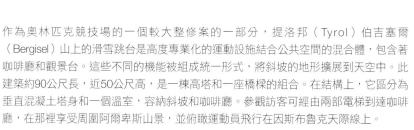

作為奧林匹克競技場的一個較大整修案的一部分,提洛邦(Tyrol)伯吉塞爾(Bergisel)山上的滑雪跳台是高度專業化的運動設施結合公共空間的混合體,包含著咖啡廳和觀景台。這些不同的機能被組成統一形式,將斜坡的地形擴展到天空中。此建築約90公尺長,近50公尺高,是一棟高塔和一座橋樑的組合。在結構上,它區分為垂直混凝土塔身和一個溫室,容納斜坡和咖啡廳。參觀訪客可經由兩部電梯到達咖啡廳,在那裡享受周圍阿爾卑斯山景,並俯瞰運動員飛行在因斯布魯克天際線上。

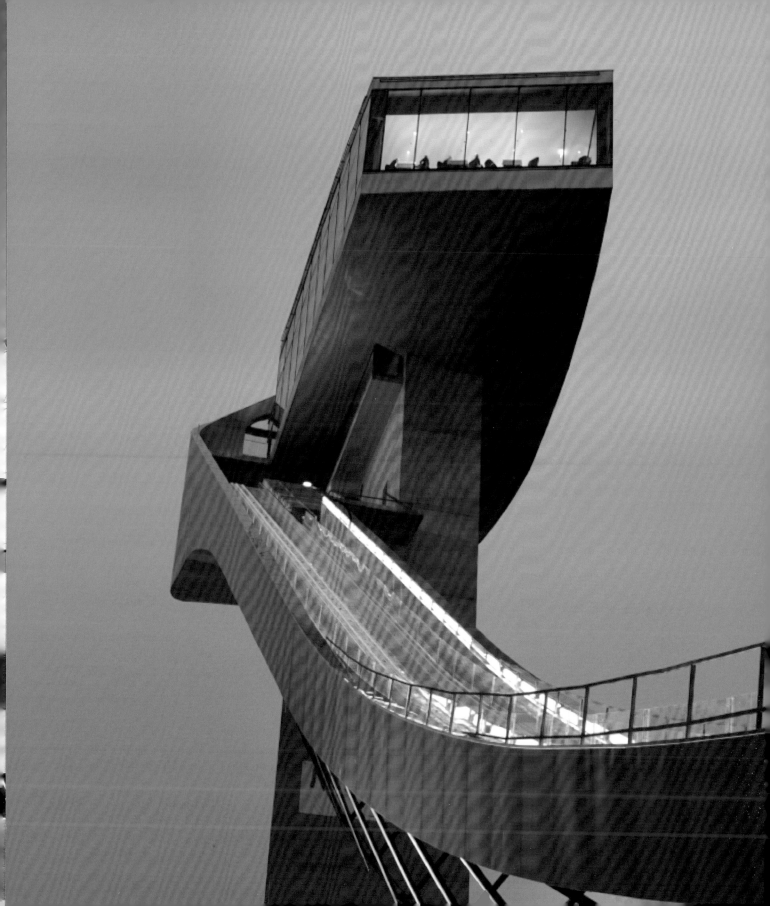

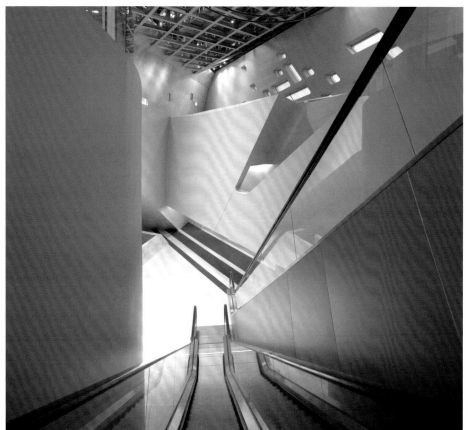

PHÆNO SCIENCE CENTRE

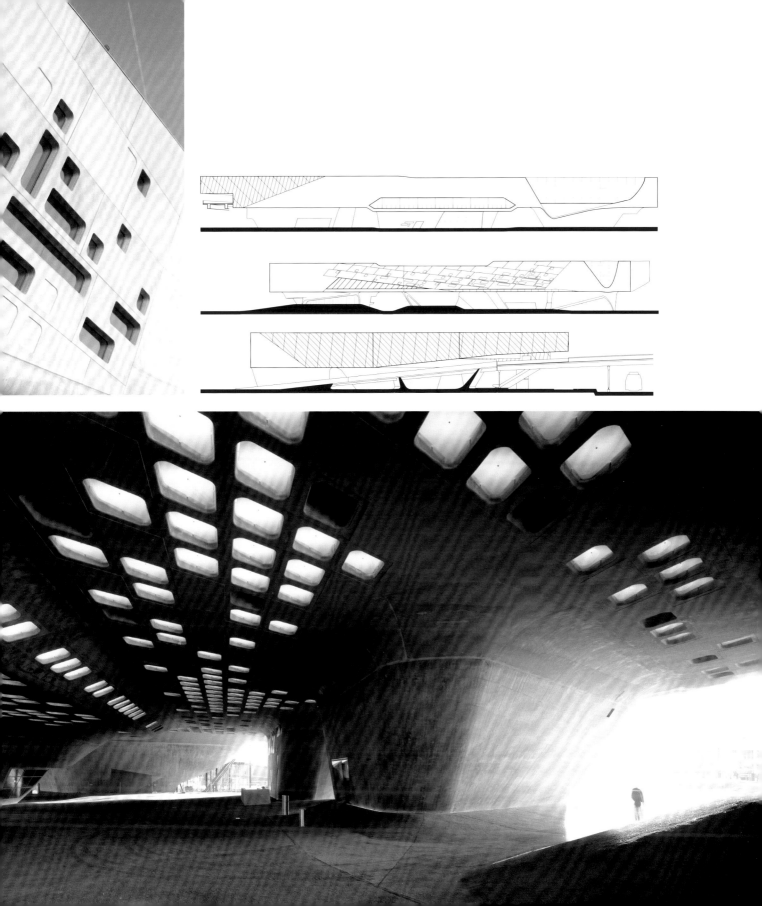

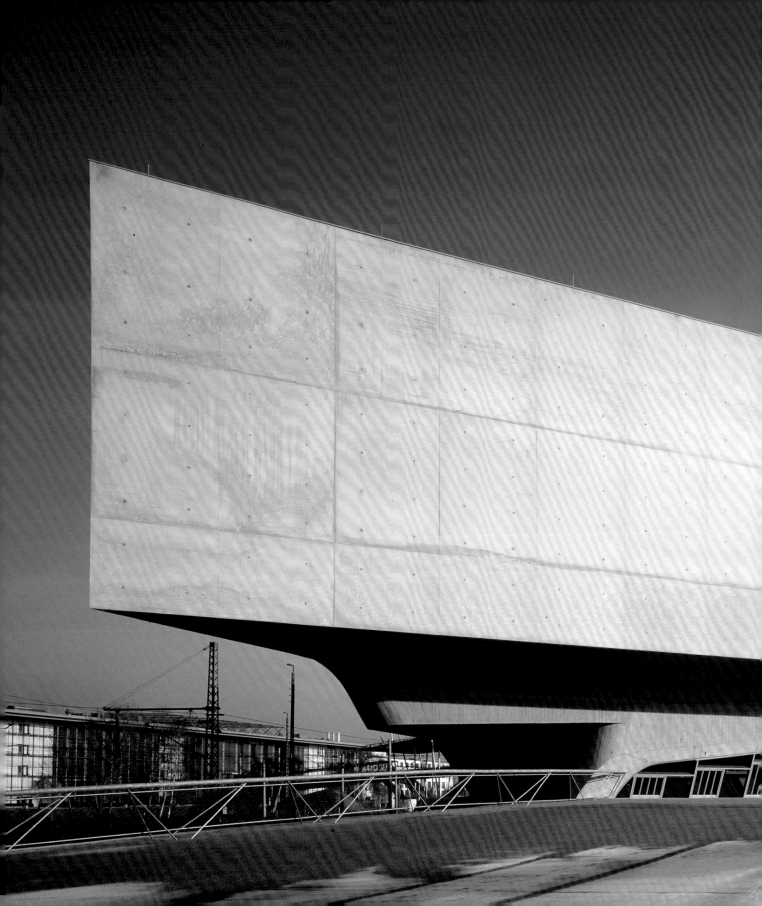

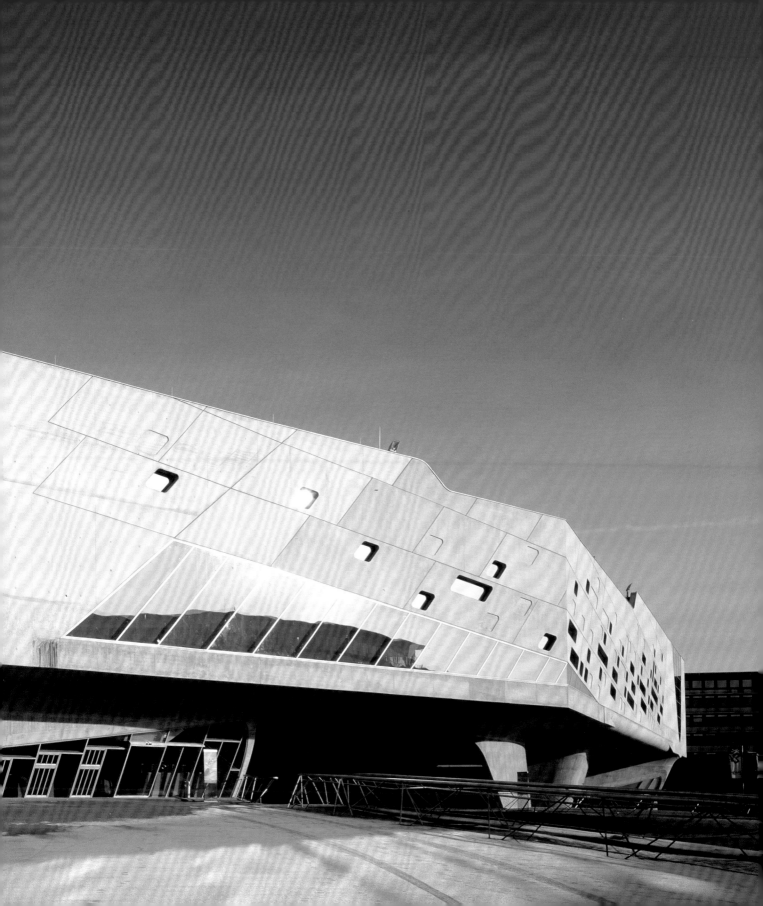

西班牙・羅馬 2000

網狀組織

MESHWORKS

Rome, Italy 2000

122

作為兩年一度的羅馬麥迪奇別墅（Villa Medici）當代藝術展覽的一部分，我們被要求與其他四十位建築師和藝術家，一起選擇別墅花園的一部分進行裝置作品，並將其連接到城區。這件作品將羅馬九公里長的古城牆呈現為典型的文藝復興花園廣場之一，為參觀者創造了新的體驗。

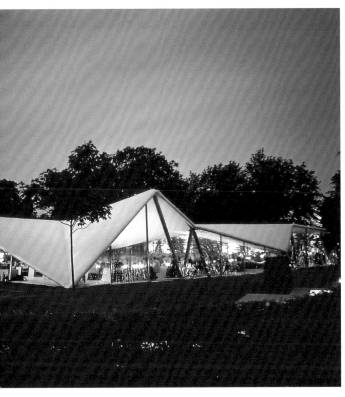

位於倫敦海德公園的蛇形藝廊（Serpentine Gallery）委託我們為其三十週年慶祝活動創造一個展館。位於畫廊外的前方草坪上，這個帳篷般的設計採用了三角形屋頂，與傳統織物的拉伸結構概念相結合。折面透過延伸到地面上幾個不同的點而與基地接合，同時藉由起伏來產生各種內部空間。裡面是一群精心設計過的桌子場域，其顏色從白色漸層到黑色，增強了整個空間消散的運動感。雖然原定僅設置五天，但由於反應熱烈而延長至兩個月。現在這個臨時建築位於雅典史特拉特福（Stratford-upon-Avon）的皇家莎士比亞公司（Royal Shakespeare Company）。

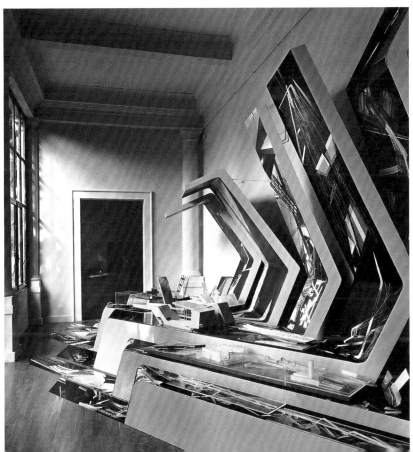

我們為2000年威尼斯雙年展英國館展出了一系列最新作品，包括折疊、扭轉、捆束或碎裂。其中三個設計案是匯聚或分配各種軌跡的橋樑；第四個是前景的運動和軌跡，促使參觀者移動通過「心靈」（The Mind）故事。

這個設計背後的決定性因素，是希望投射出博物館，越過蓮凱路（Lendkai）通向河岸。懸挑的部分需要高到足以讓陽光進入，於是歸結出一個3至6公尺高的高頂棚的概念，這將產生出一個有相當面積且具遮蔽性的彈性空間，並扮演如同大型公共場所的功能。頂棚的形態來自鋼筋混凝土構成的倒錐形蘑菇柱結構邏輯，博物館位於最強壯的懸挑處之下，主要的垂直動線通過最大蘑菇的中空莖部。頂部扇形展開效果使得這個形態上部產生巨大的環向張力，也促成下面環向壓力的成立。頂棚內空間被圍蔽起來，用來容納如演講廳和表演廳這種需要親密感、隔音或隔絕光線的空間。

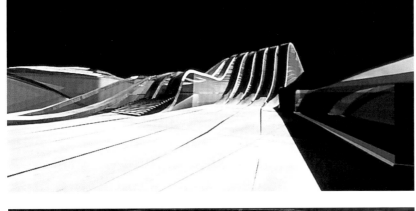

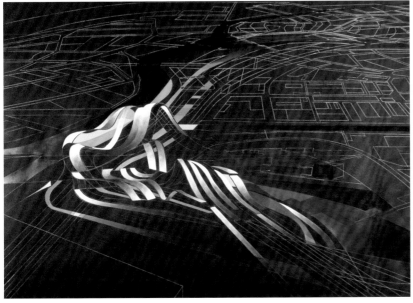

史特拉斯堡大清真寺

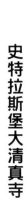
這間新建清真寺的概念是一個矩陣（matrix）。矩陣由一通過祈禱者的軸線或禮拜的朝向（qibla），及來自萊茵河曲線的兩個方向所建立。當兩軸相交時，它們碎化並產生空間量體；這個定向場（directional field）[28]的焦點即是清真寺。設計上細心區分了建築機能：世俗空間位於街道高度，清真寺和中庭則被抬升到地面之上，飄浮於城市上空。一個中央內院，是一個沉思空間，從下方世俗的樓層通達，並作為入口。公共場所遵循傳統伊斯蘭建築的原則，有朝向麥加的禱告行列、中庭內跨越一樓的水道，以及實現和諧比例的幾何圖案。另外，在結構體的流動線條中也令人聯想到了伊斯蘭書法。

譯註28：物理學名詞，被哈蒂借用為設計操作方法。

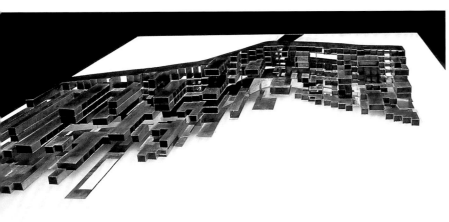

JVC中心旅館大樓

瓜達拉哈拉的Centro JVC旅館的基地是個引人入勝的環境，其上有十個相互關聯的建築物，包括會議中心、博物館、辦公室、娛樂和購物中心，以及一所大學。未來位於該地區北邊人工湖泊的五星級旅館方案，將為該中心創造一個強大而親切的圖像。觀景和其他基地特定關係來建立網格系統的形狀，並立基於客房的模矩之上。旅館客房是構成旅館整體紋理的空間構成元素（spatial sub-entity），在湖邊設有一層的「旅館微粒」（hotel-particles）[29]，從水位開始，隨著水位上升增加了垂直向度。透過從地面的打開與抬升，讓建築物成為景觀的一部分。

譯註29：Particle（微粒）來自物理學領域，微粒個體以及微粒群的自組織性的集體行為，在設計領域中啟發了以之為想像來重新定義事物本質的設計手法，hotel-particles是把旅館客房視為particle來以之操作。

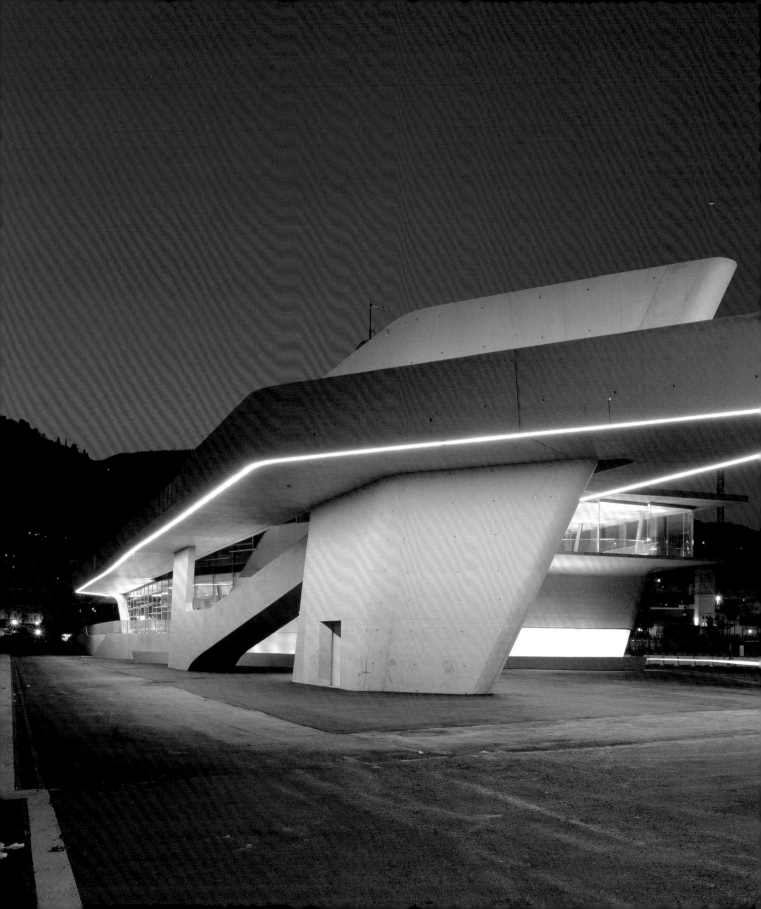

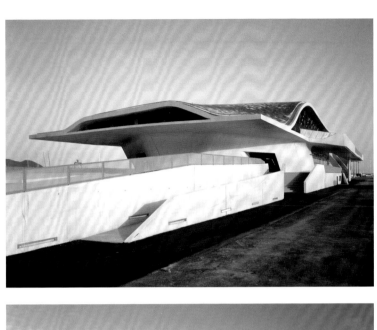

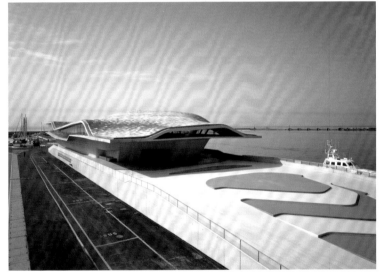

這座新航運碼頭在城市和水岸之間鍛造了創新的親密關係。建築宛如牡蠣,以硬殼包住柔軟的流動元素,起伏的混凝土屋頂為乘客遮擋住地中海的豔陽。這個複合體是由三個互鎖的元素組成:行政辦公室、供國際渡輪和郵輪停靠的碼頭,以及供當地與區域渡輪停靠的第二碼頭。整體而言,這棟建築是做為海陸之間的平滑過渡,一座從固體漸漸轉變成液體的人造陸台。航運站的內部配置以餐廳和等候室等做為組織焦點,引導乘客穿越一連串的動態空間。從建築物的窗戶和露台,可以欣賞到阿瑪菲海岸(Amalfi Coast)、薩萊諾灣(Salerno)和奇倫托區(Cilento)的壯麗景致,入夜之後則像港口燈塔一樣綻放光芒——對基地的諾曼(Norman)與薩拉森(Saracen)歷史做了象徵性回應。

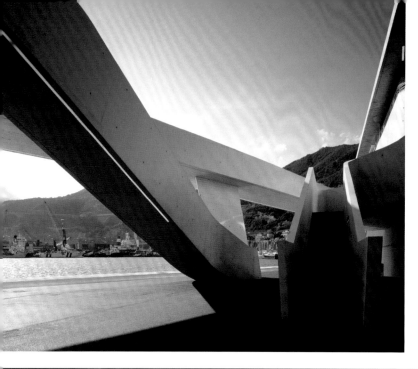

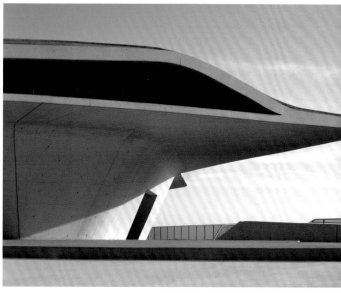

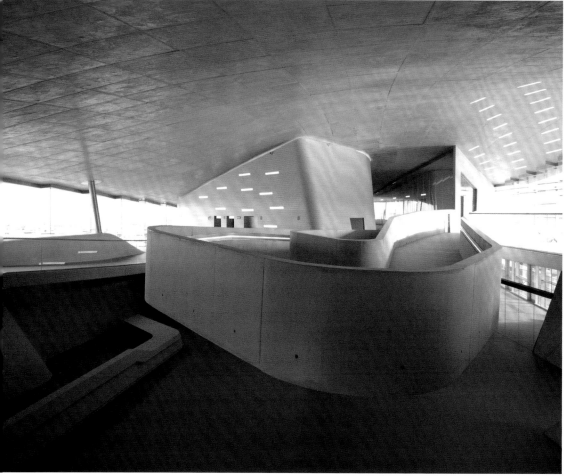

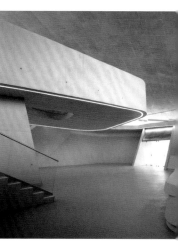

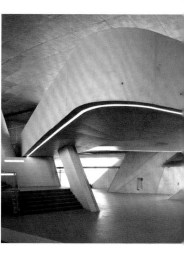

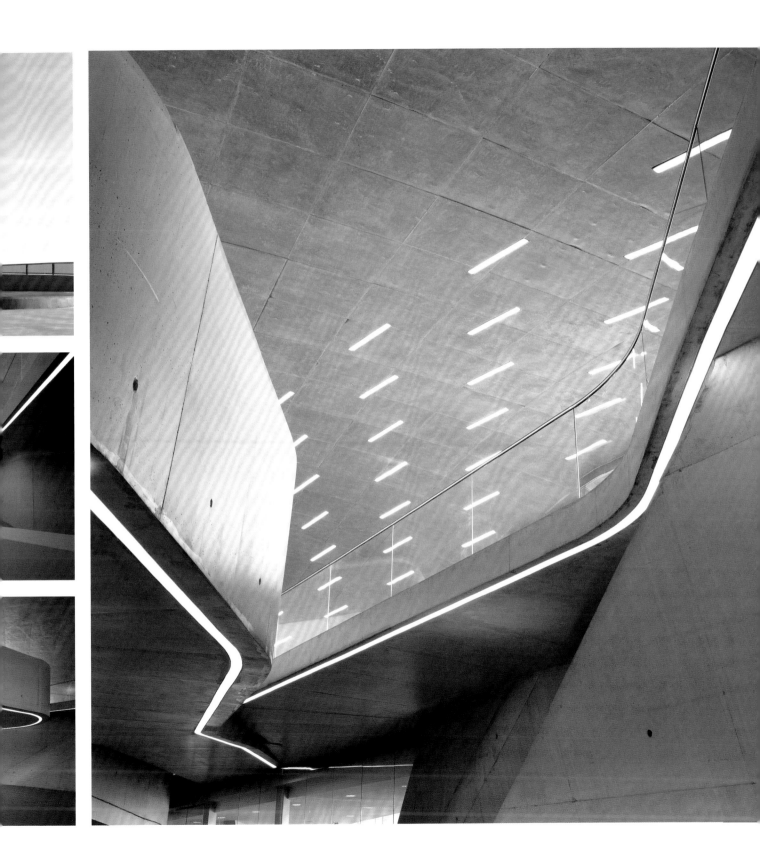

沃 夫 斯 堡 美 術 館
（Kunstmuseum Wolfsburg）
有兩塊剩餘區域一直沒做出清
楚界定，我們想要把這個對偶
空間（dual space）轉變成多
功能Lounge區。這個休憩區
有部分是做為斐諾科學中心
[pp. 116–21] 的試驗台，結合
了聚集點、影片放映室、等候
室、起居室、公共空間、藝廊
和門廳的功能。一條動態的空
間流（spatial flow）連結了上
下兩層，而標題「Lounge」
一詞則是直接指出該空間同時
混合了隔絕與舒適、匿名與社
交、放鬆與刺激。

與派屈克‧舒馬赫合作

奧地利‧維也納 2001

阿爾貝蒂娜博物館增建案

ALBERTINA EXTENSION
Vienna, Austria 2001
In collaboration with Patrik Schumacher

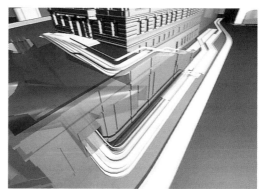

這個美術館增建案是以圖形結構（graphic structure）來進行設計，將動線
和視覺連結以環繞或穿越既有美術館基座的方式編織起來。我們選擇兩種
不同的媒材，對這些圖形結構加以物質化。第一種是用鋼鐵和玻璃製成的
流動形態的線性網，安置在迤邐搖擺通往主入口的增建人行道上。第二種
是三個以對角相連的投影圓錐體構成，以光線和視線孔道的方式穿透如堡
壘（Bastei）般的巨大體塊。投影線的靈感來自德國藝術家杜勒（Albrecht
Dürer）[30]的投影幾何和它在巴洛克建築上的應用。

譯註30：1471-1528，德國中世紀末期、文藝復興時期著名的油畫家、版畫家、雕塑家及藝
術理論家。

台場是一座填海造陸的人工島，這個充滿活力的都市空間，是文化實驗的完美地點。古根漢臨時博物館將進行為期十年的干預介入，扮演即時性的文化熱點。為了呼應臨時性的結構特質，我們採用了輕量封皮。兩個表面像摺紙一樣摺出形狀，彼此傾靠，包裹住寬敞的空間，同時創造出風格獨具的造型和可以不斷重新界定的空間。雖然空間概念極為簡單，但以蛇皮似的像素圖案統整起來的兩個摺面，鮮活生動，它們的尺寸、抽象程度和動態輪廓，保證會帶給人們興奮的空間感。

與派屈克‧舒馬赫合作

新加坡 2002

緯壹科技城總體規劃

ONE-NORTH MASTERPLAN

Singapore 2002

In collaboration with Patrik Schumacher

新加坡這座科技城的總體規劃案，讓我們第一次有機會建構一整個都市區的人工景觀。這項壯舉的好處也很驚人：可以打造原創的都市天際線和可辨識的全景，還可運用豐富多樣的廣場和巷弄來創造強烈的場所感。沙丘狀的巨構形式（megaform）是用屋頂表面接連而成，形成一種空間上的凝聚感，這種凝聚感在現代大都會中已變得相當罕見。一股統整的力量將高矮胖瘦、多樣萬變的建築形體收整得服服貼貼。線條的起伏模式界定了街道和路徑，將無限的多樣性吸納協調於連貫的形式之下，這就是運用「自然」幾何而非柏拉圖幾何[31]的優點所在。

譯註31：在幾何學發展歷史上，柏拉圖提出五個正立方體的定義，做為宇宙萬物的構成基礎。柏拉圖認為，自然界中有形萬物是流動而稍縱即逝的，而這些有形之物背後的「形式」或「理念」則是普遍的、恆常不變的。柏拉圖式的幾何學，強調不存在於現實世界中的抽象而完美的理想形式。

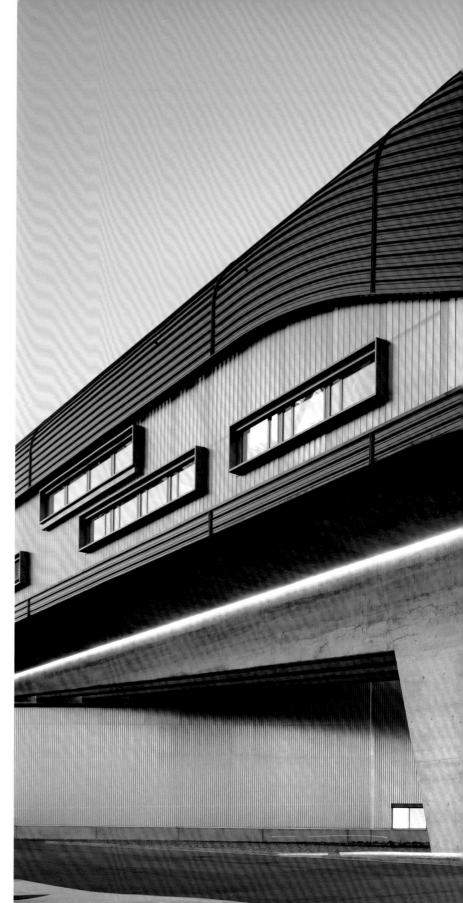

這棟建築是BMW整個工廠複合體的神經中樞,所有的活動動線都聚集在此,然後分散出去,因此,這棟建築必須讓生產的循環路徑以及工人和訪客的循環路徑都能穿越該空間。這種中心地位表現在動態的空間系統上,這套系統把廠區的北邊整個封住,然後以廠辦中心做為匯流點。這塊中心區域,或說「市集廣場」(market place),為全體員工和行政服務提供了一塊空間,因而強化了它的交流性格。

在結構方面,最主要的組織策略是一個剪刀狀的剖面,連結底樓和一樓,讓整個廠辦中心變成一個連續的場域。兩組階梯狀的平台像巨大的樓梯,從北往南和從南往北一路揚升,並在兩者之間形成長向的連續空隙。空隙底部是稽核區,也是每個人的關注焦點;空隙上方是半成品的汽車在眾目睽睽之下沿著軌道於生產線的不同單位間移動。如瀑落般層層串接的樓板,大到足以容許各式各樣的靈活運用,在單一的樓面上創造出更開放的視覺溝通。這點又因為內部組織的透明性而得到強化。我們以機能混合避開傳統的階層區隔;例如,把工程和行政辦公室安置在體力勞工日常活動的軌道裡。

我們將停車轉變成一個動態奇景,如此避開了在建築物前方設置大型停車場的問題。將建築物內或外所看到的車輛移動感,設計融入在停車空間的安排上,這使得整個場域隨著場力線(field line)而移動、顯色和閃閃發光,並在建築物內部達到頂點。

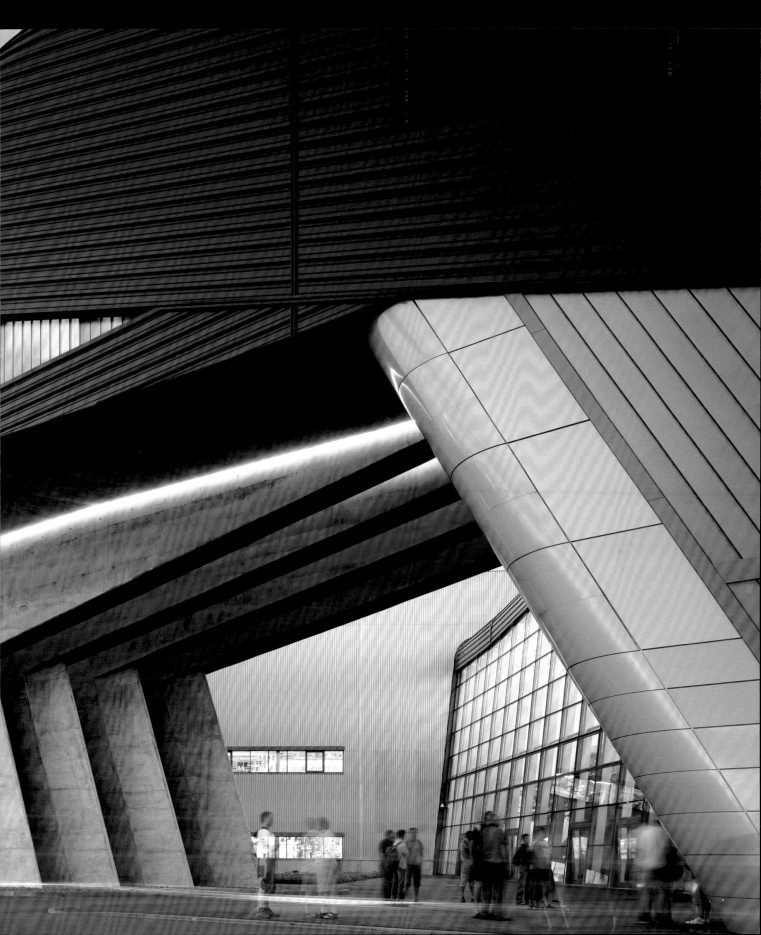

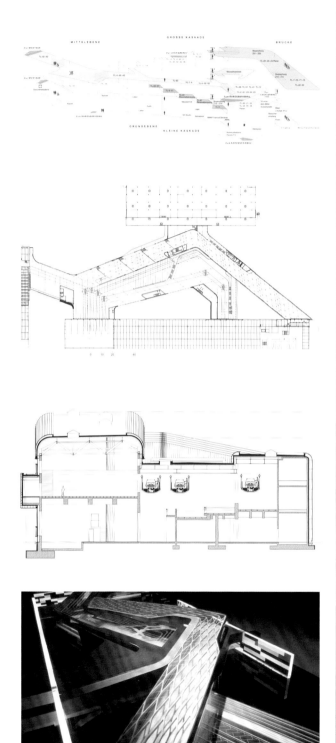

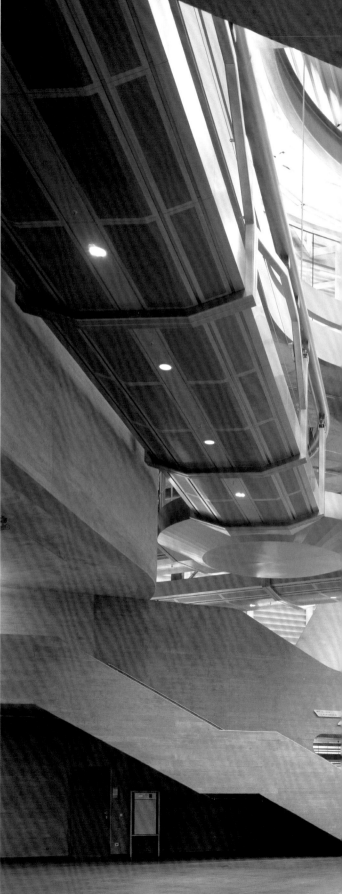

BMW PLANT CENTRAL BUILDING

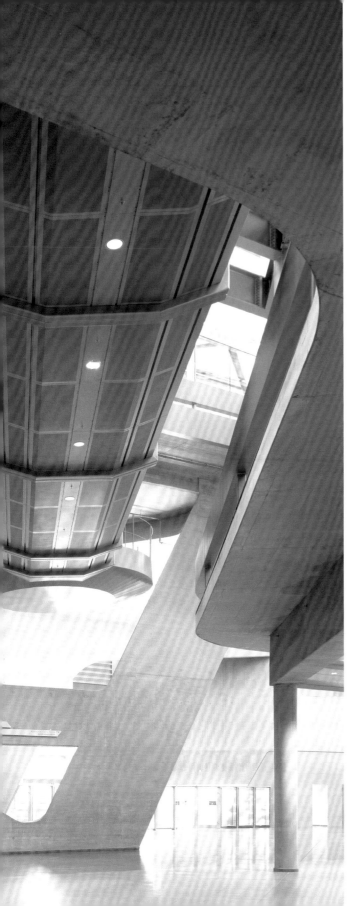

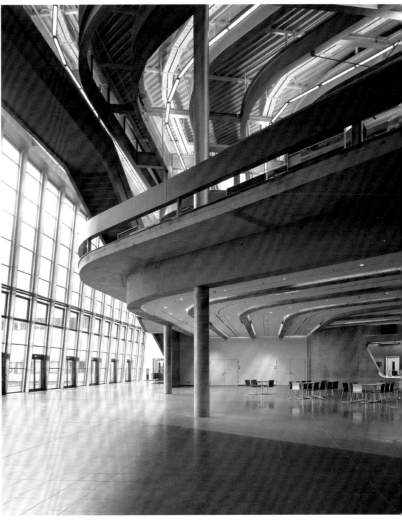

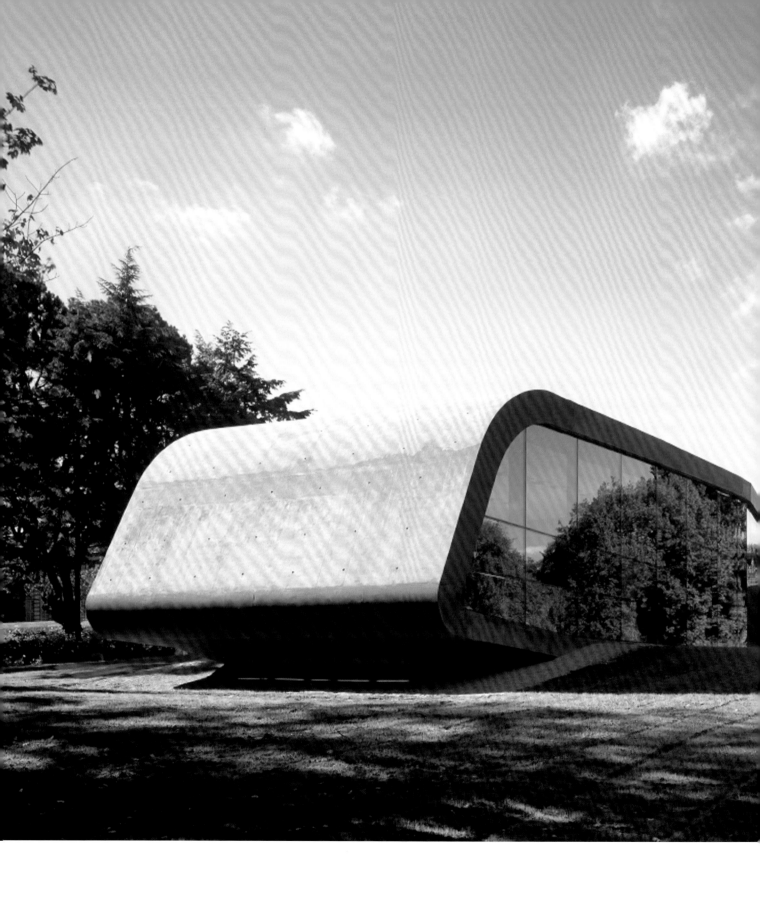

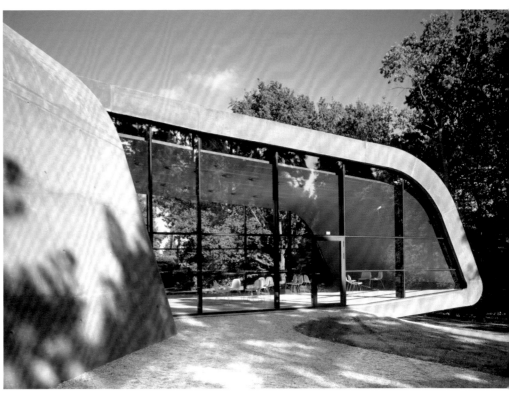

奧德羅普格博物館增建案

奧德羅普格博物館的增建計畫讓它有機會把不同的建築物和花園整合成單一實體。這個組合體立刻變成地景上的一個醒目特色,為原本的花園地形做了增添,將建物前方的平原與後方的斜坡花園區隔開來。我們研究了輪廓,將它抽象化,然後抬高、扭轉,形成一個殼體,變成博物館的圍界。當遊客朝新增建的部分走來時,會在花園裡與藝術品不期而遇,從各種不同的精彩角度欣賞大大小小的裝置與雕塑。我們把藝廊的內部地景改造成一連串流動、連結的空間,與戶外形成對比。

新建築用一座中庭與原有的法國區展廳隔開。所有展廳都呈南北向,位於門廳和商店後面,電梯的厚牆、樓梯和儲藏空間將門廳與展覽空間區隔開來。一條長斜坡道將特展展區與館藏展區分開,並引領觀眾走向面對花園的多功能廳和咖啡館。展出丹麥與法國藝術藏品的多個展廳,是建築組構的核心。我們用一個新展廳與原本位於花園尾端的高更舊展間連結起來,同時把一座狹長的中庭封住。我們把這個新空間當成提案裡最大的單一區域,利用它創造與其他展廳之間的視覺連結,並可望向花園後方類似迴廊的空間。

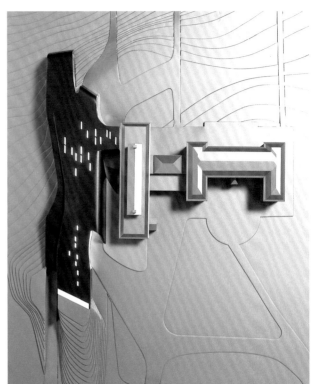

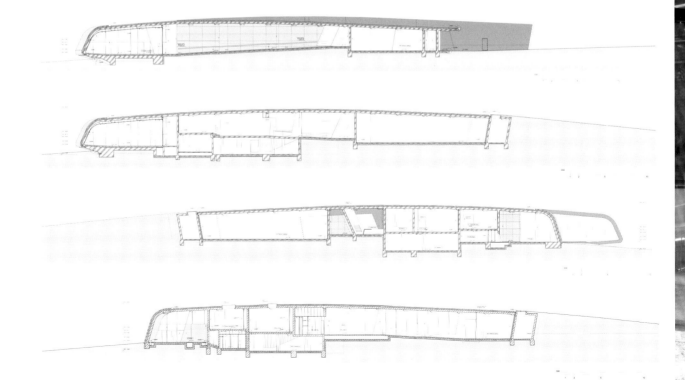

ORDRUPGAARD MUSEUM EXTENSION

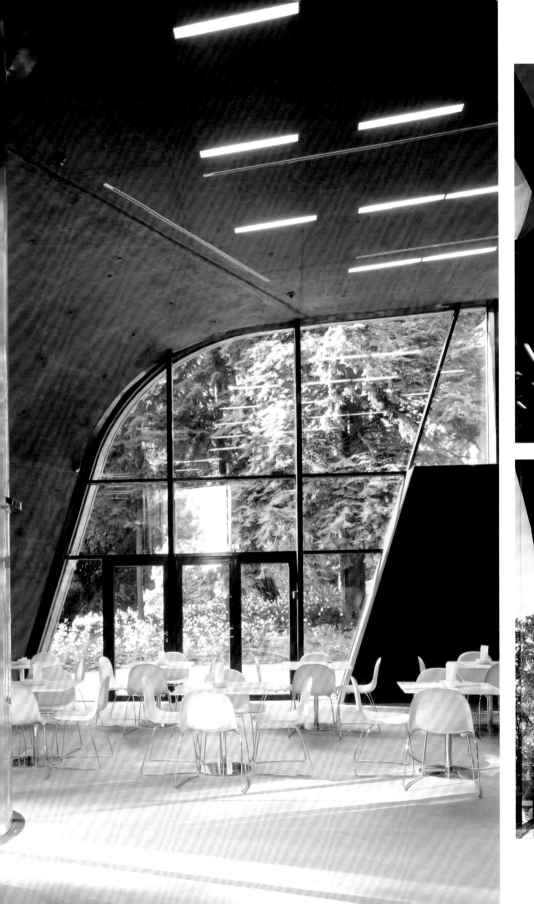

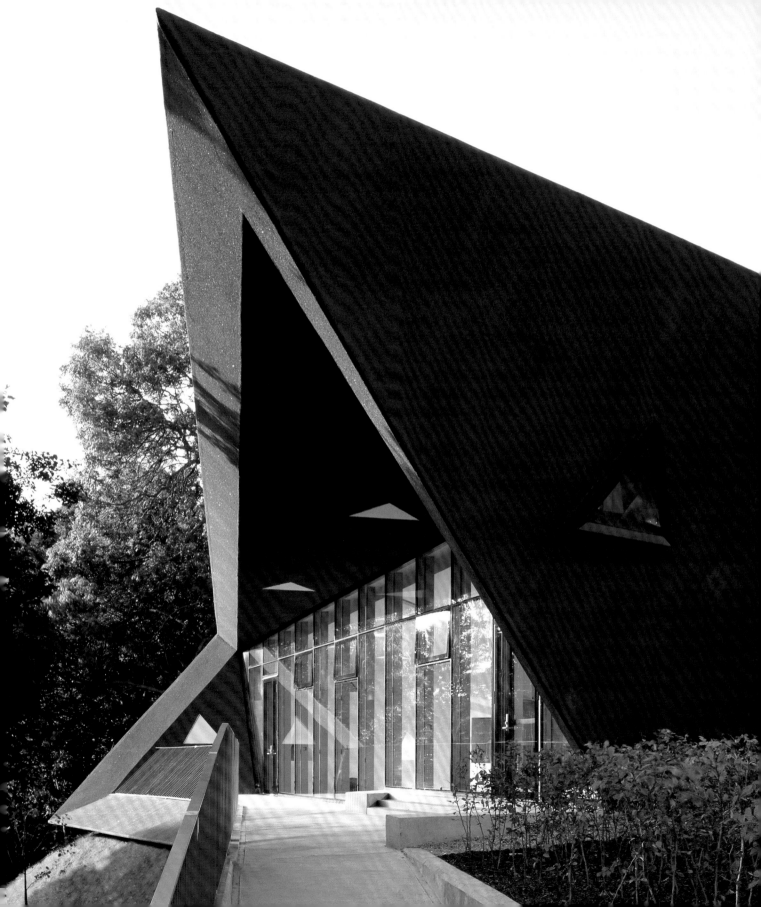

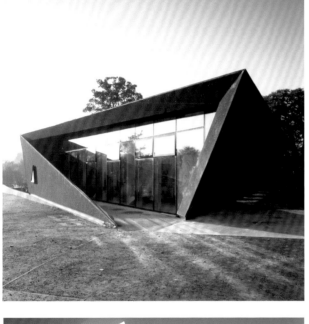

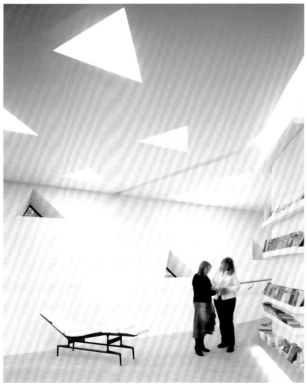

立面圖（上）

我們的目的，是在豐富的森林地景與人造的停車場和醫院之間，創造一個過渡區。我們用同樣的耐候鋼材料（Cor-Ten steel），包覆屋頂和兩個對立的牆面，在摺疊的表面和連續的地板之間玩設計。屋頂的大懸挑將建築物往下延伸到地面，混凝土基座則將中心往外帶，與周圍的地景區連為一氣。內部以開放式廚房為中心，房間排列在四周；辦公室位於北立面，直接望向停車場和入口。面東的房間私密性較高，外部看起來是半透光的立面。從位於東北邊的入口，可以直接看到中央的廚房空間和面南的玻璃立面。

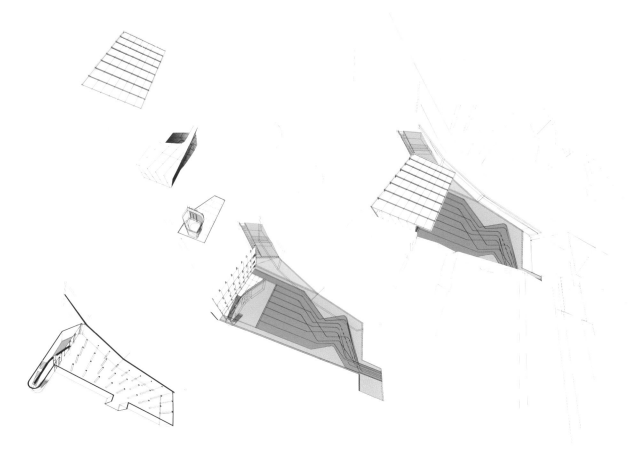

客戶希望我們為他的酒莊設計一棟世紀末風格的新館，把他曾祖父在1910年委託興建的舊館包含進去。舊館將成為這座新容器裡的一件珠寶。跟俄羅斯娃娃一樣，這座新館未來也將被收納在酒莊的增建裡，變成它的另外一層。經過多項研究，我們決定用剖面切割發展出這個容器。剖面的形狀是從舊館的長方形扭曲而成，一種狀似醒酒器的變形記憶。我們不是刻意如此，而是注意到了就忽視不了。我們為舊酒設計了一款新瓶子。

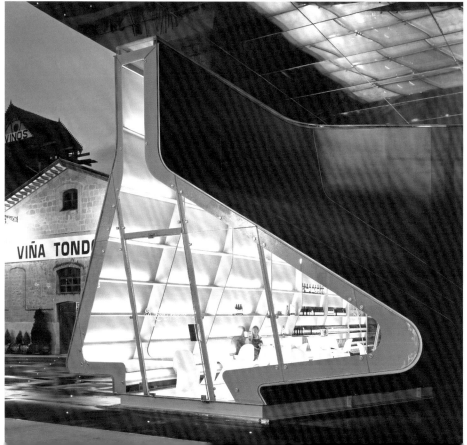

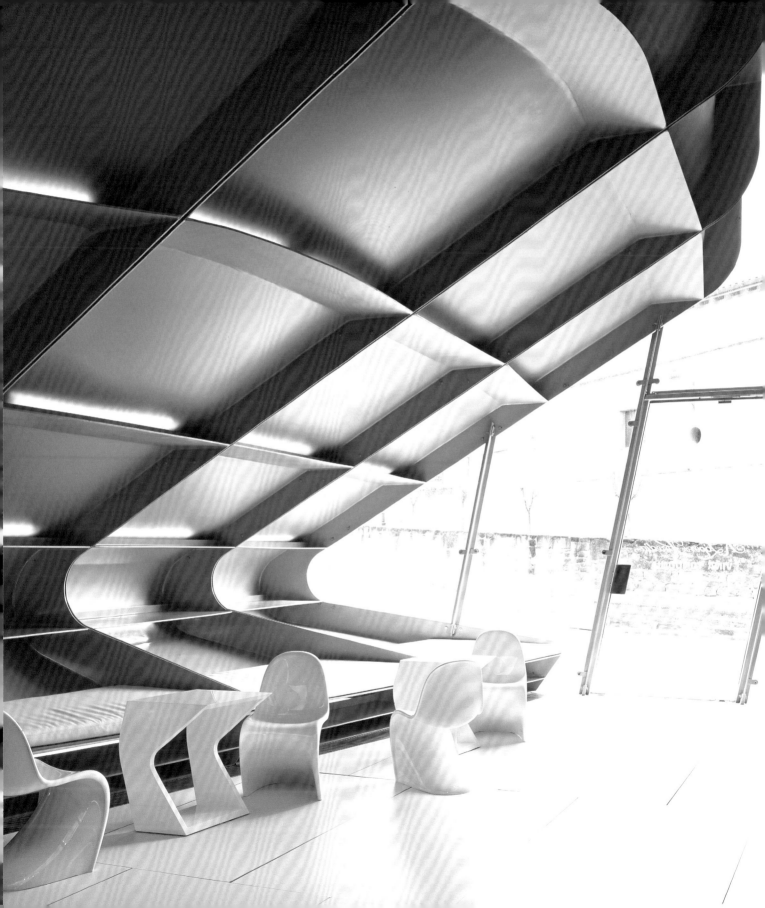

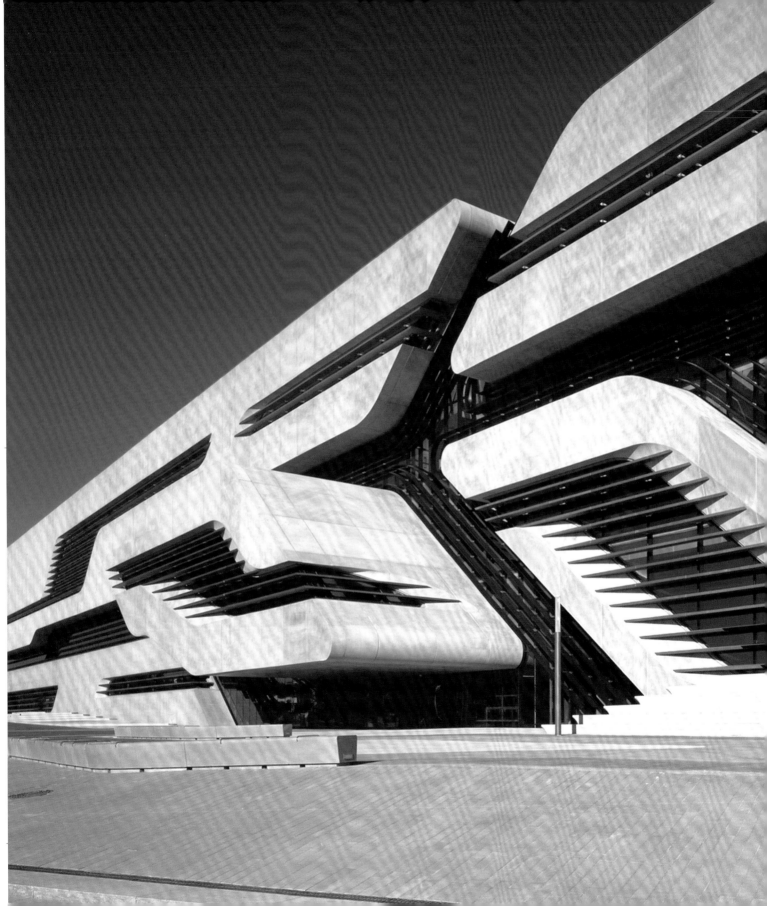

活石大樓

這座政府大樓結合檔案館、圖書館和運動設施,雖然是嚴格遵照計畫書的路線進行設計,但建築的形式卻會讓人聯想起橫躺的巨大樹幹。檔案館位於樹幹的堅實底部,接著是略為多孔的圖書館,運動設施和採光良好的辦公室位於頂部,樹幹在那裡分枝,變得輕盈許多。分枝部分標示出不同機構的接點和入口。各部門在地面層分享各式各樣的公共空間;往上走,每個機構各自獨立,有自己的核心區做為內部的垂直動線。

訪客抵達後,可順著指標直接從大廳通往底樓檔案館的教育空間,或是搭電梯和手扶梯前往一樓的公共主幹道。這條幹道順著立面形成內縮的玻璃帶狀區,從那裡隨即可抵達圖書館的閱覽室和檔案室。幹道中央位於建築物的核心區,是公共設施所在地,由三個機構共同分享,包括禮堂和兩間會議室。這些共享的公共空間也構成從「樹幹」往外凸的中央體塊,為到訪的民眾提供巨大的懸挑頂篷。

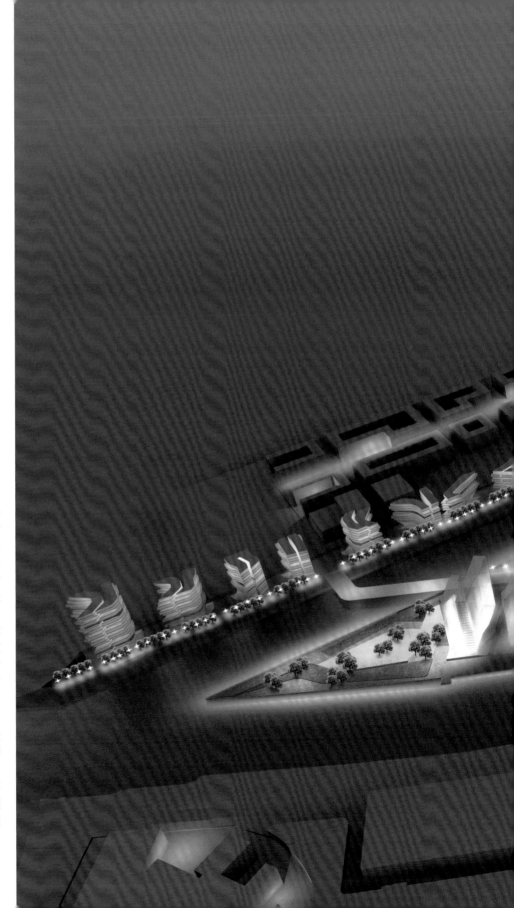

我們為這個前港口和工業區所
做的規劃，讓戲劇化的地形
與內維翁河（River Nervion）
的大彎弧，對畢爾包井然分明
的都市網格發揮潛移默化的影
響。建築物排列出細緻的紋
理，貫穿基地的長軸，可緊縮
以符合既有紋理的小尺度，也
能擴大以回應更開放的空間。
這項規劃同時容納了歷史建築
和新的投資，並跟兩邊寬闊的
公共河岸連結起來。

一連串的橋樑和一條延伸的電
車系統構成活動脊柱，連接
下游的社區與市中心；一套優
雅的建築模塊系統（building
block，每個模塊超過1000平
方公尺），讓規劃區擁有整體
的一致性。建築模塊的平台層
確立了防洪的臨界高度，並
為地下停車場創造空間。將這
個平台與建築群的發展連結
起來，可讓河岸大道更靠近河
流，讓居民親近河岸。

透過細膩的高低差處理，創造
出豐富的公私空間模式，讓隱
私與社群生活可以輕鬆平衡。
整體結構在密集的營造環境中
伴隨著充滿空隙的紋理感，讓
未來的住戶和工人都可享受到
多采多姿的戶外場所。

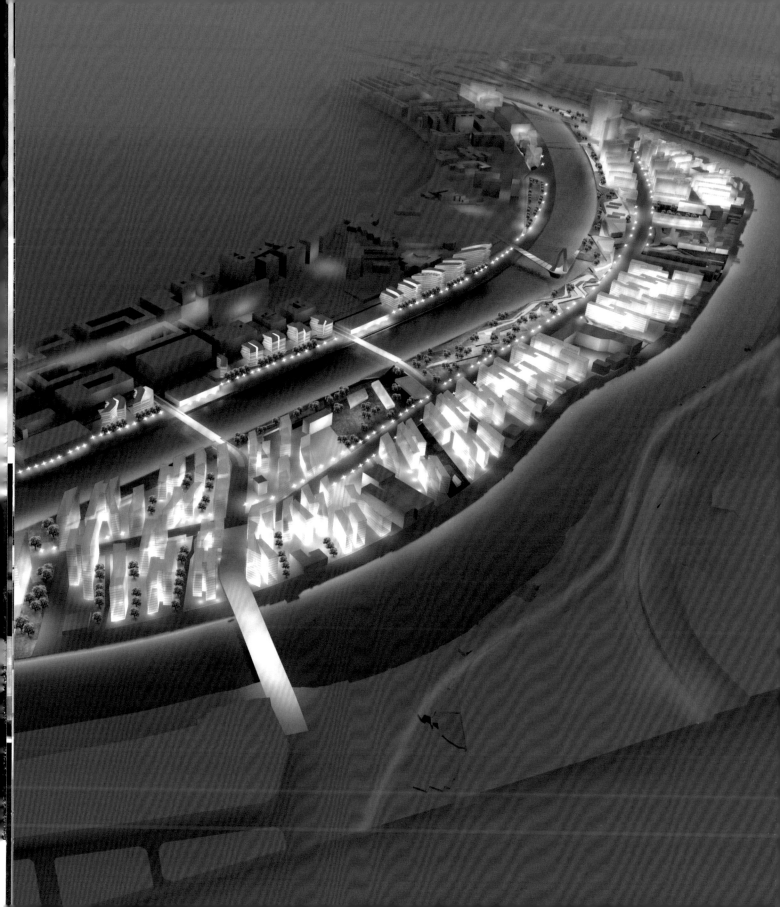

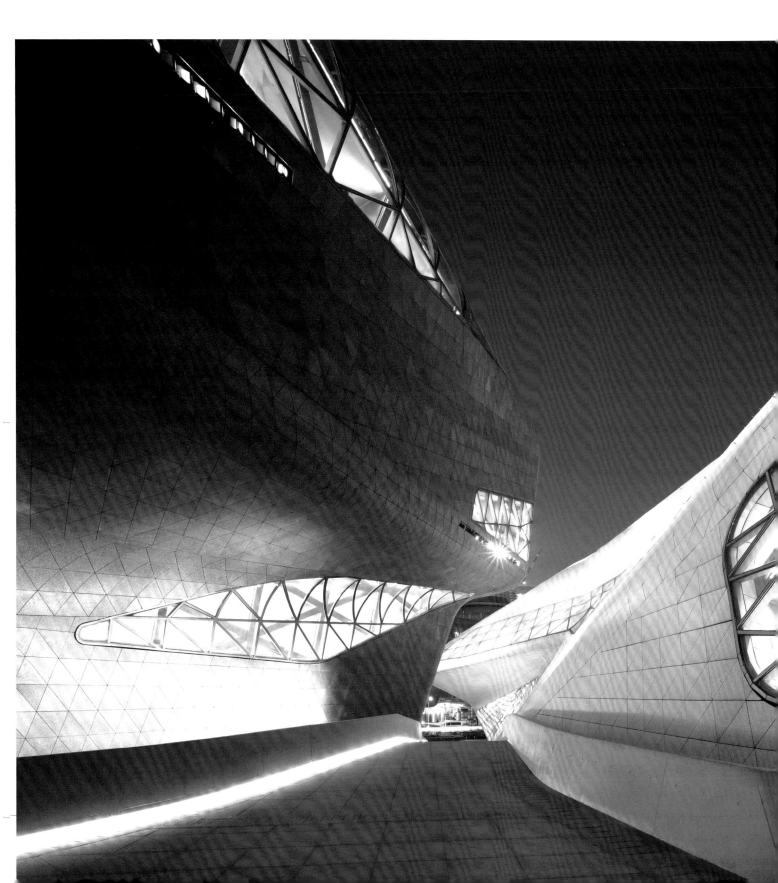

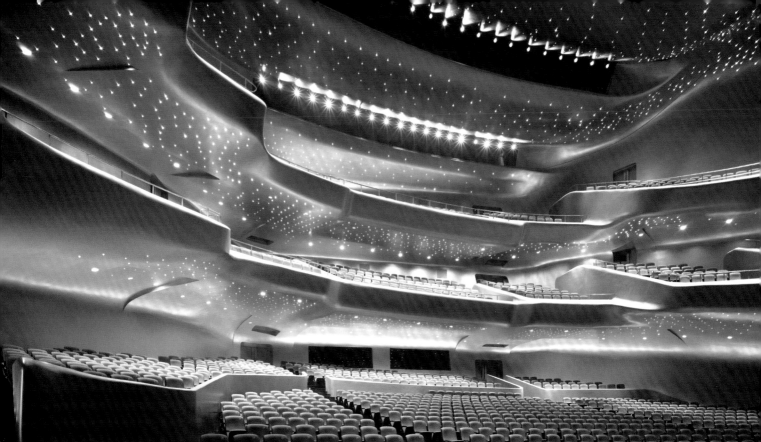

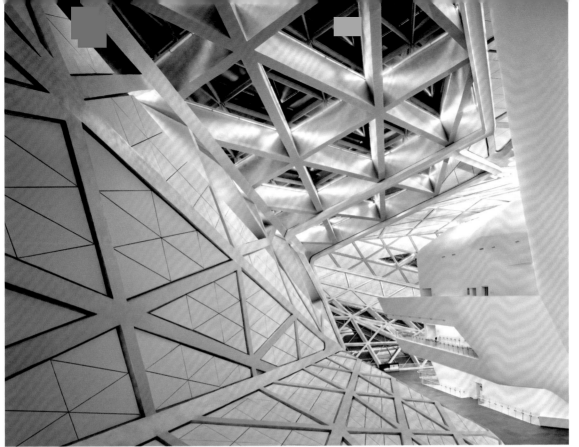

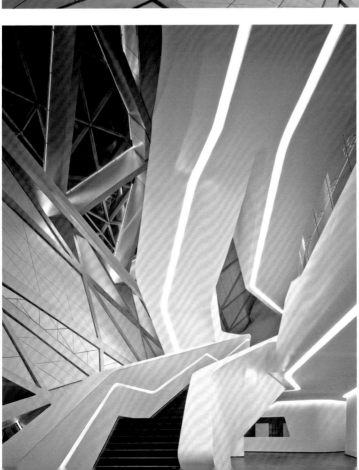

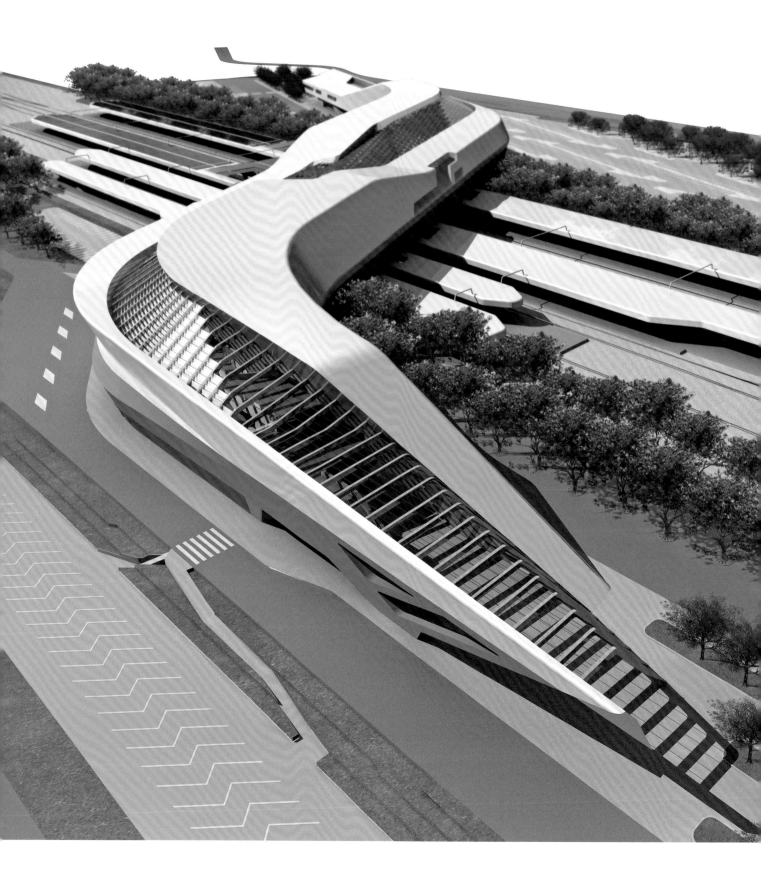

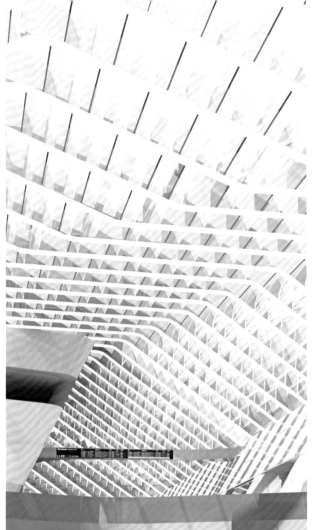

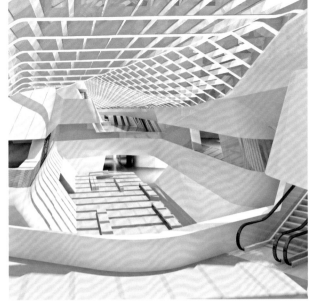

與派屈克·舒馬赫合作
義大利 · 拿坡里 2003-17

拿坡里-阿夫拉哥拉高鐵站

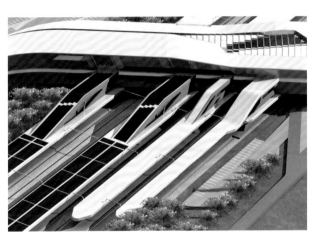

HIGH-SPEED TRAIN STATION NAPOLI-AFRAGOLA

Naples, Italy 2003–17

in collaboration with Patrik Schumacher

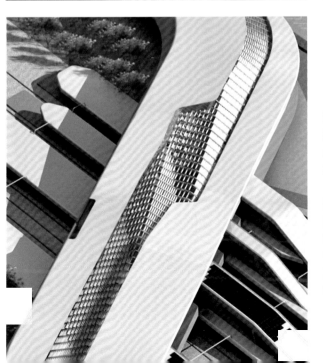

這座新高鐵站以橋樑形式橫跨在鐵軌上方。這項建築案最大的挑戰，是要打造一個組織完善的交通轉運站，並可做為進入拿坡里的新門戶。空中穿廊是通往不同月台的必經之地，我們想把它擴大成真正的旅客大廳，因而構思出橋樑的形式。

這座通過式車站（through-station）是規劃中的商業園區的樞紐，負責連結周邊的各個城鎮，橋形大廳讓乘客可以用都市化的公共連結方式跨越軌道，為通過式車站提供新的表現形式。橋樑的觀念進一步讓兩條延伸的園區順著軌道展開，將基地與周圍的地景和商業園區連結起來。建築物內部同樣延續這種以移動感為訴求的語言，用旅客的移動軌跡來決定空間的幾何。

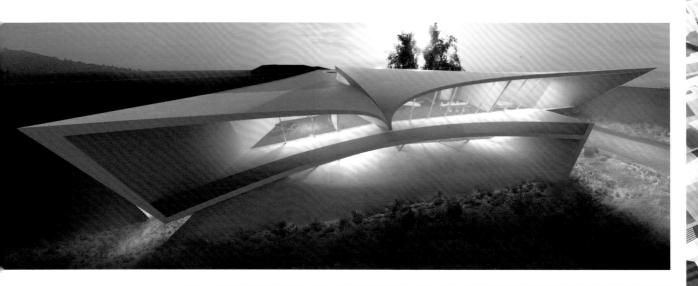

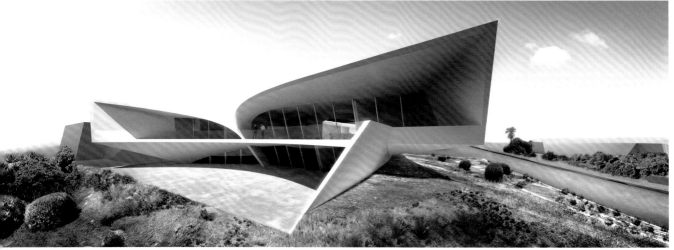

加州住宅

與派屈克・舒馬赫合作
美國・加州 2003-

CALIFORNIA RESIDENCE
California, USA 2003–
In collaboration with Patrik Schumacher

這是一棟俯瞰太平洋的住宅,我們在基地上加了一個人工合成的新地形庇護新的結構體,動感屋頂與圍牆結為一體,將私人與家庭空間攏聚起來,凸顯出海洋的景觀。結構幾何在平面和剖面上做了極端變形,呼應這種內部動感,讓所有的結構元素融入一個無縫皮層,可毫無阻礙地看到前庭和內部的景觀。這棟住宅與鄰近的結構體一起對美國郊區常見的類型學觀念提出批判。

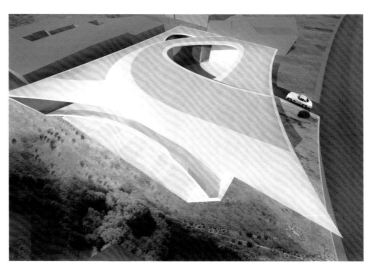

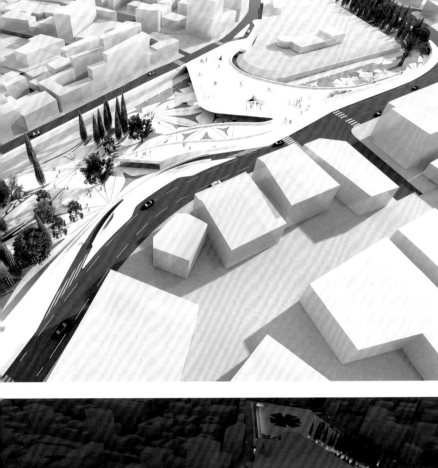

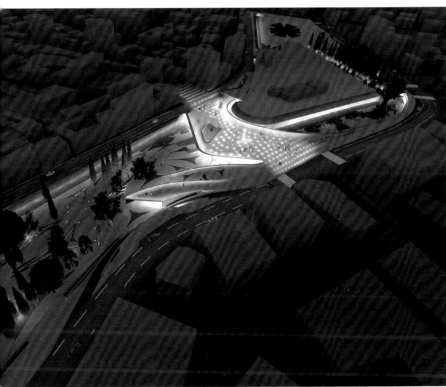

為了替尼科西亞城創造一座都市廣場，我們面對深厚的歷史傳統與矛盾：那些巨大的威尼斯式堡壘雖然提供居民保護不受外敵侵略，卻也將城市的古老部分與現代部分隔離開來。

我們的構想是採取建築干預的形式，把它當成大規模都市規劃的一部分，期望將整座城牆、護城河和現代市區的邊緣綜合組織成統一的整體。在這個宏大的願景裡，護城河變成一條「綠帶」，一條圈住圍牆的項鍊，是放鬆休閒的所在，也是藝術和雕刻裝置的場地。

我們把護城河架高加寬，增加動線，經由橋接的街道抵達，成為通往內城的新門戶，這些街道因為使用地下停車場而沒有車輛穿梭。城牆恢復往日的榮耀，由棕櫚步道護翼，通宵都有燈光照明，宣示它的存在以及它與嶄新、統一的尼科西亞的關聯。

基地平面圖

這條纜車線位於提洛邦阿爾卑斯山區
（Tyrolean Alps），我們在2005年與史
卓堡工程公司（Strabag）一起贏得競
圖，內容包括四座新纜車站和跨越因河
（River Inn）的斜張橋。這是我們在因斯
布魯克的第二個案子，前一個案子為伯
吉塞爾滑雪跳台[pp.114-115]。

每座車站都有自己獨特的涵構、地形、
海拔和動線。「殼」（shell）與「影」
（shadow）這兩個對比元素，呈現出車
站的空間質地，輕量、有機的雙曲面玻璃
屋頂結構，宛如「漂浮」在混凝土的基座
頂端，以此種人造地景來描述內部的行移
與動線。我們希望每座車站都能使用冰河
成形的流體語言，像一條凍結在山腰上
的溪流，所以我們花了很多時間研究諸
如冰磧石（glacial moraines）和冰凌移動
等自然現象。這種高度靈活的語言讓殼
體結構能根據不同的參數做調整，並維
持一以貫之的形式邏輯。新的生產方法，
包括數控銑削（CNC milling）[34]、熱成型
（thermoforming）[35]以及為汽車工業發展
出來的種種製造科技，讓這個用電腦輔
助生產出來的設計，可以自動且精準地
轉換成流線型的建築結構。

譯註34：利用電腦來運算控制生產系統內的製程
設備。CNC的最大特色，就是將不同系列的切削
加工動作存入控制器中，因此不需人力介入就能
依程式執行多種不同步驟。

譯註35：一種將熱塑性塑膠材料製成各種製品的
加工成型方法。將材料置於模具中，加熱模具使
材料軟化覆蓋於模具表面，再以機器擠壓或是抽
真空以大氣擠壓，經過冷卻階段固化後即完成。

NORDPARK CABLE RAILWAY
Innsbruck, Austria 2004-7
In collaboration with Patrik Schumacher

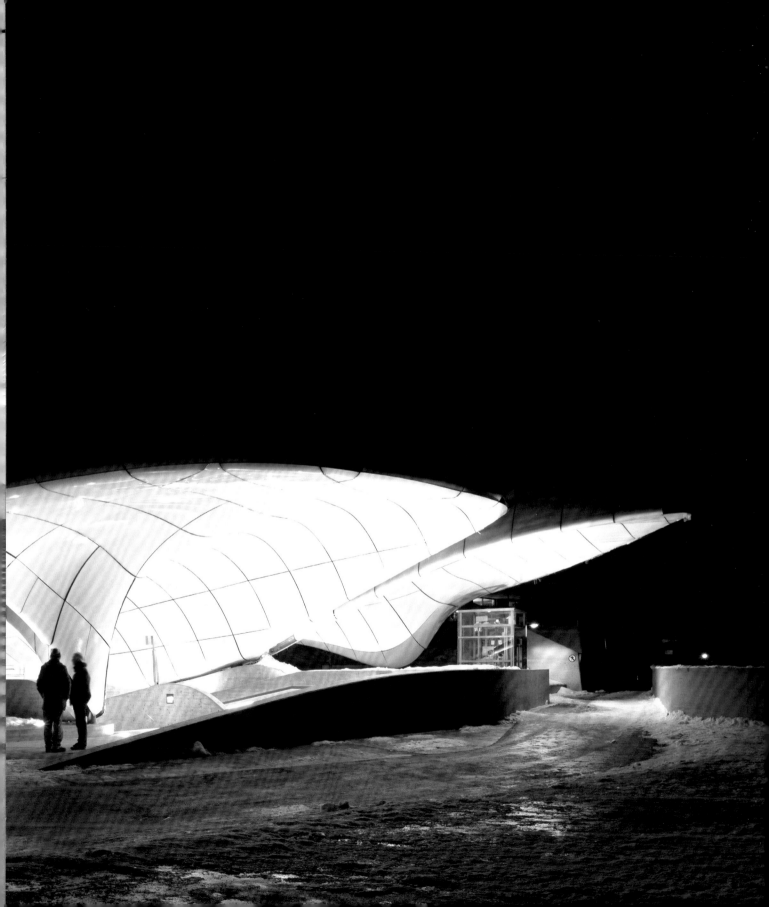

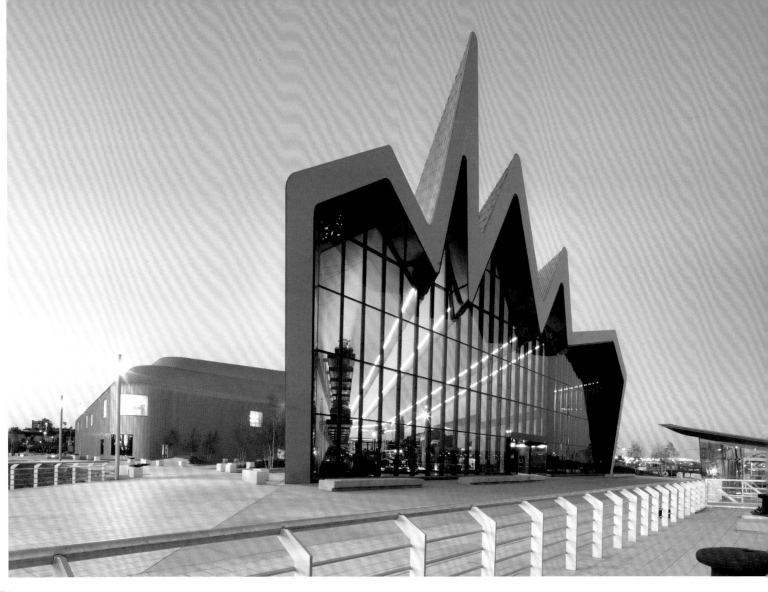

河濱博物館

英國・格拉斯哥

RIVERSIDE MUSEUM

Glasgow, UK 2004-11

格拉斯哥這座新博物館的設計靈感來自於它的涵構，以及克萊德河（River Clyde）的歷史發展和格拉斯哥本身所提供的獨特遺產[36]。從城市流向河川的設計，象徵兩者之間的動態關係，由博物館為兩者發聲並扮演彼此的過渡，同時積極鼓勵展覽與大環境之間的連結。

隧道狀的建築形構在博物館裡創造出一條內部路徑，變成城市與河流的中介，可以根據展覽的配置密封或滲透。因此，這座博物館在象徵上與機能上都是開放而流動的，積極參與它的涵構與內容，以便與格拉斯哥的歷史和未來互聯。當觀眾在展覽之間移動時，也會逐漸感受到他們與外部涵構的關係。

建築剖面沿著一條轉向改道的線性路徑伸拉，在頭尾兩端開啟。橫剖面的輪廓像是要把一道波浪或「褶皺」（pleats）封裝起來。靠外側的褶皺內部圍蔽成室內隔間，用來容納支持性服務和「黑盒子」（black-box）展覽，讓中央的主空間成為無柱的開放性空間，以最大的靈活性展出這座博物館的世界級收藏。

譯註36：十九世紀時，英國蘇格蘭南方的格拉斯哥工業蓬勃發展，當時全世界的船隻和火車大多在此製造，並有「大英帝國第二大城」的美譽。格拉斯哥經過20世紀的經濟大蕭條導致衰退後，1990年代起逐漸轉型成為歐洲的文化與體育之都。

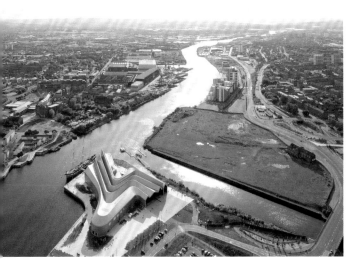

與派屈克·舒馬赫合作

義大利·米蘭 2004-17

米蘭城市生活

這個總體規劃的基地包括一座大公園、三棟辦公大樓、商用建築、教育和社會設施、一座博物館和兩個複合式住宅群，由不同建築師設計興建[37]。這塊基地先前是歷史悠久的米蘭展覽中心（Fiera Milano），位在好幾條都市主軸線的交會處。

活力四射的都市紋理為建築物的幾何提供靈感，成為設計的核心：一棟170公尺高的辦公大樓（興建中）連接到兩層樓的商用空間以及由七棟建築組成的住宅群（2014年完工）。住宅大樓排列成彎環狀，由一條寬闊的人行大道切分開來，經由這條大道可望向並通往公園與哈蒂大樓（Hadid Tower）。住宅大樓從五層逐漸增加到十三層，屋頂的輪廓形成一條蜿蜒的曲線，呼應整體住宅群的流動形式。陽台和露台可通往豐富多樣的私人空間，包括內部與外部，它們所形成的曲線運動，界定出建築體的封皮。

一系列步道在公園裡幅合，形成一道渦漩，哈蒂大樓就位於渦漩正中心。大樓基座的曲線幾何被這些張力激活起來，從人行大道和商業廊道會合的地表浮現。這股扭力貫穿整座大樓，也就是渦漩的真實核心，將水平能量轉化成垂直推力。

譯註37：三棟分別是由札哈·哈蒂設計的扭曲大廈、日本建築師磯崎新設計的垂直大廈和由美國猶太裔建築師丹尼爾·里伯斯金（Daniel Libeskind）設計的彎曲大廈。

CITY LIFE MILANO

Milan, Italy 2004-17

In collaboration with Patrik Schumacher

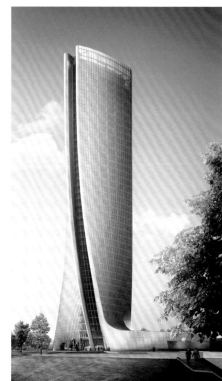

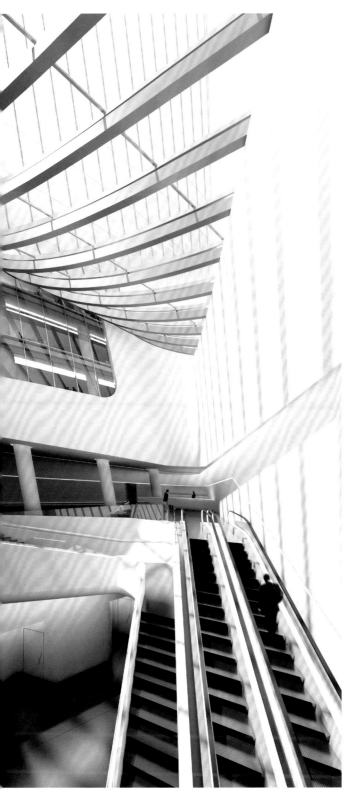

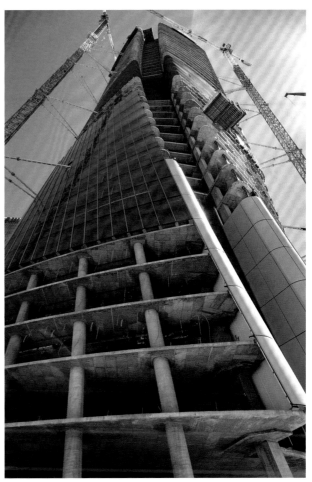

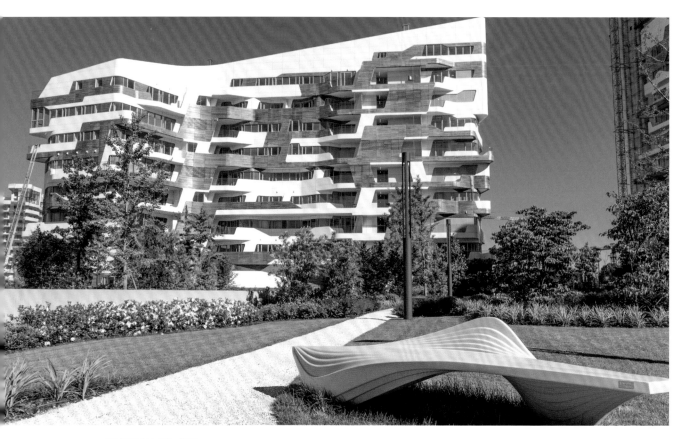

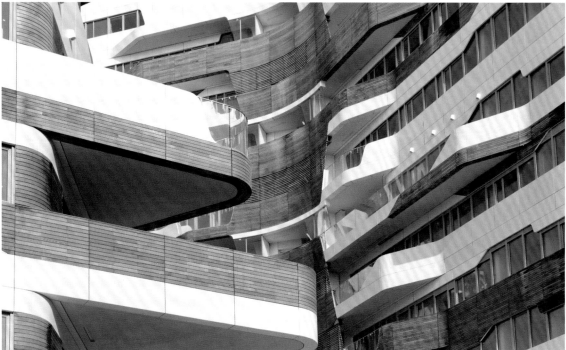

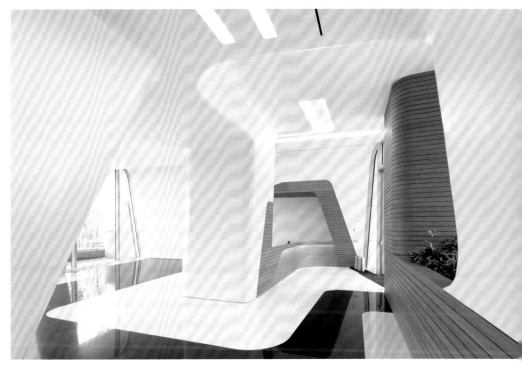

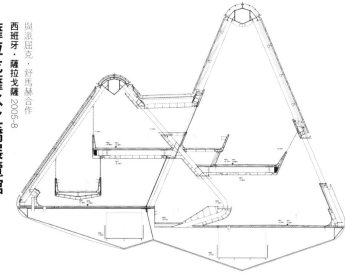

我們想要設計一座水之橋展覽館,探索沿著曲形路徑伸拉的菱形剖面,組織核心是四個做為結構元素和空間圈圍的主桁架或「豆莢」(pod)。這些堆疊互鎖的豆莢可以彼此支撐,讓荷重分布在四個而非單一元素上。互鎖對我們的設計產生預料之外的美妙影響。訪客經由間隙小空間穿越一個個莢體,它們扮演過濾器或緩衝區的角色,將聲音與視覺從一個展覽空間慢慢調整到另一個。

設計這棟建築的皮層時,鯊魚鱗片的外觀和性能提供了迷人範例。它們的圖案可以用簡單的直線脊系統(system of rectilinear ridges)輕鬆包覆在複雜的曲率上,事實證明,它們不但性能良好、耀眼吸睛,而且經濟實惠。我們用簡單的瓦片重疊出複雜的圖案,創造出這個皮層,其中有些瓦片還可繞著樞軸旋轉,開關部分立面。光線穿越的孔徑從細點到全開不等,可藉此調整光的質地。

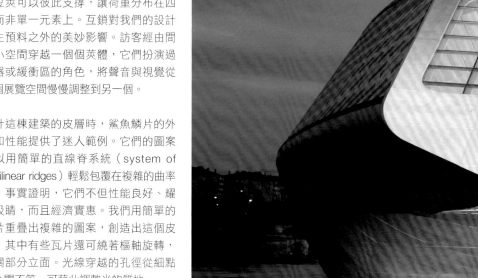

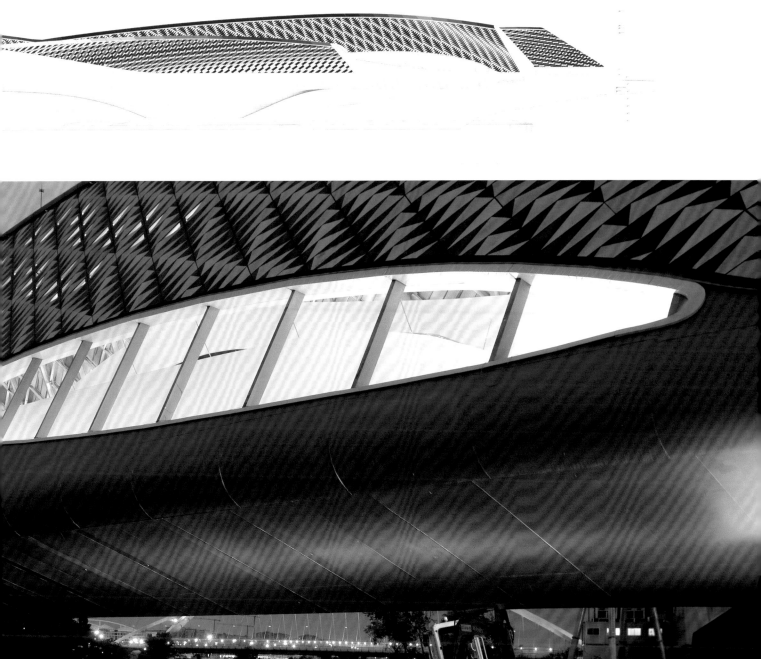

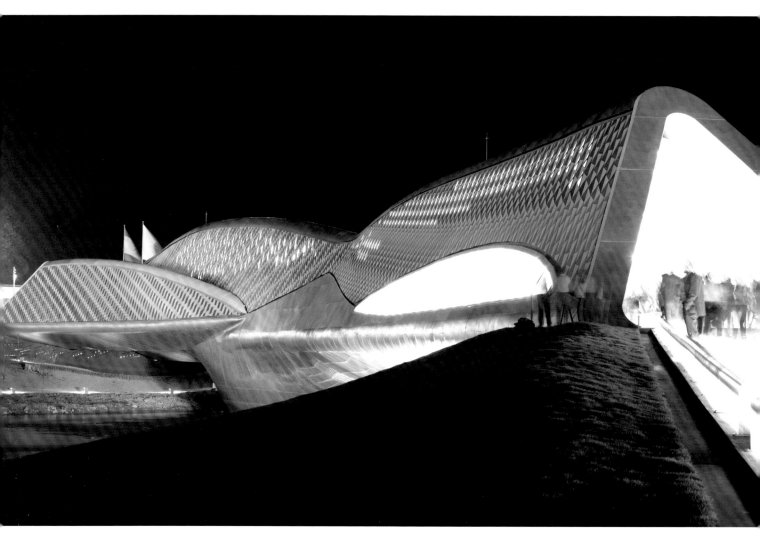

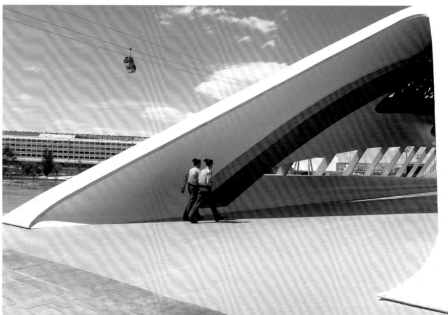

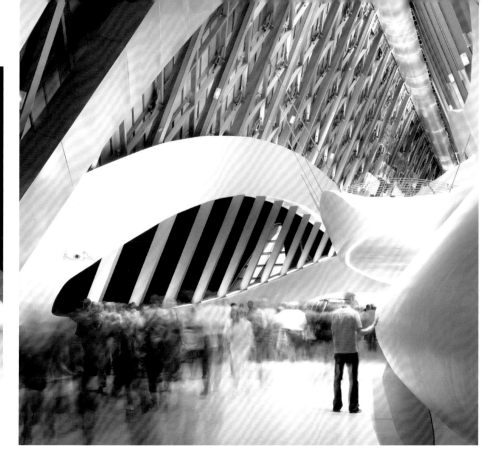

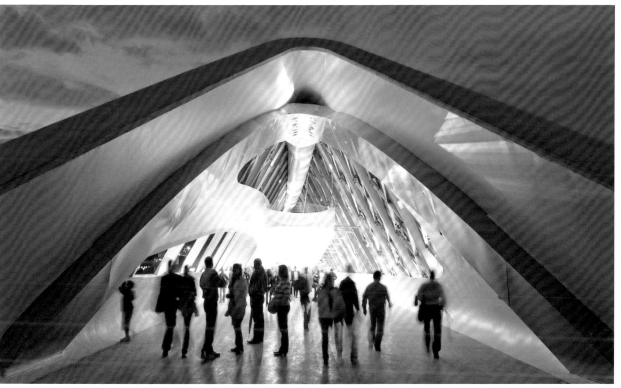

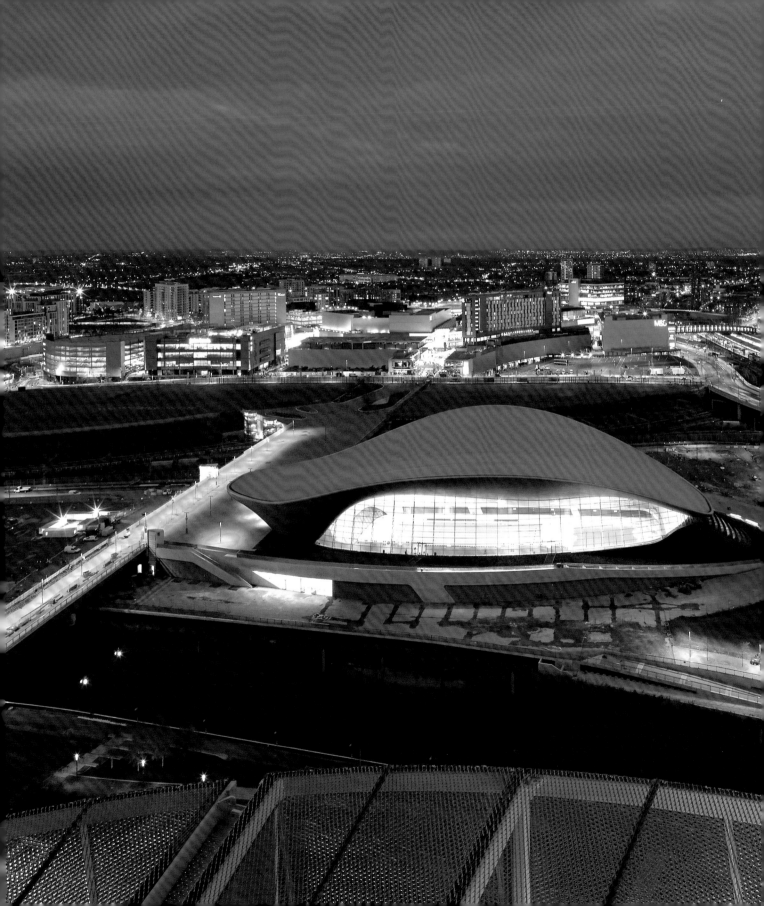

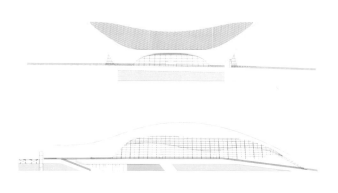

我們的設計是2012年倫敦奧運的主場館之一，靈感來自於活水的流動幾何，設計的重點在於打造一個與奧運河景園區彼此共鳴的空間和周遭環境。建築物座落在與史塔福城市大橋（Stratford City Bridge）垂直的正交軸線上，三座泳池沿著軸線排列：訓練池位於橋下，競賽池和潛水池則設置在巨大的泳館內部。泳館的基部框成墩座，與大橋緊鄰連接。這個墩座把各式各樣的計畫項目容納在單一建築體內，與大橋和地景融為一體。墩座從橋上浮現，順著泳館四周瀉落到下方的運河高度。我們用雙曲幾何塑造拋物線拱形結構，創造鮮明獨特的大屋頂，用起伏的造型區分內部的競賽池和潛水池。屋頂突伸的範圍超過下方泳館的外牆，覆蓋了外部的階梯區和橋樑入口，不管從哪一邊進入，屋頂都宣告了中心的存在。

結構方面，屋頂在三個主要位置上與地面相接，屋頂和墩座之間填入玻璃立面。這樣的配置可確保比賽期間臨時裝設的一萬五千個觀眾席沿著池邊排列，沒有任何結構物妨礙視野。比賽結束後，臨時座位席移走，換上玻璃板（座位降到兩千五百個），讓場館變身成社區和菁英訓練中心。該中心已於2014年開放，供民眾使用。

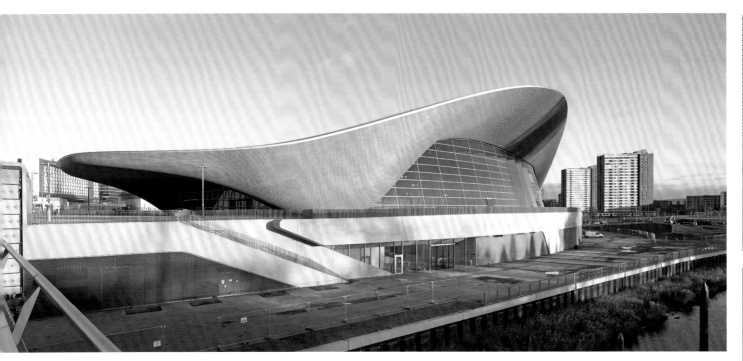

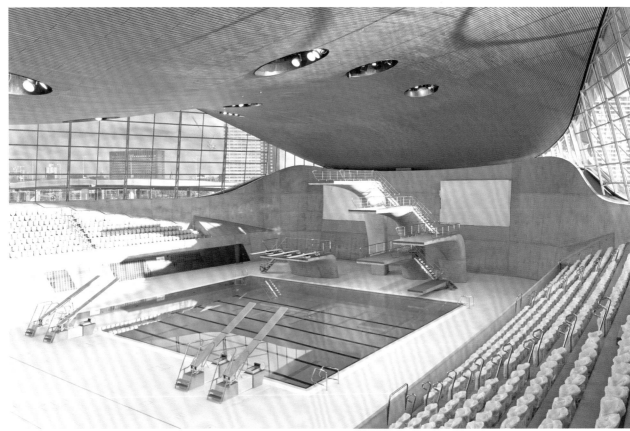

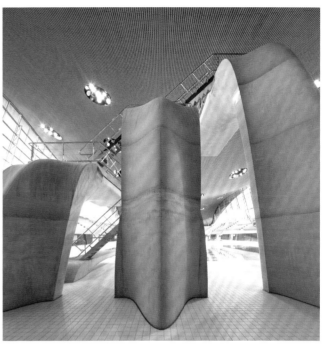

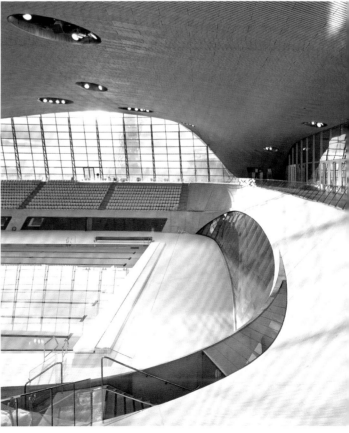

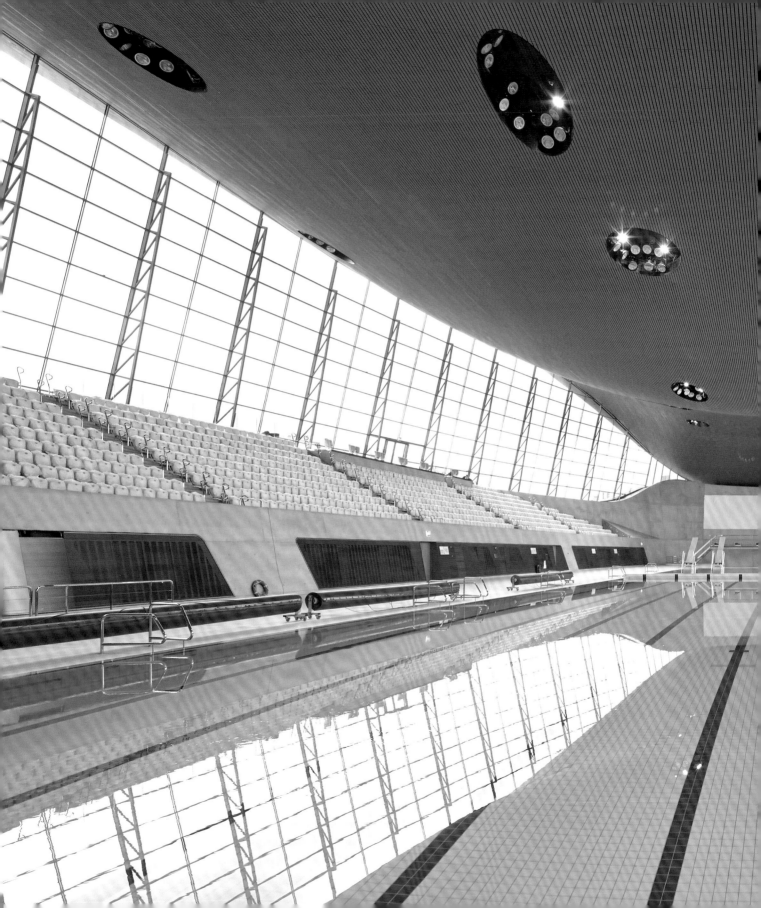

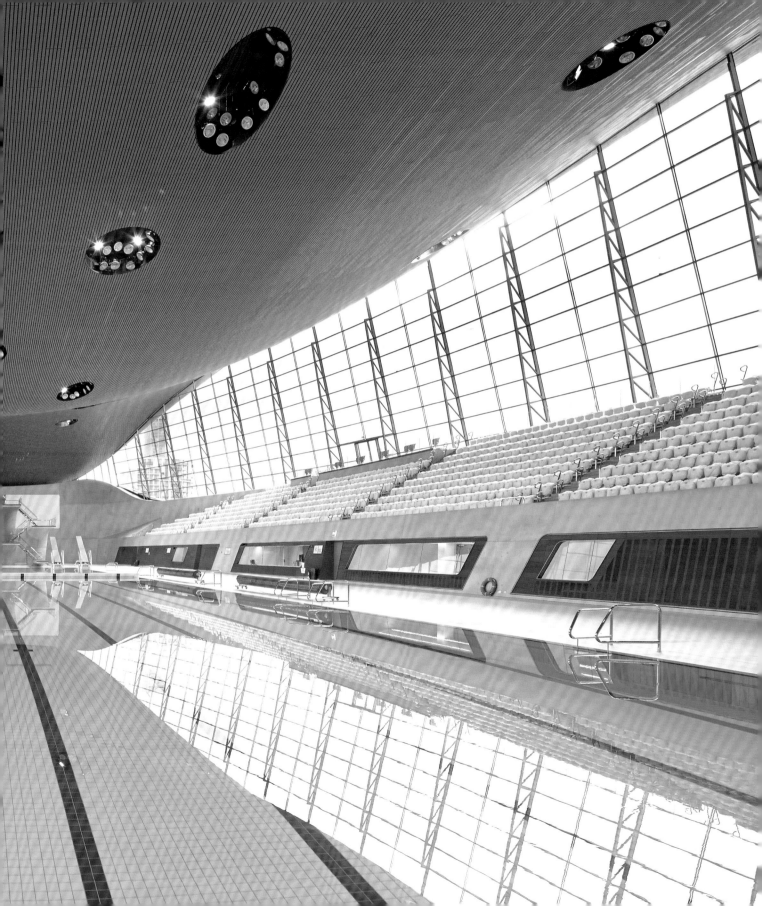

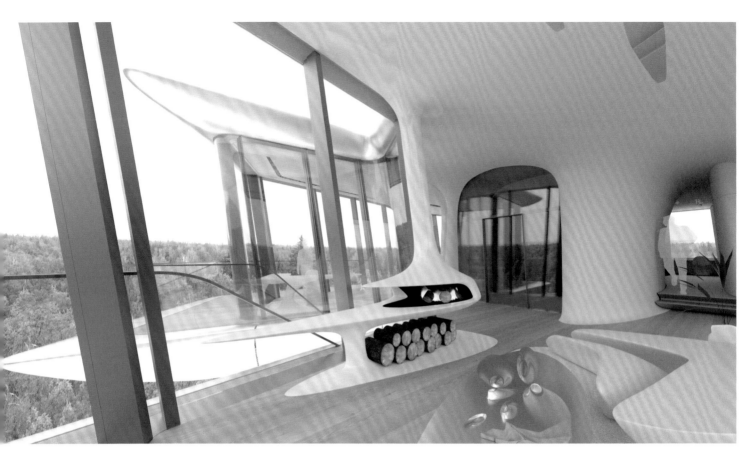

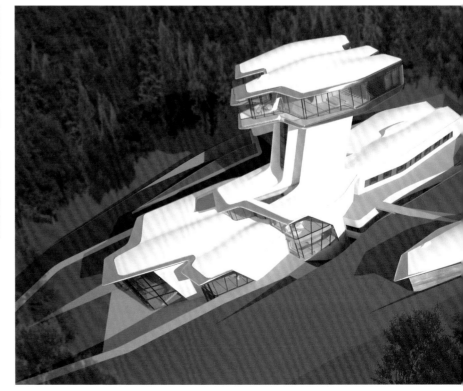

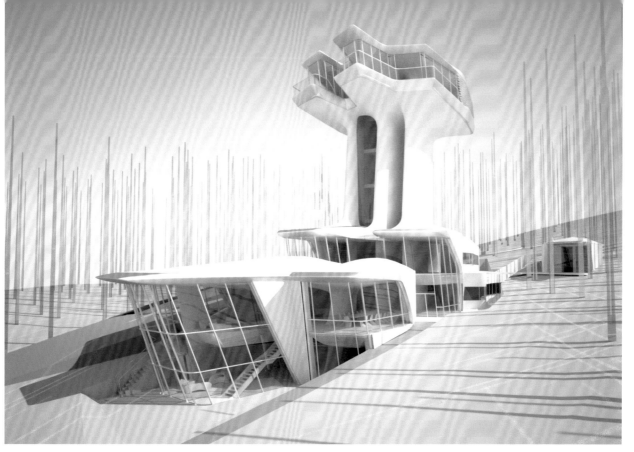

這個計畫由兩個主要部分組成：第一部分融入山坡地景，第二部分則是一個分離的量體，漂浮在離地22公尺的高空上。這棟建築以流動的幾何形式從地景上垂直浮升，但有部分內嵌在山坡裡。水平形式吸收既有的土地形構，並以人造階地佔據其上。我們把戶外地形拉到建築內部，讓建築重新接回自然環境。這種雙向過程消融了內外之間的差異，創造出初步的流動觀念，然後轉化成垂直向上的第二形式。

CAPITAL HILL RESIDENCE

Moscow, Russia 2006-

In collaboration with Patrik Schumacher

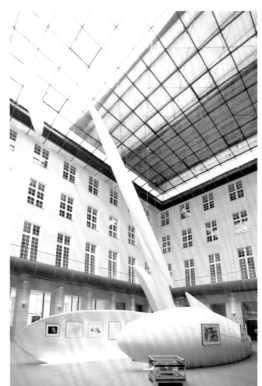

德國古根漢

與派屈克・舒馬赫合作
德國・柏林 2005

DEUTSCHE GUGGENHEIM
Berlin, Germany 2005
In collaboration with Patrik Schumacher

這個介入型展館是一個挖空的實體,讓觀眾穿越一連串挖鑿出來的空隙。各種橢圓形空間的相互關係,是根據展出作品的大小和數量發展而成。這些橢圓形順著觀眾的參觀路徑變得越來越富動態感,然後在進入中庭大廳時化為固體,變成戲劇性十足的殼狀水平和垂直結構,朝屋頂的玻璃竄升。

都市星雲

與派屈克・舒馬赫合作
英國・倫敦・倫敦設計節 2007

URBAN NEBULA
London Design Festival, London, UK 2007
In collaboration with Patrik Schumacher

這項裝置的目的是要探索混凝土的潛力,測試是否可用傳統的預鑄技術加上電腦數控機壓成形,以混凝土這種媒材來打造可重複的流動形式。這件作品的個別元素創造出一種流動感,有違於我們平常對混凝土這種惰性材料的認知。星雲裡的明暗區塊顯而易見,我們透過元件的擺放位置創造出六角形和三角形的空隙。

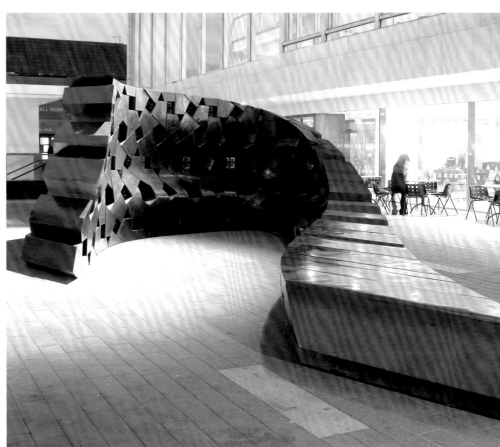

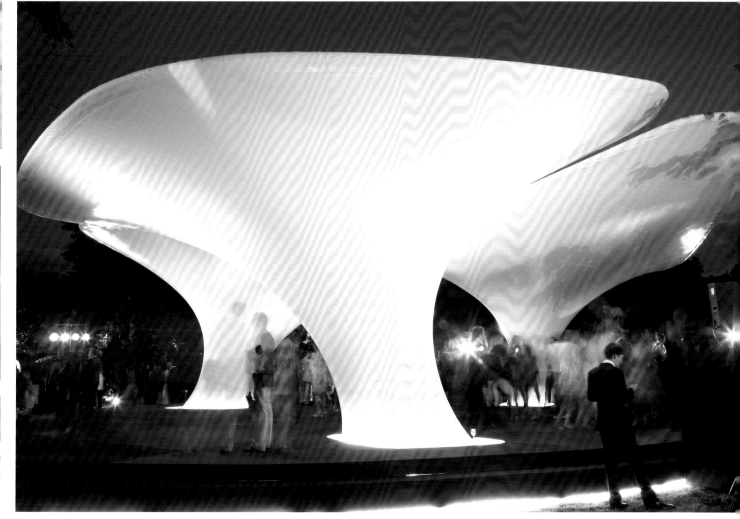

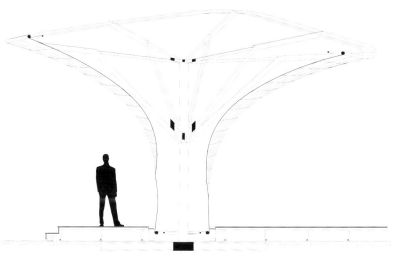

與派屈克·舒馬赫合作

英國·倫敦·蛇形藝廊 2007

紫丁香

LILAS

Serpentine Gallery, London, UK 2007

In collaboration with Patrik Schumacher

這項裝置是為蛇形藝廊一年一度的夏日盛會設計的，用三個織物「遮陽傘」繞著一個中心點架構出一個露天空間。每個遮陽傘都從一個鉸接的小基部發展成懸臂的大菱形。靈感來自花瓣複雜的自然幾何，陽傘與陽傘懸空交疊但不碰觸。亭館獨自矗立在空曠場地的矮平台上，可從四面八方進入。白天可提供遮蔭，到了晚上，經過能量轉換變成照明光源。

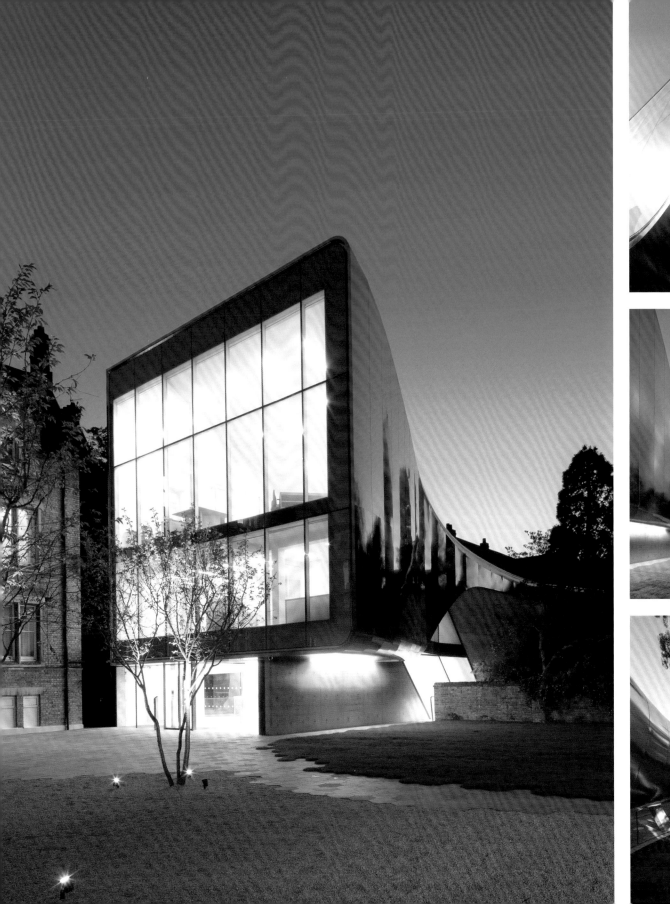

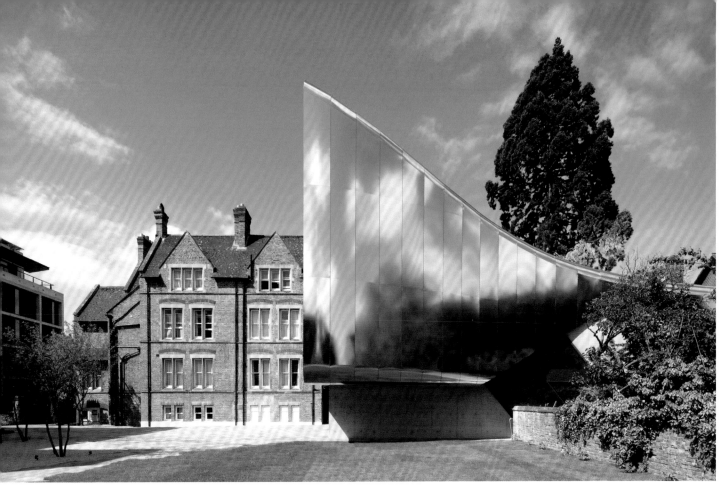

聖安東尼學院的中東研究中心擁有牛津大學首屈一指的現代中東收藏，以及世界級的私人文件和歷史照片檔案。Investcorp大樓提供1127平方公尺的樓層空間，讓中東研究中心圖書館與檔案館的擴充空間增加兩倍，還有一間117個座位的演講廳，位於地面下方，利用熱迷宮（thermal labyrinth）[38]通風。另一座類似的迷宮位於圖書館的檔案室下方，為保存該館著名的收藏進行必要的環境控制。

Investcorp大樓迂迴穿過聖安東尼學院狹窄的基地，與受到保護的既有建築和樹木連結融合，但仍保有各自的獨立性。圖書館閱覽室西立面的彎弧形式，收容了那株百年紅杉和它的遼闊根系；我們在基礎板下方加裝排水系統，確保樹木能得到足夠水分。東邊的檔案館閱覽室和圖書館辦公室，朝著對面1970年代粗獷主義（Brutalist）風格的希爾達貝斯館（Hilda Besse Building）[39]揚升，但並未超過相鄰建築的屋頂線。

譯註38：建築中用以減少空調負荷，增加自然通風的迷宮狀構造。戶外較熱的新鮮空氣，先通過設置於地底的混凝土迷宮狀通道冷卻，之後再進入室內空間，如此減少了空調的需求量。室內空氣受熱後緩緩上升從建築上方排出，又帶動了冷空氣進入與整體空氣對流。

譯註39：建於1967-71，由Howell Killick Partridge and Amis設計，二次戰後，建築師們盛行將混凝土、磚頭等材料用於建物上，多運用於集合住宅、公共建設，並且表面粗糙不加修飾，呈現出材料真實的一面。

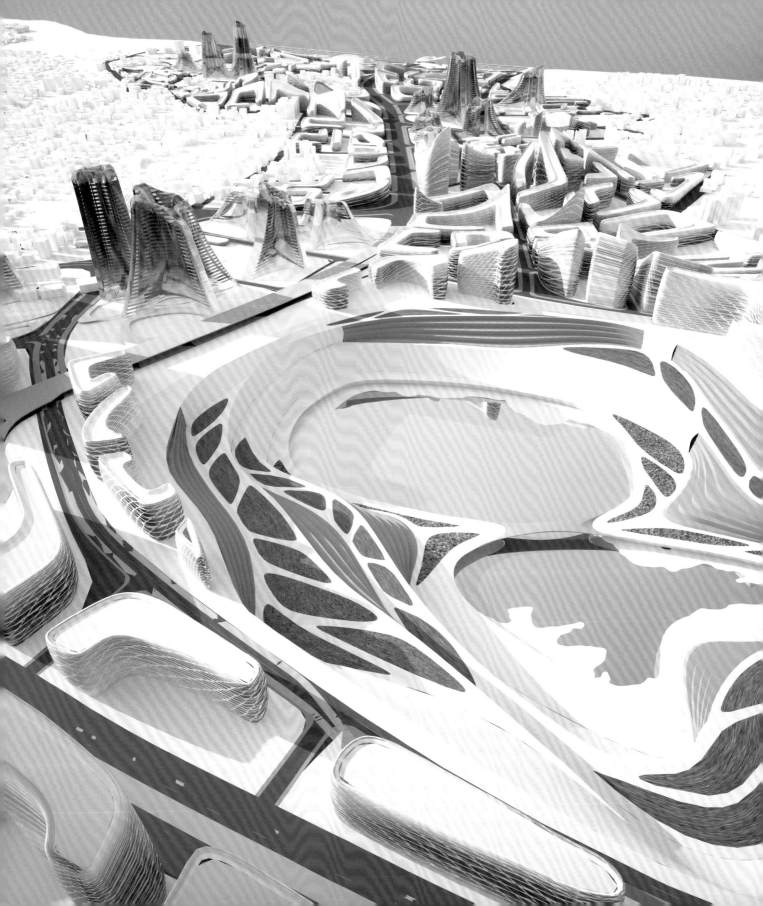

與派屈克‧舒馬赫合作

土耳其‧伊斯坦堡 2006-

卡爾塔爾-朋迪克區總體規劃

我們對卡爾塔爾-朋迪克區的總體規劃目標，是要鼓勵伊斯坦堡變成一個多中心的城市，矯正該城歐洲部分的單中心偏見[40]。這項規劃將形成一股經濟動力，把財富的漣漪效應擴散到與總體規劃相鄰的區域。可容納十萬人居住和工作的城市區塊，將催生出一個活力四射的區域。為了達到這項目標，我們提出格子狀的街道網格，加上三個主要的密集建築群，形成具有動力感的天際線，並善用濱海的地理位置與海景。一條新的林蔭大道將成為此區的主動脈，做為這項總體規劃的「脊柱」，連結北方的地鐵站和南方的火車站與公路樞紐。兩個主要的商業區南北各一。北方的採石區將改造成主要的休閒娛樂區，環著湖景興建；至於濱海與面海的南方，則發展成文化區。

譯註40：伊斯坦堡是世界上唯一一橫跨兩大洲（歐洲與亞洲）的城市，歐洲一側為經濟和歷史中心，僅三分之一人口居住於亞洲一側。

KARTAL-PENDIK MASTERPLAN
Istanbul, Turkey 2006–
In collaboration with Patrik Schumacher

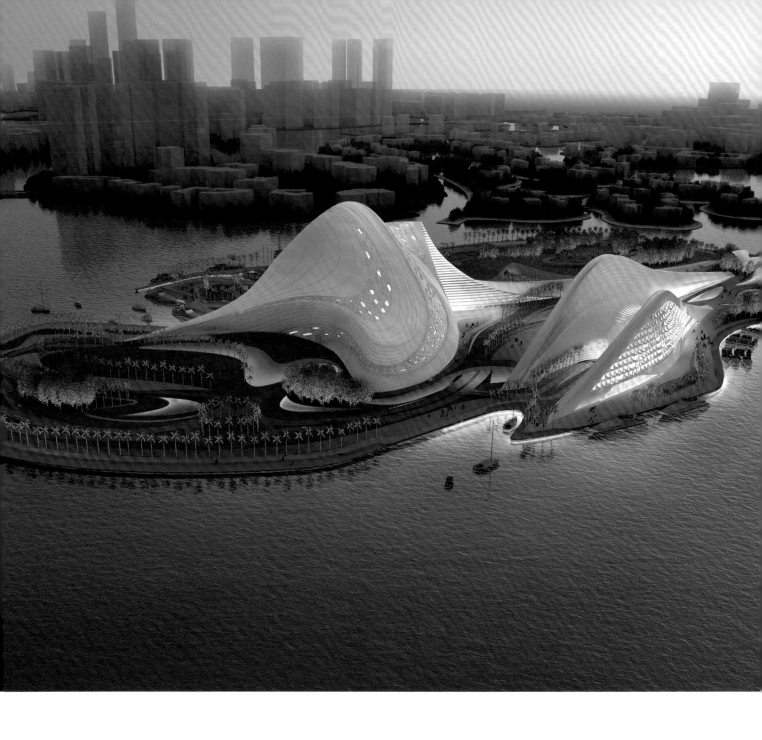

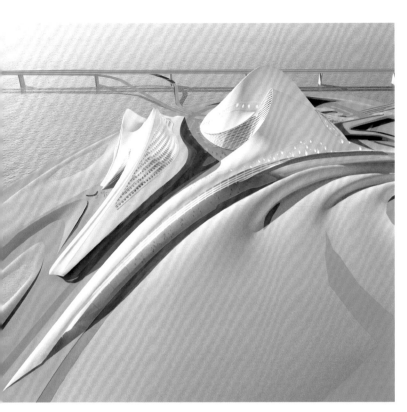

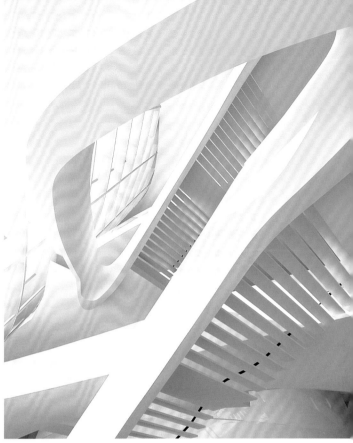

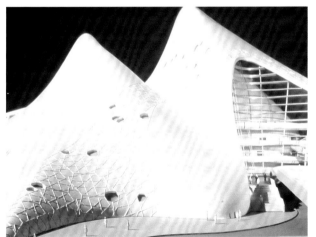

與派屈克・舒馬赫合作

阿拉伯聯合大公國・杜拜 2006-

杜拜歌劇院

這項地標性開發計畫位於杜拜河（Dubai Creek）的一座島上，包括一座兩千五百個座位的歌劇院、一座八百個座位的戲劇院、佔地五千平方公尺的藝廊，外加一所表演藝術學校和一棟六星級飯店。我們提議把上述所有設施安置在單一的結構體內，結構體的形狀會讓人聯想起附近的沙丘。代表歌劇院和戲劇院的兩座山峰朝地面俯衝而下，在觀眾入口處像扇貝一樣散開。比底樓高一層的主門廳創造出溫和多層次的地景，為表演廳和藝廊服務。其他廊廳漂浮在上方，處處都是令人驚訝的景致。

表演廳的流動造型像是從底下的主殼上浮現。不過，這個內殼並未真的碰觸到主殼，而是讓兩個殼面消失成中間的一道光縫。

DUBAI OPERA HOUSE
Dubai, UAE 2006–
In collaboration with Patrik Schumacher

197

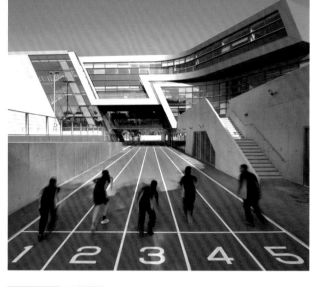

伊芙琳葛蕾絲中學

與派屈克‧舒馬赫合作
英國‧倫敦‧布里克斯頓 2006-10

這個案子讓我們有機會在充滿活力的南倫敦歷史區拓展教育的多樣性，把住宅區的建築擴建成社區都市再生的一部分。這塊基地的戰略位置極佳，位於住宅區的兩條主幹道中間，可以打造出連貫一致的形式，為該區和鄰近區域提供強烈鮮明的都市性格與身分。

這座學校提供學生可積極學習的安心環境，以及適合漸進式教學的氣氛。為了維持「校中校」（schools within-schools）[41]的教育原則，我們在高度機能性的空間裡設計了一些自然分區模式，讓裡頭的四所小學校不管在內部外部都有自己獨特的身分。這些空間都有寬闊的環境，以及最大量的自然採光、通風和低調耐用的質感。在四所學校分享的公共空間裡，我們用聚集的節點把各式各樣的設施分配交織起來，鼓勵學生互動交流。

為了鼓勵互動，戶外的共享空間也分成不同層次，在多種機能融合的基礎上，創造非正式的社交和教學空間。

譯註41：1990年代興起的教育改革理念，歐美許多都會學區開始推動小型高中教育改革運動，具體有效的做法包括小規模學校、校中校，在學校中建立更小的教育單位，提供學生個別注意、促進學習動機及取得資訊去幫助他們達到長期目標。

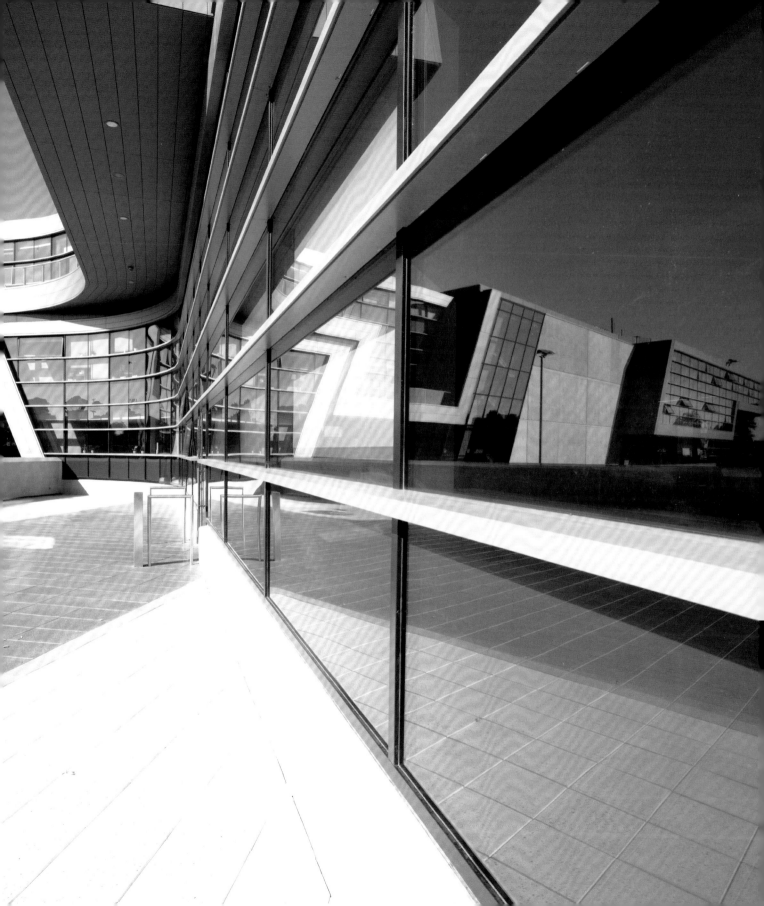

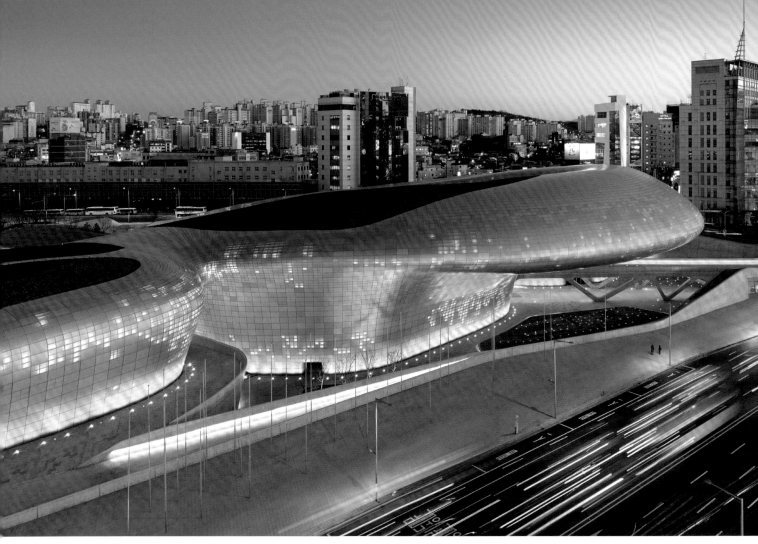

東大門設計廣場

與派屈克・舒馬赫合作
南韓・首爾 2007-14

DONGDAEMUN DESIGN PLAZA
Seoul, South Korea 2007–14
In collaboration with Patrik Schumacher

我們把東大門設計廣場規劃成首爾歷史最悠久、最繁忙地區的文化樞紐，內容包含設計博物館、圖書館、教育設施和景觀公園。這是一個老少咸宜的場所，可以在這裡交換想法，探索新的科技和媒材，還有不斷更新的展覽和活動上演，為城市注入文化活力。考古過程中挖掘到的古城牆和文物，也將成為廣場組構的一部分。

公園如綠洲在密集的都市裡蔓延，甚至攀升到屋頂上。公園表面的空隙和曲折變化，讓遊客可以窺見下方充滿創新感的設計世界。韓國庭園設計裡的一些傳統元素，例如層巒疊嶂等，我們用當代手法做了重新詮釋，沒有任何單一特色主導全場。我們將廣場與公園融合成無縫連續的流動地景，模糊了建築與自然的界線。

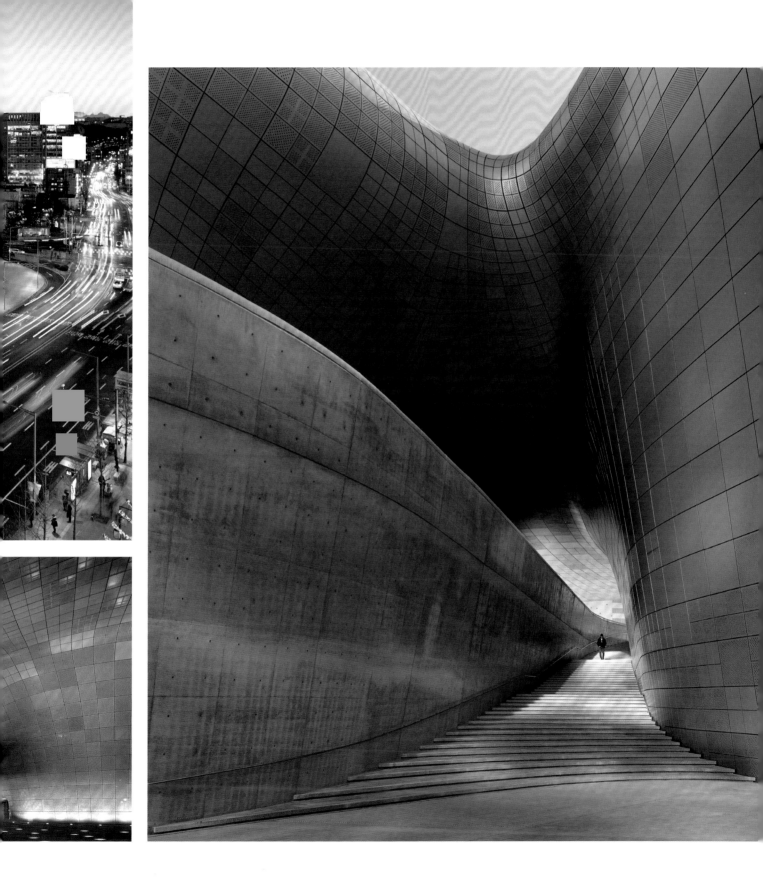

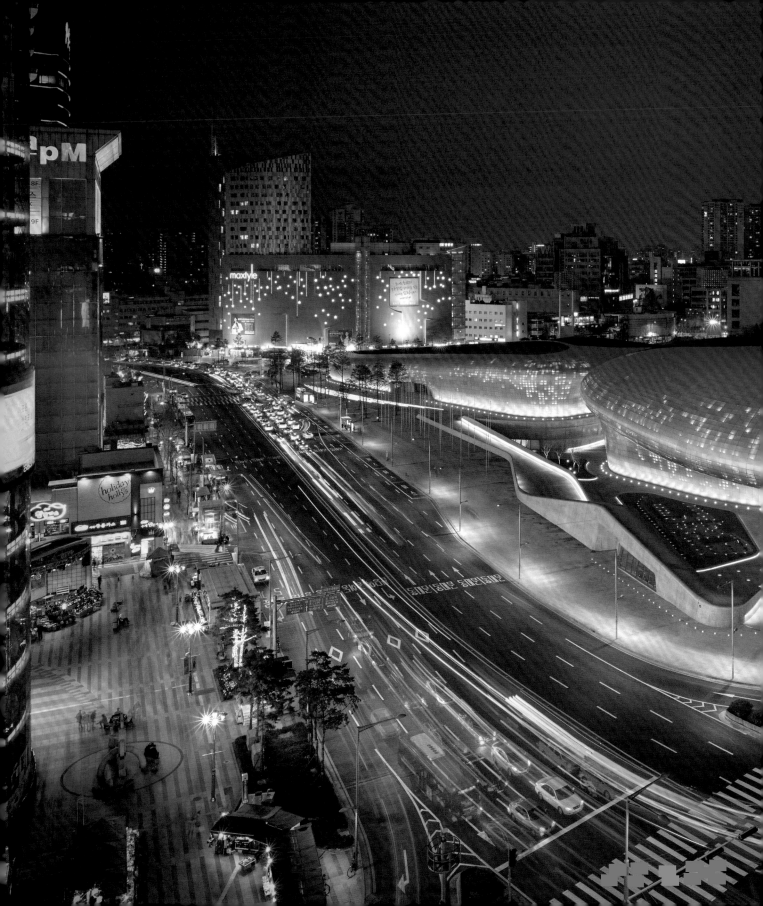

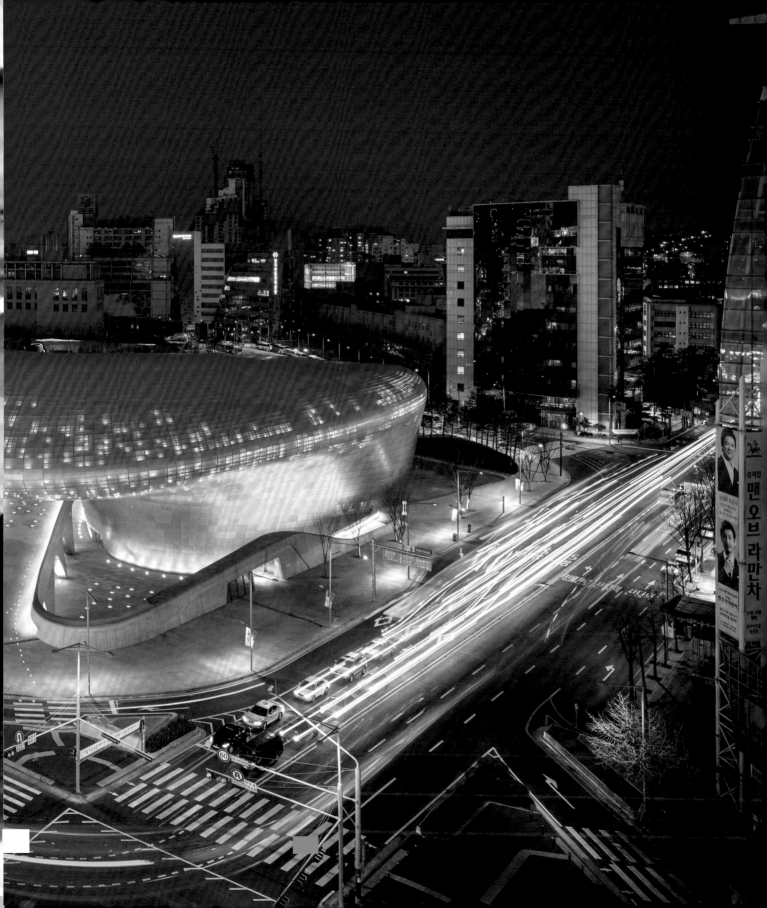

雷吉歐水岸

與派屈克・舒馬赫合作

義大利・雷吉歐 2007-

Matrix route 矩陣路徑

Exhibition layout 展覽配置

Museum and aquarium
博物館和水族館

Library 圖書館

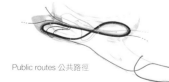

Public routes 公共路徑

這座地中海歷史博物館和多功能建築，座落在把西西里島與義大利本土分隔開的狹窄海峽邊。博物館的形式靈感來自於海星，延續我們對有機形態學（organic morphology）的探索。嚴格對稱的形狀清楚對應到不同的剖面和設施，但運動與開口則是遵循自然系統的流動幾何。

博物館包含展覽空間、修復設備、檔案館、水族館和圖書館；這座多功能建築將由三個主結構圍繞著一個有部分遮頂的「廣場」組合而成，廣場將海岸延伸到建築體裡。

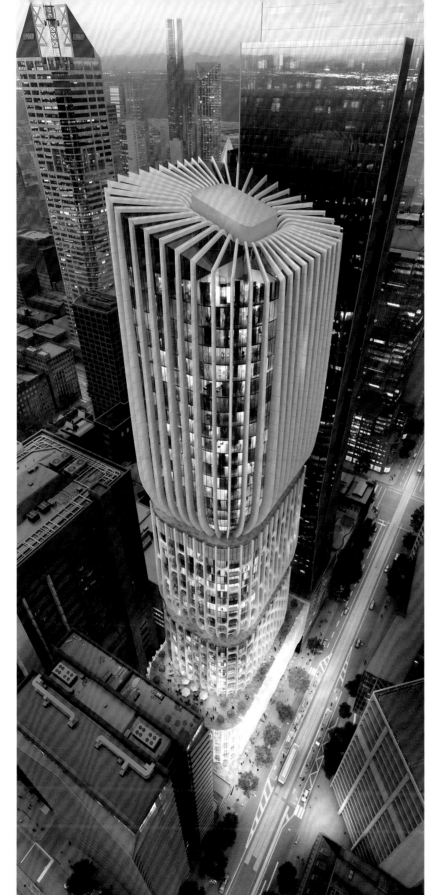

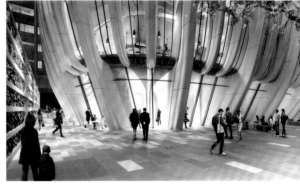

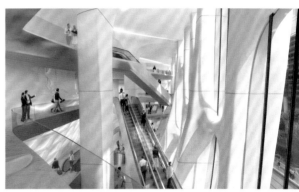

與派屈克‧舒馬赫合作

澳洲‧墨爾本 2015-

柯林斯街582-606號

基地位於墨爾本中央商業區西陲，一個正在改變的地區。大樓的配置靈感來自於混合性的用途規劃，把大樓的整個量體稀釋成層層相疊的小瓶子，每個瓶子容納一個不同的計畫項目。瓶子和瓶子的交接處是共享空間，為公眾和住戶提供體驗城市的新方式。

餐廳和新的公共展示空間位於底樓，辦公室和附屬的用餐空間位於最下面那個瓶子的頂部，可以直接看到九樓的公共露台。這個公共樓層的上方，是各種大小的住宅單位。

每個瓶子都微微內傾，為底部提供額外的開放空間。面對柯林斯街的立面，由雕刻狀的弧形柱子構成優雅的柱廊，支撐該棟建築獨特的立面系統。

582-606 COLLINS STREET

Melbourne, Australia 2015–

In collaboration with Patrik Schumacher

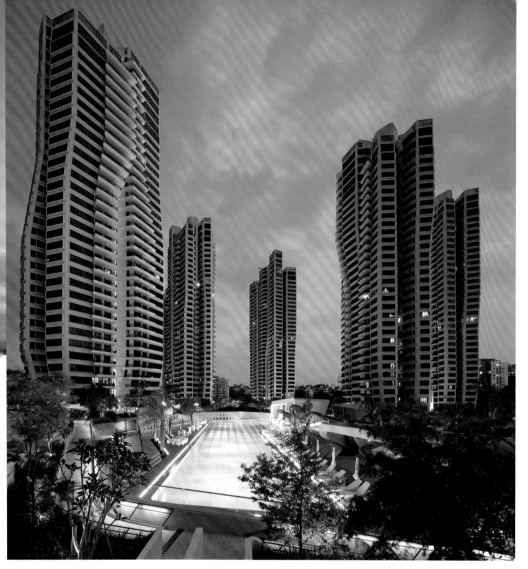

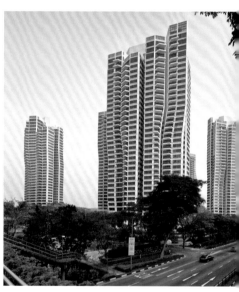

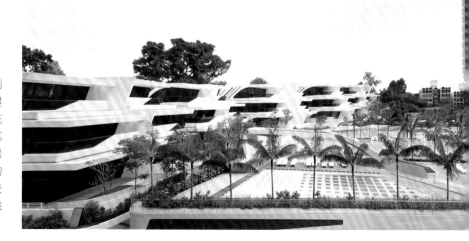

麗敦住宅群

新加坡 2007-14

與派屈克‧舒馬赫合作

D'LEEDON

Singapore 2007–14

In collaboration with Patrik Schumacher

這個開發案位於新加坡第十區的中心，包括七座住宅大樓、十二棟半獨立別墅，以及整體的景觀和休閒設施。大樓在接近地面時朝內傾斜，創造出私人花園用地。獨特的花瓣造型格局，讓公寓三面開窗，廚房、浴室以及客廳和臥房都能享有自然通風，為住戶提供最高的生活品質。大樓頂端收成一連串高低交疊的指狀長條，將建築紋理與天空接融起來。

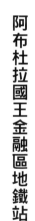

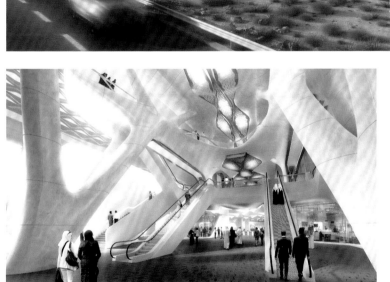

阿布杜拉國王金融區（KAFD）地鐵站
將成為利雅德新地鐵網一號線的重要轉
運站，以及四號線（通往機場）和六號
線的終點站。從地鐵站穿過天橋就可轉
乘當地的單軌鐵路。KAFD地鐵站的六
個月台位於四個公共樓層和兩層地下停
車場上方，可融入金融區的都市涵構，
呼應多式聯運中心的機能需求以及該區
的未來願景。

我們根據KAFD對於通道、天橋和地鐵
線的總體規劃，把車站放在網格的中
心。我們繪製了穿越基地的連結圖解
和交通，將行人在建築物內的路徑清
楚描繪出來，讓內部動線得到最好的
安排，避免出現壅塞現象。最終結果
是由一系列相對的正弦波（opposing
sinewaves）定義的三向度網格[43]，作為
建築動線的骨幹，並延伸到外殼上。

譯註43：正弦波（sinewave）是一種由數學
三角函數中的正弦函數（sine）定義的曲線，
其特徵是不斷重覆、高低振盪的波浪狀滑順曲
線。此設計採用一正一反的正弦波作為建築幾
何的基本格子（網格），再於格子上賦予結構
系統及外殼構造。

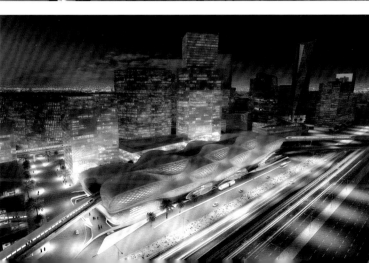

與派屈克・舒馬赫合作
沙烏地阿拉伯・利雅德 2012-

阿布杜拉國王金融區地鐵站

*KING ABDULLAH FINANCIAL
DISTRICT METRO STATION*

Riyadh, Saudi Arabia 2012-
In collaboration with Patrik Schumacher

211

香奈兒行動藝術館

與派屈克‧舒馬赫合作
中國‧香港 2007-8

MOBILE ART PAVILION FOR CHANEL
Hong Kong, China 2007-8
In collaboration with Patrik Schumacher

香奈兒以其平滑的層次著稱,這些細膩的做工構成優雅、凝聚的整體,這棟展館的形式就是在歌頌香奈兒的經典作品。這棟建築非常契合香奈兒的初衷,不管整體結構或細節,都要別緻、機能和萬用。展館的有機形式是從自然界的螺旋形狀演化而來,順著一個環形做參數形變,繞著它的圓周創造出連續多樣的展覽空間,並以一座65平方公尺的中庭做為中心。這樣的安排也讓訪客在穿越空間時可以看到彼此,有助於把觀看藝術當成一種集體經驗。

殼體是由一連串遞減的拱段構成。因為展館將旅行到三大洲,這樣的分段讓零件的寬度不會超過2.25公尺,方便運送。隔板的接縫於是變成外部立面上的搶眼元素,創造出一種空間節奏。能量線匯聚在展館內,不斷重新定義每個空間的性質,同時引導展覽的移動路徑。這裡的挑戰在於,如何將智性與物理轉化成感性──用超乎預期並讓人全然沉醉的環境實驗,在世界各地歌頌這個經典時尚品牌,當這件總體藝術品從亞洲巡迴到美國和歐洲時,將會不斷改造,持續創新。

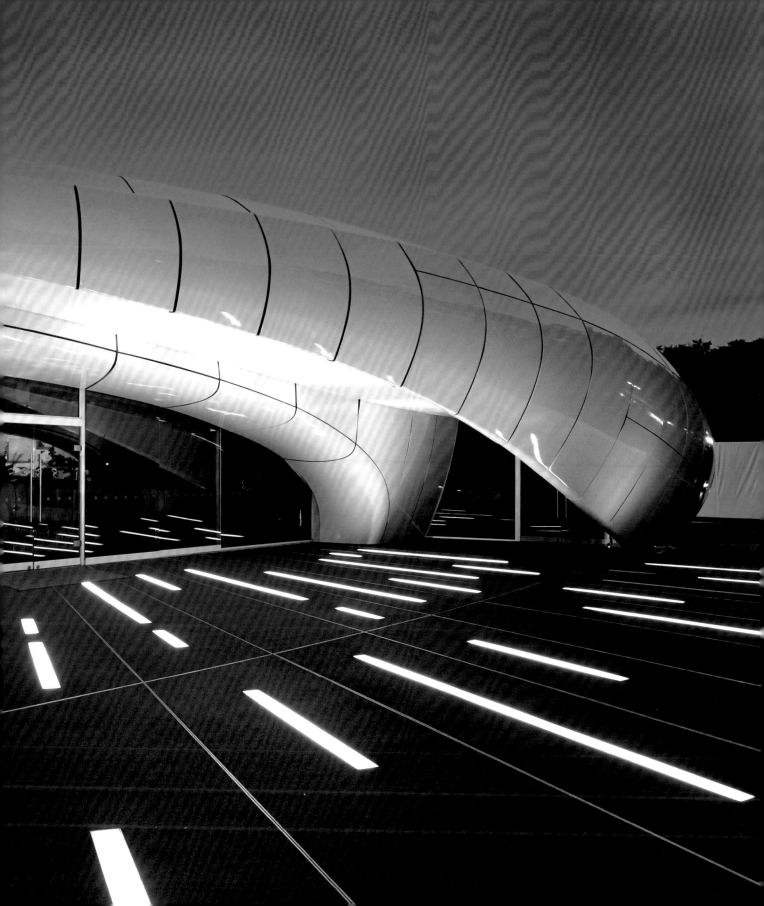

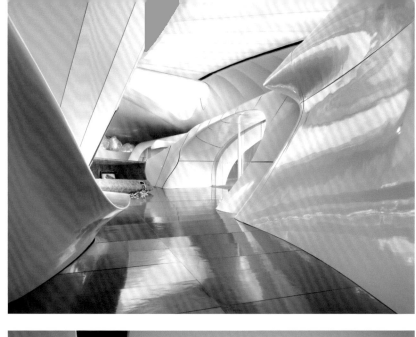

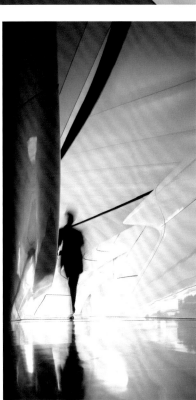

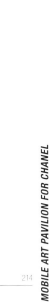

MOBILE ART PAVILION FOR CHANEL

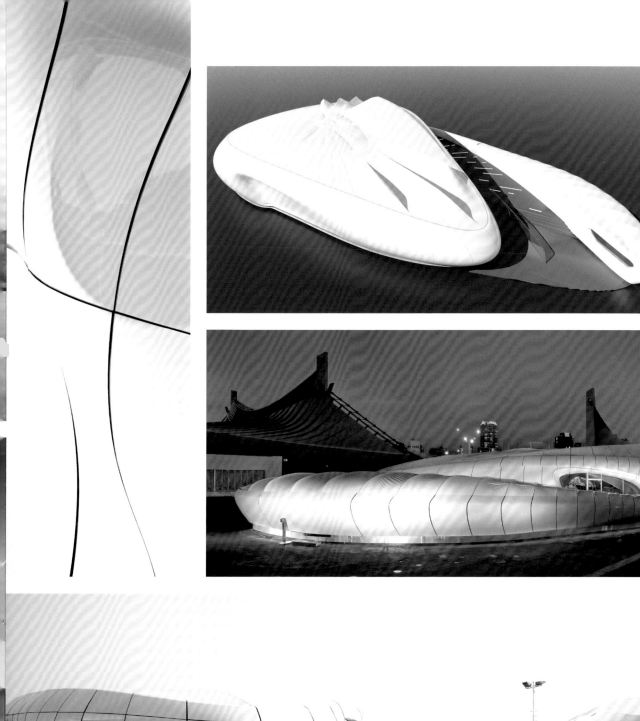
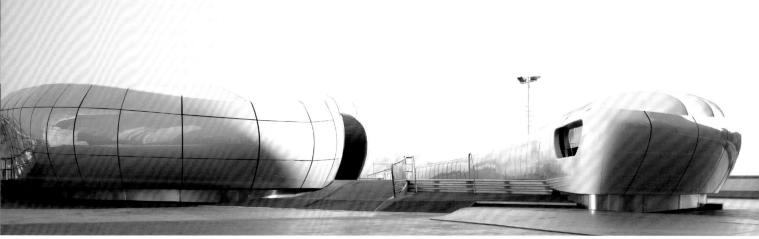

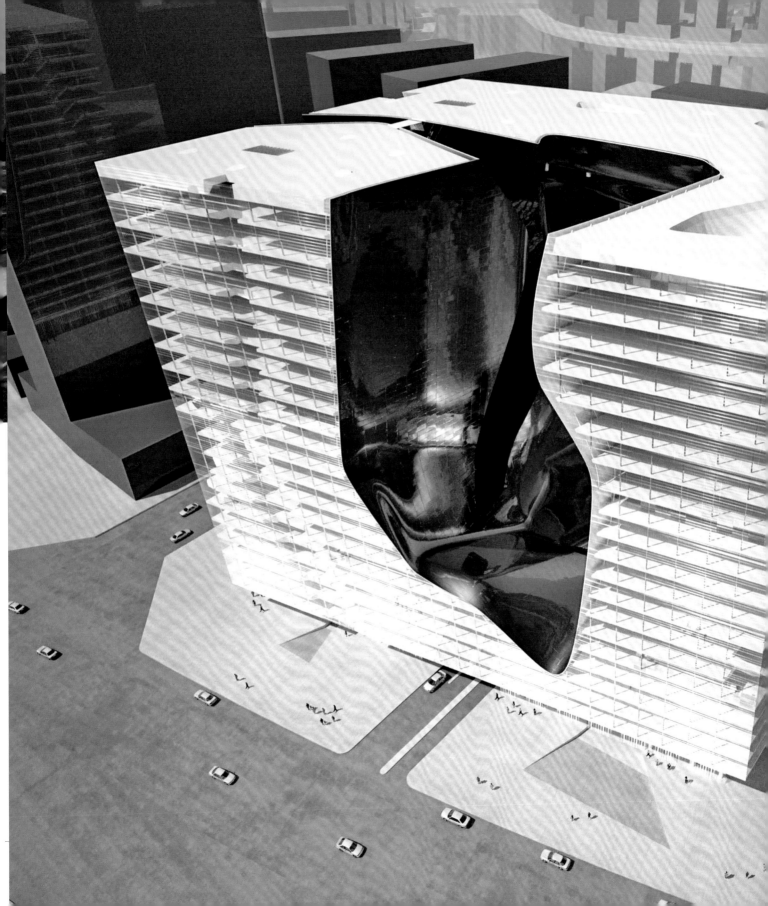

與派屈克・舒馬赫合作

阿拉伯聯合大公國・杜拜 2007-10

「OPUS」辦公大樓

位於商業灣（Business Bay）開發區，是奧姆尼亞特公司（Omniyat）的旗艦店暨零售大樓，基地包含兩塊地皮，用一道連續的低層平台串接起來，在構想上，平台上面的兩棟大樓是一個統一量體：一個盤旋在地面上空的立方體，以自由形式挖鑿一個虛體。立方體是以傳統的垂直層板系統結構而成，由中央核提供服務性設施，讓八個邊靠近立面的區域都可使用。挖蝕出來的虛體部分覆上套色雙層玻璃，本身也被當成一個體塊，切穿立方體的邊緣。虛體內部的高原為大樓提供娛樂區和休息區。底樓是一個開放場域，將訪客領進兩個獨立的大廳。像素（pixallated）條紋的燒結圖案（Reflective fritting pattern）為玻璃立面提供反射性和物質性，並可降低太陽輻射熱。白天時立方體看起來鮮活有力，虛體是空的；晚上的感覺剛好相反：立方體看起來是暗的，缺乏物質感，反倒是被燈光激活的虛體，從遠處就可看到。

'OPUS' OFFICE TOWER

Dubai, UAE 2007-10

In collaboration with Patrik Schumacher

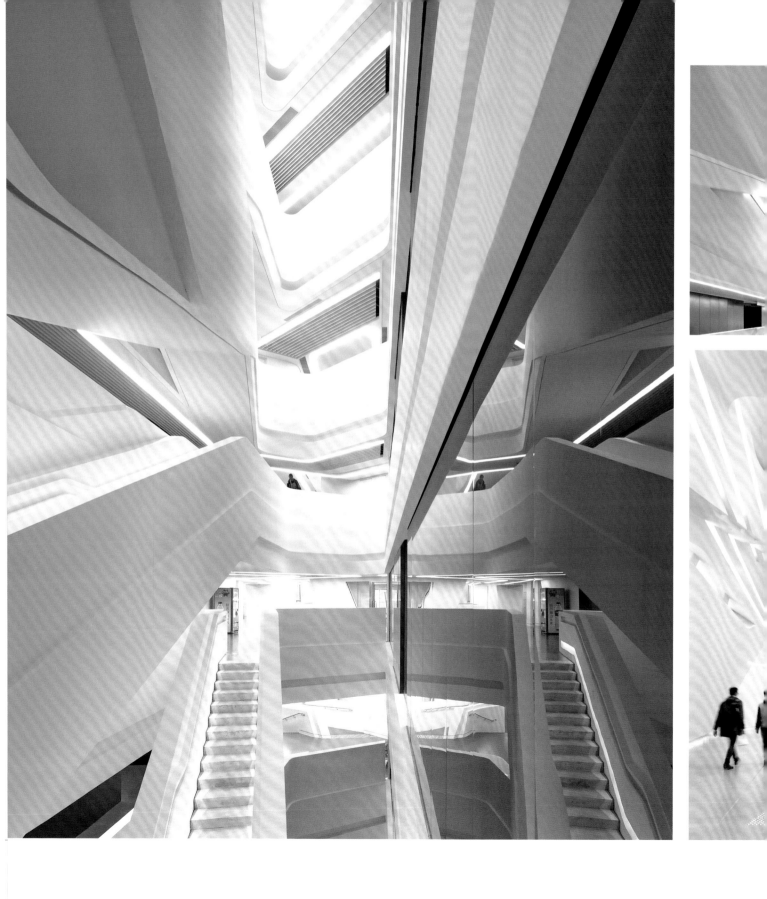

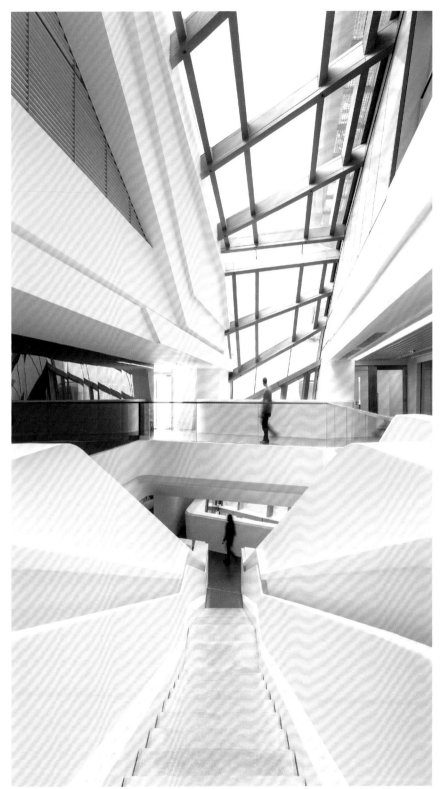

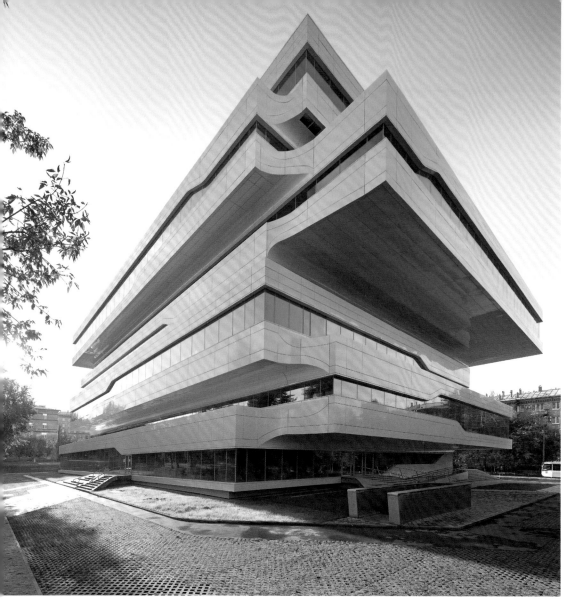

DOMINION OFFICE BUILDING
Moscow, Russia 2012–15
In collaboration with Patrik Schumacher

與派屈克·舒馬赫合作

俄羅斯·莫斯科 2012–15

多明尼翁辦公大樓

多明尼翁辦公大樓位於滾珠軸承街（Sharikopodshipnikovskaya Street），該地是莫斯科的主要工業區和住宅區，這棟大樓是該區最早為日益成長的創意和IT部門所興建的新計畫之一。一連串的垂直層板在每一層利用連結的曲形元素造成偏移，中庭貫穿所有樓層，將自然光帶入建築中央。每一層樓的廊道朝中庭突伸，與外牆上的錯位相呼應，並用一連串交互連結的樓梯穿越中央空間。底樓有餐廳將中庭連結到戶外露臺和後方的滾珠軸承街，各樓層的廊道上也設有咖啡點心區和休閒區，讓中庭變成眾多樓層的共享空間，有助於大樓內部不同公司的員工互動交流。辦公空間安排在一套標準的直線開間系統裡，可提供許多不同的可能性，供小公司、正在擴張的公司或大公司使用。

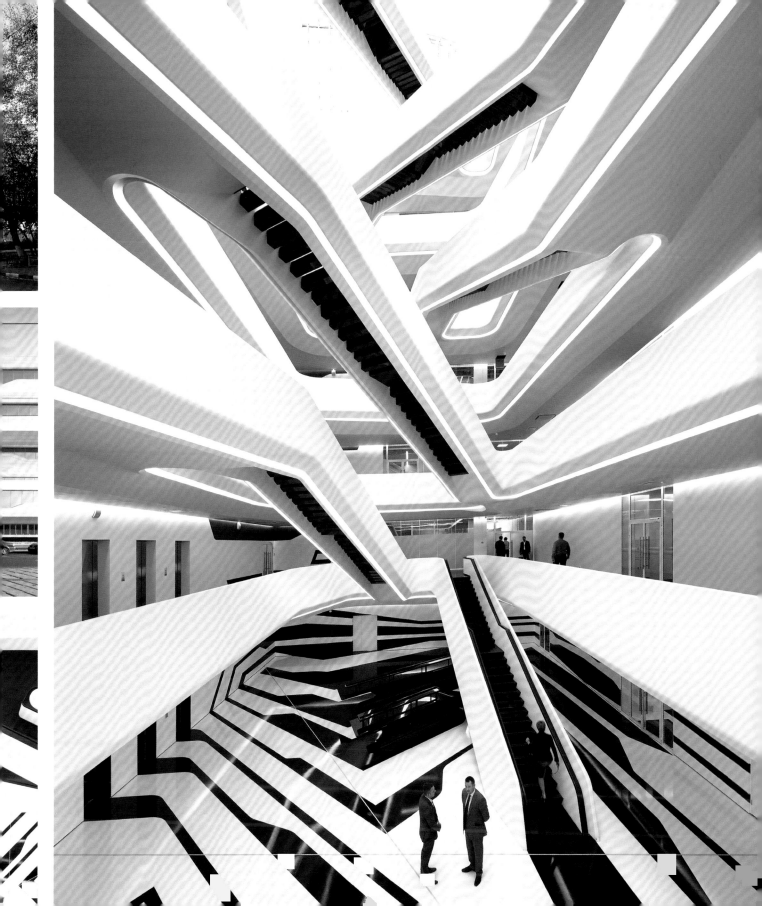

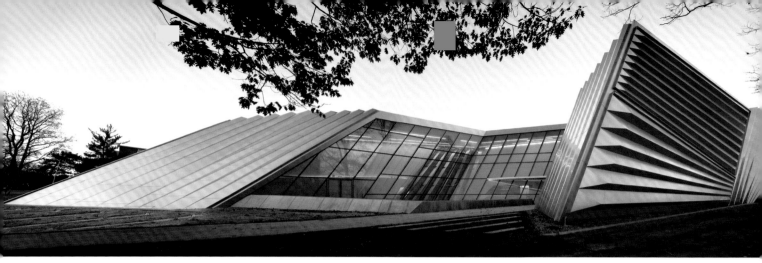

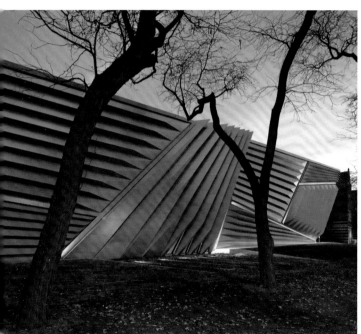

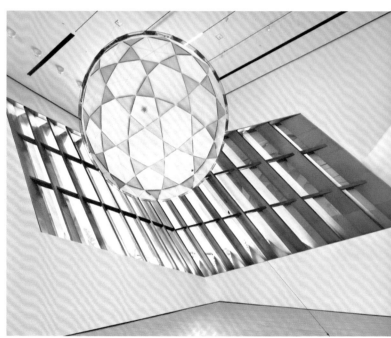

ELI & EDYTHE BROAD ART MUSEUM
East Lansing, Michigan, USA 2007–12
In collaboration with Patrik Schumacher

伊萊與伊迪絲·布羅德美術館
美國·密西根州·東蘭辛 2007–12
與派屈克·舒馬赫合作

這座美術館位於密西根州立大學，最初的構想是要打造一塊「景觀地毯」（landscape carpet），從基地所在的都市紋理中撿拾一些鬆散的線頭，以不同的運動方向交織起來，跨越或平行於基地。用汲取自周遭結構的線性運動圖案，構成這塊地毯的基底，然後把地毯摺疊成建築物的量體。立面上的每塊拼貼都從構圖裡擷取出一個不同方向，把外殼打造成具有方向性的銳利體塊。整棟建物以戲劇性的姿態往西傾斜，由俯瞰廣場、12公尺高的正面構成昂起的頭部，接著直線往東，面向雕塑花園，在那裡融入地景。玻璃鋼骨的外皮加上漸層的穿孔，藉由變化不斷的形貌讓建築顯得生氣盎然。這些變化也在每個展廳裡過濾和引導光線。

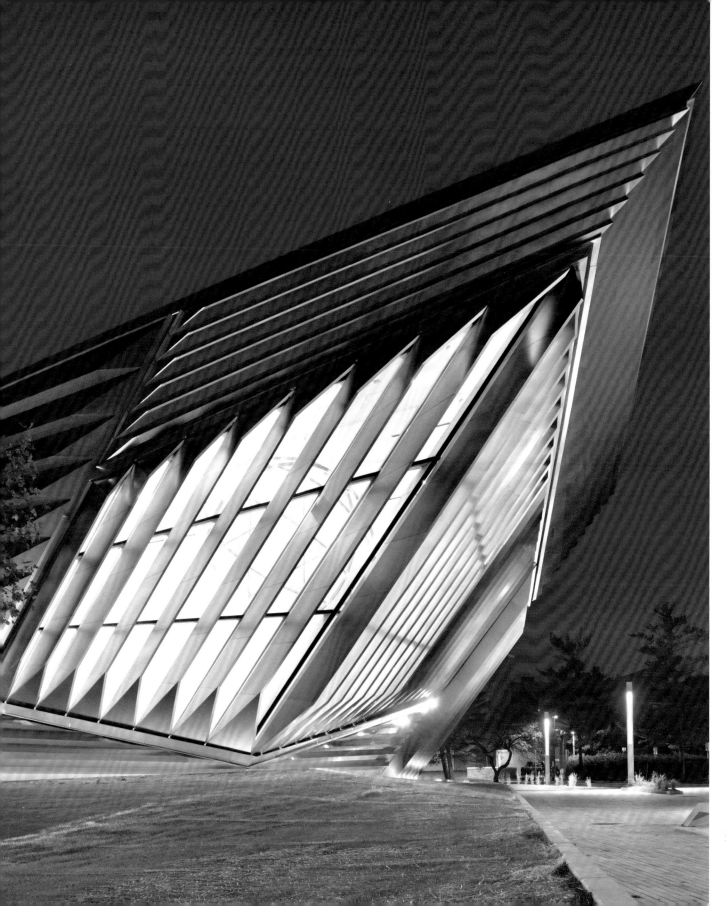

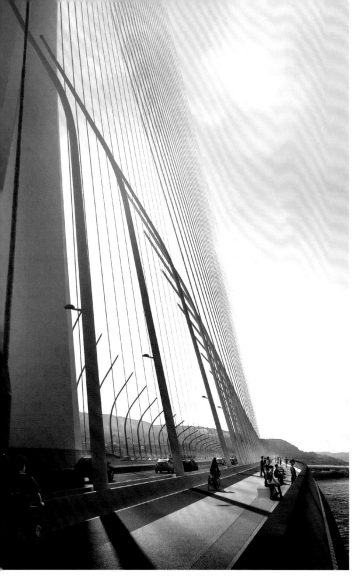

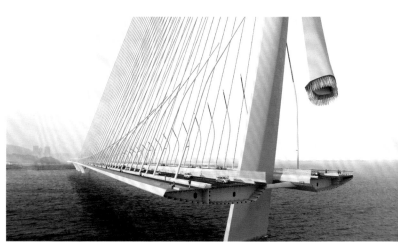

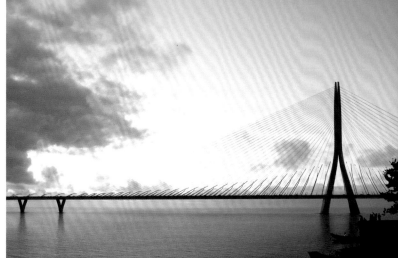

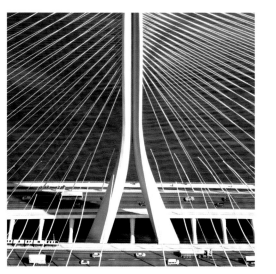

淡江大橋

新北市 2015—

與派屈克‧舒馬赫合作

DANJIANG BRIDGE

Taipei, Taiwan 2015—

In collaboration with Patrik Schumacher

淡江大橋位於流經大台北的淡水河河口，是建構台灣北部基礎建設整體升級的重要項目。藉由連接多條主要道路，淡江大橋可以增加鄰接區域間的連通性，並減少穿越當地市鎮中心的交通量。斜張橋的設計僅使用一座混凝土結構塔柱來支撐長達920公尺的車道、輕軌和人行甲板，從而最大限度地減少了對城市天際線的視覺衝擊。這將是世界上最長的單塔不對稱斜張橋。

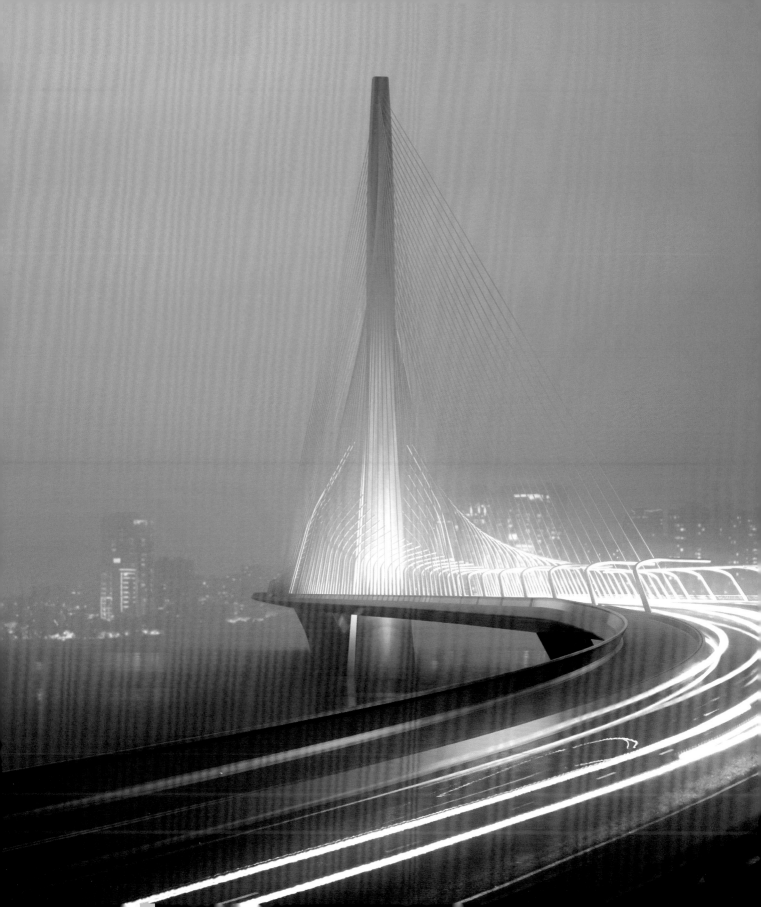

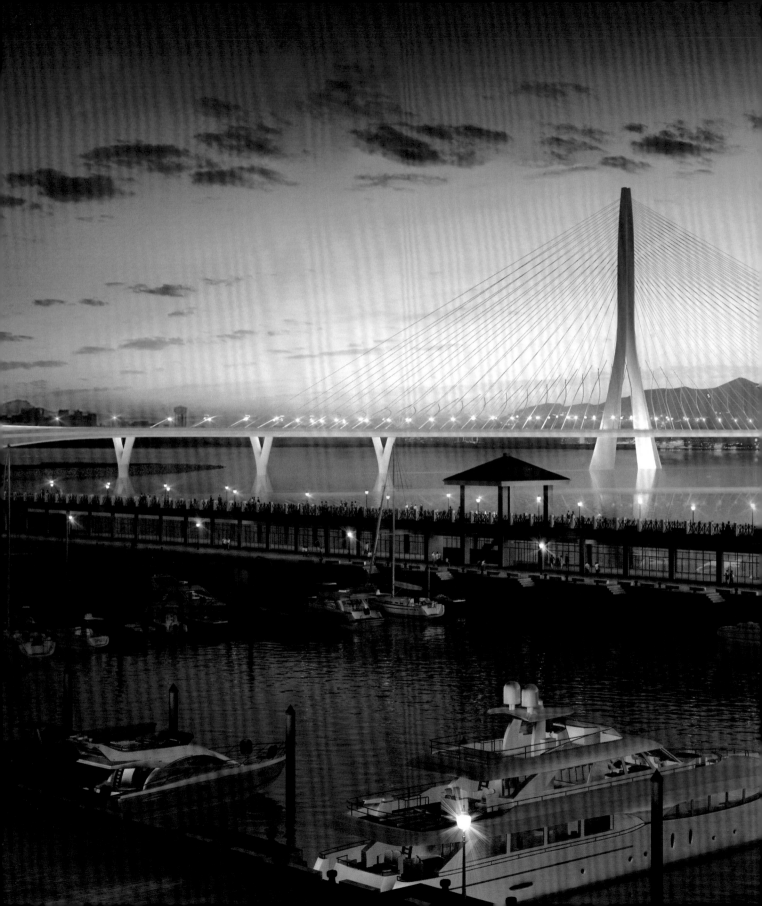

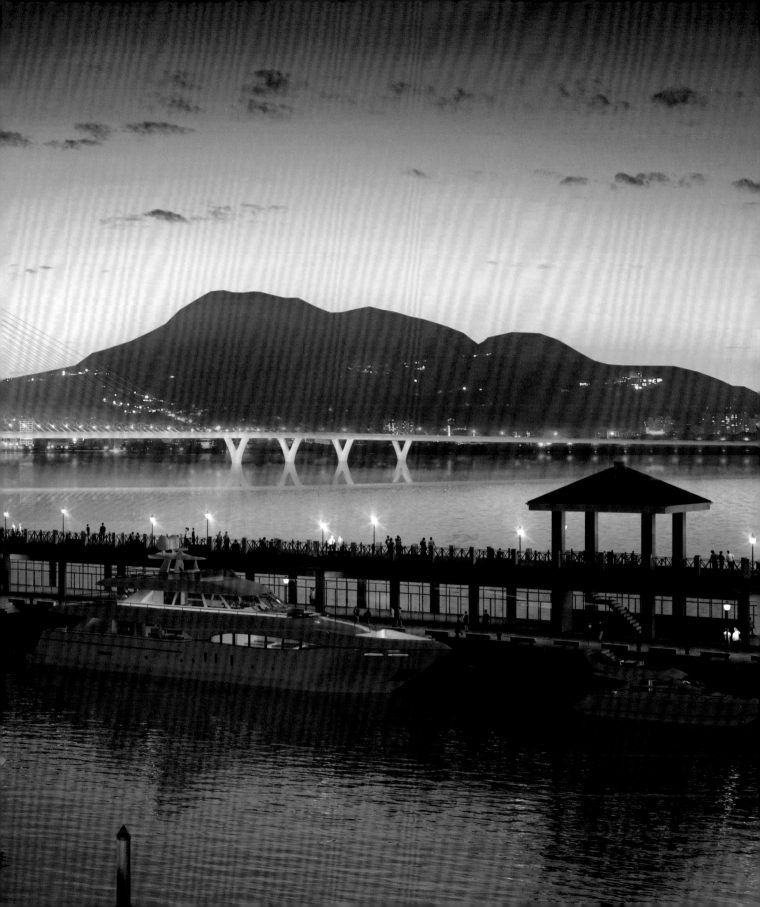

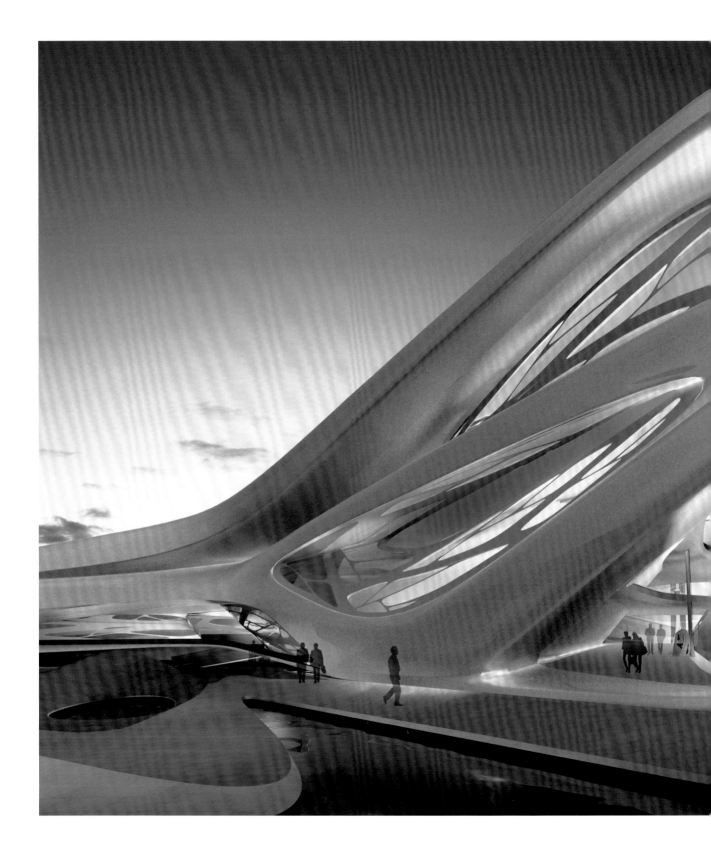

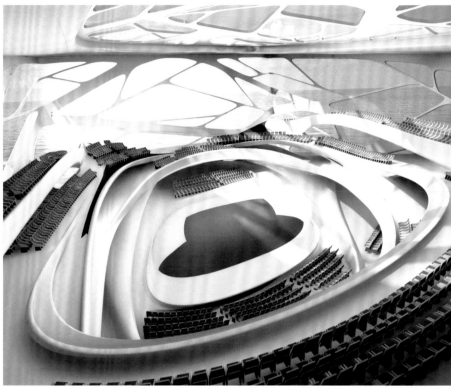

與派屈克・舒馬赫合作

阿拉伯聯合大公國・阿布達比 2008-

阿布達比表演藝術中心

做為薩迪亞特島（Saadiyat Island）上文化機構的一部分，這個表演藝術中心的獨特形式語言源於自然界中可發現的一些組織系統。我們使用了生長模擬的、過程來發展一組基本幾何，再與編程化圖解（programmatic diagrams）[44]疊加，成為一系列的重複循環，而後將這種生物類比（分枝，莖，果實及葉子）的主要元件從抽象圖解轉化為建築設計。此文化園區的中心軸線是一條從謝赫・扎耶德博物館（Sheikh Zayed museum）延伸到海邊的人行走廊，這個軸線與海濱廊道交互作用，產生了一套樹枝狀幾何系統，促使在其中的島狀區域形成獨特肌體，以容納五個主要的音樂廳。

譯註44：一種透過程式撰寫及演算而成的圖象幾何，用以解決特定設計問題，發展設計方案。也是一種結合電腦技術、日益盛行的設計工作方法。

ABU DHABI PERFORMING ARTS CENTRE
Abu Dhabi, UAE 2008–

In collaboration with Patrik Schumacher

233

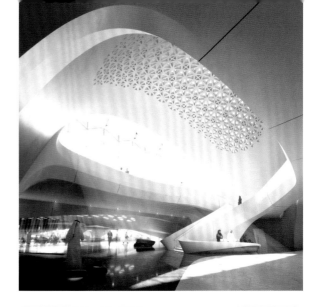

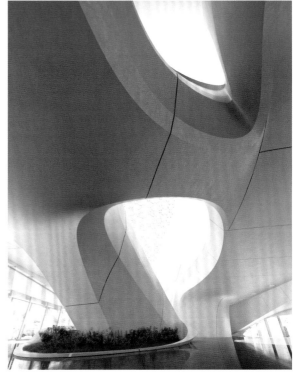

BEE'AH總部

阿拉伯聯合大公國·沙迦 2014–

與派屈克·舒馬赫合作

BEE'AH HEADQUARTERS

Sharjah, UAE 2014–

In collaboration with Patrik Schumacher

234

Bee'ah是中東一個領先而全面的環境及廢棄物綜合管理公司，新建的總部大樓是該公司正在進行的轉型工作之一，藉由在本大樓中提供基礎建設、工具和支援，來實現環境目標。

位於Bee'ah廢物管理中心相鄰基地上，新總部被設想為一系列相交的沙丘，其目的是為了適應盛行當地的夏季季風（Shamal winds），並極力確保在內部空間中的光線和景觀。兩座中央沙丘將設有管理辦公室、訪客中心和行政部門。一個中庭連接起兩個沙丘，在建築物內部創造了一個供工作人員使用的「綠洲」。

物理環境因素的考量被整合到各個設計面向，將由100％可再生能源供給電力。基於反射太陽光的效能，建築外皮的材料經過仔細挑選，部分外皮和建築物結構採用標準正交的尺寸[45]，建築中有顯著比例將以回收材料建造。新總部的房屋系統也與Atelier Ten公司共同研發，盡可能減少冷卻所需的能源和飲用水消耗。

譯註45：90度格子系統。

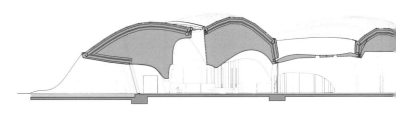

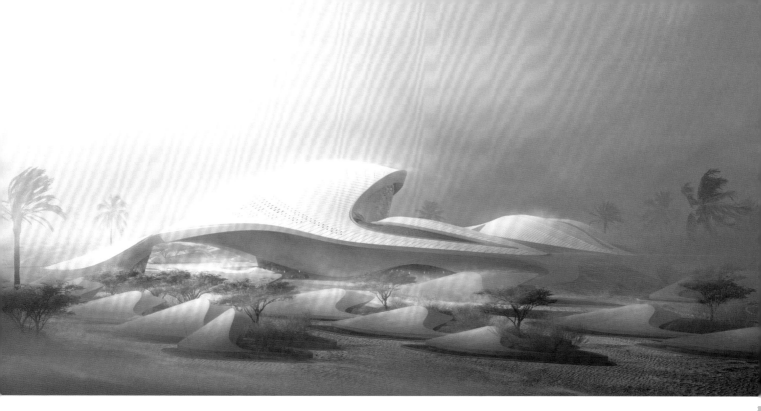

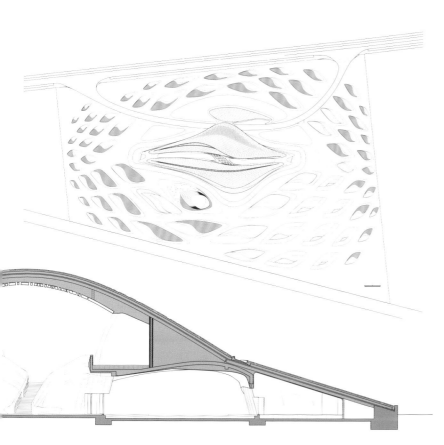

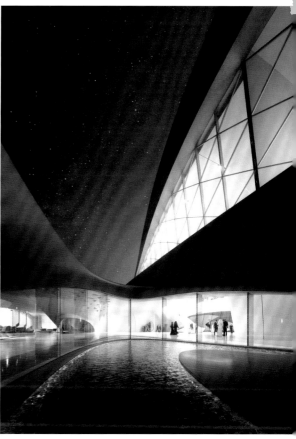

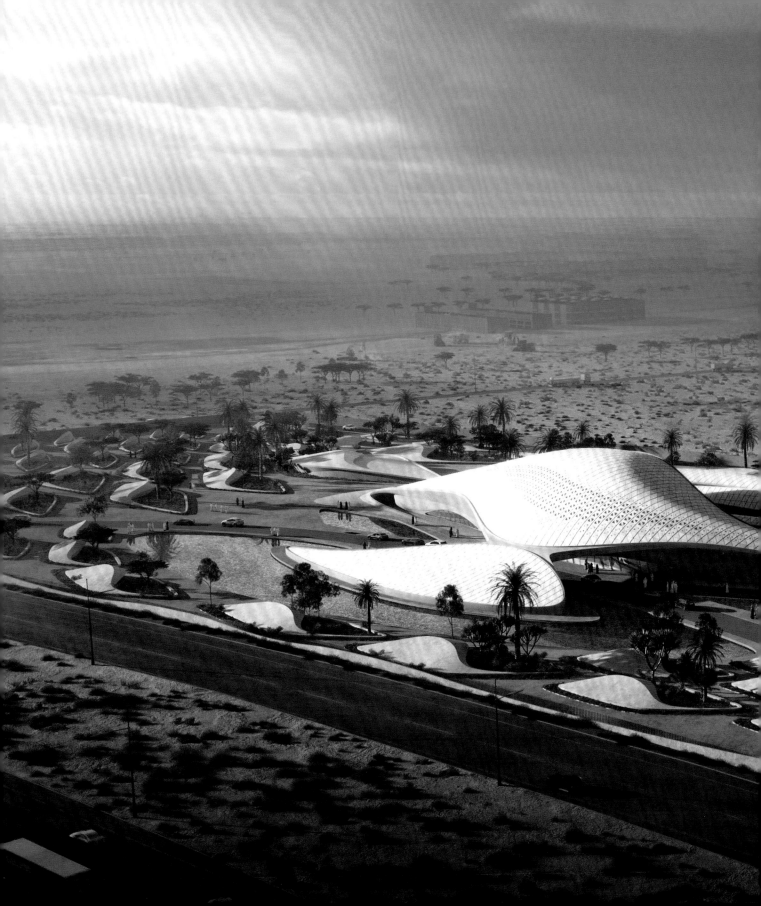

這個為安特衛普港務局新總部做的設計，包括兩個實體：一個現有的消防站，以及一個漂浮在保留建築物之上的新結晶體。它們的合體形成了深入人心的新地標，俯瞰著城市和港口。

新的擴建在消防站的中庭上方非對稱地懸停，並由立面上的三角形玻璃板片加以定義：白天反映著天空色調和顏色變化的琢面（facets）[46]，夜間則將建築物轉變成一塊發光水晶，一如安特衛普歷史性的鑽石產業印證。外牆板片在建築物南端是平貼的，隨著往北側逐漸產生角度，使得立面在一端是光滑的表面，到了另一端形成波紋狀的紋理。

老消防站的中庭上方以一個玻璃屋頂封起，並被改造成新港口大樓的主要入口接待區。訪客可以從這個挑空大廳進入歷史悠久的公共閱覽室和圖書館，將其設置在已停用並進行精心修復和歷史建築保存的消防車庫。一座連結原始建築和擴建區的外部空橋在此提供了全景視野。

譯註46：寶石切割後的多面體上的每個單一平面化多邊形，或建築外牆上有相似的幾何性質的外牆板片。

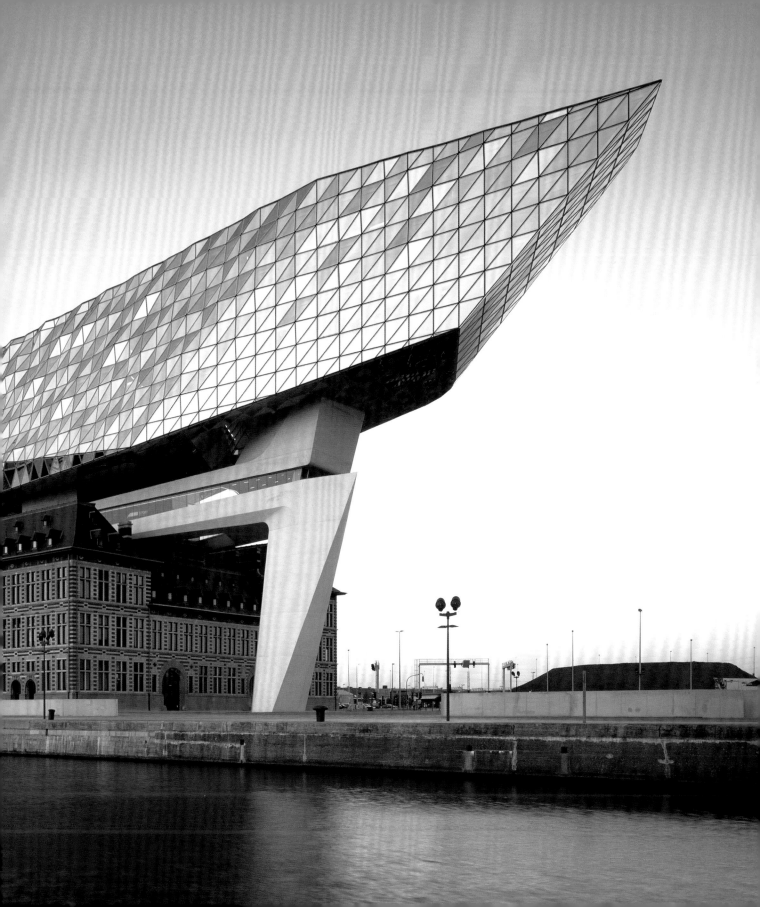

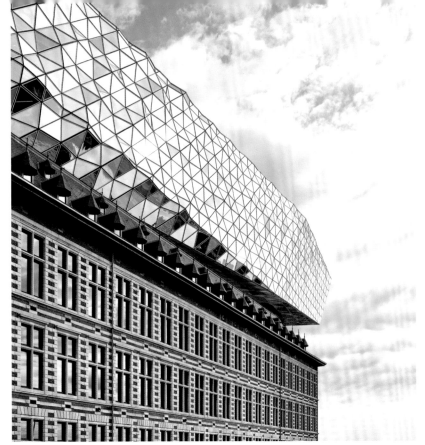
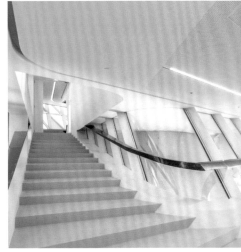

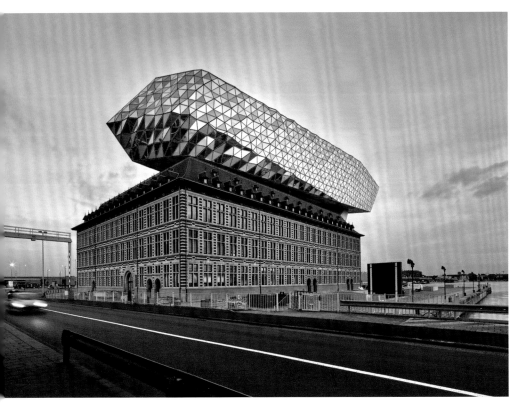

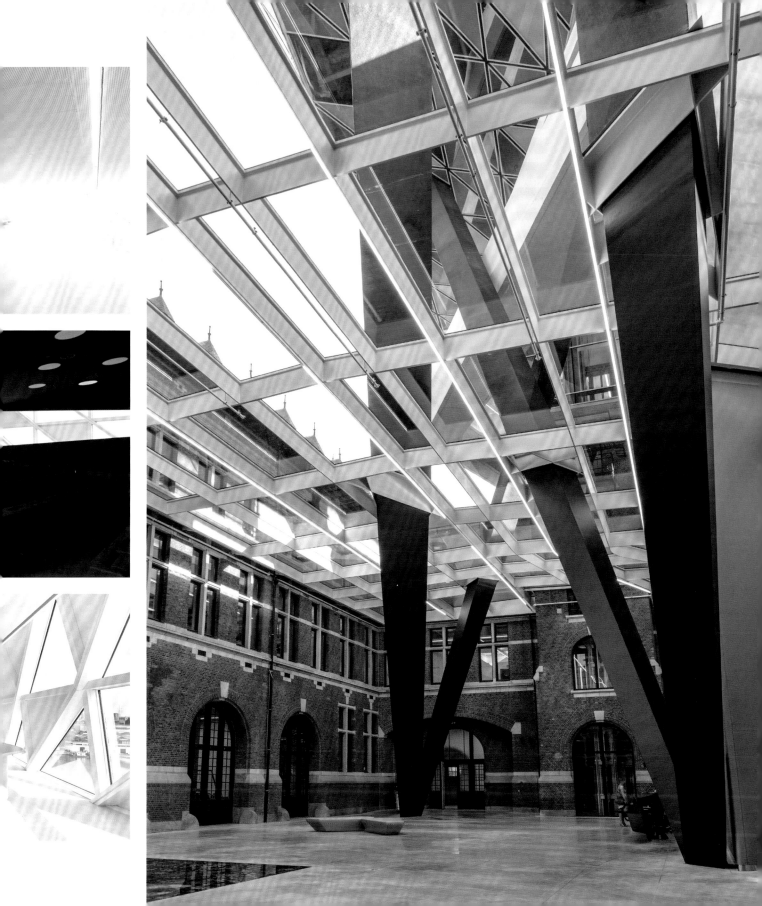

維也納經濟大學的新圖書館以一個多面體（
polygonal block）的姿態矗立於校園中心。該設計採
用立方體形式，並加上傾斜且筆直的邊緣。建築物
外觀上的直線在向內移動時分開，並且變得蜿蜒而
流動，產生一個自由形體的內部峽谷，成為核心的
公共廣場。寬闊的坡道和樓梯從入口處而上，通過
中央圖書館區，此區又以漏斗狀擴展為建築物中的
六個樓層。頂層兩層樓設有閱覽室和學生工作區，
可俯瞰普拉特公園（Prater Park）的景色。其他設施
都被納入在單一又可獨立二分如緞帶般的量體，這
兩條緞帶彼此相互纏繞，塑造在其中以玻璃包覆的
聚會空間。

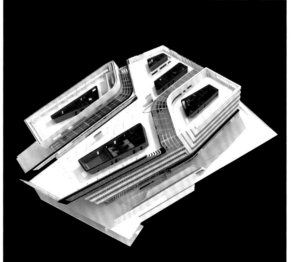

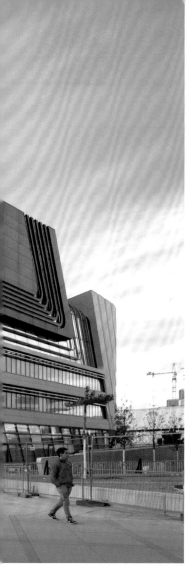

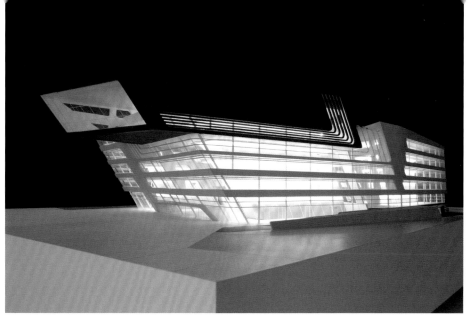

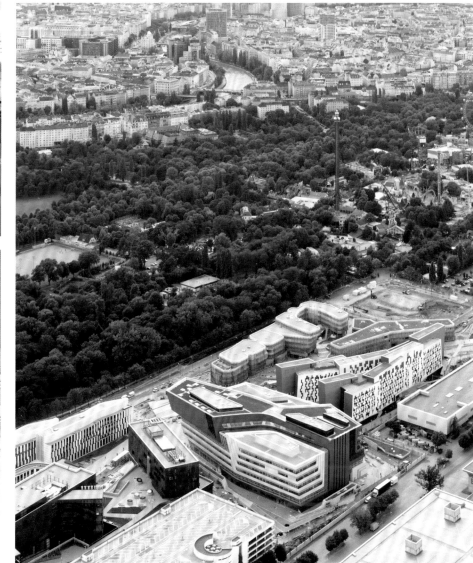

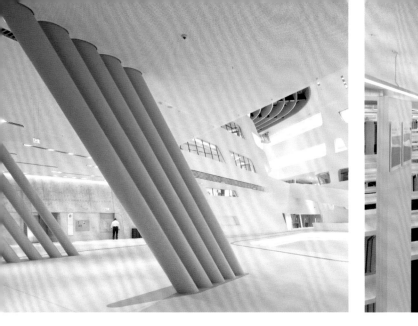
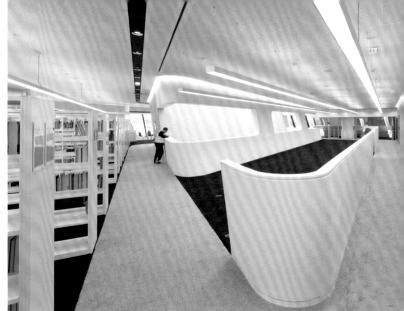
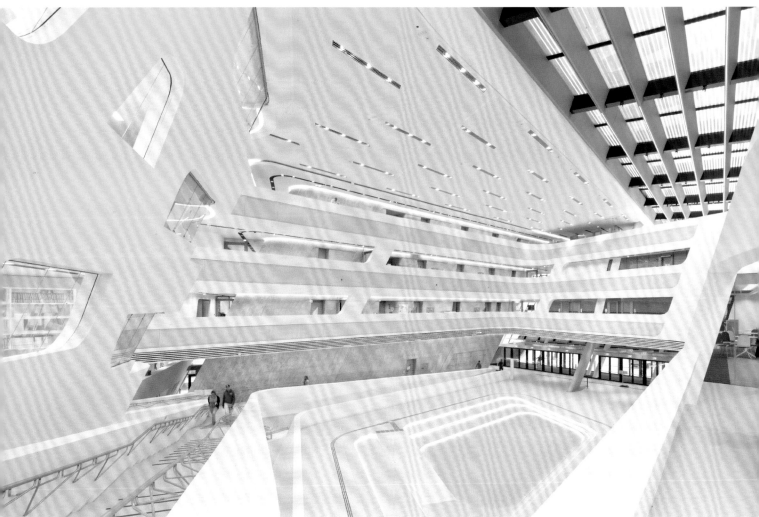

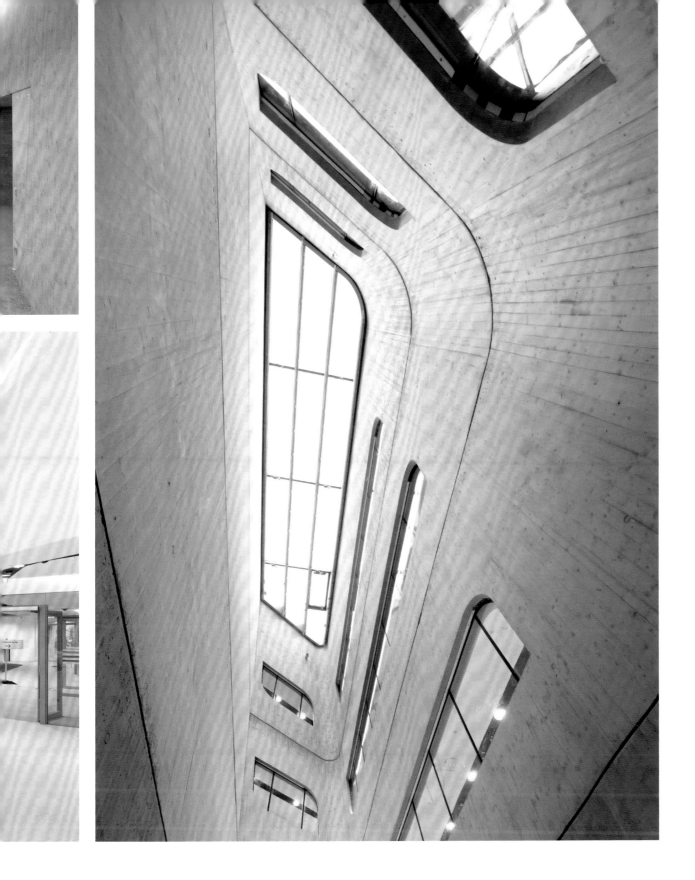

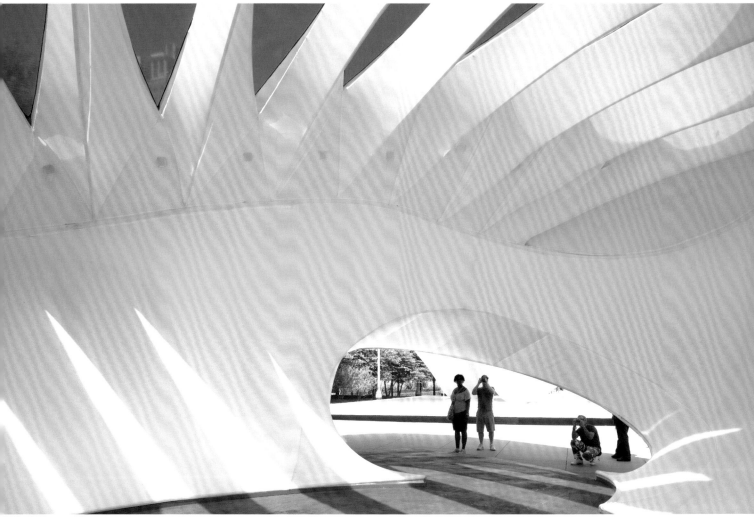

伯恩罕臨時性紀念展館

與派屈克·舒馬赫合作

美國·伊利諾伊州·芝加哥 2009

BURNHAM PAVILION

Chicago, Illinois, USA 2009

In collaboration with Patrik Schumacher

這個臨時展館（pavilion）的設計讚頌著芝加哥最頂尖的建築和工程聲譽，並將新的形式概念與大膽而歷史性的城市規劃記憶相結合[47]。這個建築物由複雜的彎曲鋁材結構組成，每個元件都被加工成形及焊接，而形成其獨特的曲線形式，再於外部和內部以織物表皮緊實地包裹在金屬框架上，產生了流體般的形狀，並作為投影放映的螢幕。此設計使這個臨時建築能夠最大化它的材料循環回收及再利用，在這個百年慶典結束之後，可以在其他地點重新組裝。

譯註47：丹尼爾·伯恩罕（Daniel Barham）為美國著名建築師與都市設計師，1909年出版《*Plan of Chicago*》一書，其內容為芝加哥總體規劃及都市設計領域帶來極大影響。此臨時展館是百年紀念的活動之一。

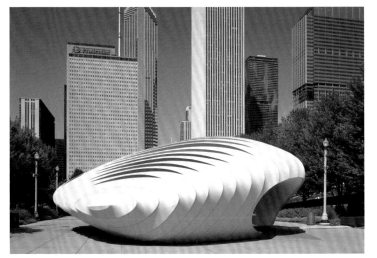

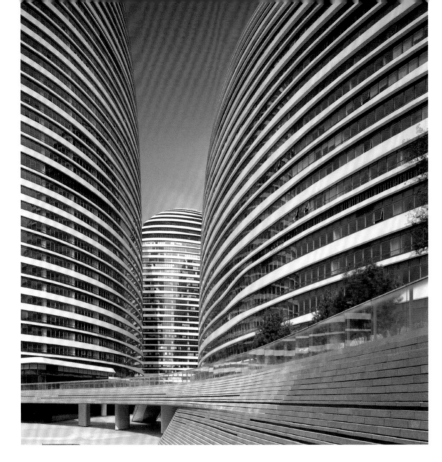

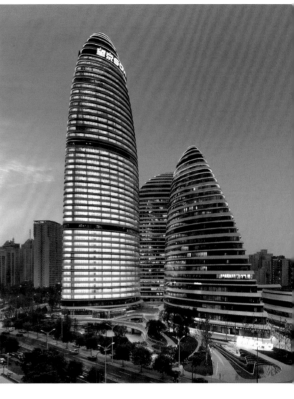

與派屈克・舒馬赫合作

望京SOHO

中國・北京 2009–14

WANGJING SOHO

Beijing, China 2009–14

In collaboration with Patrik Schumacher

247

這個辦公和零售的複合體,位於北京首都機場和市中心之間的半路上,由三座彎曲的高樓組成,高度為118至200公尺之間。這些高樓被設計為交織在一起的「山脈」,揉合了建築和景觀,也創造了新的公共空間,將當地社區空間連在一起,包括南邊的公園和北邊的地景花園。每個高樓的門廳都向外朝向城市,並延伸穿過每座建築物到中央購物街和高樓之間的廣場。並置的高樓流體形態隨著觀看的角度而不斷變化,有時看起來是獨立建築物,有時則呈現與其他建築相連的組合。

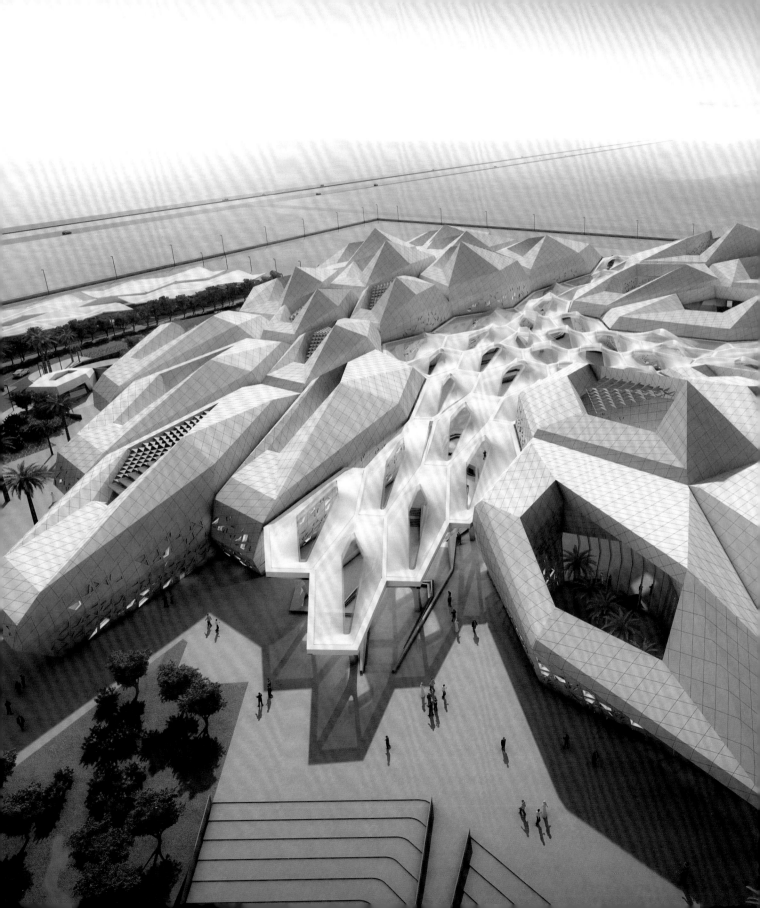

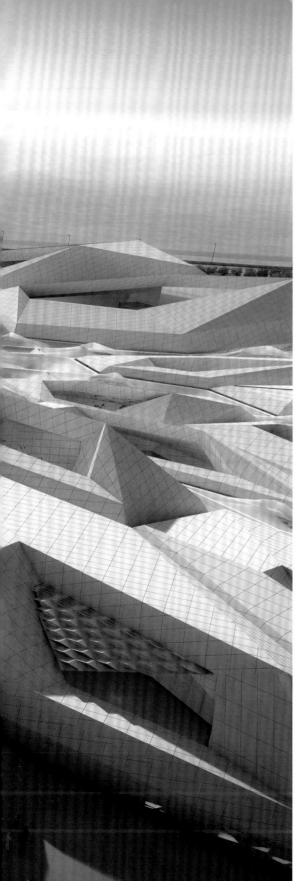

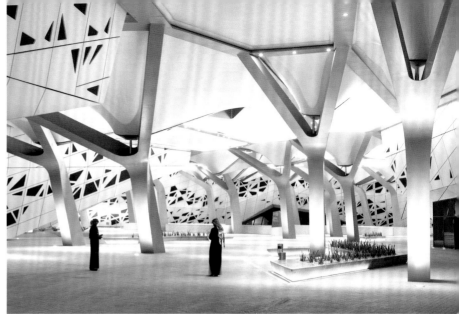

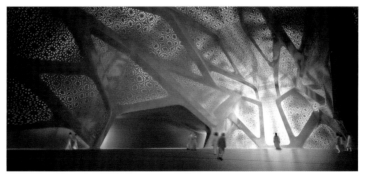

與派屈克・舒馬赫合作

沙烏地阿拉伯・利雅德 2009-16

阿布杜拉國王石油研究中心

KING ABDULLAH PETROLEUM STUDIES & RESEARCH CENTRE

Riyadh, Saudi Arabia 2009-16

In collaboration with Patrik Schumacher

雖然這個研究中心的設計要求以紮實的物理環境考量為前提，但建築上仍努力創造一個有機的形式，它以一種不斷擴展或轉變的形式語言，超越了簡單的技術策略，但並未在設計特徵上有所妥協。其結果是從沙漠中湧現結晶式的細胞結構，並回應了環境條件和內部機能限制。

一貫化的空間及結構策略驅動了計畫中的所有要素。每棟建築物都被區分為個別單元功能，能夠因應其需求上的變化。在外部提供堅實外殼的同時，將內部打開來，成為一系列有遮蔽的庭院，讓受控制的日光能照射到每個空間。這個有層次和緩衝空間的系統，在充滿耀眼陽光的外部到陰涼且被過濾的內部之間，創造了柔和的過渡。

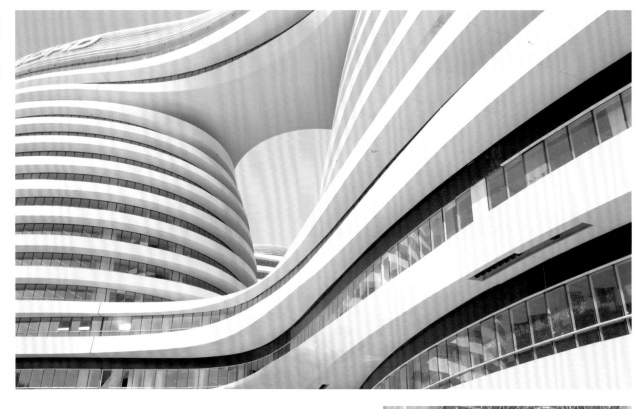

銀河SOHO是辦公室、零售和娛樂的複合建築，靈感來自北京的宏偉規模，由五個連續而流動的量體組成，彼此相互分開、融合或由拉伸的橋樑連接在一起。它們在各個方向彼此調適，產生一個全景建築，沒有折角或突兀的過渡，打破其形式構成上的流動性。

內部中庭反映了中國傳統建築的合院，創造一個連續開放空間的內部世界。在這裡，量體的融合在每個建築物之間創造了連續的相互調適和流體運動，平移的高台產生深刻的沉浸感和包圍感，隨著訪客越走進建築，他們將步入由連續曲線所創造出連貫一氣形式邏輯的親暱空間。

較低的三個樓層容納零售和娛樂場所，其上的樓層為商業群集的工作空間。該建築的頂部作為酒吧、餐館和咖啡館，可以欣賞到城市中最寬的一條大道。這些不同的功能通過一系列親密內部連接，始終與城市相連，共同建立銀河SOHO成為北京的主要城市地標。

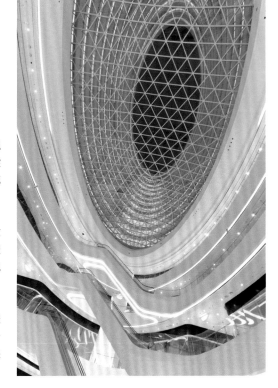

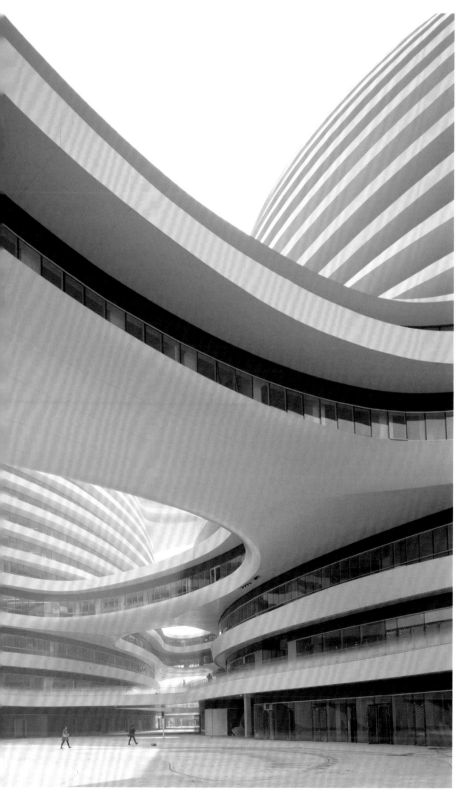

與派屈克‧舒馬赫合作

凌空SOHO

中國‧上海 2010–14

辦公和零售綜合大樓位於虹橋商業區內的凌空經濟園區，可連通高速鐵路和地鐵系統，同時也靠近機場和市中心。

設計概念基於簡單的四個平行樓板。設計中提出8.4公尺格子和大約18公尺建築深度的簡單模矩系統，帶來了便利性和靈活性。建築外殼主要由四種元件構成：細長的元素藉由做為零售使用的彎曲裙樓連接在一起，一個連續的金屬色帶以書法般姿態包圍著它們，以及一個綠的屋頂。

這些元件的簡單性與中間區域的「擠壓」形成鮮明對比──創造了親密的內院，內院又由樓板分岔而來的橋樑所圍塑，其結果是一個完全整合的空間體驗與動態的室內及外部公共空間。

SKY SOHO

Shanghai, China 2010–14

In collaboration with Patrik Schumacher

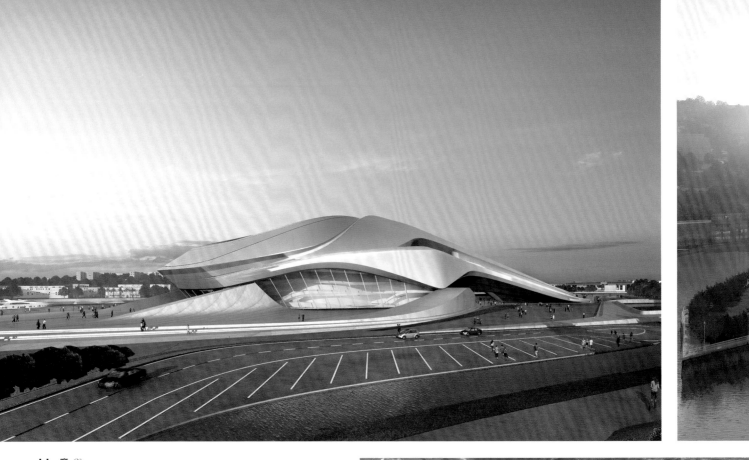

拉巴特大劇院

與派屈克·舒馬赫合作

摩洛哥·拉巴特 2010–

GRAND THEATRE DE RABAT

Rabat, Morocco 2010–

In collaboration with Patrik Schumacher

此案的地點位於拉巴特（Rabat）和薩勒（Salè）兩個城市之間，西北方是歷史悠久的歐代亞城堡（Kasbah Oudayas），東北方為機場，西南方為皇宮，東方為安瓦吉發展區（Amwaj），週邊有布賴格賴格河（Bouregreg）定義了公園景觀。設計是以一個流暢的掃掠（sweep）並延伸到天空而產生了一個外殼，塑造其自身形式的同時覆蓋兩個演講廳，然後再沿著拱形回到地面並融合到地景之中。

隱藏在這種形式姿態背後的是聲學策略和劇場後台組織的經濟性。建築的堅實性為戶外圓形劇場屏蔽了陽光和來自穆萊·哈桑橋（Moulay Hassan bridge）上的噪音，而三座劇院位置的對位調整，讓建築物得以共用後台設施，從而減少所需空間。其雕塑形式流入主門廳，塑造了大階梯，並為訪客提供了直覺的視覺引導，創造了一個無縫流暢的空間體驗。

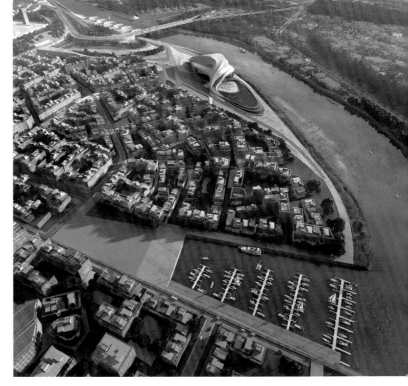

與派屈克·舒馬赫合作

西班牙·畢爾包 2010—

畢爾包巴斯克銀行總部

BBK HEADQUARTERS

Bilbao, Spain 2010—

In collaboration with Patrik Schumacher

畢爾包巴斯克銀行（Bilbao Bizkaia Kutxa bank）的新總部位於佐羅索瑞半島（Zorrotzaurre peninsula）的東南端。由於地點的顯著性需要一個強而有力的建築宣示來加以回應，我們在設計方案中提出了一個由兩個星形平面所定義的雕塑形式，在塔頂和底部相互旋轉45度，使得這些「星星」彼此融合，一顆星的外圍點成為另一顆星的內點，結果呈現隨著視角而變化的輪廓。

建築物進一步由外骨骼結構（structural exoskeleton）而定義，一方面做為主要結構，同時也做為外牆次結構的支撐，因而免除了內部柱子的需要。塔樓頂部設有全景觀景台，也構成企業辦公室的一部分，而塔樓底部則與花瓣狀裙樓合在一起，設有入口大廳、銀行分行、體育館和慈善活動辦公室，使塔樓能夠直接與地面產生關係。

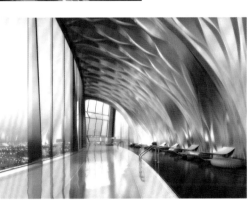

與派屈克·舒馬赫合作

美國·佛羅里達州·邁阿密 2012—

壹仟博物館

ONE THOUSAND MUSEUM

Miami, Florida, USA 2012—

In collaboration with Patrik Schumacher

這座六十六層超級豪華住宅大樓擁有從比斯坎灣（Biscayne Bay）到邁阿密海灘的美景。沿著高樓側面網格曲線向上流動的混凝土「外骨骼」結構，使內部樓板徹底地免除了柱子。在高樓底部，外骨骼的線條伸展開來直到角落處，形成一個堅固的管狀物，抵抗了邁阿密嚴峻的風載重力。低層將容納商業空間和停車場，上方為公寓，最高兩層住宅設有複層閣樓，頂樓為水上活動中心、休閒區和活動空間。

紅沙發 Red Sofa, 1988

威森堡陶藝 Waecthenberg Ceramics

波動沙發 Wave Sofa, 1988

曲面燈具 Warped Plane Lamp, 1987

伍希沙發 Whoosh Sofa, 1988

福維克全室地壁毯設計 Vorwerk Wall-To-Wall Carpeting, 1990

向維納爾‧潘頓'致敬 Hommage à Verner Panton, 1990

譯註1：維納爾‧潘頓（Verner Panton, 1926-1998）為丹麥設計師，著名的曲線形潘頓椅即出自其手。

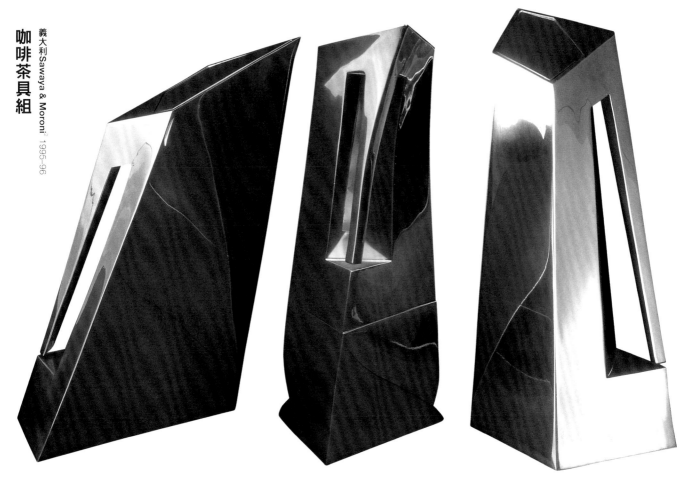

為義大利設計品牌Sawaya & Moroni設計的桌上雕塑（table sculpture），其中分為四個獨立元素：茶壺、咖啡壺、奶精罐、糖罐。就像是三度空間的七巧板，每一塊可拼合為一體。不使用時，非直角容器合體為一組輕巧的結構，成為一件可隨身攜帶的單品。當使用時，物件「爆發」為碎片般的容器，顯露它們該有的功能。這樣的設計，是一次對容器間交融互動的深入研究，探索了新的可能，其中包含幾何的交互作用，以及以居家物為尺度的動態雕塑，甚至，也可視為是一次為大型結構暖身的功課。

譯註2：1984年創立於義大利米蘭，是設計師 William Sawaya 與 Paolo Moroni 共同合作的建築設計事業下，專門開發設計家具的部門。

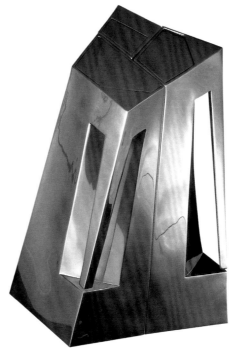

TEA AND COFFEE SET
Sawaya & Moroni 1995–96

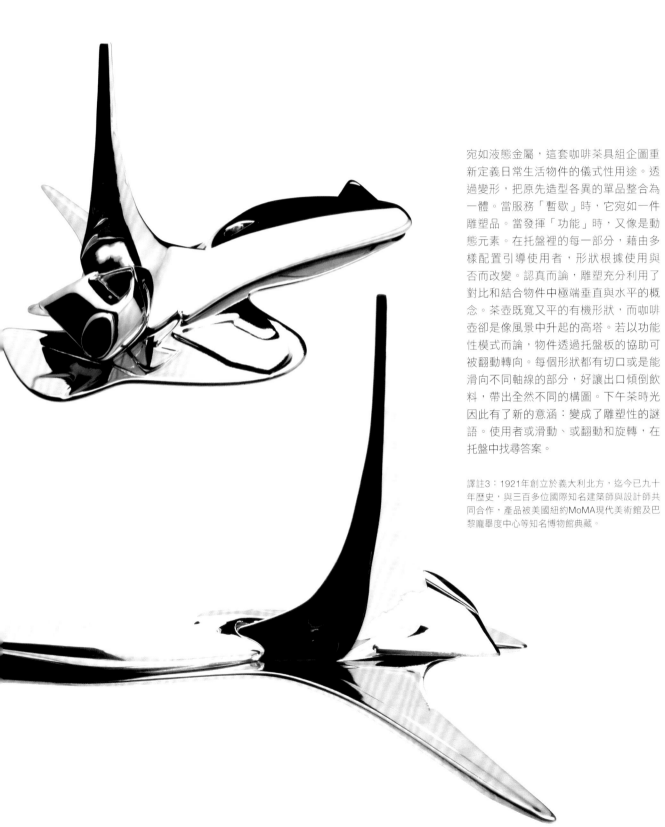

宛如液態金屬，這套咖啡茶具組企圖重新定義日常生活物件的儀式性用途。透過變形，把原先造型各異的單品整合為一體。當服務「暫歇」時，它宛如一件雕塑品。當發揮「功能」時，又像是動態元素。在托盤裡的每一部分，藉由多樣配置引導使用者，形狀根據使用與否而改變。認真而論，雕塑充分利用了對比和結合物件中極端垂直與水平的概念。茶壺既寬又平的有機形狀，而咖啡壺卻是像風景中升起的高塔。若以功能性模式而論，物件透過托盤板的協助可被翻動轉向。每個形狀都有切口或是能滑向不同軸線的部分，好讓出口傾倒飲料，帶出全然不同的構圖。下午茶時光因此有了新的意涵：變成了雕塑性的謎語。使用者或滑動、或翻動和旋轉，在托盤中找尋答案。

譯註3：1921年創立於義大利北方，迄今已九十年歷史，與三百多位國際知名建築師與設計師共同合作，產品被美國紐約MoMA現代美術館及巴黎龐畢度中心等知名博物館典藏。

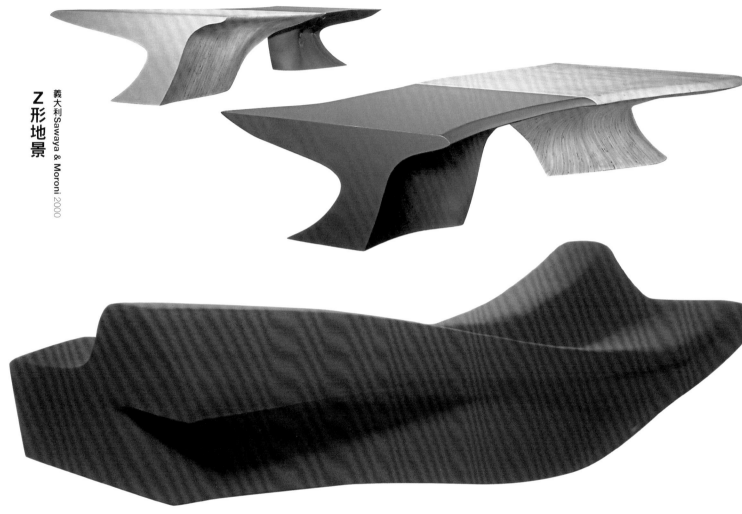

在這套簡潔休閒家具（lounge furniture）組背後的原初概念，來自地景的形態構成（landscape formations）。每一個片段的作品都扮演著合為一個整體的一部分。十一個元素以類型學的（typological）、功能性的、符合人體工學的考量成形。預先設定好的組合，很可能會或多或少因為突兀感和不確定性而被否定。像拼合而成的七巧板，每一件可以是敞開的，也可被重置重組。舉例來說，這個休閒盒（lounging box）將硬空間、軟空間交織出的流動，削掉了一塊；軟空間自地板浮現，被重塑為舒適的座位；硬空間在頂端有垂直的平面，給予桌子、層架、桌檯、吧檯等所需的升抬。

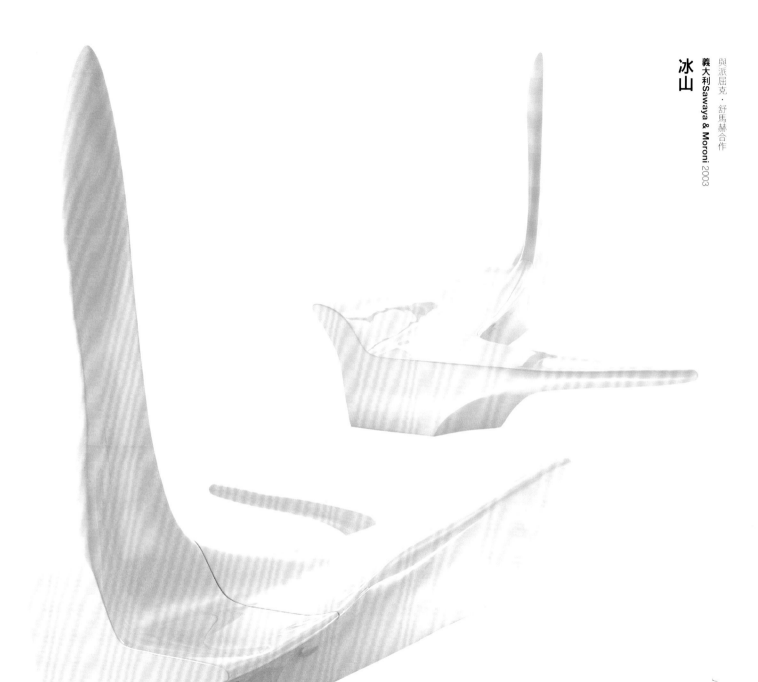

為居家擺飾所設計的液態造型。這個沙發／躺椅允許以多種不同的方向、坐下的位置與坐姿來使用。兩個高叉的冰柱看似朝相反方向向外射出，但其實是共同以形態操作變化（morphed together）而成為一個和諧整體，呈現一個具有形態走向的物體被融化後又凍結的狀態。整體可分為兩個部分，一部分較垂直，像刺一般的突出，另一部分傾向水平，平躺的姿勢。以鋼和木頭打造，帶著珍珠白的亮面汽車烤漆，結構是以最符合人體工學的輪廓模鑄打造。

ICEBERG
Sawaya & Moroni 2003
In collaboration with Patrik Schumacher

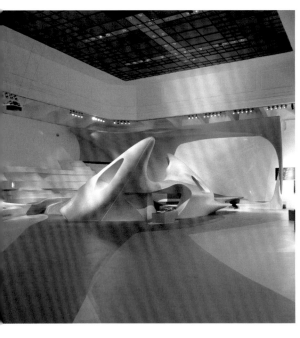

冰風暴

2003

與派屈克・舒馬赫合作

ICE STORM

Österreichisches Museum für Angewandte Kunst *2003*

In collaboration with Patrik Schumacher

透過建立宣言來引領新形態的生活方式和休閒放鬆環境，這件作品收集並融合先前設計過的家具元素和裝置，像是Z形地景[p.264]、冰山[p.265]和Z-Play以及居家風潮（Domestic Wave）中的冰流（Ice-Flow）。這些相異元素，被帶入有機的漩渦，並透過新設計的兩組硬質沙發來加以融合。這半抽象的模鑄表面可被解讀為一間從單一而連續的塊體雕刻而成的公寓，一種複雜且滿是皺褶、壁龕、凹槽、突起的室內景觀（interiorscape）。設計語言強調著複雜的曲線性（curvilinearity）、透過變形技術而臻至無縫流暢的過渡。這種變形使得傳統家具物件變成了一個更大有機體的融合器官。一些未緊臨整體的元素，例如Z-Play的物件，看似漂浮在場景周邊的散漫碎片。訪客被邀請居住於此，去探索一種開放的審美體驗，鼓勵所有人去重新思考我們所習以為常的居家風格與行為。

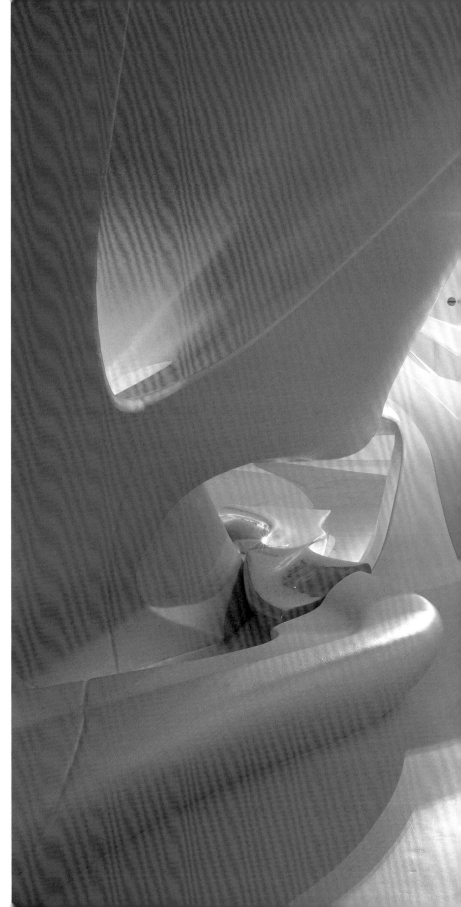

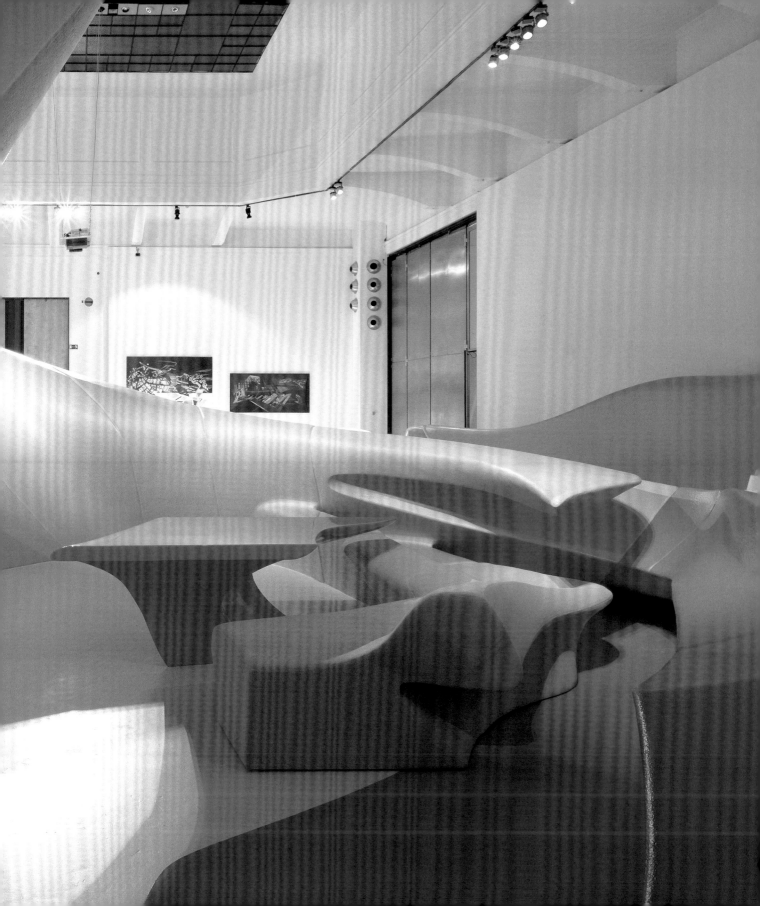

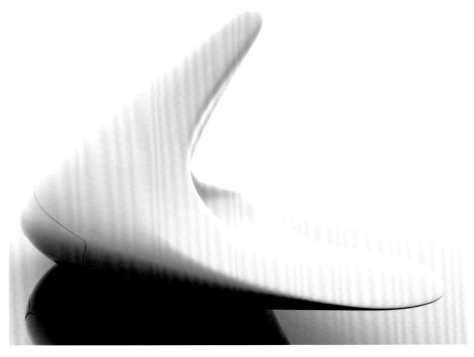

與派屈克‧舒馬赫合作

Kenny Schachter 2005

貝盧長椅

BELU BENCH

Kenny Schachter 2005

In collaboration with Patrik Schumacher

以自主獨立生活的單細胞生物為構想，卻容許多功能使用，這件作品可被視為桌子、檯面、椅子或是容器，或單純只是可供倚靠的表面。一個帶著有機幾何複合體（complex）的液態形體。貝盧能夠生成多樣的接合狀態，端看它與人體直接碰觸時的關係。它不僅只是展示的物件，也是空間中生動的姿態，扮演着多樣功能的同時，定義著周遭環境。這些獨特的幾何體被保留下原始的概念，但縮小了整體比例。這個系列保留了更多直接介入居家環境的可能性。

與派屈克‧舒馬赫合作

義大利Sawaya & Moroni 2007

札哈‧哈蒂碗系列60、70及壓克力材

ZAHA HADID BOWLS 60, 70 AND METACRYLIC

Sawaya & Moroni 2007

In collaboration with Patrik Schumacher

曲線幾何的液態體。這只銀碗回應著自周邊（perimeter）生成出的一股能量擴散，這是對自然力量探索的一次邀請，賦予任何環境一次獨特的脈絡關係。一開始也許顯得缺乏預定計畫、任其自然發生，整只碗內所散發出的全然液態感，遵循著最至關重要的形式邏輯，也就是我們對連續變形以及流暢過渡的系統研究。

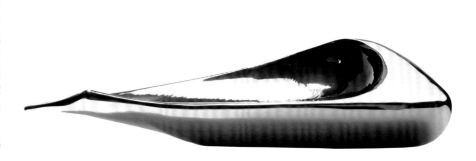

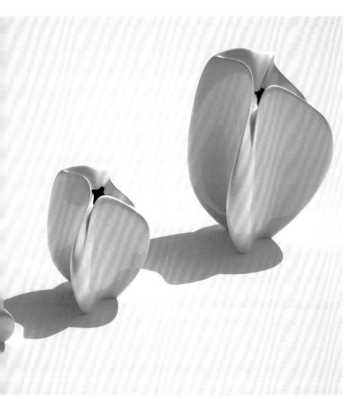

與派屈克・舒馬赫合作

Established & Sons 2005

水之桌

謎樣的液態形體引發觀者的好奇心。水平桌面和垂直桌角的關係被模糊了，這張桌子暗示著運動的行進，藉由液體的動態姿勢形成連續性表面。透過表面上三點的突變，桌面成了渾然一體、半透明矽膠質地的非滑面觸感表層。桌面的顏色漸變反映出這些突變，創造出一種超現實效果，並強調了桌子的整體形式。下層結構是由聚脂纖維（polyester）製成，材料特性得以完成幾何造型也能減輕重量。

In collaboration with Patrik Schumacher

Established & Sons 2005

AQUA TABLE

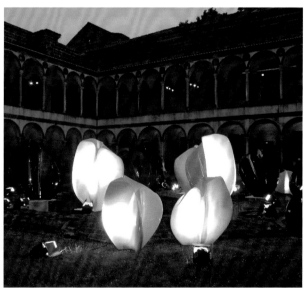

與派屈克・舒馬赫合作

Serralunga 2006–7

流

將進階的三維模鑄技術結合旋轉成型（rotational moulding）科技的一項實驗。這個計劃定義了產品設計和雕塑的新類型學。曲折的物體將笛卡爾的座標幾何學融入連續性的表層。

In collaboration with Patrik Schumacher

Serralunga 2006–7

FLOW

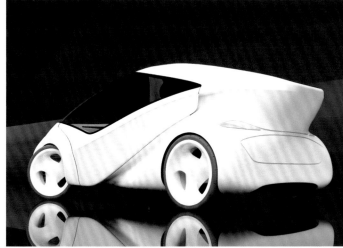

與派屈克‧舒馬赫合作
Kenny Schachter 2005-8

Z形車 I 和 II

Z-CAR I AND II
Kenny Schachter 2005-8
In collaboration with Patrik Schumacher

Z形車 I 是以氫為動力的兩人座三輪城市車。它的成功款——Z形車 II 是一輛四人座的四輪版本。它們的流線型體結合了功能性、靜音操作（quiet operation）以及流體力學的表現。完全零排放，以充電式鋰電池為動力。採用電動輪轂電機（electric in-wheel motors）可節省空間並增加性能表現。這個簡潔的設計得力於大程度在機械和電動零件上，充分考量重量和空間上的配置。

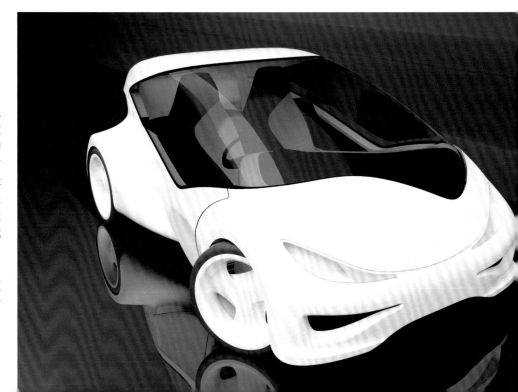

這個設計出自我們對自然現象的觀察，像是冰的融化、冰川的流動。我們發展出一個系統，可以闡述這種設計語言，好創造出具有連續性流線組合且符合人體工學的廚具單品。這個組合中包括了一個主中島，以及一個自烹飪和用餐水平平台升起的懸臂造型，由此進入一個垂直的數位表面。第二中島包含了一個洗水槽、洗碗機和層架。周遭的壁面由波浪狀的元素組成，彼此迴轉，並以各種方式拼組出多重的圖樣。表層處理（cladding）選擇以可耐麗（Corian）[4]時尚包覆，基於材質屬性於熱成型後的半透明性及耐用度。主中島鎖定符合二十一世紀的電子產品：像是2000盞由程式控制展示多樣訊息的LED燈，以及保持食物溫熱的隱藏加熱膜。

譯註4：由美國杜邦公司於1960世紀60年代創造發明，具穩定性、可塑性、備無縫拼接、抗汀、抗衝擊等特性的實體面材。

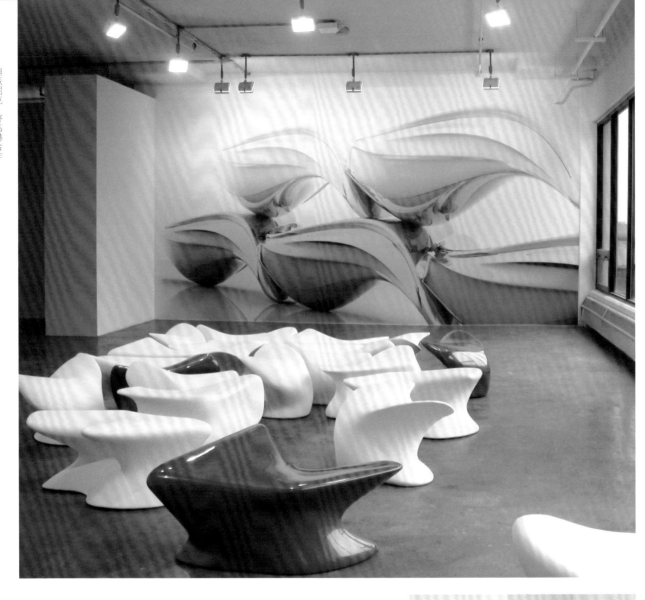

這套家具組延續了我們對於設計世界中無縫流動性（seamless fluidity）的探索，在此是以居家生活的尺度呈現。拜近來三維空間設計軟體及製造業的進展所賜，這組作品多重的曲線幾何反映著我們對人體工學的研究細節，這些研究帶領我們再思考介於家具與空間之間的平衡。當中的每項物件如同獨立自存的個體，各自功能完整。合在一起，又成為令人愉悅的整體，在其中，軟遇見尖、凸遇到凹，就像在磁場中被磁力吸聚的碎片。皺褶、壁龕、凹槽、突起的韻律，追隨著一致的形式邏輯。同樣的設計概念可見於之前的Z形地景[p. 264]、冰風暴[pp. 266–67]、水之桌[p. 269]以及美洲之門飯店[p. 155]。

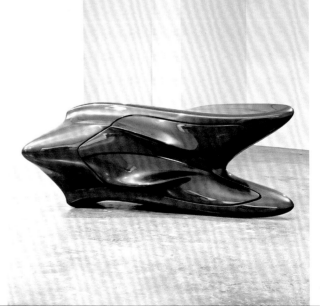

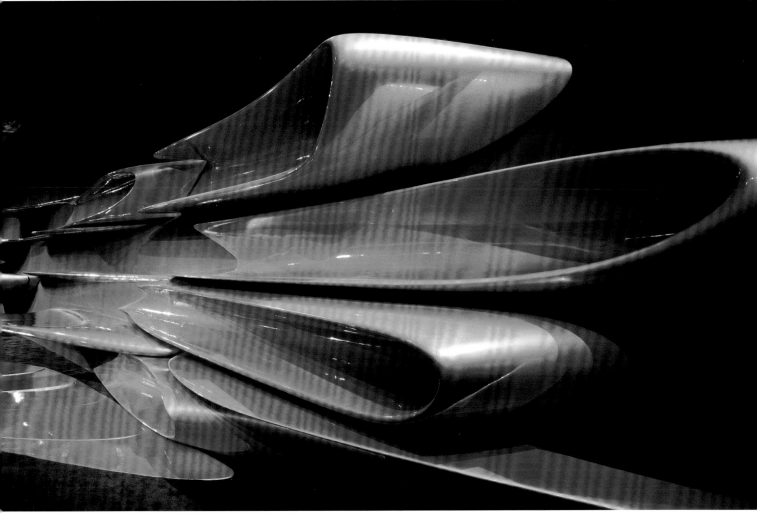

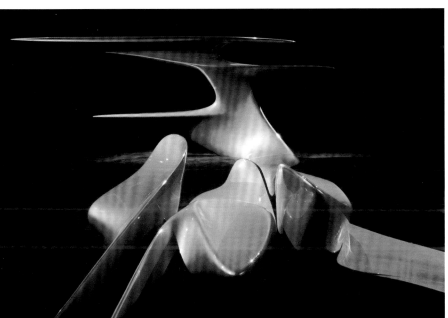

與派屈克・舒馬赫合作

David Gill Galleries 2007

沙丘之形

為威尼斯雙年展發想的這個案子，是一個有機的集合家具元素，從層架、桌子、椅凳到一棵人工樹。裝置中的每一個部分，透過融合樹脂曲面，並以橘金色上光，挑戰着笛卡爾幾何學（Cartesian geometries）。設計元素採用常見的拓樸法則，但以獨特的設計特徵區隔差異，保持各自的雕塑獨立性卻又彼此嵌入。每一件單品提供多面向的使用，展示出一種包含曲面、展示和座椅等元素的創意組合。

DUNE FORMATIONS
David Gill Galleries 2007

In collaboration with Patrik Schumacher

273

噴火口桌

與派屈克・舒馬赫合作

David Gill Galleries 2007

CRATER TABLE

David Gill Galleries 2007

In collaboration with Patrik Schumacher

一張桌子的精髓以及與之相關的物件,皆被精簡到最單純的形式,一種對功能最極致的表達。從表層浮出的物件看似定義了功能,但用另類觀點檢視時,這些碗或燭台並沒有獨立的形體,它們單純是桌子連續表層的整體元素之一,同時其中三個在表面下的奇點(singularity)形成這張桌子的識別特色。三個噴火口(crater)被三股看似隱形的力量鑄模成形,兩股延展力道令人放心地通向地面,第三股力量在空間中懸吊著,很明顯是一個碗。為了獲致最極致的動態與謎樣表層,我們利用了鋁的特性,來創造液態形體。

月亮系統

與派屈克・舒馬赫合作

B&B Italia 2007

MOON SYSTEM

B&B Italia 2007

In collaboration with Patrik Schumacher

月亮系統是一個獨特嶄新的座椅概念,結合了義大利家具領導品牌的製造經驗以及我們多年來對複合曲線幾何的研究。在這組系列作品中,設計將人體工學與美學融合而成一個連續的造型之中。每個元素本身自成一組,重新定義了座椅系統。這個系統重新自我配置,形狀相異的不同物件在實虛、正負、物件與空間之間,透過旋轉、互鎖,隱藏自身特色來融入整體組合。傳統的沙發形態被液化為(liquefied)具彈性且舒適的設計,好接納各式各樣的使用者。

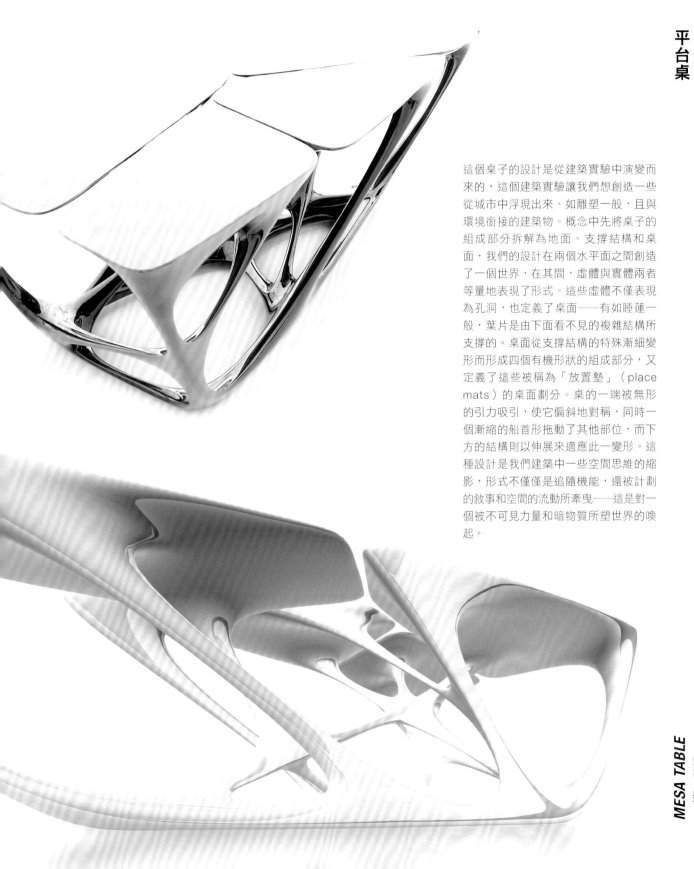

這個桌子的設計是從建築實驗中演變而來的，這個建築實驗讓我們想創造一些從城市中浮現出來、如雕塑一般，且與環境銜接的建築物。概念中先將桌子的組成部分拆解為地面、支撐結構和桌面，我們的設計在兩個水平面之間創造了一個世界，在其間，虛體與實體兩者等量地表現了形式。這些虛體不僅表現為孔洞，也定義了桌面——有如睡蓮一般，葉片是由下面看不見的複雜結構所支撐的。桌面從支撐結構的特殊漸細變形而形成四個有機形狀的組成部分，又定義了這些被稱為「放置墊」（place mats）的桌面劃分。桌的一端被無形的引力吸引，使它偏斜地對稱，同時一個漸縮的船首形拖動了其他部位，而下方的結構則以伸展來適應此一變形。這種設計是我們建築中一些空間思維的縮影，形式不僅僅是追隨機能，還被計劃的敘事和空間的流動所牽曳——這是對一個被不可見力量和暗物質所塑世界的喚起。

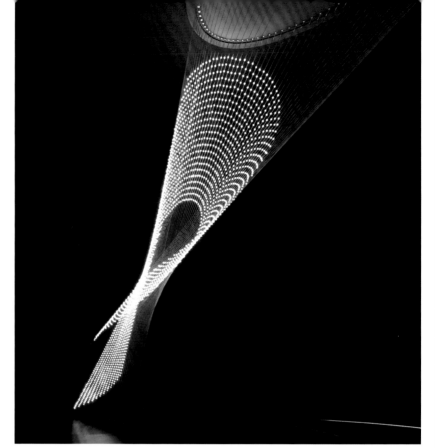

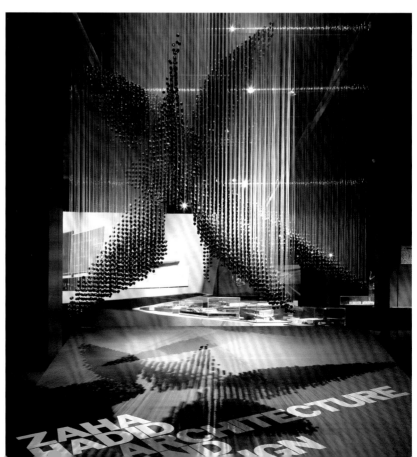

ZAHA HADID 吊燈

施華洛世奇水晶宮 2008

與派屈克‧舒馬赫合作

ZAHA HADID CHANDELIER

Swarovski Crystal Palace 2008

In collaboration with Patrik Schumacher

這件為施華洛世奇（Swarovski）所做的設計，靈感來自「自組織系統」（self-organizing systems）[5]和奈米技術，挑戰了吊燈應該為何的既定概念，並將其重新定義為一個支配（engage）空間的物件，而不僅僅是懸掛在天花板上的一個物品。86條纜線以45度角從地板拉伸到天花板，施以超過八噸的拉力，形成帶有二千七百個自內發光晶體的一個槽紋錐狀體。圍繞在錐體上的流體渦流上，這些晶體在淡藍色調中刻畫出一種飄逸的靈性。這個為巨大室內空間而設、超過15公尺長的吊燈，仍保有高度的細緻。

譯註5：「自組織」常見於生物群體之中，指系統在無領導或指示下，所有個體依照普遍簡單的行為原則及相互作用，而產生全局集體有序、有意義行為模式的一種過程，譬如魚群集體性的游動。

蜂擁吊燈

與派屈克‧舒馬赫合作

Established & Sons倫敦家具公司 2006

SWARM CHANDELIER

Established & Sons 2006

In collaboration with Patrik Schumacher

在倫敦設計博物館的展覽中，此一吊燈的設計是一群黑色晶體的組成物，其形式是動態而非靜態，並且快速切過空間，在實際和感知的時間中創造運動。它複雜層疊的組合並不是以任何比例系統為前提，也不追求對稱性。相反地，其整合狀態來自於控制下的爆炸動力所產生的空間關係。吊燈的翼瓣匯聚成一個更大的有機整體，它們彼此間並非維持純然或中性，而是相互適應著爆發中的力量。

與派屈克 · 舒馬赫合作

Sawaya&Moroni 2005

渦流吊燈

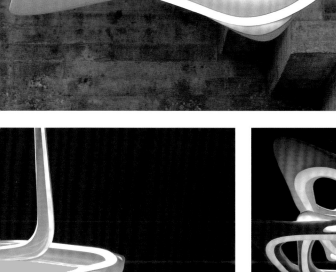

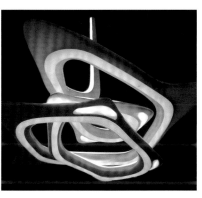

流動性和無縫性是最能描述這個1.8公尺寬吊燈外觀的概念術語，它的複雜曲線依循著雙螺旋，從起始點連接到末端，形成無限光帶。平面上，這個物件像是星形一般從中心向外突起，強調一個來自想像中的離心力。兩個透明壓克力發光螺旋內嵌在不透明表面中，嵌入式LED燈條提供多種燈光動感變化模式（animated）並可程式控制的燈光效果。有直接光或間接光，可以創造不同的照明環境，以配合吊燈安裝的特定空間。這種新的室內設計語言是由先進的數位製造工法推動的，邀請使用者創造性地探索吊燈的互動特質與回應其帶來的特殊美學。

VORTEXX CHANDELIER
Sawaya & Moroni 2005
In collaboration with Patrik Schumacher

與派屈克・舒馬赫合作
Alessi Spa 2005–8

CREVASSE VASE
Alessi Spa 2005–8
In collaboration with Patrik Schumacher

這些花瓶是從單一塊體切割出來,並沿兩條對角線劃線,從而產生翹曲反轉的表面。它們能夠以不同的配置組合在一起來創造實體形式,也可獨自擺放成獨特物品。這一套設計的遊戲本質意味著可改變配置以形成各種不同形狀,同時使用者也可以創建一系列物件,如一個無限變異的七巧板拼圖組。

與派屈克・舒馬赫合作
德國WMF餐廚製品公司 2007

WMF餐具組

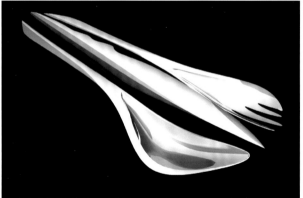

WMF CUTLERY
WMF 2007
In collaboration with Patrik Schumacher

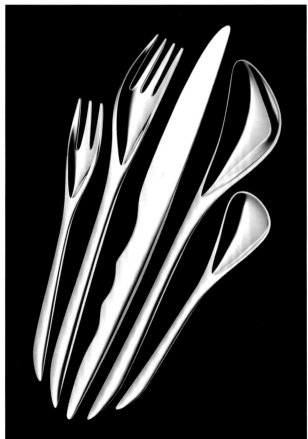

我們對建築研究與工業設計探索之間的張力,產生了這套獨特的餐具組。每件作品都有個別的形式表現,然而,當放在一起時,它們也能彼此互補而統整為單一實體。雕塑出來的表面連續性形成幾何複雜的物體,常用於汽車設計中的加速曲線(accelerated curves)使得它們具有極端的動態性呈現。餐具是從不銹鋼固體加以鍛造,進而拋光到鏡面。材料厚度在某些部分是很極端的,使餐具組的每個項目都能符合人體工學。

SERIES ZH DOOR HANDLES
Valli & Valli 2007

In collaboration with Woody Yao

這些門把是特別為馬德里的美洲之門飯店（Puerta America Hotel）[p. 155]的公共空間和一樓客房所設計的，動態與高度客製化的建築成為這些門把的特徵。材料的冰冷與設計中感性的流動毫不費力地融合在一起，在此空間形態定義了起點與終點。純粹的線條有機地合併成一和諧的鏈帶，創造出美麗與複雜的空間旅程。

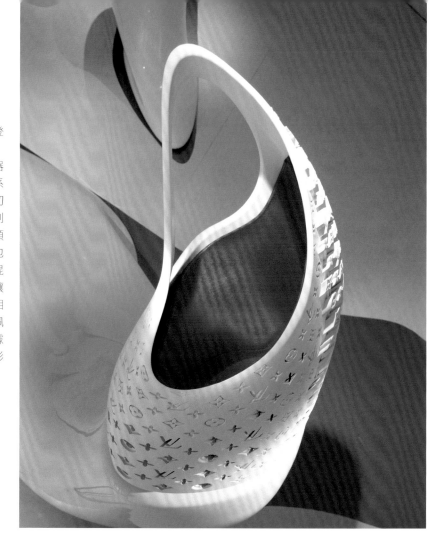

ICONE包

路易‧威登 2006

與派屈克‧舒馬赫合作

ICONE BAG

Louis Vuitton 2006

In collaboration with Patrik Schumacher

基於功能上的反映，我們將路易威登
（Louis Vuitton）經典的「水桶包」
（Bucket）重新詮釋為一個通用容器
（generic container）。在這裡，一系
列形式的操作（擠出、變形、剝皮和切
片），伴隨著材料選擇，創造了一系列
差異化的袋子，呈現傳統的幾種袋子類
型——肩揹手拿包（pochette）、晚宴包
（clutch）和水桶包之間的交叉混合。混
合這些形式產生一系列可能的關係，讓
組成零件在一個一致性的組成內得以相
互置換。不同組合的可能性，觸發與佩
戴者之間的遊戲化互動，並且可以依據
場合需求不同，個別地調整水桶包的形
式和功能。

MELISSA鞋

與派屈克‧舒馬赫合作

Melissa / Grendene S/A 2008

MELISSA SHOE

Melissa/Grendene S/A 2008

In collaboration with Patrik Schumacher

與時尚領域的合作提供了一個令人興奮，同時能表現空間概念在不同尺度和不同
媒材上的機會。這個設計使用了身體上的流動與有機輪廓，鞋的不對稱特
質傳達了與生俱來的動感，誘發了連續不斷的變形。這個概念應用了
運動中的鞋子所帶來的感覺，取代靜態性的櫥窗展示。鞋子從地
面浮現出來，用柔軟優雅的動作爬上腳踝；以舞蹈般有機的塑
材攀附於皮膚，一種輕而隱性的質感模糊了身體和物體之
間的界限。

譯註6：巴西Grendene鞋廠的旗下品牌之一。

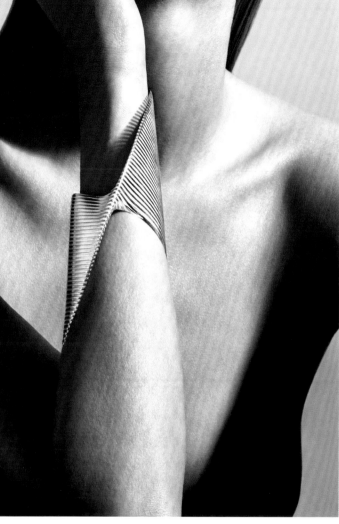

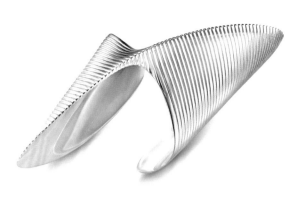

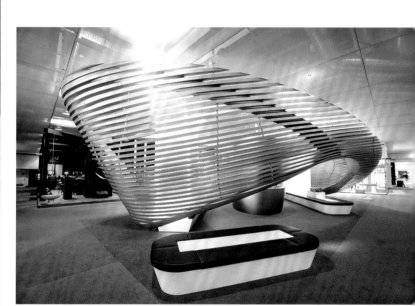

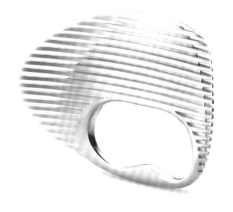

喬治・傑生（Georg Jensen）的薄片（LAMELLAE）系列八件作品包括五只戒指和三支袖鐲，於2016年巴塞爾國際鐘錶珠寶博覽會（Baselworld 2016）中首次展出。這些作品採用三維設計和製造工藝，進行設計和精煉優化。有些是以純銀製成的，其他則以黑銠（black rhodium）製作並鑲嵌黑鑽。

譯註7：1866-1935，丹麥珠寶設計師，同時也是國際知名珠寶設計公司與品牌。

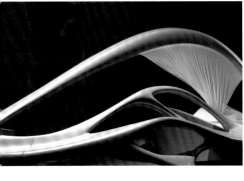

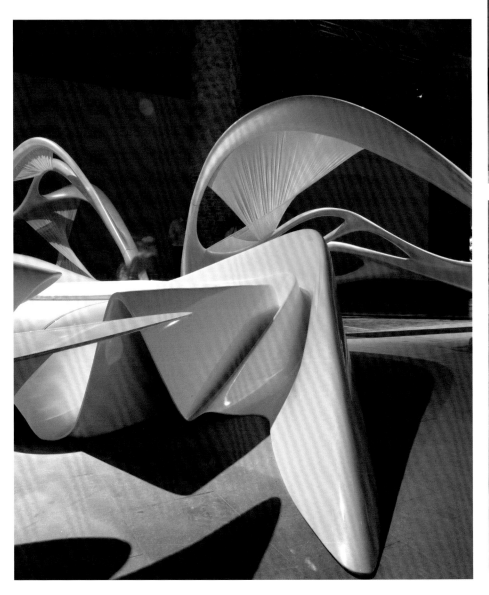

義大利・威尼斯 2008
與派屈克・舒馬赫合作

威尼斯雙年展蓮花裝置

LOTUS, VENICE BIENNALE

Venice, Italy 2008

In collaboration with Patrik Schumacher

這件裝置作品的構想是一個可拆分的外殼，能夠壓縮和擴展成為可坐臥或儲存的空間；一套多重的折疊（folds），在形式上和功能上將這些功能結構化。空間在兩個極端狀態之間來回變動：一個是聚縮的、排斥周圍環境的；另一個則是在環境中展開、分散和相互扣連。家具和建築合為一體並可移動，當各個部分從聚攏狀態中被釋放出來，就成為了書桌、椅子、床、擱架、掛衣桿和茶几。當這設計誘人地褪去外殼與揭開它內部相互嵌合的組件，就揭示了居住的多樣性與可能性的提升。

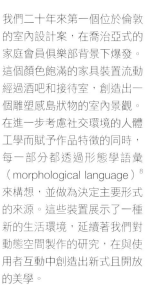

與派屈克‧舒馬赫合作

家庭酒吧

英國‧倫敦 2008

我們二十年來第一個位於倫敦的室內設計案，在喬治亞式的家庭會員俱樂部背景下爆發。這個顏色飽滿的家具裝置流動經過酒吧和接待室，創造出一個雕塑感島狀物的室內景觀。在進一步考慮社交環境的人體工學而賦予作品特徵的同時，每一部分都透過形態學語彙（morphological language）[8] 來構想，並做為決定主要形式的來源。這些裝置展示了一種新的生活環境，延續著我們對動態空間製作的研究，在與使用者互動中創造出新式且開放的美學。

譯註8：意指設計者借用生物領域中研究相近物種與世代之間的形態連續變化軌跡的概念，做為設計的操作方法，並產生相對應的形式語彙。

HOME BAR

London, UK 2008

In collaboration with Patrik Schumacher

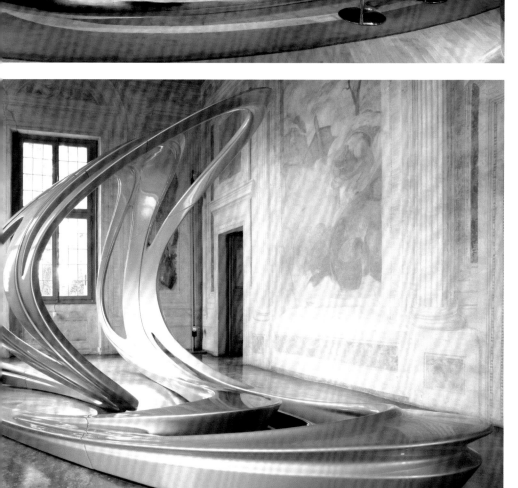

與派屈克‧舒馬赫合作

靈光

義大利‧威尼斯 2008

為了紀念帕拉底歐（Andrea Palladio）[9]誕辰五百週年，我們選擇了由帕拉底歐於1555年設計，其構思和建造都說明了他建築理論的弗斯卡利別墅（Villa Foscari，亦稱為La Malcontenta），並探索其中一個房間的邏輯和關係系統。建築物本質上的平衡，因我們所引入的動態原件而鬆動，設計拋開從帕拉底歐比例理論所衍生出的歐幾里德數學，轉而探索先進數位技術的潛力，於是衍生出反映虛空間結構的空間形態——超凡的空間骨架。

譯註9：文藝復興時期最著名的義大利建築師，作品與理論大幅取自古羅馬時期建築，重視對稱與比例原則，影響後世深遠，產生以古典羅馬風格為目標的「帕拉底歐主義」。

AURA

Venice, Italy 2008

In collaboration with Patrik Schumacher

CIRRUS

Cincinnati, Ohio 2008
In collaboration with Patrik Schumacher

位於羅森塔當代藝術中心 [pp. 97-99] 的這個裝置作品，從牆到地面以條紋化和編織的方式展開，形成了一個室內的「織毯」。一系列虛空間結構化了這個雕塑，創造出座位與倚靠的區域。這些動態性雕塑特質依循著流動性和多孔性的建築語言，每個獨特的條狀單元都是這個作品的編織拓撲（woven topology）中不可或缺的要素。

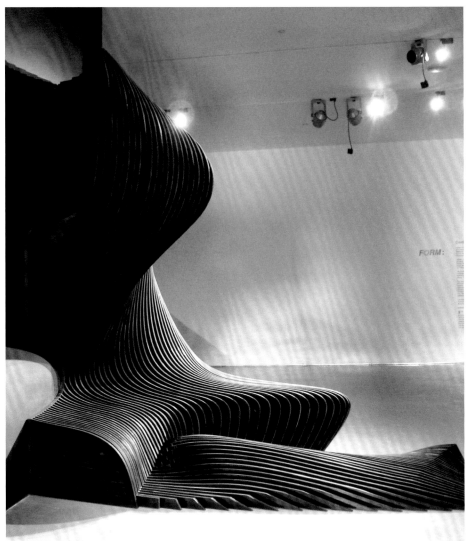

首爾桌

與派屈克‧舒馬赫合作
NY Projects[10] 2008

SEOUL DESK AND TABLE

NY Projects 2008
In collaboration with Patrik Schumacher

該設計藉由結構元素與流線形態兩者之間的混成[11]，來探索水平和垂直的過渡中的某種片刻狀態。這張桌子利用先進的汽車設計和製造技術，由碳纖維（carbon fibre）的複雜工序所製成，使其具有優異的輕量化和強度，以及紋路特徵化的表面處理。

譯註10：位於紐約的國際藝術顧問和製作公司，2007年由Yung Hee Kim創立。
譯註11：指桌腳到桌面之間，或結構到表面之間，或垂直到水平之間，以連續過渡來銜接兩者。

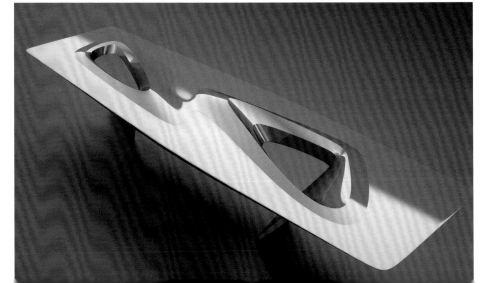

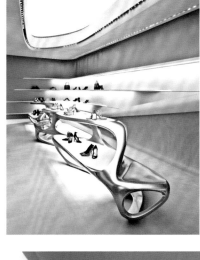

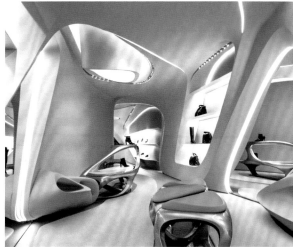

設計理念基於幾何形態嬉戲般的對話，創造出褶皺和凹槽的韻律。沉浸在玫瑰金中、由玻璃纖維製成的中央展示單元，用以陳列Stuart Weitzman系列產品並提供座位，這些元素的並置定義了商店的不同區域，牆壁和天花板上玻璃鋼筋混凝土（glass-reinforced concrete）的使用表現出堅固性，也表現出複雜曲率的精準度。根植於一個微妙的單色調濃淡變化色系，此設計創造了一個可讓人進行探索與發現的地景，增強了消費者與精品之間的聯繫。

譯註12：標榜設計與細節的全球製鞋品牌，與時尚界關係密切，常見於頒獎典禮紅毯上。

STUART WEITZMAN BOUTIQUES
Milan, Hong Kong & Rome 2013-14
In collaboration with Patrik Schumacher

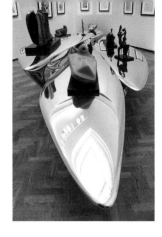

與派屈克・舒馬赫合作
Hauser&Wirth [13] 2008

桌、擱架及展示設計

這是為了展示亨利・摩爾
（Henry Moore）[14]創作中少見
的小型雕塑設計，以最新汽車
製造技術將實心鋁塊切成基本
形狀，而後專業技工用手工焊
接和手工拋光，製作出平滑無
縫的物件。伸展於框架上的織
物有如畫布一般構成了牆。

譯註13：1992年創立於瑞士的國際
性當代藝廊。

譯註14：大型抽象雕塑公共藝術而
聞名的英國現代主義雕塑家。

TABLE, SHELF AND EXHIBITION DESIGN

Hauser & Wirth 2008
In collaboration with Patrik Schumacher

與派屈克・舒馬赫合作
Sawaya&Moroni 2008

勺形沙發

這個流線型曲線性幾何的沙發設計，是過去40年
來在設計實踐中追求形態設計語言的延續。一開始
以無計畫和自發性（unscripted and spontaneous）
的狀態開始，量體的流動性依循的主要形式邏輯，
是我們對連續變換和平滑過渡系統的研究。設計
的進化譜系清楚地呈現在包括Z形地景 [p.264]、下
午茶廣場 [p.263]、水之桌 [p. 269] 和美洲之門飯店
[p.155] 等作品中。這件作品在表面上的光線反射
之外，產生了更多維度的關係。

SCOOP SOFA

Sawaya & Moroni 2008
In collaboration with
Patrik Schumacher

路華畫廊 2008

KLORIS裝置

這個戶外雕塑像是一個爆炸的抽象花朵，倏忽地出現在地景上。它的運動似乎暫時停頓，創造了戲劇化的懸挑座位。最終產品是原始設計的直接轉譯，使用最新的數控銑削技術製造（computer-controlled milled formwork）。外殼由玻璃纖維製成，新式鍍鉻效果的表面處理，使之同時地嵌入與反映著週圍環境。

KLORY

Rover Gallery 2008

In collaboration with Patrik Schumacher

與派屈克‧舒馬赫合作

施華洛世奇 2009

光滑系列

GLACE COLLECTION

Swarovski 2009

In collaboration with Patrik Schumacher

這件新款首飾歌頌著一個二元性，一個是施華洛世奇（全球知名奧地利水晶製造商）精準切割水晶的純粹度，以及另一在外形上美妙的有機形式。這些作品從自然界中顯而易見的蜻蜓形態演變而來，反映了設計和實踐中，每個階段的持續實驗和發明。每個微小的晶體都描述著一個時刻，如被擷獲於某個暫時停頓狀態，表現出流體、生物形態和嚴格規律性的晶體之間的張力。在每個曲面的扭曲或轉折當中，動態形式和人體工學的考量都被無縫銜接整合。不對稱的優雅傳達了內在的運動感，誘人地包圍了鑲嵌的晶體顆粒，而輕質的有機部分則轉譯了晶體的光線折射。顆粒在動態疊置中排列對齊，以加強其優雅且造型化的設計。

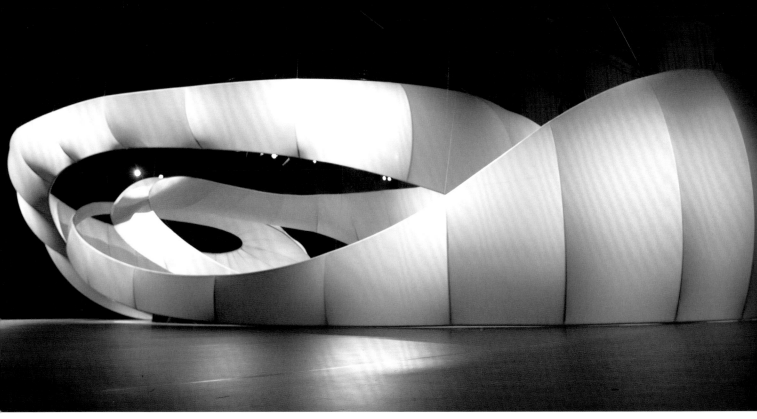

巴哈音樂廳

與派屈克・舒馬赫合作

英國・曼徹斯特 2009

J. S. BACH MUSIC HALL
Manchester, UK 2009
In collaboration with Patrik Schumacher

曼徹斯特美術館中此一獨特的裝置,是特別為約翰・塞巴斯蒂安・巴哈（Johann Sebastian Bach）的音樂而設計。懸掛於天花板、由半透明布料薄膜加上內部鋼結構銜接而成的巨大帶狀物（ribbon）,在空間中盤繞,為作曲家複雜的和聲刻劃出視覺空間性的回應。帶狀物在表演者的位置上方朝側邊傾斜,瀑布似地落下到地面上並捲繞在觀眾席週邊,室內被塑造成膨脹、融合和相互滑動的流體空間。透過將帶狀物圍繞在其自身,壓縮成扶手的尺寸,而後又拉伸到房間的整個高度,實現了空間機能的層層區分。布料表面以恆定但有變化的節奏起伏,它在結構框架上被拉伸,產生外側的高張力外皮與內側的柔軟翻騰之間的差異變化。懸掛在舞台上方的透明壓克力音響反射板,隱藏在布料薄膜內不被察覺。

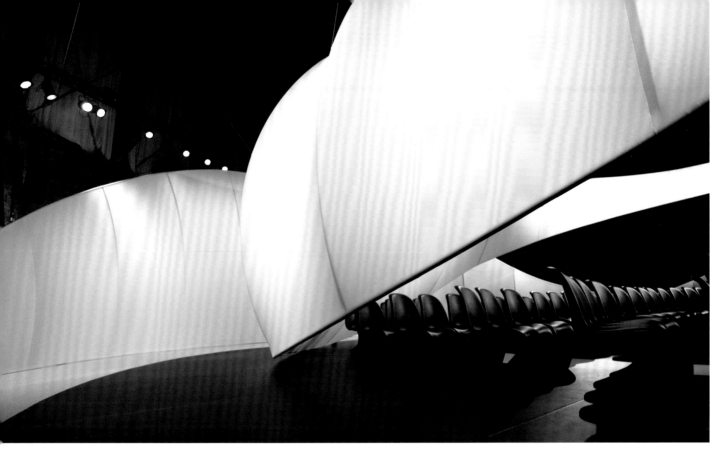

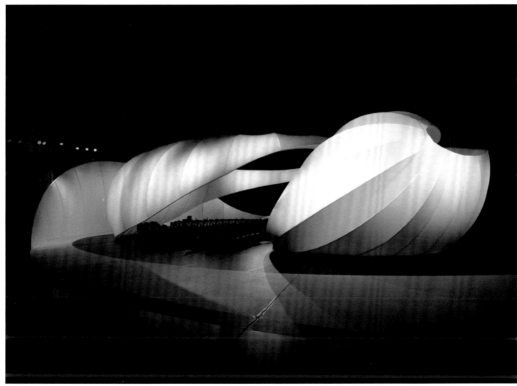

AVILION TRIFLOW 水龍頭

與派屈克‧舒馬赫合作

Aviiion Triflow¹⁵ 2009

AVILION TRIFLOW TAPS

Avilion Triflow 2009

In collaboration with Patrik Schumacher

這個為廚房浴室水龍頭所做的革命性新設計,其靈感來自水運動的啟發。製造方式採用最新的快速原型法的陶瓷成核(ceramic coring)技術,讓每一個水龍頭都成為訂製藝術品。過濾水的獨立通道是由電子觸控裝置控制,以及熱冷溫度的單一控制桿,都整合至主體形式之中。

譯註15:設立於1979年,廚房流理台冷熱水及過濾水整合設備及水龍頭的製造商。本案是該企業慶祝三十週年的委託設計。

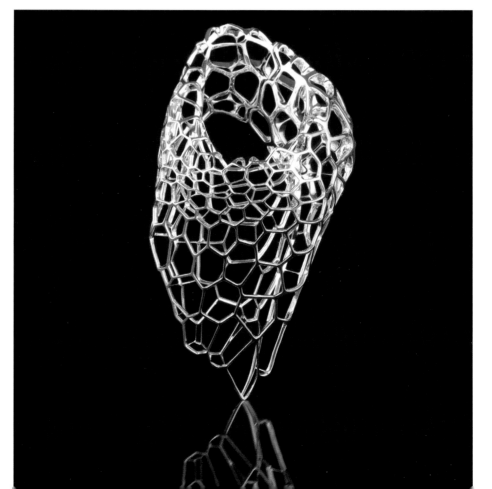

群形袖鐲

與派屈克‧舒馬赫合作

Sayegh珠寶商 2009

SKEIN SLEEVE BRACELET

Sayegh Jeweller 2009

In collaboration with Patrik Schumacher

這款由敘利亞珠寶商委託的多稜面飾品設計,企圖以金銀花絲的網格結構,拉伸環繞手臂。亮面白金網格,以及像水滴般沿著形體流下的白色鑽石,強調了作品中精美的複雜幾何。

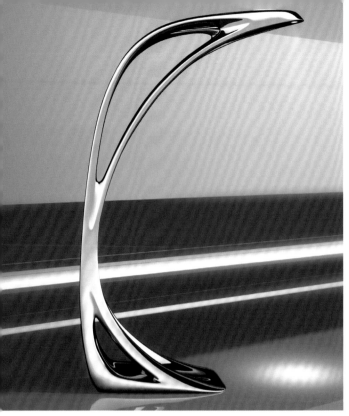

此為Artemide設計的桌燈獨特形式語言，來自對自然世界生長系統的探索。類似一片樹林上的樹冠，在這裡一個連續而彎曲的樹冠，自底部廣袤而相互聯繫的支撐網絡中出現。此有機類比的主要組成部分，從抽象圖形轉變為流體設計，燈的結構隨著從地面上升，時而增加複雜性，如同成長中的生物體般，中心支撐體發芽分枝，採用更大半徑的幾何形狀以增強結構的動態張力。自然界的來源繼續賦予設計特徵，這些分枝形成框架與空洞，增強了正負、凹凸、張力壓力間的對比。分枝遵循著形態學的一致形式邏輯，又再從中央結構湧出來支撐光源。

譯註16：Artemide為義大利知名燈飾品牌。

與派屈克‧舒馬赫合作

Artemide[16] 2002

基因桌燈

這個層架單元的設計探討極小曲面（minimal surfaces）或最佳化形狀（optimal geometries）的幾何學和數學，這些是平均曲率為零的曲面（將線框浸入肥皂液中以形成薄膜，可以製成極小曲面的實體模型）。眾所周知的莫比烏斯環和克萊因瓶（Klein bottle），就是不可定向的極小曲面（non-orientable minimal surfaces）[18]的例子。該設計使用各個模組的幾何特徵以創造高度的排列組合變化與多樣性，裝飾方面則由模組本身的結構和幾何特性導出。

譯註17：以塑料製造家具與居家用品的知名品牌。
譯註18：可定向的曲面，譬如球面或甜甜圈形（Torus），可用一套「一致化」的方向系統（經緯與垂直方向）分佈在表面上所有位置；不可定向的曲面，則在方向系統分佈時產生不一致之處。再以莫比烏斯環上的物體移動加以說明：同一個物體在環上某一處出發，繞行一週後回到原點時，將與原來的物體原始方向不同（左右鏡射或上下顛倒）。

GENESY LAMP
Artemide 2009
In collaboration with Patrik Schumacher

與派屈克‧舒馬赫合作

Magis[17] 2010

浪潮

TIDE
Magis 2010
In collaboration with Patrik Schumacher

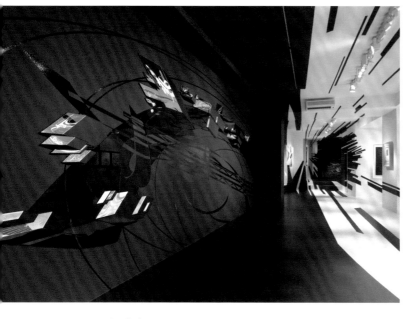

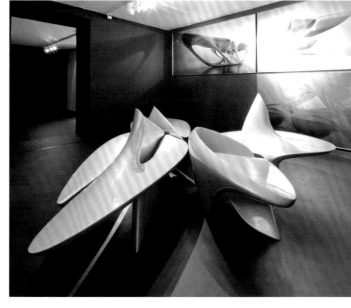

ZAHA HADID: ARCHITECTS & SUPREMATISM
Zurich, Switzerland 2010
In collaboration with Patrik Schumacher

與派屈克·舒馬赫合作

瑞士·蘇黎世 2010

札哈·哈蒂：建築師與絕對主義展

這個開創性的展覽適逢第41屆巴塞爾藝術博覽會（Art Basel），展覽中將俄羅斯前衛作品與設計作品並列，將二維繪圖投影到三維空間中，形成動態且黑白色調的設計，畫廊實際上成為一幅空間繪畫，畫面的尺寸放大到讓人可以進入。我們從俄羅斯前衛派中擷取了早期靈感，特別是馬列維奇（Kazimir Malevich）的作品。他的重大發現在於以「抽象」做為一種啟發式原則，推動創造性工作，達到前所未見的開創境界。我們拒絕擬仿（mimesis），讓創意解放傾洩在無限容受的空白畫布上。空間或世界本身成為純粹、無偏見的創造場所。我們的工作將馬列維奇、埃爾·利西茨基（El Lissitzky）和亞歷山大·羅欽可（Alexander Rodchenko）的繪畫和雕塑中彎曲的和反重力的空間轉化為獨特的建築語言。

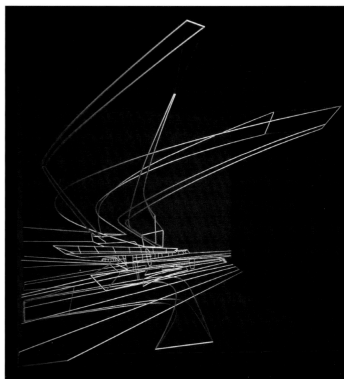

與派屈克・舒馬赫合作

義大利・帕多瓦 2009-10

札哈・哈蒂：帕多瓦理性宮展

ZAHA HADID: PALAZZO
DELLA RAGIONE PADOVA

Padua, Italy 2009-10

In collaboration with Patrik Schumacher

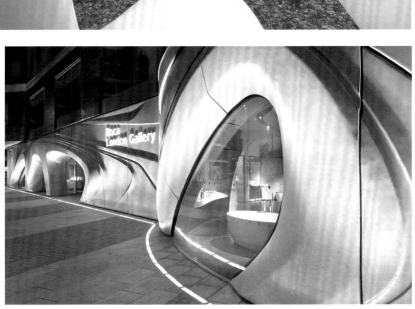

本案回顧了數位設計與營造方法的實驗與研究。展覽的設計尊重中世紀宮殿的空間紋理特色，同時引入了數位與流動性設計，將空間組織成一個具有眾多獨立而連接片段和簇群的單一流動地景。包含不同高度的展示塊體的元件系統（component system）成群地飛行（swarming）穿過此沙龍空間（salone），反映倒置的屋頂並對之重新平衡，在尊重其完整性的同時也給予一個新形象。每個塊體的頂面作為展示，包含各種媒材，如：圖樣、繪畫、發展模型、原型和影片，並以設計主題編排。

與派屈克・舒馬赫合作

英國・倫敦 2009-10

羅卡倫敦畫廊

ROCA LONDON GALLERY

London, UK 2009-11

In collaboration with Patrik Schumacher

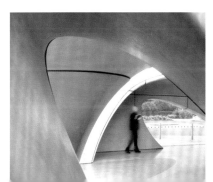

全球羅卡畫廊的最前哨位於倫敦西倫敦的皇家碼頭。此一設計中，水扮演著主導角色如同變形器的作用，無礙地移動穿越立面，雕鑿出內部空間且流經主畫廊。外觀上的一系列開口，表現出水的蝕刻效果，佈滿著水滴狀吊燈（drops of light）的白色室內環境，則是畫廊內的藝術品背景。這些水滴連接不同的空間區域，包括會議室、咖啡廳/酒吧、圖書館、多媒體牆、接待區和播放螢幕。內部還具有最新技術，結合視聽、音響和照明設備，帶領畫廊客戶進行真正尖端的體驗。

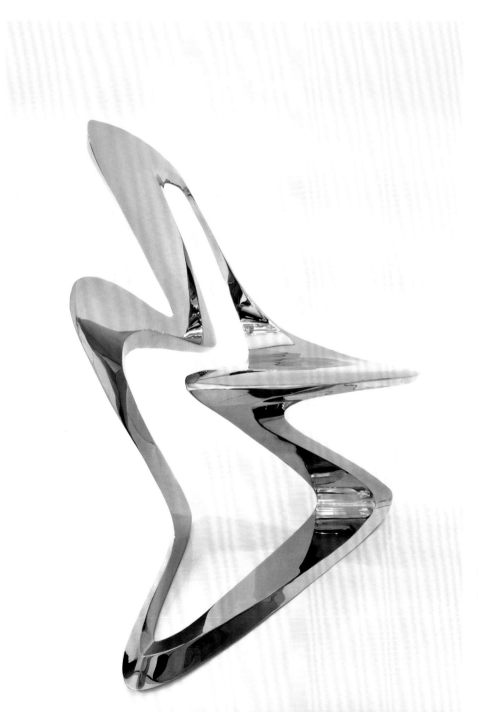

Z-CHAIR

Sawaya & Moroni 2011

In collaboration with Patrik Schumacher

以簡單的三維形態曲折地穿越空間，此一設計再現了形式與功能、優雅與實用、差異化和連續性之間的連續對話。幾何抽象形成的線性環圈，沿其路徑清楚地闡釋於細窄線流和平坦表面，相互交替的語言之中，使整體形狀具備人體工學和一貫的穩定性。優雅的組成與其清晰表達之間二元對立的消除，是通過鮮明的轉角和寬而平滑曲線之間的微妙遊戲而順利完成。

為壁紙公司Marburg設計的四套系列
——Cellular、Stria、Swirl和Elastika,是其
獨家「藝術邊界」(Art Borders)系列的
一部分,這是一項備受期待的合作,證
實技術創新和藝術視野兩者間令人興奮
的配對組合。在德國法蘭克福Heimtextil
國際紡織品展覽會期間,這系列以其生
動的空間和流動性,跳脫慣常模式。寬
度9公尺、高度3.3公尺的獨特設計,通過
增加和壓縮空間來呈現動感。互補圖樣
(complementary drawings)[19]沒有明確
的開始或結束,將牆壁去物質化成為深
層而動態影像的無盡畫布。

譯註19:一種可以四方重複且圖案接續的圖樣。一
個最小的互補圖樣單元中,左側必須是右側的接續
圖樣,上側必須是下側的接續圖樣。

札哈‧哈蒂：流動與設計展

與派屈克‧舒馬赫合作
巴林‧穆哈拉格 2010

ZAHA HADID:
FLUIDITY & DESIGN
Muharraq, Bahrain 2010
In collaboration with Patrik Schumacher

這次展覽的重點是繼續探索流動性的新形式建築語言，包括所有設計尺度，揭示設計案的空間複雜性，反過來又展示了對空間激進性的重新詮釋。展覽的設計尊重「本馬塔大廈」（Bin Matar House）[20]內部的正交本質和組織結構，同時應用設計本身的有機流動性。這些作品範圍涵蓋了從特別委託的珠寶設計到大型家具物件。

譯註20：位於巴林，是由穆罕默德-艾爾哈里發文化研究中心重建的傳統巴林建築之一。

札哈‧哈蒂：一個建築展

與派屈克‧舒馬赫合作
法國‧巴黎 2011

ZAHA HADID:
UNE ARCHITECTURE
Paris, France 2011
In collaboration with Patrik Schumacher

2010年，香奈兒公司捐贈了他們的「行動藝術館」[pp. 212-15]給阿拉伯世界研究所，該機構提供了位於巴黎市中心的一個落腳處，成為「行動藝術館」的永久住所，現在做為阿拉伯國家對外展示的窗口。「一個建築」（UNE ARCHITECTURE）做為新館的開幕展覽，是近幾年設計研究議題的專題探索。這個展覽邀請參觀者進行三個不同層次的體驗：發掘行動藝術館（建築）、觀看展覽設計（場景），並欣賞設計作品（展覽）。

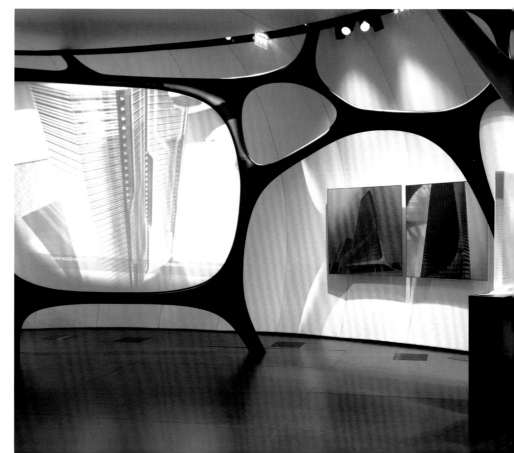

與派屈克·舒馬赫合作
美國·賓州·費城 2011-12

ZAHA HADID: FORM IN MOTION
Philadelphia, Pennsylvania, USA 2011-12
In collaboration with Patrik Schumacher

札哈·哈蒂：動態形式展

在費城藝術博物館的展覽中，我們創造了一個全面環境以展示近期的家具和物品設計案，包括平台桌 [p. 275]和Z形車 I 的原型[p.270]。此展覽是哈蒂首次在美國以自己創作的空間展示自己的作品。展覽設計包括聚苯乙烯（polystyrene）的起伏結構，伴隨著曲線幾何形狀的乙烯基（vinyl）圖形。在開發流體運動的形式語言時，此一設計強調了設計工作本質的連續性，以及建築、都市與設計領域如何緊密相連。

與派屈克·舒馬赫合作
德國·科隆 2012

ZAHA HADID: PARAMETRIC TOWER RESEARCH
Cologne, Germany 2012
In collaboration with Patrik Schumacher

札哈·哈蒂：參數化高樓研究展

在科隆的AIT建築沙龍（AIT ArchitekturSalon）展覽會上，展示一系列著眼於參數主義研究的設計案，包括模型、繪畫和多媒體呈現的新高樓類型。這些嘗試開始於小型尺度的設計，最終到達巨大的城市規劃，反映了企圖滿足所有尺度設計的雄心壯志。內部空間中的地板、牆壁和天花板消失，讓出空間給特地為了這個建築而設計的場景，白色混凝土的表面提供了黑色布料、白色膜、銀色圖紙，以及動畫投影所需的空間。

義大利陶瓷製品公司Lea Ceramiche所委託的這個設計，是米蘭大學十八世紀庭院的現代重新詮釋，它將剛性的笛卡爾幾何轉化為動態空間的線性流動。這個複雜而三維曲面幾何的裝置作品，也包括平面的瓷磚，有助於建立不同元素組成的雕刻感和形式動態，其間實體與虛體之間保持著平衡關係。每個單獨的部分不僅可以解釋為整體的一部分，也可以視為被一個磁力場所捕獲的片段。

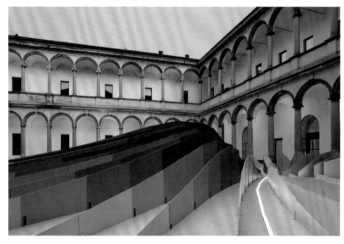

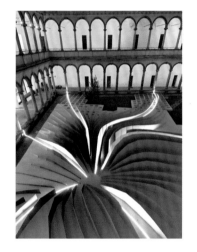

這個漂浮階梯企圖回應畫廊空間的輕盈，每個懸吊的階踏都以Ductal（一種超高性能混凝土）鑄造成獨立的帶狀，抗拉強度允許帶狀物的厚度能保持相對較薄。每一個踏面都向地面漸次靠近，透過在義大利由Il Cantiere[21]設計的單一且可調整模具鑄造而成。此樓梯特別設計成可拆卸式。

譯註21：客製化水泥製品公司。

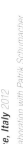

在威尼斯雙年展的這件以金屬褶板製造的裝置中，我們希望表達對幾位先驅者成果的肯定，包括費利克斯·坎德拉（Félix Candela）、海因茨·伊斯勒（Heinz Isler）和弗雷·奧托（Frei Otto）等[22]，他們透過形式發現（form-finding）的過程獲致優雅的設計，此外也包括當代研究者，例如菲利浦·布拉克（Philippe Block）[23]，其成果包括石材抗壓薄殼結構。我們企圖探討的一個特定研究領域是輕量薄殼與張力結構的結合。過去我們完成了一些複雜的薄殼設計，以及一些張力結構，這個設計是我們第一次試圖去整合這兩個世界。

譯註22：費利克斯·坎德拉、海因茨·伊斯勒、弗雷·奧托等是二十世紀之中，追求結構形式創新與實驗的建築浪潮中的代表人物，於1950至1970年代完成許多薄殼曲面作品。

譯註23：結構工程師、建築師，任教於蘇黎世聯邦理工學院建築系，致力於石造結構研發，及電腦運算創新性的結構設計。帶領BRG團隊，以石塊構成自由曲面薄殼結構為展出作品，在2016威尼斯建築雙年展大放異彩。

與派屈克·舒馬赫合作

義大利·威尼斯 2012

海芋裝置和展覽設計

ARUM INSTALLATION AND EXHIBITION

Venice, Italy 2012

In collaboration with Patrik Schumacher

CITCO
ZAHA HADID
COLLECTION

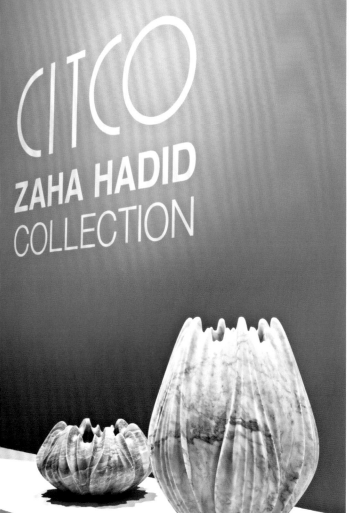

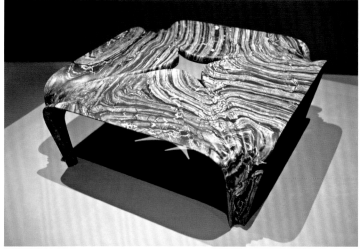

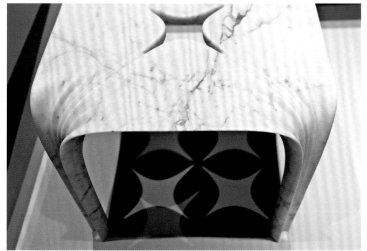

與派屈克・舒馬赫合作

義大利・米蘭 2015

CITCO大理石系列

CITCO MARBLE
COLLECTION
Milan, Italy 2015
In collaboration with Patrik Schumacher

在義大利Citco石材公司的這一系列花瓶和桌子，札哈・哈蒂以她個人獨一無二的方式重新詮釋了大理石。Tau花瓶的有機外觀，呈現如一系列複雜的褶皺，材料的堅固本質矛盾地以脆弱的美學呈現。方桌從中央處的空洞以扇形展開，向角落聚攏成微妙的褶皺，並繼續向下成為桌腳。展覽中每個物件都有五個變體。

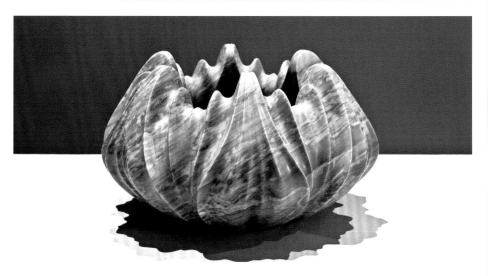

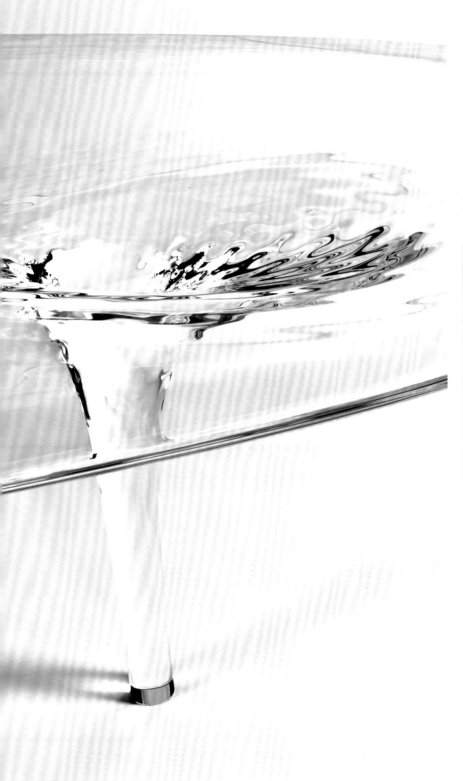

與派屈克‧舒馬赫合作

大衛‧吉爾畫廊 [24] 2012

液態玻璃餐桌／咖啡桌

這個設計由檯面下方明顯而微妙的波浪與波紋，以及看似從桌面上方傾倒在水中漩渦的瞬時凍結而成為桌腳，表現了桌面平坦的基本幾何形狀，從靜態轉變為液態。透明的壓克力材料強化了這種感覺。透過萬花筒般的無限折射作用下，展現完美無瑕，增加了深度和複雜性，於是產生了一種在表面上的動態感，能夠根據使用者不同的觀看位置而不斷變化。該設計並未在功能性或人體工學的要求上有所妥協，同時也是我們以探索空間中的運動為實踐目標的一貫演化。

譯註24：2012年創立於倫敦，展出當代前衛藝術和設計作品。

LIQUID GLACIAL DINING & COFFEE TABLE
David Gill Galleries 2012
In collaboration with Patrik Schumacher

ZAHA HADID RETROSPECTIVE
State Hermitage Museum, St Petersburg, Russia
27 June – 27 September 2015

這是札哈・哈蒂於俄羅斯首次舉辦的回顧展，其中特別強調了俄羅斯前衛藝術（Russian Avant-garde）對她設計上的影響，尤其是她早期的職業生涯。回顧展於冬宮歷史悠久的尼古拉夫斯基廳（Nicolaevsky Hall）登場，展覽透過多媒體，包括影片、攝影及裝置，展出哈蒂近四十年間，最具開創性的繪畫、素描、模型及設計物件。

「大膽擁抱新知和堅信創新力量，這兩者引領我走向俄羅斯前衛藝術。」2004年，哈蒂在艾米塔吉博物館獲頒普立茲克建築獎時說道：「我理解到現代建築是建立在抽象藝術所實現的突破創新之上，而這個作為戰勝先前難以想像得到的自由創造境界，其概念是空間本身，在不失去一致性與連貫度，也許能透過扭曲和變形，獲致動態感與複雜度。」

Malevich's Tektonik [18]
London, UK, 1976–77
Fourth-year Student Project

Dutch Parliament Extension [19]
The Hague, Netherlands, 1978–79
Design Team Office for Metropolitan Architecture (OMA): Zaha Hadid, Rem Koolhaas, Elia Zenghelis, with Richard Perlmutter, Ron Steiner, E. Veneris

Museum of the Nineteenth Century [19]
London, UK, 1977–78
Fifth-year Student Design Thesis

Irish Prime Minister's Residence [20]
Dublin, Ireland, 1979–80
Design Team Zaha Hadid with K. Ahari, Jonathan Dunn

Parc de la Villette [21]
Paris, France, 1982–83
Design Team Zaha Hadid with Jonathan Dunn, Marianne van der Waals, Michael Wolfson

59 Eaton Place [21]
London, UK, 1981–82
Design Team Zaha Hadid with Jonathan Dunn, K. Knapkiewicz, Bijan Ganjei, Wendy Galway

The Peak [22–23]
Hong Kong, 1982–83
Design Team Zaha Hadid with Michael Wolfson, Jonathan Dunn, Marianne van der Waals, N. Ayoubi
Presentation Michael Wolfson, Alistair Standing, Nan Lee, Wendy Galway
Structural Engineer Ove Arup & Partners: David Thomlinson

The World (89 Degrees) [24]
1983
Painting

Melbury Court [24]
London, UK, 1985
Design Team Zaha Hadid with Brian Ma Siy, Michael Wolfson

Grand Buildings, Trafalgar Square [25–27]
London, UK, 1985
Design Team Zaha Hadid with (in the early stages) Brian Ma Siy
Competition Team Michael Wolfson, Brian Ma Siy, Marianne Palme, Kar Hwa Ho, Piers Smerin

Halkin Place [28]
London, UK, 1985
Design Team Zaha Hadid with Brian Ma Siy, Piers Smerin

Kyoto Installations [28]
Kyoto, Japan, 1985
Installations

Tents and Curtains, Milan Triennale [29]
Milan, Italy, 1985
Design Team Zaha Hadid with Piers Smerin, Michael Wolfson

24 Cathcart Road [29]
London, UK, 1985–86
Client Bitar
Design Team Zaha Hadid with Michael Wolfson, Brett Steele, Nan Lee, Brenda MacKneson

Hamburg Docklands [30]
Hamburg, Germany, 1986
Masterplanning Workshops

New York, Manhattan: A New Calligraphy of Plan [31]
1986
Painting

Kurfürstendamm 70 [32]
Berlin, Germany, 1986
Client EUWO Holding AG
Design Team Zaha Hadid with Michael Wolfson, Brett Steele, Piers Smerin, Charles Crawford, Nicola Cousins, David Gomersall
Client Feasibility Berlin Senate
Co-architect Stefan Schroth
Structural Engineer Ove Arup & Partners: Peter Rice, John Thornton
Glazing Consultant RFR Engineers: Hugh Dutton
Quantity Surveyor Büro am Lützowplatz: Wilfraed Kralt
Total Area 820 m² (7 floors)

IBA-Block 2 [33]
Berlin, Germany, 1986–93
Client Degewo AG
Design Team Zaha Hadid with Michael Wolfson, David Gomersall, Piers Smerin, David Winslow, Päivi Jääskeläinen
Co-architect Stefan Schroth
Total Area 2,500 m² (long block: 3 floors; tower: 8 floors)

Azabu-Jyuban [34]
Tokyo, Japan, 1986
Client K-One Corporation
Design Team Zaha Hadid with Michael Wolfson, Brenda MacKneson, Alistair Standing, Signy Svalastoga, Paul Brislin, Nicola Cousins, David Gomersall, Edgar González, Erik Hemingway, Simon Koumjian, Päivi Jääskeläinen
Models Daniel Chadwick, Tim Price
Project Architect (Japan) Satoshi Ohashi
Co-architect Hisashi Kobayashi & Associates
Structural Engineer Ove Arup & Partners: Peter Rice, Yasuo Tamura
Total Area 340 m² (6 floors)

Tomigaya [35]
Tokyo, Japan, 1986
Client K-One Corporation
Design Team Zaha Hadid with Michael Wolfson, Brenda MacKneson, Alistair Standing, Signy Svalastoga, Paul Brislin, Nicola Cousins, David Gomersall, Edgar González, Erik Hemingway, Simon Koumjian, Päivi Jääskeläinen, Patrik Schumacher
Models Daniel Chadwick, Tim Price
Project Architect (Japan) Satoshi Ohashi
Co-architect Hisashi Kobayashi & Associates
Structural Engineer Ove Arup & Partners: Peter Rice, Yasuo Tamura
Total Area 238 m² (2 floors)

West Hollywood Civic Center [36]
Los Angeles, California, USA, 1987
Administrative Buildings

Al Wahda Sports Centre [37]
Abu Dhabi, UAE, 1988
Client Sheikh Tahnoon bin Saeed Al Nahyan
Design Team Zaha Hadid with Michael Wolfson, Satoshi Ohashi
Structural Engineer Ove Arup & Partners: Peter Rice

Metropolis [38]
1988
Painting

Berlin 2000 [39]
1988
Painting

Victoria City Areal [40–41]
Berlin, Germany, 1988
Client City of Berlin (Building Authority)
Design Team Zaha Hadid with Michael Wolfson, Nicholas Boyarsky, Patrik Schumacher, Edgar González, Paul Brislin, Nicola Cousins, Signy Svalastoga, C.J. Lim, Kim Lee Chai, Israel Numes, Mathew Wells, Simon Koumjian
Model Daniel Chadwick
Structural Engineer Ove Arup & Partners: Peter Rice, Mathew Wells
Total Area c. 75,000 m² (15 floors)

A New Barcelona [42]
Barcelona, Spain, 1989
Design Team Zaha Hadid with Patrik Schumacher, Simon Koumjian, Edgar González

Tokyo Forum [43]
Tokyo, Japan, 1989
Client Tokyo Metropolitan Government
Design Team Zaha Hadid with Brian Ma Siy, Patrik Schumacher, Vincent Marol, Philippa Makin, Bryan Langlands, David Gomersall, Jonathan Nsubuga
Model Daniel Chadwick
Total Area 135,000 m² (8 floors)

Hafenstraße Development [44–45]
Hamburg, Germany, 1989
Client Free and Hanseatic City of Hamburg (Building Authority)
Design Team Zaha Hadid with Patrik Schumacher, Signy Svalastoga, Edgar González, Bryan Langlands, Philippa Makin, Nicola Cousins, Mario Gooden, Ursula Gonsior, Claudia Busch, Vincent Marol
Model Daniel Chadwick
Co-architect Mirjane Markovic
Structural Engineer Ove Arup & Partners: Peter Rice
Total Area Corner building: 871 m² (8 floors); middle site building: c. 2,800 m² (10 floors)

Monsoon Restaurant [46–47]
Sapporo, Japan, 1989–90
Client JASMAC Corporation
Design Team Zaha Hadid with Bill Goodwin, Shin Egashira, Kar Hwa Ho, Edgar González, Bryan Langlands, Ed Gaskin, Yuko Moriyama, Urit Luden, Craig Kiner, Dianne Hunter-Gorman, Patrik Schumacher

Consultants Michael Wolfson, Satoshi Ohashi, David Gomersall
Model Daniel Chadwick
Producer Axe Co Ltd
Total Area 435 m² (2 floors)

Osaka Folly, Expo '90 [48]
Osaka, Japan, 1989–90
Client and Sponsor Fukuoka Jisho Co Ltd
Organizer Workshop for Architecture & Urbanism
Design Team Zaha Hadid with Edgar González, Urit Luden, Satoshi Ohashi, Kar Hwa Ho, Patrik Schumacher, Voon Yee-Wong, Simon Koumjian, Dianne Hunter-Gorman, Nicola Cousins, David Gomersall
Model Daniel Chadwick
General Producer Arata Isozaki
Contractor Zenitaka Corporation
Total Area 435 m²

Leicester Square [49]
London, UK, 1990
Client *Blueprint* magazine
Design Team Zaha Hadid with Graham Modlen, Vincent Marol, Simon Koumjian, Patrik Schumacher, Craig Kiner, Cristina Verissimo, David Gomersall, Philippa Makin, Dianne Hunter-Gorman, Maria Rossi, Mya Manakides

Zollhof 3 Media Park [50–51]
Düsseldorf, Germany, 1989–93
Client Kunst- und Medienzentrum Rheinhafen GmbH
Design Zaha Hadid
Project Architects Brett Steele, Brian Ma Siy
Project Team Paul Brislin, Cathleen Chua, John Comparelli, Elden Croy, Craig Kiner, Graeme Little, Yousif Albustani, Daniel R. Oakley, Patrik Schumacher, Alistair Standing, Tuta Barbosa, David Gomersall, C.J. Lim
Models Ademir Volic, Daniel Chadwick
Feasibility and Competition Michael Wolfson, Anthony Owen, Signy Svalastoga, Edgar González, Craig Kiner, Patrik Schumacher, Ursula Gonsior, Bryan Langlands, Ed Gaskin, Yuko Moriyama, Graeme Little, Cristina Verissimo, Maria Rossi, Yousif Albustani
Consultant Architect Roland Mayer
Project Manager Vebau GmbH
Project Co-ordinator Weidleplan Consulting GmbH
Structural Engineers Boll und Partner; Ove Arup & Partners
Services Engineers Jaeger, Mornhinweg und Partner; Ove Arup & Partners; Ingenieurbüro Werner Schwarz GmbH
Façade Consultant Institut für Fassadentechnik
Fire Specialist Wilfred Teschke
Building Physicist Dr Schäcke & Bayer GmbH
Traffic Consultant Waning Consult GmbH
Cost Consultant Tillyard GmbH

Vitra Fire Station [52–55]
Weil am Rhein, Germany, 1990–94
Client Vitra International AG: Rolf Fehlbaum
Design Zaha Hadid
Project Architect Patrik Schumacher
Consultant Architect Roland Mayer
Detail Design Patrik Schumacher, Signy Svalastoga
Design Team Simon Koumjian, Edgar González, Kar Wha Ho, Voon Yee-Wong, Craig Kiner, Cristina Verissimo, Maria Rossi, Daniel R. Oakley, Nicola Cousins, David Gomersall, Olaf Weishaupt

Models Daniel Chadwick, Tim Price
Project Manager, Construction Drawings and Building Supervision GPF & Assoziierte: Roland Mayer, Jürgen Roth, Shahriar Eetezadi, Eva Weber, Wolfgang Mehnert

Music-Video Pavilion [56–57]
Groningen, Netherlands, 1990
Client City Planning Department Groningen
Design Team Zaha Hadid with Graham Modlen, Urit Luden, Edgar González, Vincent Marol, Maria Rossi, Dianne Hunter-Gorman, Cristina Verissimo, Yousif Albustani, Craig Moffatt, Craig Kiner
Model Daniel Chadwick
Co-architect Karelse Van der Meer
Total Area 24.5 m² (4 levels: ground floor, 2 balconies and video room)

Hotel and Residential Complex [58]
Abu Dhabi, UAE, 1990
Client Sheikh Tahnoon bin Saeed Al Nahyan
Design Team Zaha Hadid with Vincent Marol, Craig Kiner, Yousif Albustani, Satoshi Ohashi, Patrik Schumacher, Daniel R. Oakley, Philippa Makin, Dianne Hunter-Gorman
Model Daniel Chadwick
Structural Engineer Ove Arup & Partners
Total Area 47,000 m² (2 retail floors, 1 office floor, 28 hotel floors)

Interzum 91 [59]
Gluzendorf, Germany, 1990
Exhibition Stand Design

London 2066 [60–61]
London, UK, 1991
Client British *Vogue*
Design Team Zaha Hadid with Daniel R. Oakley, Voon Yee-Wong, Graham Modlen, Craig Kiner, Cristina Verissimo, Yousif Albustani, Patrik Schumacher, Mascha Veech-Kosmatschof, Graeme Little
Computer Modelling Daniel R. Oakley

The Hague Villas [62]
The Hague, Netherlands, 1991
Design Team Zaha Hadid with Craig Kiner, Patrik Schumacher, Yousif Albustani, James Braam, Daniel R. Oakley, John Stuart, Cristina Verissimo, David Gomersall
Model Craig Kiner
Structural Engineer Ove Arup & Partners

The Great Utopia [63]
New York, New York, USA, 1992
Design Team Zaha Hadid with Patrik Schumacher, Yousif Albustani, Daniel R. Oakley, David Gomersall, Simon Koumjian
Models Tim Price, Ademir Volic

Vision for Madrid [64]
Madrid, Spain, 1992
Design Team Zaha Hadid with Patrik Schumacher, Daniel R. Oakley, Simon Koumjian, Yousif Albustani, Craig Kiner, Paco Mejias

Arthotel Billie Strauss [65]
Nabern, Germany, 1992
Design Team Zaha Hadid with Patrik Schumacher, Yousif Albustani, Daniel R. Oakley, David Gomersall

Concert Hall [65]
Copenhagen, Denmark, 1992–93
Design Zaha Hadid with Patrik Schumacher
Design Team Paul Brislin, Brian Ma Siy, John Comparelli, Nicola Cousins, Edgar González, Douglas Grieco, C. J. Lim, Mya Manakides, Guido Schwark
Structural Engineer Ove Arup & Partners
Acoustics Consultant Arup Acoustics: Malcolm Wright
Theatre Consultant Theatre Projects Consultants

Rheinauhafen Redevelopment [66–67]
Cologne, Germany, 1992
Design Zaha Hadid
Design Team Patrik Schumacher, Daniel R. Oakley, Craig Kiner, Yousif Albustani, Cathleen Chua, David Gomersall, John Stuart, Simon Koumjian
Model Tim Price

Carnuntum [68–69]
Vienna, Austria, 1993
Design Team Zaha Hadid with Patrik Schumacher, Douglas Grieco, Wendy Ing, Brian Ma Siy, Paola Sanguinetti, Edgar González, David Gomersall
Model Daniel Chadwick

Cardiff Bay Opera House [70–73]
Cardiff, UK, 1994–96
Client Cardiff Bay Opera House Trust: The Rt Hon. Lord Crickhowell, Chairman
Design Zaha Hadid
Project Architect Brian Ma Siy
Design Team Patrik Schumacher, Ljiljana Blagojevic, Graham Modlen, Paul Brislin, Edgar González, Paul Karakusevic, David Gomersall, Tomás Amat Guarinos, Wendy Ing, Paola Sanguinetti, Nunu Luan, Douglas Grieco, Woody Yao, Voon Yee-Wong, Anne Save de Beaurecueil, Simon Koumjian, Bijan Ganjei, Nicola Cousins
Models Ademir Volic, Michael Kennedy, James Wink
Percy Thomas Partnership Ian Pepperell, Richard Roberts, Russell Baker, Richard Puckrin
Project Manager Stanhope Properties: Peter Rogers
Structural Engineer Ove Arup & Partners: Jane Wernick, David Glover, John Lovell
Services Consultant Ove Arup & Partners: Simon Hancock
Acoustics Consultant Arup Acoustics: Richard Cowell, Nigel Cogger
Theatre Consultant Theatre Projects Consultants: David Staples, Alan Russell, Anne Minors
Quantity Surveyor Gardiner & Theobald; Tillyard: Brett Butler, Peter Coxall
Arts Consultant AEA Consulting: Adrian Ellis, Jan Billington
Brief Consultant Inter Consult Culture: Charlotte Nassim
Construction Manager Lehrer McGovern Bovis: Alan Lansdell
Total Area 25,000 m²

Spittelau Viaducts [74–77]
Vienna, Austria, 1994–2005
Client SEG Developers
Design Zaha Hadid with Edgar González, Douglas Grieco, Paul Brislin, Patrik Schumacher, Woody Yao
Project Architects Woody Yao, Markus Dochantschi
Detail Design Zaha Hadid with Woody Yao, Markus Dochantschi, Wassim Halabi, Garin O'Aivazian, James Geiger

Design Team Clarissa Mathews, Paola Sanguinetti, Peter Ho, Anne Save de Beaurecueil, David Gomersall
Structural Engineer Friedreich & Partner
Total Area 2,600 m²

Blueprint Pavilion, Interbuild 95 [78]
Birmingham, UK, 1995
Clients *Blueprint* magazine; Montgomery Exhibitions Ltd
Design Zaha Hadid with Paul Brislin and Woody Yao
Design Team Tomás Amat Guarinos, Oliviero Godi, Maha Kutay, Clarissa Mathews, Graham Modlen, Anne Save de Beaurecueil, Leena Ibrahim
Computer Imagery Flexagon Studio: Thomas Quihano, Wassim Halabi
Structural Engineer Ove Arup & Partners: Rob Devey, Shiguru Hikone, Colin Jackson, Darren Sri-Tharan, Jane Wernick
Quantity Surveyor Tillyard: Brett Butler
Total Area 120 m²

42nd Street Hotel [79]
New York, New York, USA, 1995
Clients Weiler Arrow Management Co; Milstein Properties
Design Team Zaha Hadid with Douglas Grieco, Peter Ho, Clarissa Mathews, Anne Save de Beaurecueil, Voon Yee-Wong, Woody Yao, Paul Brislin, Graham Modlen, Patrik Schumacher, David Gomersall, Bijan Ganjei
Model Richard Armiger
Images for Model Dick Stracker
Computer Imagery Rolando Kraeher
Structural Engineer Ove Arup & Partners
Total Area 180,000 m²

Spittalmarkt [80]
Berlin, Germany, 1995
Design Zaha Hadid with Patrik Schumacher
Competition Team Patrik Schumacher, Woody Yao, Wassim Halabi, David Gomersall, Graham Modlen
Design Development Patrik Schumacher, James Geiger

Lycée Français Charles de Gaulle [81]
London, UK, 1995
Design Team Zaha Hadid with Douglas Grieco, Edgar González, Paul Brislin, Brian Ma Siy, Paola Sanguinetti, Woody Yao, David Gomersall

Pancras Lane [81]
London, UK, 1996
Design Team Zaha Hadid with Brian Ma Siy, Paul Brislin, Edgar González, Patrik Schumacher, Douglas Grieco, Woody Yao, Paola Sanguinetti

Boilerhouse Extension [82]
London, UK, 1996
Client Victoria & Albert Museum
Design Team Zaha Hadid with Patrik Schumacher, Brian Ma Siy, Graham Modlen, Ljiljana Blagojevic, Paul Karakusevic, David Gomersall, Woody Yao, Markus Dochantschi, Wassim Halabi, Ivan Pajares Sanchez, Maha Kutay, Simon Yu, Tomás Amat Guarinos, James Geiger, Tilman Schall, Alan Houston
Structural Engineer Ove Arup & Partners: Jane Wernick
Building Services Ove Arup & Partners: Simon Hancock
Construction Manager Ove Arup & Partners (PMS): Peter Platt-Higgins

Cost Consultant Davis Langdon & Everest: Rob Smith
Total Area 10,000 m²

Wish Machine: World Invention [83]
Kunsthalle, Vienna, Austria, 1996
Client Kunsthalle Wien: Herbert Lachmeyer, Curator, Brigitte Felderer
Design Team Zaha Hadid with Patrik Schumacher, Simon Yu, Wassim Halabi, Markus Dochantschi, David Gomersall, Woody Yao, Paul Karakusevic
Total Area 900 m²

Master's Section, Venice Biennale [84]
Venice, Italy, 1996
Design Team Zaha Hadid with Patrik Schumacher, Markus Dochantschi, Woody Yao, Wassim Halabi, Garin O'Aivazian, David Gomersall, Simon Yu, Yousif Albustani, Giuseppe Anzalone Gherardi

Habitable Bridge [84–85]
London, UK, 1996
Client The Rt Hon. John Gummer, Secretary of State for the Environment; Royal Academy
Sponsor Thames Water
Design Team Zaha Hadid with Patrik Schumacher, Ljiljana Blagojevic, Paul Karakusevic, Graham Modlen, Woody Yao, Markus Dochantschi, Tilman Schall, Colin Harris, Thilo Fuchs, Shumon Basar, Katrin Kalden, Anne-Marie Foster
Models Alan Houston, Michael Howe
Computer Design Wassim Halabi, Simon Yu, Garin O'Aivazian
Structural Engineer Ove Arup & Partners: Jane Wernick, Sophie Le Bourva
Services Consultant Ove Arup & Partners: Simon Hancock, Dorte Rich Jorgensen
Transportation Consultant Ove Arup & Partners: John Shaw
Construction Manager Ove Arup & Partners: Harry Saradjian
Cost Consultant Davis Langdon & Everest: Rob Smith, Sam Mackenzie
Total Area 40,000 m²

La Fenice [86]
Venice, Italy, 1996
Design Team Zaha Hadid with Graham Modlen, Maha Kutay, Simon Yu
Computer Design Wassim Halabi

Philharmonic Hall [87]
Luxembourg, 1997
Client Ministry of Public Buildings
Design Zaha Hadid with Patrik Schumacher
Design Team Garin O'Aivazian, Markus Dochantschi, Woody Yao, Wassim Halabi, Jan Hübener, Anna Klingmann, Tilman Schall, Filipe Pereira, Shumon Basar, Mark Hemel, Yousif Albustani, Graham Modlen, Anuschka Kutz, David Gomersall
Total Area 7,100 m²

Landesgartenschau 1999 [88–91]
Weil am Rhein, Germany, 1996–99
Client Landesgartenschau Weil am Rhein GmbH
Design Zaha Hadid with Patrik Schumacher and Mayer Bährle

Project Architect Markus Dochantschi
Project Team Oliver Domeisen, Wassim Halabi, Garin O'Aivazian, Barbara Pfenningstorff, James Lim
Models June Tamura, Jim Heverin, Jon Richards, Ademir Volic
Co-architect Mayer Bährle Freie Architekten BDA
Total Area 800 m²

Museum of Islamic Arts [92–93]
Doha, Qatar, 1997
Client State of Qatar
Design Zaha Hadid with Patrik Schumacher and Woody Yao
Design Team Shumon Basar, Graham Modlen, Markus Dochantschi, Anuschka Kutz, Garin O'Aivazian, Filipe Pereira, Ivan Pajares Sanchez, Wassim Halabi, Ali Mangera, Edgardo Torres, Julie Fisher, Andrew Schachman, Oliver Domeisen, Julie Richards, Irene Huttenrauch, Tia Lindgren
Total Area 28,000 m²

Sheikh Zayed Bridge [94–95]
Abu Dhabi, UAE, 1997–2010
Client Abu Dhabi Municipality
Design Zaha Hadid
Project Architect Graham Modlen
Project Team Garin O'Aivazian, Zahira Nazer, Christos Passas, Sara Klomps, Steve Power
Project Engineers Joe Barr, Mike King, Mike Davies; Highpoint Rendel
Structural Consultant Rendel Palmer & Tritton
Lighting Hollands Licht
Materials Piers, decking: reinforced concrete; arches: steel
Size 842m (length) × 64m (height) × 61m (width)

Campus Center, Illinois Institute of Technology [96]
Chicago, Illinois, USA, 1998
Design Zaha Hadid with Patrik Schumacher
Design Team Yousif Albustani, Anuschka Kutz, Oliver Domeisen, Shumon Basar, Inken Witt, Jee-Eun Lee, Wassim Halabi, Ivan Pajares Sanchez, David Gomersall, Stéphane Hof, Woody Yao, Markus Dochantschi, Marco Guarnieri, Ali Mangera, Jim Heverin, Jon Richards, Terence Koh, Simon Yu, James Lim, Tilman Schall
Structural and Civil Engineer Ove Arup & Partners: Jane Wernick
Building Services Ove Arup & Partners: Simon Hancock
Acoustics Consultant Arup Acoustics: Andrew Nicol
Construction Manager Ove Arup & Partners: Peter Platt-Higgins
Quantity Surveyor Davis Langdon & Everest: Sam Mackenzie, Brian Irving
Fire and Means of Escape Ove Arup & Partners: Chris Barber
Information Technology Ove Arup & Partners: Volker Buscher
Urban Context Report Space Syntax Laboratory: Bill Hillier, Mark David Major

Lois & Richard Rosenthal Center for Contemporary Art [97–99]
Cincinnati, Ohio, USA, 1997–2003
Design Zaha Hadid
Project Architect Markus Dochantschi
Assistant Project Architect Ed Gaskin
Project Team Ana Sotrel, Jan Hübener, David Gerber,

Christos Passas, Sonia Villaseca, James Lim, Jee-Eun Lee, Oliver Domeisen, Helmut Kinzler, Patrik Schumacher, Michael Wolfson, David Gomersall
Competition Team Shumon Basar, Oliver Domeisen, Jee-Eun Lee, Terence Koh, Marco Guarinieri, Stéphane Hof, Woody Yao, Ivan Pajares Sanchez, Wassim Halabi, Nan Atichapong, Graham Modlen
Study Models Chris Dopheide, Thomas Knüvener, Sara Klomps, Bergendy Cooke, Florian Migsch, Sandra Oppermann, Ademir Volic
Presentation Model Ademir Volic
Local Architect KZF Design: Donald L. Cornett, Mark Stedtefeld, Dale Beeler, Amy Hauck-Hamilton, Deb Lanius
Construction Manager Turner Construction Company: Craig Preston, Bill Huber, Bob Keppler
Structural Engineer THP Limited Inc: Shayne O. Manning, Murray Monroe, Andreas Greuel, Jason Jones
Acoustics Consultant Arup Acoustics: Neill Woodger, Andrew Nicol, Richard Cowell
Services Consultant Heapy Engineering: Ron Chapman, Gary Eodice, Kirby Morgan, Fred Grable
Security Consultant Steven R. Keller & Associates: Steven Keller, Pete Rondo
Theatre Consultant Charles Cosler Theatre Design
Lighting Consultant Office for Visual Interaction: Enrique Peiniger, Jean M. Sundin

The Mind Zone [100]
London, UK, 1998–2000
Client New Millennium Experience Company
Design Zaha Hadid
Project Architect Jim Heverin
Project Team Barbara Kuit, Jon Richards, Paul Butler, Ana Sotrel, Christos Passas, Graham Modlen, Oliver Domeisen
Competition Team Graham Modlen, Patrik Schumacher, Oliver Domeisen, Garin O'Aivazian, Simon Yu, Wassim Halabi, Jim Heverin, Jon Richards
Models Jon Richards, Jim Heverin, Eddie Can, Helmut Kinzler; A Models
Artist Liaison Doris Lockhart-Saatchi
Artists/Exhibit Collaborators Research Studios: Neville Brody; Richard Brown, Nancy Burson, Brian Butterworth, Helen Chadwick, Hussein Chalayan, Richard Deacon, Escape, Ryoji Ikeda, Herbert Lachmayer (with Matthias Fuchs and Sylvia Eckermann), Langlands & Bell, Ron Mueck, New Renaissance, Urs B. Roth, Gavin Turk
Structural Engineer Ove Arup & Partners
Building Services Ove Arup & Partners
Cladding Design Consultant DCAb
Construction Manager McAlpine/Laing Joint Venture
Principal Contractor Hypsos Expo
Steel Contractor Watson Steel Structures Ltd
GRP Contractor SP Offshore
Quantity Surveyor Davis Langdon & Everest
Lighting Consultant Hollands Licht

UNL/Holloway Road Bridge [101]
London, UK, 1998
Design Team Zaha Hadid with Christos Passas, Ali Mangera, Patrik Schumacher, Woody Yao, Sonia Villaseca, Eddie Can, Jorge Ortega, Helmut Kinzler
Structural Engineer Jane Wernick Associates
Building Services Ove Arup & Partners: Simon Hancock
Transport and Flow Capacity Ove Arup & Partners: Fiona Green

Construction Programme Ove Arup & Partners: Harry Saradjain
Quantity Surveyor Davis Langdon & Everest: James Woodrough

Pet Shop Boys World Tour [101]
1999
Design Zaha Hadid
Project Architect Oliver Domeisen
Design Team Bergendy Cooke, Jee-Eun Lee, Christos Passas, Caroline Voet, Susann Schweizer, Thomas Knüvener
Lighting Design Marc Brickman

Car Park and Terminus Hoenheim-Nord [102–5]
Strasbourg, France, 1998–2001
Client Compagnie des Transports Strasbourgeois
Design Zaha Hadid
Project Architect Stéphane Hof
Sketch Design Team Stéphane Hof, Sara Klomps, Woody Yao, Sonia Villaseca
Project Team Silvia Forlati, Patrik Schumacher, Markus Dochantschi, David Salazar, Caroline Voet, Eddie Can, Stanley Lau, David Gerber, Chris Dopheide, Edgar Gonzáles
Project Consultant Mayer Bährle Freie Architekten BDA: Roland Mayer
Local Architect Albert Grandadam
General Engineer Getas/Serue
Structural Engineer Luigi Martino
Total Area 25,000 m²; tram station: 3,000 m²

MAXXI: National Museum of XXI Century Arts [106–9]
Rome, Italy, 1998–2009
Client Italian Ministry of Culture
Design Zaha Hadid with Patrik Schumacher
Project Architect Gianluca Racana
Site Supervision Team Anja Simons, Paolo Matteuzzi, Mario Mattia
Design Team Anja Simons, Paolo Matteuzzi, Fabio Ceci, Mario Mattia, Maurizio Meossi, Paolo Zilli, Luca Peralta, Maria Velceva, Matteo Grimaldi, Amin Taha, Caroline Voet, Gianluca Ruggeri, Luca Segarelli
Competition Team Ali Mangera, Oliver Domeisen, Christos Passas, Sonia Villaseca, Jee-Eun Lee, James Lim, Julia Hansel, Sara Klomps, Shumon Basar, Bergendy Cooke, Jorge Ortega, Stéphane Hof, Marcus Dochantschi, Woody Yao, Graham Modlen, Jim Heverin, Barbara Kuit, Ana Sotrel, Hemendra Kothari, Zahira El Nazel, Florian Migsch, Kathy Wright, Jin Wananabe, Helmut Kinzler
Planning ABT srl (Rome)
Structure Anthony Hunt Associates (London); OK Design Group (Rome)
M&E Max Fordham & Partners (London); OK Design Group (Rome)
Lighting Equation Lighting Design (London)
Acoustics Paul Gillieron Acoustic (London)
Size 30,000 m²

Museum for the Royal Collection [110]
Madrid, Spain, 1999
Design Zaha Hadid with Patrik Schumacher
Design Team Sonia Villaseca, Caroline Voet, Jorge Ortega, Eddie Can, Paola Cattarin, Jee-Eun Lee, David Gomersall, Chris Dopheide, Silvia Forlati, J.R. Kim
Structural Engineer Ove Arup & Partners: David Glover, Ed Clark

Services Engineer Ove Arup & Partners: Simon Hancock
Cost Consultant Davis Langdon & Everest: Eloi Ruart
Museum Design Consultant Bruce McAllister

Reina Sofia Museum Extension [111]
Madrid, Spain, 1999
Design Zaha Hadid with Patrik Schumacher
Design Team Sonia Villaseca, Jorge Ortega, Eddie Can, Paola Cattarin, Christos Passas, Chris Dopheide, Bergendy Cooke, Jee-Eun Lee, Caroline Voet, Oliver Domeisen, David Gomersall, Electra Mikelides
Structural Engineer Ove Arup & Partners: David Glover, Ed Clark
Services Engineer Ove Arup & Partners: Simon Hancock
Cost Consultant Davis Langdon & Everest: Eloi Ruart
Museum Design Consultant Bruce McAllister

Rothschild Bank Headquarters and Furniture [111]
London, UK, 1999
Client N. M. Rothschild & Sons
Design Zaha Hadid
Design Team Graham Modlen, Barbara Kuit, Zahira Nazer, Oliver Domeisen
Models Florian Migsch, Bergendy Cooke, Thomas Knüvener, Jee-Eun Lee

Royal Palace Hotel and Casino [112]
Lugano, Switzerland, 1999
Design Zaha Hadid
Design Team Ali Mangera, Barbara Kuit, Thomas Knüvener, Paola Cattarin, Woody Yao, Patrik Schumacher, Jorge Ortega, Eddie Can, Silvia Forlati, Oliver Domeisen, Jee-Eun Lee, Bergendy Cooke
Collaborators Zahira Nazer, Jan Hübener, Yoash Oster
Structural Engineer Ove Arup & Partners: David Glover, Colin Jackson, Ed Clark
Environmental Engineer Ove Arup & Partners: Simon Hancock
Casino Consultant Edward Lyon Design

Metapolis, Charleroi/Danses [112]
Charleroi, Belgium, 1999
Design Zaha Hadid
Design Team Caroline Voet, Woody Yao, Stéphane Hof, Shumon Basar, Paola Cattarin, Bergendy Cooke, Chris Dopheide
Technical Consultant DCAb
Costume Consultant Susan Schweizer
Fabrics Consultant Marie O'Mahony
Couturier Thomas Zaepf

National Library of Quebec [113]
Montreal, Quebec, Canada, 2000
Design Zaha Hadid with Patrik Schumacher
Design Team Sonia Villaseca, Stéphane Hof, Chris Dopheide, Djordje Stojanovic, Dillon Lin, Lida Charsouli, Garin O'Aivazian, David Gerber, Andreas Durkin, Liam Young, Christos Passas, Sara Klomps
Competition Model Ademir Volic
Local Architect Albert Grandadam
Structural Engineer Adams Kara Taylor: Hanif Kara
Cost Consultants Davis Langdon & Everest: Guy Rezeau; Hanscomb Consultants
Environmental Engineer Max Fordham Partnership: Henry Luker, Sam Archer

Acoustics Consultants Arup Acoustics; Peutz & Associés France

Lighting Consultant Office for Visual Interaction: Enrique Peiniger, Jean M. Sundin

Bergisel Ski Jump [114–15]

Innsbruck, Austria, 1999–2002

Design Zaha Hadid

Project Manager Markus Dochantschi

Project Architect Jan Hübener

Project Team Matthias Frei, Cedric Libert, Silvia Forlati, Jim Heverin, Garin O'Aivazian, Sara Noel Costa de Araujo

Competition Team Ed Gaskin, Eddie Can, Yoash Oster, Stanley Lau, Janne Westermann

Structural Engineer Christian Aste

Project Management Georg Malojer

Services Engineers Technisches Büro Ing. Heinz Pürcher; Technisches Büro Matthias Schrempf; Peter Fiby

Ski Jump Technology Bauplanungsbüro Franz Fuchslueger

Lighting Consultant Office for Visual Interaction: Enrique Peiniger, Jean M. Sundin

Phæno Science Centre [116–21]

Wolfsburg, Germany, 2000–5

Client Neulandgesellschaft GmbH, on behalf of the City of Wolfsburg

Design Zaha Hadid with Christos Passas

Co-architect Mayer Bährle Freie Architekten BDA

Project Architect Christos Passas

Assistant Project Architect Sara Klomps

Project Team Sara Klomps, Gernot Finselbach, David Salazar, Helmut Kinzler

Competition Team Christos Passas, Janne Westermann, Chris Dopheide, Stanley Lau, Eddie Can, Yoash Oster, Jan Hübener, Caroline Voet

Special Contributor Patrik Schumacher

Contributors Silvia Forlati, Günter Barczik, Lida Charsouli, Marcus Liermann, Kenneth Bostock, Enrico Kleinke, Constanze Stinnes, Liam Young, Chris Dopheide, Barbara Kuit, Niki Neerpasch, Markus Dochantschi

Project Architects (Mayer Bährle) Rene Keuter, Tim Oldenburg

Project Team (Mayer Bährle) Sylvia Chiarappa, Stefan Hoppe, Andreas Gaiser, Roman Bockemühl, Annette Finke, Stefanie Lippardt, Marcus Liermann, Jens Hecht, Christoph Volckmar

Structural Engineers Adams Kara Taylor; Tokarz Frerichs Leipold

Services Engineers NEK; Büro Happold

Cost Consultant Hanscomb GmbH

Lighting Consultants Fahlke & Dettmer; Office for Visual Interaction

Area 27,000 m²

Meshworks [122]

Rome, Italy, 2000

Design Zaha Hadid

Design Team Simon Koumjian, Patrik Schumacher, Caroline Voet

Installation Team Justin Porcano, Alfredo Greco, Michael Osmen, Daniel Arbelaez, Peter Kohn

Serpentine Gallery Pavilion [123]

London, UK, 2000

Client Serpentine Gallery

Design Zaha Hadid

Project Architect Jim Heverin

Project Manager Eric Gabriel

Structural Engineer CETEC Consultants

Quantity Surveyor Howard Associates

Lighting Consultant Maurice Brill Lighting Design

Contractor Gap Sails + Structures

British Pavilion, Venice Biennale [123]

Venice, Italy, 2000

Design Zaha Hadid

Project Architect Woody Yao

Design Team Eddie Can, Jan Hübener, Gianluca Racana

Installation Team Chris Dopheide, Alessandra Calglia, Justin Porcano, Michael Osmen, Daniel Arbelaez

Kunsthaus Graz [124]

Graz, Austria, 2000

Design Zaha Hadid with Patrik Schumacher

Design Team Sonia Villaseca, Stanley Lau, Paola Cattarin, David Gerber, Eddie Can, Gianluca Racana, Yoash Oster, Janne Westermann

Structural Engineer Adams Kara Taylor: Hanif Kara

Façade Consultant Adams Kara Taylor: Hanif Kara

Cost Consultant Davis Langdon & Everest: Sam Mackenzie

La Grande Mosquée de Strasbourg [125]

Strasbourg, France, 2000

Design Zaha Hadid with Patrik Schumacher

Design Team Ali Mangera, David Gerber, David Salazar, Jorge Ortega, Caroline Voet, Eddie Can, Patrik Schumacher, Woody Yao,
Stéphane Hof, Hon Kong Chee, Steve Power, Edgar González, Garin O'Aivazian

Local Architect Albert Grandadam

Structural Engineer Adams Kara Taylor: Hanif Kara

Environmental Engineer Max Fordham Partnership: Henry Luker, Sam Archer

Acoustics Consultants Arup Acoustics; Peutz & Associés France

Lighting Consultant Office for Visual Interaction: Enrique Peiniger, Jean M. Sundin

Cost Consultant Davis Langdon & Everest: Guy Rezeau

Centro JVC Hotel [125]

Guadalajara, Mexico, 2000

Client Omnitrition de México

Design Zaha Hadid

Project Architect Jim Heverin

Project Team Helmut Kinzler, Edgar Gonzáles, Eddie Can, Jorge Ortega, Zulima Nieto, Jose Rojo

Structural Engineer Adams Kara Taylor

Building Services Büro Happold

Fire Consultant Arup Fire

Salerno Maritime Terminal [126–29]

Salerno, Italy, 2000–16

Client Comune di Salerno Palazzo di Città

Design Zaha Hadid with Patrik Schumacher

Project Architect Paola Cattarin

Design Team Vincenzo Barilari, Andrea Parenti, Anja Simons, Giovanna Sylos Labini, Cedric Libert, Filippo Innocenti

Competition Team Paola Cattarin, Sonia Villaseca, Christos Passas, Chris Dopheide

Design Consultants:

Local Executive Architect Interplan Seconda: Alessandro Gubitosi

Costing Building Consulting: Pasquale Miele

Structural Engineers Ingeco: Francesco Sylos Labini; Ove Arup & Partners (preliminary design); Sophie Le Bourva

M&E Engineers Macchiaroli & Partners: Roberto Macchiaroli; Itaca: Felice Marotta; Ove Arup & Partners (preliminary design)

Maritime/Transport Engineer Ove Arup & Partners (London, UK): Greg Heigh

Lighting Equation Lighting Design (London, UK): Mark Hensmann

Main Contractor Passarelli SpA

Site Supervision:

Director of Works Gaetano Di Maio

Architecture Paola Cattarin

Structure Giampiero Martuscelli

MEP Roberto Macchiaroli

Contract Administration Pasquale Miele

Health & Safety Alessandro Gubitosi

Area 4,500 m²

Zaha Hadid Lounge [130]

Wolfsburg, Germany, 2001

Design Zaha Hadid

Project Architects Woody Yao, Djordje Stojanovic

Albertina Extension [130]

Vienna, Austria, 2001

Design Zaha Hadid with Patrik Schumacher

Project Architect Lars Teichmann

Design Team Ken Bostock, Dillon Lin, Tiago Correia, Sandra Oppermann, Raza Zahid

Temporary Museum, Guggenheim Tokyo [131]

Tokyo, Japan, 2001

Client Guggenheim Foundation

Design Zaha Hadid

Project Architect Patrik Schumacher

Design Team Gianluca Racana, Ken Bostock, Vivek Shankar

Total Area 7,000 m²

One-North Masterplan [131]

Singapore, 2002

Design Zaha Hadid with Patrik Schumacher

Project Director Markus Dochantschi

Project Architects (Masterplan Phase) David Gerber, Dillon Lin, Silvia Forlati

Project Team (Masterplan Phase) David Mah, Gunther Koppelhuber, Rodrigo O'Malley, Kim Thornton, Markus Dochantschi

Project Architects (Rochester Detail Planning Phase) Gunther Koppelhuber

Project Team (Rochester Detail Planning Phase) Kim Thornton, Hon Kong Chee, Yael Brosilovski, Fernando Pérez Vera

Competition Team David Gerber, Edgar González, Chris Dopheide, David Salazar, Tiago Correia, Ken Bostock, Patrik Schumacher, Paola Cattarin, Dillon Lin, Barbara Kuit, Woody Yao

Models Riann Steenkamp, Chris Dopheide, Ellen Haywood, Helena Feldman

Presentation Models Delicatessen Design Ltd: Ademir Volic

Urban Strategy Lawrence Barth, Architectural Association

Infrastructural Engineer Ove Arup & Partners: Simon Hancock, Ian Carradice, David Johnston
Infrastructural Audits JTC Consultants Pte Ltd
Transport Engineer MVA: Paul Williams, Tim Booth
Landscape Architect Cicada Pte Ltd
Lighting Consultant Lighting Planners Associates: Kaoru Mende
Planning Tool Consultant B Consultants: Tom Barker, Graeme Jennings

BMW Plant Central Building [132–35]
Leipzig, Germany, 2001–5
Design Zaha Hadid with Patrik Schumacher
Project Architects Jim Heverin, Lars Teichmann
Project Team Matthias Frei, Jan Hübener, Annette Bresinsky, Manuela Gatto, Fabian Hecker, Cornelius Schlotthauer, Wolfgang Sunder, Anneka Wegener, Markus Planteu, Robert Neumayr, Christina Beaumont, Achim Gergen, Caroline Anderson
Competition Team Lars Teichmann, Eva Pfannes, Ken Bostock, Stéphane Hof, Djordje Stojanovic, Leyre Villoria, Liam Young, Christiane Fashek, Manuela Gatto, Tina Gregoric, Cesare Griffa, Yasha Jacob Grobman, Filippo Innocenti, Zetta Kotsioni, Debora Laub, Sarah Manning, Maurizio Meossi, Robert Sedlak, Niki Neerpasch, Eric Tong, Tiago Correia
Partner Architects IFB Dr Braschel AG; Anthony Hunt Associates
Structural Engineers IFB Dr Braschel AG; WPW Ingenieure GmbH
M&E Engineer IFB Dr Braschel AG
Cost Consultant IFB Dr Braschel AG
Lighting Design Equation Lighting Design
Landscape Architect Gross.Max

Ordrupgaard Museum Extension [136–39]
Copenhagen, Denmark, 2001–5
Design Zaha Hadid
Project Architect Ken Bostock
Design Team Caroline Krogh Andersen
Competition Team Patrik Schumacher, Ken Bostock, Adriano De Gioannis, Sara Noel Costa de Araujo, Lars Teichmann, Vivek Shankar, Cedric Libert, Tiago Correia
Model Riann Steenkamp
Associate Architect PLH Arkitekter
Structural Engineers Jane Wernick Associates; Birch & Krogboe
M&E Design Ove Arup & Partners; Birch & Krogboe
Lighting Consultant Arup Lighting
Acoustics Consultant Birch & Krogboe

Maggie's Centre Fife [140–41]
Kirkcaldy, UK, 2001–6
Client Maggie's Centre
Design Zaha Hadid
Project Architects Jim Heverin, Tiago Correia
Project Team Zaha Hadid, Jim Heverin, Tiago Correia
Structural Engineer Jane Wernick Associates
Services Engineer K.J. Tait Engineers
Underground Drainage SKM Anthony Hunts
Quantity Surveyor CBA Chartered Quantity Surveyors
Planning Supervisor Reiach & Hall Architects
Landscape Architect Gross.Max
Building Surveyor GLM Ltd
Total Area 250 m²

López de Heredia Pavilion [142–43]
Haro la Rioja, Spain, 2001–6
Client López de Heredia
Design Zaha Hadid
Project Architect Jim Heverin
Project Team Tiago Correia, Matthias Frei, Ana M. Cajiao
Partner Architect IOA Arquitectura: Joan Ramon Rius, Nuria Ayala, Xavier Medina, Candi Casadevall
Structural Engineer Jane Wernick Associates
M&E Engineer Ove Arup & Partners: Ann Dalzell

Monographic Exhibition [144]
Rome, Italy, 2002
Design Zaha Hadid with Patrik Schumacher
Project Architects Gianluca Racana, Woody Yao
Design Team Tiago Correia, Adriano De Gioannis, Barbara Pfenningstorff, Ana M. Cajiao, Maurizio Meossi, Manuela Gatto, Thomas Vietzke, Natalie Rosenberg, Ken Bostock, Barbara Kuit, Christos Passas, Sara Klomps
Local Architect ABT s.r.l.

Price Tower Arts Center [144]
Bartlesville, Oklahoma, USA, 2002
Design Zaha Hadid with Patrik Schumacher
Project Architect Markus Dochantschi
Project Team Matias Musacchio, Ana M. Cajiao, Jorge Seperizza, Mirco Becker, Tamar Jacobs, Viggo Haremst, Christian Ludwig, Ed Gaskin

City of Towers, Venice Biennale [145]
Venice, Italy, 2002
Client Alessi
Design Zaha Hadid with Patrik Schumacher
Design Team Thomas Vietzke, Natalie Rosenberg, Woody Yao

Pierres Vives [146–48]
Montpellier, France, 2002–12
Client Département de l'Hérault
Design Zaha Hadid
Project Architect Stéphane Hof
Project Team Joris Pauwels, Philipp Vogt, Rafael Portillo, Jaime Serra, Renata Dantas, Melissa Fukumoto, Jens Borstelmann, Kane Yanegawa, Loreto Flores, Edgar Payan, Lisamarie Villegas Ambia, Karouko Ogawa, Stella Nikolakaki, Hon Kong Chee, Caroline Andersen, Judith Reitz, Olivier Ottevaere, Achim Gergen, Daniel Baerlecken, Yosuke Hayano, Martin Henn, Rafael Schmidt, Daniel Gospodinov, Kia Larsdotter, Jasmina Malanovic, Ahmad Sukkar, Ghita Skalli, Elena Perez, Andrea B. Castè, Lisa Cholmondeley, Douglas Chew, Larissa Henke, Steven Hatzellis, Jesse Chima, Adriano De Gioannis, Simon Kim, Stéphane Carnuccini, Samer Chamoun, Ram Ahronov, Ross Langdon, Ivan Valdez, Yacira Blanco, Marta Rodriguez, Leonardo Garcia, Sevil Yazici, Hussam Chakouf, Marie-Perrine Placais, Monica Noguero, Naomi Fritz, Stephanie Chaltiel
Local Architect Blue Tango (design phase); Chabanne et Partenaires (execution phase)
Structure Ove Arup & Partners
Services Ove Arup & Partners (concept design); GEC Ingénierie
Acoustics Rouch Acoustique: Nicolas Albaric
Cost Consultant Gec-LR: Ivica Knezovic
Size 35,000 m²

Museum Brandhorst [149]
Munich, Germany, 2002
Design Zaha Hadid with Patrik Schumacher
Project Architect Barbara Pfenningstorff
Design Team Adriano De Gioannis, Cornelius Schlotthauer, Maurizio Meossi, Filippo Innocenti, Rocio Paz, Eric Tong, Ana M. Cajiao, Flavio La Gioia, Viggo Haremst, Manuela Gatto, Tamar Jacobs, Thomas Vietzke, Natalie Rosenberg, Christos Passas
Structural Engineer ASTE: Andreas Glatzl, Christian Aste
NME and General Lighting Max Fordham Partnership: Henry Luker
Exterior Lighting Office for Visual Interaction: Enrique Peiniger, Jean M. Sundin
Glass Façade RFR Ingénieurs: Jean-François Blassel

Zorrozaurre Masterplan [150–51]
Bilbao, Spain, 2003–
Client Management Committee for the Urban Development of the Peninsula of Zorrozaurre, Bilbao
Design Zaha Hadid with Patrik Schumacher
Project Architects Manuela Gatto, Fabian Hecker
Project Team Juan Ignacio Aranguren, Daniel Baerlecken, Yael Brosilovski, Helen Floate, Marc Fornes, James Gayed, Steven Hatzellis, Alvin Huang, Yang Jingwen, Gunther Koppelhuber, Graham Modlen, Brigitta Lenz, Susanne Lettau, Fernando Pérez Vera, Judith Reitz, Marta Rodriguez, Jonathan Smith, Marcela Spadaro, Kim Thornton, Zhi Wang
Local Architect Arkitektura Eta Hirigintza Bulegoa S.A.
Engineer Ove Arup & Partners
Landscape Architect Gross.Max
Total Area 60 hectares

BBC Music Centre [152]
London, UK, 2003
Client BBC
Design Zaha Hadid with Patrik Schumacher
Project Architects Steven Hatzellis, Graham Modlen, Ergian Alberg
Project Team Karim Muallem, Ram Ahronov, Adriano De Gioannis, Simon Kim, Yansong Ma, Rafael Schmidt, Markus Planteu
Structural Engineer Ove Arup & Partners: Bob Lang
Services Consultant Ove Arup & Partners: Nigel Tonks
Acoustics Consultant Arup Acoustics: Richard Cowell
Theatre Consultant Anne Minors Performance Consultants
Cost Consultant Davis Langdon & Everest: Sam Mackenzie

Desire [152]
Graz, Austria, 2003
Design Zaha Hadid with Patrik Schumacher
Project Architect Rocio Paz
Design Team Filippo Innocenti, Zetta Kotsioni, Alexander de Looz
Structural Engineer B Consultants

Guggenheim Museum Taichung [153]
Taichung, Taiwan, 2003
Design Zaha Hadid with Patrik Schumacher
Project Architect Dillon Lin
Design Team Jens Borstelmann, Thomas Vietzke, Yosuke Hayano
Production Team Adriano De Gioannis, Selim Mimita, Juan Ignacio Aranguren, Ken Bostock, Elena Perez, Ergian Alberg, Rocio Paz, Markus Planteu, Simon Kim

Structural Engineer Adams Kara Taylor: Hanif Kara, Andrew Murray, Sebastian Khourain, Reuben Brambleby, Stefano Strazzullo
Services Consultant IDOM Bilbao
Cost Consultant IDOM UK Ltd; IDOM Bilbao
Model Photography David Grandorge

The Snow Show [154]
Lapland, Finland, 2003–4
Design Zaha Hadid with Patrik Schumacher
Project Architects Rocio Paz, Woody Yao
Design Team Yael Brosilovski, Thomas Vietzke, Helmut Kinzler
Structural Engineer Adams Kara Taylor
Lighting Design Zumtobel Illuminazione s.r.l., with HFG-Karlsruhe Scenography class, Prof. M. Simon

NYC 2012 Olympic Village [154]
New York, New York, USA, 2004
Design Zaha Hadid with Patrik Schumacher
Project Manager StudioMDA: Markus Dochantschi
Project Architect Tiago Correia
Design Team Ana M. Cajiao, Daniel Baerlecken, Judith Reitz, Simon Kim, Dillon Lin, Yosuke Hayano, Ergian Alberg, Yael Brosilovski, Daniel Li, Yang Jingwen, Li Zou, Laura Aquili, Jens Borstelmann, Juan Ignacio Aranguren
Urban Strategy Lawrence Barth
Structural Engineer Ove Arup & Partners: Bob Lang
Infrastructural Engineer Ove Arup & Partners: Ian Carradice
Transport Engineer Ove Arup & Partners: David Johnston
Building Services Ove Arup & Partners: Andrew Sedgwick
Lift Consultant Ove Arup & Partners: Mike Summers, Warrick Gorrie
Mechanical Engineer Ove Arup & Partners: Emmanuelle Danisi
Fire Consultant Ove Arup & Partners: Barbara Lane, Tony Lovell
Security Consultant Arup Security Consulting: John Haddon, Simon Brimble
Façade Consultant Ove Arup & Partners: Edith Mueller
Materials Ove Arup & Partners: Clare Perkins
Lighting Design L'Observatoire International: Hervé Descottes
Landscape Architect Gross.Max: Eelco Hooftmann
Cost Consultant Davis Langdon Adamson: Nick Butcher, Ethan T. Burrows
Video Animation and 3D Visuals Neutral
Photography David Grandorge

Hotel Puerta America – Hoteles Silken [155]
Madrid, Spain, 2003–5
Client Grupo Urvasco
Design Zaha Hadid
Project Architect Woody Yao
Project Design Thomas Vietzke, Yael Brosilovski, Patrik Schumacher
Design Team Ken Bostock, Mirco Becker
Total Area 1,200 m²

Guangzhou Opera House [156–61]
Guangzhou, China, 2003–10
Client Guangzhou Municipal Government
Design Zaha Hadid
Project Directors Woody Yao, Patrik Schumacher

Project Leader Simon Yu
Project Team Jason Guo, Yang Jingwen, Long Jiang, Ta-Kang Hsu, Yi-Ching Liu, Zhi Wang, Christine Chow, Cyril Shing, Filippo Innocenti, Lourdes Sánchez, Hinki Kwong, Junkai Jian
Competition Team (1st Stage) Filippo Innocenti, Matias Musacchio, Jenny Huang, Hon Kong Chee, Markus Planteu, Paola Cattarin, Tamar Jacobs, Yael Brosilovski, Viggo Haremst, Christian Ludwig, Christina Beaumont, Lorenzo Grifantini, Flavio La Gioia, Nina Safainia, Fernando Pérez Vera, Martin Henn, Achim Gergen, Graham Modlen, Imran Mahmood
Competition Team (2nd Stage) Cyril Shing, YanSong Ma, Yosuke Hayano, Adriano De Gioannis, Barbara Pfenningstorff
Local Design Institute Guangzhou Pearl River Foreign Investment Architectural Designing Institute
Structural Engineers SHTK; Guangzhou Pearl River Foreign Investment Architectural Designing Institute
Façade Engineers KGE Engineering
Building Services Guangzhou Pearl River Foreign Investment Architectural Designing Institute
Acoustics Consultant Marshall Day Acoustics
Theatre Consultant ENFI
Lighting Design Consultant Beijing Light & View
Project Management Guangzhou Municipal Construction Group Co Ltd
Construction Management Guangzhou Construction Engineering Supervision Co Ltd
Structure, Services and Acoustics (Competition Stage) Ove Arup & Partners
Cost Consultant Guangzhou Jiancheng Engineering Costing Consultant Office Ltd
Principal Contractor China Construction Third Engineering Bureau Co Ltd
Area 70,000 m²

High-Speed Train Station Napoli-Afragola [162–63]
Naples, Italy, 2003–17
Client TAV s.p.a.
Design Zaha Hadid with Patrik Schumacher
Project Director Filippo Innocenti
Project Architects Paola Cattarin, Roberto Vangeli
Design Team Michele Salvi, Federico Bistolfi, Cesare Griffa, Paolo Zilli, Mario Mattia, Tobias Hegemann, Chiara Baccarini, Alessandra Bellia, Serena Pietrantonj, Roberto Cavallaro, Karim Muallem, Luciano Letteriello, Domenico Di Francesco, Marco Guardincerri, Davide Del Giudice
Competition Team Fernando Pérez Vera, Ergian Alberg, Hon Kong Chee, Cesare Griffa, Karim Muallem, Steven Hatzellis, Thomas Vietzke, Jens Borstelmann, Robert Neumayr, Elena Perez, Adriano De Gioannis, Simon Kim, Selim Mimita
Structural and Geotechnical Engineers Adams Kara Taylor: Hanif Kara, Paul Scott; Interprogetti: Giampiero Martuscelli
Environmental Engineers Max Fordham Partnership: Henry Luker, Neil Smith; Studio Reale: Francesco Reale, Vittorio Criscuolo Gaito
Cost Consultant Building Consulting: Pasquale Miele
Fire Safety Macchiaroli & Partners: Roberto Macchiaroli
Transport Engineer JMP: Max Matteis
Landscape Architect Gross.Max: Eelco Hooftman
Acoustics Consultant Paul Gillieron Acoustic
Building Regulation, Coordination Local Team Interplan Seconda: Alessandro Gubitosi
General Contractor Ati Astaldi
Total Area 20,000 m²

California Residence [164]
San Diego, California, USA, 2003–
Design Zaha Hadid with Patrik Schumacher
Associate Kenneth Bostock
Project Architects Claudia Wulf, Elke Presser
Design Team (previous proposals) Christos Passas, Barbara Pfenningsdorf, Daniel Fiser, Tyen Masten, Marcela Spadaro, Theodora Ntatsopouloui
Civil Engineering/Planning Florez Engineering, Inc
Contractor Wardell Builders
Construction Morley
Electrical Design Nutter
Estimator Gilbane Building Company
Façade Consultant Front, Inc
Lighting Office for Visual Interaction
Local Architect Public | Architecture + Planning
Soils Consultant Geocon, Inc
Structural and Systems Engineers Nabih Youssef Associates
Sustainable Design Consultant KEMA Services, Inc
Vertical Landscape Consultant Patrick le Blanc
Site Area 20,000 m²
Floor Area 11,000 m²

Eleftheria Square Redesign [165]
Nicosia, Cyprus, 2005–17
Client The City of Nicosia
Design Zaha Hadid with Patrik Schumacher
Project Architect Christos Passas
Project Team Dimitris Akritopoulos, Anna Papachristoforou, Thomas Frings, Irene Guerra, Jesus Garate, Ivan Ucros, Javier Ernesto-Lebie, Vincent Nowak, Mathew Richardson, Giorgos Mailis, Sevil Yazici, Ta-Kang Hsu, Sylvia Georgiadou, Phivos Scroumbelos, Marilena Sophocleous
Competition Project Architects Christos Passas, Saffet Kaya Bekiroglu
Competition Team Inanc Eray, Viviana Muscettola, Michelle Pasca, Daniel Fiser
Structural Engineer Hyperstatic Engineering
M&E/Services Unemec
Lighting Consultant Kardorff Ingenieure
Project Management Modinos & Vrahimis
Cost Consultant MDA Consulting Ltd
Open Area 35,300 m²
Interior Area 7,175 m²

Nordpark Cable Railway [166–69]
Innsbruck, Austria, 2004–7
Client Innsbrucker Nordkettenbahnen GmbH
Design Zaha Hadid with Patrik Schumacher
Project Architect Thomas Vietzke
Design Team Jens Borstelmann, Markus Planteu
Production Team Caroline Krogh Andersen, Makakrai Suthadarat, Marcela Spadaro, Anneka Wegener, Adriano De Gioannis, Peter Pichler, Susann Berggren
Local Partner Office/Building Management Malojer Baumanagement
Structural Engineer Bollinger Grohmann Schneider Ziviltechniker
Façade Planning Pagitz Metalltechnik GmbH
Contractor Strabag AG
Engines and Cables Contractor Leitner GmbH
Planning Advisors ILF Beratende Ingenieure ZT GmbH; Malojer Baumanagement
Concrete Base Baumann + Obholzer ZT
Bridge Engineer ILF Beratende Ingenieure ZT GmbH
Lighting Zumtobel Illuminazione s.r.l.

Riverside Museum [170–71]

Glasgow, UK, 2004–11

Client Glasgow City Council
Design Zaha Hadid Architects
Project Director Jim Heverin
Project Architect Johannes Hoffman
Project Team Achim Gergen, Agnes Koltay, Alasdair Graham, Andreas Helgesson, Andy Summers, Aris Giorgiadis, Brandon Buck, Christina Beaumont, Chun Chiu, Daniel Baerlecken, Des Fagan, Electra Mikelides, Elke Presser, Gemma Douglas, Hinki Kwong, Jieun Lee, Johannes Hoffmann, Laymon Thaung, Lole Mate, Malca Mizrahi, Markus Planteu, Matthias Frei, Mikel Bennett, Ming Cheong, Naomi Fritz, Rebecca Haines-Gadd, Thomas Hale, Tyen Masten
Competition Team Malca Mizrahi, Michele Pasca di Magliano, Viviana R. Muscettola, Mariana Ibanez, Larissa Henke
Services Büro Happold
Acoustics Büro Happold
Fire Safety FEDRA
Cost Consultants Capita Symonds
Project Management Capita Symonds
Area 11,300 m²

City Life Milano [172–75]

Milan, Italy, 2004–17

Client City Life Consortium
Design Zaha Hadid with Patrik Schumacher
Project Director Gianluca Racana
Residential Complex:
Project Architect Maurizio Meossi
Design Team Vincenzo Barilari, Cristina Capanna, Giacomo Sanna, Paola Bettinsoli, Gianluca Bilotta, Fabio Ceci, Veronica Erspamer, Arianna Francioni, Stefano Iacopini, Mario Mattia, Serena Pietrantonj, Florindo Ricciuti, Giulia Scaglietta, Giovanna Sylos Labini, Anja Simons, Marta Suarez, Tamara Tancorre, Giuseppe Vultaggio, Massimiliano Piccinini, Samuele Sordi, Alessandra Belia
Site Supervision Team Cristina Capanna, Veronica Erspamer, Stefano Iacopini, Giulia Scaglietta, Florindo Ricciuti
Competition Team Simon Kim, Yael Brosilovski, Adriano De Gioannis, Graham Modlen, Karim Muallem, Daniel Li, Yang Jingwen, Tiago Correia, Ana Cajiao, Daniel Baerlecken, Judith Reitz
Structural Consultant MSC Associati
M&E Consultant Hilson Moran Italia
Fire Safety Ing. Silvestre Mistretta
Project Specifications Building Consulting
General Contractor City Contractor srl
Electrical Consultant (Construction) Impes
Mechanical Engineering Consultant (Construction) Panzeri
Façade Planning Permasteelisa Group
Size 7 buildings from 5–13 storeys; 38,000 m² gross surface, 230 units; 2-storey undergound car park 50,000 m²
Generali Tower/Retail Space:
Project Architect Paolo Zilli
Design Team Andrea Balducci Caste, H. Goswin Rothenthal, Gianluca Barone, Carles S. Martinez, Arianna Russo, Giuseppe Morando, Pierandrea Angius, Vincenzo Barilari, Stefano Paiocchi, Sara Criscenti, Alexandra Fisher, Agata Banaszek, Marco Amoroso, Alvin Triestanto, Letizia Simoni, Subharthi Guha, Marina Martinez, Luis Miguel Samanez, Santiago F. Achury, Massimo Napoleoni, Massimiliano Piccinini, Annarita

Papeschi, Martha Read, Peter McCarthy, Line Rahbek, Mario Mattia, Matteo Pierotti, Shahd Abdelmoneim
Site Supervision Team Andrea Balducci Caste, Pierandrea Angius, Vincenzo Barilari
Competition Team Simon Kim, Yael Brosilovski, Adriano De Gioannis, Graham Modlen, Karim Muallem, Daniel Li, Yang Jingwen, Tiago Correia, Ana Cajiao, Daniel Baerlecken, Judith Reitz
Management J&A/Ramboll
Structural Engineer AKT; Redesco (tower); Holzner&Bertagnolli + Cap (basement)
M&E Max Fordham + Manens-TIFS
Project Specifications Building Consulting
Façade Planning Arup
Lifts Jappsen
Fire Safety Mistretta
Height 170m; 44 storeys
Total Gross Floor Area 122,700 m²: office 67,000 m²; retail 15,000 m²; parking, storage & plantrooms 40,700 m²

Zaragoza Bridge Pavilion [176–79]

Zaragoza, Spain, 2005–8

Client Expoagua Zaragoza 2008
Design Zaha Hadid with Patrik Schumacher
Project Architect Manuela Gatto
Project Team Fabian Hecker, Matthias Baer, Soohyun Chang, Feng Chen, Atrey Chhaya, Ignacio Choliz, Federico Dunkelberg, Dipal Kothari, Maria José Mendoza, José M. Monfa, Marta Rodriguez, Diego Rosales, Guillermo Ruiz, Lucio Santos, Hala Sheikh, Marcela Spadaro, Anat Stern, Jay Suthadarat
Competition Team Feng Chen, Atrey Chhaya, Dipal Kothari
Engineering Consultant Ove Arup & Partners
Cost Consultant Ove Arup & Partners; IDOM
Size 270m (length); 185m from island to right bank, plus 85m from island to Expo riverbank

London Aquatics Centre [180–85]

London, UK, 2005–11

Client Olympic Delivery Authority
Design Zaha Hadid Architects
Project Director Jim Heverin
Project Architects Glenn Moorley, Sara Klomps
Project Team Alex Bilton, Alex Marcoulides, Barbara Bochnak, Carlos Garijo, Clay Shorthall, Ertu Erbay, George King, Giorgia Cannici, Hannes Schafelner, Hee Seung Lee, Kasia Townend, Nannette Jackowski, Nicholas Gdalewitch, Seth Handley, Thomas Soo, Tom Locke, Torsten Broeder, Tristan Job, Yamac Korfali, Yeena Yoon
Project Team (Competition) Saffet Kaya Bekiroglu (project architect), Agnes Koltay, Feng Chen, Gemma Douglas, Kakakrai Suthadarat, Karim Muallem, Marco Vanucci, Mariana Ibanez, Sujit Nair
Sports Architects S&P Architects
Structural Engineer Ove Arup & Partners
Services Ove Arup & Partners
Fire Safety Arup Fire
Acoustics Arup Acoustics
Façade Engineers Robert-Jan Van Santen Associates
Lighting Design Arup Lighting
Kitchen Design Winton Nightingale
Maintenance Access Reef
Temporary Construction Edwin Shirley Staging
Security Consultant Arup Security
AV & IT Consultants Mark Johnson Consultants
Access Consultants Access=Design

CDM Coordinator Total CDM Solutions
BREEAM Consultant Southfacing
Quantity Surveyor & Project Manager CLM
Main Contractor Balfour Beatty
Timber Sub-Contractor Finnforest Merk GmbH
Concrete Sub-Contractor Morrisroe
Site Area 36,875 m²
Total Floor Area:
Legacy Basement 3,725 m²; ground floor 15,137 m²; first floor 10,168 m²
Olympic Basement 3,725 m²; ground floor 15,402 m²; first floor 16,387 m²; seating area 7,352 m²
Footprint Area 15,950 m² (legacy); 21,897 m² (Olympic)

Capital Hill Residence [186–87]

Moscow, Russia, 2006–

Design Zaha Hadid with Patrik Schumacher
Project Architect Helmut Kinzler
Project Designer Daniel Fiser
Design Team Anat Stern, Thomas Sonder, Muthahar Khan, Kristina Simkeviciute, Talenia Phua Gajardo, Mariana Ibanez, Marco Vanucci, Lourdes Sánchez, Ebru Simsek, Daniel Santos
Initial Design Stage Leader Tetsuya Yamazaki
Project Manager Capital Group: Natalia Savich
Local Architect Mar Mimarlik Ltd
Structural Engineer ENKA Engineering
M&E Engineer ENKA Engineering
Electrical Engineer HB Electric
Façade Engineer Group 5F
AV Sound Ideas UK Ltd
BMS/Security Siemens
Lighting Design Light Tecnica
Interior Design Candy & Candy Ltd
Pool Design Rainbow Pools Ltd
Landscape Panorama Landscape Design
Water Feature Design Invent Water Features Ltd
General Contractor ENKA Construction & Industry Co, Inc
Façade Consultant Wagner Group

CMA CGM Headquarters Tower [188–89]

Marseille, France, 2006–11

Client CMA CGM
Design Zaha Hadid with Patrik Schumacher
Project Director Jim Heverin
Project Architect Stéphane Vallotton
Project Team Karim Muallem, Simone Contasta, Leonie Heinrich, Alvin Triestanto, Muriel Boselli, Eugene Leung, Bhushan Mantri, Jerome Michel, Nerea Feliz, Prashanth Sridharan, Birgit Eistert, Evelyn Gono, Marian Ripoll, Andres Flores, Pedja Pantovic
Competition Team Jim Heverin, Simon Kim, Michele Pasca di Magliano, Viviana R. Muscettola
Local Architect SRA; RTA
Local Engineers Coplan (Provence)
Structural Engineer Ove Arup & Partners
Services Ove Arup & Partners
Façade Engineers Ove Arup & Partners; Robert-Jan Van Santen Associates
Cost Consultant R2M
Engineers Ove Arup & Partners
Façade Consultant Robert-Jan Van Santen Associates
Acoustician Albarique Rouche
Structural Contractor GTM Sud
Façade Contractor Epitekh
Lift Contractor Schindler
Paint Contractor SLVR

Floor finishes Unimarbres; Mattout
Waterproofiing SMAC
Mechanical G+S
Electrical Cegelec Sud-Est; Santerne
Ironmongery Chiri
Wall finishes Menuiserie Lazer (glass); MBA/Staff Parisien (plaster)
Doors Mayvaert/Portafeu
Area 94,000 m²

Deutsche Guggenheim [190]
Berlin, Germany, 2005
Client Deutsche Bank
Design Zaha Hadid with Patrik Schumacher
Lead Designer Helmut Kinzler
Design Team Tetsuya Yamazaki, Yael Brosilovski, Saleem Abdel-Jalil, Joris Pauwels, Manuela Gatto, Fabian Hecker, Gernot Finselbach, Judith Reitz, Daniel Baerlecken, Setsuko Nakamura

Urban Nebula [190]
London, UK, 2007
Client London Design Festival 2007
Design Zaha Hadid with Patrik Schumacher
Project Team Charles Walker, Daniel Dendra
Structural Engineer Adams Kara Taylor
Manufacturer Aggregate Industries
Size 240cm × 1,130cm × 460cm

Lilas [191]
London, UK, 2007
Client Serpentine Gallery
Design Zaha Hadid with Patrik Schumacher
Project Architect Kevin McClellan
Structural Engineer Ove Arup & Partners
Steel Fabrication Sheetfabs Ltd
Membrane Fabrication Base Structures Ltd
Lighting Design Zumtobel Illuminazione s.r.l.
Furniture Estabished & Sons, Kenny Schachter, Sawaya & Moroni, Serralunga, Max Protetch, Swarovski
Total Area 310 m²; 5.5m (height) × 22.5m (width) × 22.5m (length)

Investcorp Building [192–93]
Oxford, UK, 2006–15
Client Middle East Centre, St Antony's College
Design Zaha Hadid
Project Director Jim Heverin
Project Associate Johannes Hoffmann, Ken Bostock
Project Architect Alex Bilton
Project Team Sara Klomps, Goswin Rothenthal, Andy Summers, George King, Luke Bowler, Barbara Bochnak, Yeena Yoon, Saleem A. Jalil, Theodora Ntatsopoulou, Mireira Sala Font, Amita Kulkarni
Structural Engineer AKTII
Mechanical/Electrical/Acoustic Engineer Max Fordham
Client's M&E Consultant Elementa
Façade Supplier Frener + Reifer
Façade Consultant Arup Façade Engineering
Client's Façade Consultant Eckersley O'Callaghan
Contractor BAM
Project Manager Bidwells
Lighting Design Arup Lighting
Cost Consultant Sense Cost Ltd
Fire Engineer Arup Fire

Planning Supervision JPPC Oxford
Forestry and Arboriculture Consultant Sarah Venner
Access David Bonnet
Landscape Design Gross.Max
CDM Andrew Goddard Associates
Visualization Cityscape
Overall Site Area 1,580 m²
Gross Internal Area 1,127 m²
Building Footprint 700 m²

Kartal-Pendik Masterplan [194–95]
Istanbul, Turkey, 2006–
Client Greater Istanbul Municipality and Kartal Urban Regeneration Association
Design Zaha Hadid with Patrik Schumacher
Overall Project Architect Bozana Komljenovic
Stage 2 Project Team Amit Gupta, Marie-Perrine Placais, Susanne Lettau, Elif Erdine, Jimena Araiza
Stage 1 Project Leaders Bozana Komljenovic, DaeWha Kang
Stage 1 Project Team Sevil Yazici, Vigneswaran Ramaraju, Brian Dale, Jordan Darnell, Oznur Erboga
Competition Leaders DaeWha Kang, Saffet Kaya Bekiroglu
Competition Team Sevil Yazici, Daniel Widrig, Elif Erdine, Melike Altinisik, Ceyhun Baskin, Inanc Eray, Fulvio Wirz, Gonzalo Carbajo
Total Area 5.5 million m² (555 hectares)

Dubai Opera House [196–97]
Dubai, UAE, 2006
Design Zaha Hadid with Patrik Schumacher
Project Director Charles Walker
Project Architect Nils-Peter Fischer
Project Team Melike Altinisik, Alexia Anastasopoulou, Dylan Baker-Rice, Domen Bergoc, Shajay Bhooshan, Monika Bilska, Alex Bilton, Elizabeth Bishop, Torsten Broeder, Cristiano Ceccato, Alessio Constantino, Mario Coppola, Brian Dale, Ana Valeria Emiliano, Elif Erdine, Camilla Galli, Brandon Gehrke, Aris Giorgiadis, Pia Habekost, Michael Hill, Shao-Wei Huang, Chikara Inamura, Alexander Janowsky, DaeWha Kang, Tariq Khayyat, Maren Klasing, Britta Knobel, Martin Krcha, Effie Kuan, Mariagrazia Lanza, Tyen Masten, Jwalant Mahadevwala, Rashiq Muhamadali, Mónica Noguero, Diogo Brito Pereira, Rafael Portillo, Michael Powers, Rolando Rodriguez-Leal, Federico Rossi, Mireia Sala Font, Elke Scheier, Rooshad Shroff, William Tan, Michal Treder, Daniel Widrig, Fulvio Wirz, Susu Xu, Ting Ting Zhang
Project Director (Competition) Graham Modlen
Project Architect (Competition) Dillon Lin
Competition Team Christine Chow, Daniel Dendra, Yi-Ching Liu, Simone Fuchs, Larissa Henke, Tyen Masten, Lourdes Sánchez, Johannes Schafelner, Swati Sharma, Hooman Talebi, Komal Talreja, Claudia Wulf, Simon Yu
Engineering Consultant Ove Arup & Partners: Steve Roberts
Acoustics Consultant Arup Acoustics: Neill Woodger
Theatre Consultant Anne Minors Performance Consultants
Lighting Consultant Office for Visual Interaction

Evelyn Grace Academy [198–99]
Brixton, London, UK, 2006–10
Client School trust: ARK Education Government: DCSF
Design Zaha Hadid with Patrik Schumacher
Project Director Lars Teichmann
Project Architect Matthew Hardcastle

Project Team Lars Teichmann, Matthew Hardcastle, Bidisha Sinha, Henning Hansen, Lisamarie Villegas Ambia, Enrico Kleinke, Judith Wahle, Christine Chow, Guy Taylor, Patrick Bedarf, Sang Hilliges, Hoda Nobakhti
Project Manager Capita Symonds
Engineers Arup
Quantity Surveyors Davis Langdon
Landscape Gross.Max
Acoustic Consultants Sandy Brown Associates
Fire Engineer SAFE
CDM Co-ordinator Arup
Size 10,745 m²

Dongdaemun Design Plaza [200–5]
Seoul, South Korea, 2007–14
Design Zaha Hadid with Patrik Schumacher
Project Leader Eddie Can Chiu-Fai
Project Manager Craig Kiner, Charles Walker
Project Team Kaloyan Erevinov, Martin Self, Hooman Talebi, Carlos S. Martinez, Camiel Weijenberg, Florian Goscheff, Maaike Hawinkels, Aditya Chandra, Andy Chang, Arianna Russo, Ayat Fadaifard, Josias Hamid, Shuojiong Zhang, Natalie Koerner, Jae Yoon Lee, Federico Rossi, John Klein, Chikara Inamura, Alan Lu
Competition Team Kaloyan Erevinov, Paloma Gormley, Hee Seung Lee, Kelly Lee, Andres Madrid, Deniz Manisali, Kevin McClellan, Claus Voigtmann, Maurits Fennis
Structural Engineer ARUP
MEPF Services Engineer ARUP
Lighting Consultant ARUP
Acoustics Consultant ARUP
Landscape Architect Gross.Max
Façade Consultant Group 5F
Geometry Consultant Evolute
Quantity Surveyor Davis Langdon & Everest
Local Architects Samoo Architects
Local Consultants Structure Postech
Mechanical Samoo Mechanical Consulting (SMC)
Electrical and Telecom Samoo TEC
Façade M&C
Civil Saegil Engineering & Consulting
Landscape Dong Sim Won
Fire Korean Fire Protection

Regium Waterfront [206]
Reggio, Italy, 2007–
Design Zaha Hadid with Patrik Schumacher
Project Architect Filippo Innocenti
Design Team Michele Salvi, Roberto Vangeli, Andrea Balducci Caste, Luciano Letteriello, Fabio Forconi, Giuseppe Morando, Johannes Weikert, Deepti Zachariah, Gonzalo Carbajo
Structural Engineer Adams Kara Taylor: Hanif Kara
M&E Engineer Max Fordham Partnership: Neil Smith
Cost Surveyor Building Consulting: Alba De Pascale, Edoardo Lima
Maritime Structures Studio Prima: Pietro Chiavaccini, Maurizio Verzoni

582–606 Collins Street [207]
Melbourne, Australia, 2015–
Client Landream, Australia
Design Zaha Hadid with Patrik Schumacher
Director Gianluca Racana
Project Director Michele Pasca di Magliano
Project Architect Juan Camilo Mogollon

Project Team Johannes Elias, Hee Seung Lee, Cristina Capanna, Sam Mcheileh, Luca Ruggeri, Nhan Vo, Michael Rogers, Gaganjit Singh, Julia Hyoun Hee Na, Massimo Napoleoni, Ashwanth Govindaraji, Maria Tsironi, Kostantinos Psomas, Marius Cernica, Veronica Erspamer, Cyril Manyara, Megan Burke, Ahmed Hassan, Effie Kuan
Local Architect PLUS Architecture
Structural Engineering Robert Bird Group
Building Services Engineering and Sustainability ADP Consulting
Planning Consultant URBIS
Quantity Surveyor WT Partnership
Façade Consultant AURECON
Landscape Designer OCULUS
Wind Engineering MEL Consultants
Traffic Engineer RATIO
Building Surveyor PLP
Fire Engineer OMNII
Waste Management Leigh Design
Pedestrian Modelling ARUP
Acoustics Acoustic Logic
Land Surveyor Bosco Jonson
Visualizations VA
Gross Floor Area 70,075 m²

Messner Mountain Museum Corones [208–9]
South Tyrol, Italy, 2013–15
Client Skirama Kronplatz/Plan de Corones
Design Zaha Hadid with Patrik Schumacher
Project Architect Cornelius Schlotthauer
Design Team Cornelius Schlotthauer, Peter Irmscher
Execution Team Peter Irmscher, Markus Planteu, Claudia Wulf
Structural Engineer IPM
Mechanical Engineer & Fire Protection Jud & Partner
Electrical Engineer Studio GM
Lighting Design Zumtobel
Principal Contractors Kargruber und Stoll (concrete); Pichler Stahlbau (façade); B&T Bau & Technologie (façade panels)
Gross Floor Area 1,000 m²
Elevation 2,275m

D'Leedon [210]
Singapore, 2007–14
Client CapitaLand-led consortium
Design Zaha Hadid with Patrik Schumacher
Project Directors Michele Pasca di Magliano, Vivivana Muscettola
Project Team Ludovico Lombardi, Clara Martins, Loreto Flores, Stephan Bohne, Amita Kulkarni, Soomeen Hahm, Yung-Chieh Huang Kanop Mangklapruk, Marina Martinez, Andres Moroni, Juan Camilo Mogollon, Michael Rissbacher, Luca Ruggeri, Luis Miguel Samanez, Nupur Shah, Puja Shah, Muhammed Shameel, Shankara Subramaniam, Manya Uppal, Katrina Wong, Paolo Zilli, Andrea Balducci Caste, Kutbuddin Nadiadi, Effie Kuan, Helen Lee, Hee Seung Lee, Annarita Papeschi, Feng Lin, Bianca Cheung, Dominiki Dadatsi, Kelly Lee, Jeonghoon Lee, Hoda Nobakhti, Judith Wahle, Zhong Tian, Akhil Laddha, Naomi Chen, Jee Seon Lim, Line Rahbek, Hala Sheikh, Carlos S. Martinez, Arianna Russo, Peter McCarthy, Sevil Yazici, Sandra Riess, Federico Rossi, Eleni Pavlidou, Federico Dunkelberg, Evan Erlebacher, Gorka Blas, Bozana Komljenovic, Sophie Le Bienvenu, Jose M. Monfa, Selahattin Tuysuz, Edward Calver
Concept Team Michele Pasca di Magliano, Viviana

Muscettola, Ta-Kang Hsu, Emily Chang, Helen Lee, Kelly Lee
Local Architect RSP
Structural Engineering AECOM
M&E Engineering (Concept) Max Fordham & Partners
M&E Engineering BECA
Quantity Surveyor Gardiner & Theobald, London
Landscape Architect Gross.Max (concept); ICN
Lighting Design LPA
Acoustics Engineering Acviron
Total Floor Area 204,387 m² (over 7 towers); 150m (height)

King Abdullah Financial District Metro Station [211]
Riyadh, Saudi Arabia, 2012–
Client Arriyadh Development Authority
Design Zaha Hadid with Patrik Schumacher
Project Principal Gianluca Racana
Project Director Filippo Innocenti
Project Associate Fulvio Wirz
Project Architect Gian Luca Barone
Project Team Abdel Halim Chehab, Alexandros Kallegias, Alexandre Kuroda, Arian Hakimi Nejad, Carine Posner, David Wolthers, Domenico Di Francesco, Izis Salvador Pinto, Jamie Mann, Manuele Gaioni, Marco Amoroso, Mario Mattia, Massimo Napoleoni, Mohammadali Mirzaei, Niki Okala, Nima Shoja, Roberto Vangeli, Sohith Perera, Stefano Iacopini
Competition Team Alexandre Kuroda, Fei Wang, Lisa Kinnerud, Jorge Mendez-Caceres
Structural Engineer Buro Happold
Services Buro Happold
Transport and Civil Engineering Buro Happold
Fire Engineering Buro Happold
Façade Consultant NewTecnic
Cost Consultant AECOM
Total Area 20,434 m²

Mobile Art Pavilion for Chanel [212–15]
Hong Kong, Tokyo, New York, Paris, 2007–8
Client Chanel
Design Zaha Hadid with Patrik Schumacher
Project Architects Thomas Vietzke, Jens Borstelmann
Project Team Helen Lee, Claudia Wulf, Erhan Patat, Tetsuya Yamazaki, Daniel Fiser
Structural Engineer Ove Arup & Partners
Cost Consultant Davis Langdon & Everest
Main Contractor/Tour Operator ESS Staging
FRP Manufacturing Stage One Creative Services Ltd
Materials Façade cladding: fibre-reinforced plastic; roof: PVC; ETFE roof lights; secondary structure: aluminium extrusions; primary structure: 74 tons of steel (pavilion: 69 tons; ticket office: 5 tons); 1,752 different steel connections
Total Area 700 m²

Heydar Aliyev Centre [216–17]
Baku, Azerbaijan, 2007–12
Client The Republic of Azerbaijan
Design Zaha Hadid and Patrik Schumacher with Saffet Kaya Bekiroglu
Project Architect Saffet Kaya Bekiroglu
Project Team Sara Sheikh Akbari, Shiqi Li, Phil Soo Kim, Marc Boles, Yelda Gin, Liat Muller, Deniz Manisali, Lillie Liu, Jose Lemos, Simone Fuchs, Jose Ramon Tramoyeres, Yu Du, Tahmina Parvin, Erhan Patat, Fadi Mansour, Jaime Bartolomé, Josef Glas, Michael Grau, Deepti Zachariah, Ceyhun Baskin, Daniel Widrig, with special thanks to Charles Walker
Site Area 111,292 m²

Auditorium Capacity 1,000
Unique Glassfibre Reinforced Polyester Panels 13,000 (40,000 m²)
Glassfibre Reinforced Concrete Panels 3,150 (10,000 m²) GRC panels
Glassfibre Reinforced Polyester Panel Production Max 70 unique panels per day
Museum Space Frame 12,569 members / 3,266 nodes
Auditorium Space Frame 17,269 members / 4,513 nodes
Total Surface Space Frame Area Approx. 33,000 m²
Internal Skin Fixing Plates 70,000
Surface Area of Inner Skin Over 22,000 m²
Metal Deck Roof Purlins at Tender Stage 3,607 – total length 10,092m
Metal Roof Deck Trays at Tender Stage 3,936 – total area 26,853 m²
Roof Area 39,000 m²
Main Contractor and Architect of Record DiA Holding
Structural Engineer Tuncel Engineering AKT
Mechanical Engineer GMD Project
Electrical Consultant HB Engineering
Façade Consultant Werner Sobek
Fire Etik Fire Consultancy
Acoustics Mezzo Stüdyo
Geotechnical Engineer Enar Engineering
Infrastructure Sigal
Lighting MBLD

'Opus' Tower [218–19]
Dubai, UAE, 2007–
Client Omniyat Properties
Design Zaha Hadid with Patrik Schumacher
Project Director Christos Passas
Competition Team Christos Passas (Project Architect), Daniel Baerlecken, Gemma Douglas, Alvin Huang, Paul Peyrer-Heimstaett, Saleem Al-Jalil
Base Built Design Team Vincent Nowak (Project Architect/ Development Phase), Dimitris Akritopoulos, Chiara Ferrari, Thomas Frings, Jesus Garate, Sylvia Georgiadou, Javier Ernesto-Lebie, Wenyuan Peng, Paul Peyrer-Heimstaett, Phivos Skroumbelos, Marilena Sophocleous
Supervision Team Fabian Hecker (Project Associate), Barbara Bochnak (Lead Architect), Dimitris Kolonis (Senior Architect), Tomasz Starczewski, Kwanphil Cho, Bruno Pereira
Hotel Interior Design Team Reza Esmaeeli (Project Architect), Eider Fernandez Eibar (Design Coordination), Laura Micalizzi (Senior Interior Designer), Emily Rohrer (Senior Interior Designer), Stella Nikolakaki, Alexandra Fischer, Raul Forsoni, Chrysi Fradellou, Sofia Papageorgiou, Christos Sazos, Kwanphil Cho, Andri Shalou, Eleni Mente (Senior Landscape Designer)
Luxury Apartments Design Team Spyridon Kaprinis (Project Architect), Thomas Frings, Chrysi Fradellou, Sofia Papageorgiou, Carlos Luna
Consultants (Design Stage):
Project Management Gleeds (London)
Local Architects Arex Consultants (Dubai)
Structural Engineer Whitbybird (London)
Fire Engineering Safe (London)
Lift Consultants Roger Preston Dynamics (London)
Traffic Consultants Cansult Limited (Dubai)
Contractors Nasa / Multiplex (main contractor), Permasteelisa (façade contractor)
Consultants (Construction Stage):
Local Architects BSBG (Dubai)
Structural Engineer BG&E (Dubai)

Fire Engineering Design Confidence (Dubai)
Façade Consultants Koltay Facades (Dubai)
Lighting Consultants DPA (Dubai/UK)
Acoustic Consultants PMK (Dubai)
Interior Consultants HBA (Dubai)
Traffic Consultants Al Tourath (Dubai)
Lift Consultants Lerch Bates (Dubai)
Security Consultants Control Risks (Dubai)
Kitchen Consultants MCTS (Dubai)
Quantity Surveying Consultants HQS (Dubai)
AV Consultants EntireTech (Dubai)
Contractors Brookfield Multiplex (main contractor), Alu Nasa
(façade contractor)

Jockey Club Innovation Tower [220–23]
Hong Kong, 2007–14
Client Hong Kong Polytechnic University
Design Zaha Hadid with Patrik Schumacher
Project Director Woody Yao
Project Leader Simon K. M. Yu
Project Team Hinki Kong, Jinqi Huang, Bianca Cheung,
Charles Kwan, Juan Liu, Junkai Jian, Zhenjiang Guo, Uli
Blum, Long Jiang, Yang Jingwen, Bessie Tam, Koren Sin,
Xu Hui, Tian Zhong
Competition Team Hinki Kwong, Melodie Leung, Long
Jiang, Zhenjiang Guo, Yang Jingwen, Miron Mutyaba, Pavlos
Xanthopoulus, Margarita Yordanova Valova
Local Architects AGC Design Ltd; AD+RG
Structural and Geotechnical Engineers Ove Arup &
Partners; Hong Kong Ltd
Building Services Ove Arup & Partners; Hong Kong Ltd
Landscape Team 73 Hong Kong Ltd
Acoustics Consultant Westwood Hong & Associates Ltd
Total Area 15,000 m²; 78m (height)

Dominion Office Building [224–25]
Moscow, Russia, 2012–15
Client Peresvet Group/Dominion-M Ltd
Design Zaha Hadid with Patrik Schumacher
Design Director Christos Passas
Project Architects Veronika Ilinskaya, Kwanphil Cho
Interior Design Team Emily Rohrer, Raul Forsoni, Veronika
Ilinskaya, Kwanphil Cho
Contributors Hussam Chakouf, Reza Esmaeeli, Thomas
Frings
Art Installation Bruno Pereira
Concept Design Design Director: Christos Passas; Project
Architect: Yevgeniy Beylkin; Design Team: Juan Ignacio
Aranguren C, Yevgeniy Beylkin, Simon Kim, Agnes Koltay,
Larisa Henke, Tetsuya Yamazaki
Local Architect AB Elis Ltd
Façade Consultant Ove Arup (London, UK)
Structural Engineer Mosproject
Concrete Engineer PSK Stroiltel Promstroicontract
MEP & General Contractor Stroigroup
Electrical MEP Novie Energiticheskie Reshenia
Façade Contractors StroyBit, Prostie reshenia/
ALUCOBOND™
Glazing Contractor MBK Stroi
Interior Contractor LCC Contractcity
GRC Architectura Blagopoluchie/Facade Light
Lighting Consultant FisTechenergo
Furniture Contractor M Factor
Total Floor Area 21,184 m²
Footprint 62m × 50.5m

Eli & Edythe Broad Art Museum [226–27]
East Lansing, Michigan, USA, 2007–12
Client Michigan State University
Design Zaha Hadid with Patrik Schumacher
Project Director Craig Kiner
Project Architect Alberto Barba
Project Team Ruven Aybar, Michael Hargens, Edgar Payan
Pacheco, Sophia Razzaque, Arturo Revilla, Charles Walker
Project Director (Competition) Nils-Peter Fischer
Project Architects (Competition) Britta Knobel, Fulvio Wirz
Competition Team Daniel Widrig, Melike Altinisik,
Mariagrazia Lanza, Rojia Forouhar
Structural Consultant Adams Kara Taylor: Hanif Kara
Environmental/M&E Consultant Max Fordham
Partnership: Henry Luker

Danjiang Bridge [228–31]
Taipei, Taiwan, 2015–
Client Directorate General of Highways, Taiwan
Status Design stage
Design Zaha Hadid with Patrik Schumacher
Competition Project Directors Charles Walker,
Manuela Gatto
Competition Project Architect Shao-wei Huang
Competition Design Associate Paulo Flores
Competition Lead Designer Saman Saffarian
Competition Project Team Evgeniya Yatsyuk, Paul Bart,
Sam Sharpe, Silviya Barzakova, Julian Lin, Ramon Weber
Delivery Project Director Cristiano Ceccato
Delivery Project Architect Shao-wei Huang
Delivery Project Team Carlos Michel-Medina, Chien-shuo
Pai, Julian Lin
Delivery Project BIM Support Paul Ehret
**Lead Structural Engineering Consultancy and JV
Partner** Leonhardt, Andrä und Partner, Germany
Local Engineering Consultants and JV Partner Sinotech
Engineering Consultants
Lighting Designer Chroma33 Architectural Lighting Design,
Taiwan
Length 920m
Height of Supporting Mast 175m

Abu Dhabi Performing Arts Centre [232–33]
Abu Dhabi, UAE, 2008–
Client Tourism Development & Investment Company of Abu
Dhabi
Design Zaha Hadid with Patrik Schumacher
Project Director Nils-Peter Fischer
Project Architects Britta Knobel, Daniel Widrig
Project Team Jeandonne Schijlen, Melike Altinisik, Arnoldo
Rabago, Zhi Wang, Rojia Forouhar, Jaime Serra Avila, Diego
Rosales, Erhan Patat, Samer Chamoun, Philipp Vogt, Rafael
Portillo
**Structural, Fire, Traffic and Building Services
Consultants** WSP Group, with WSP (Middle East): Bill Price,
Ron Slade
Acoustics Consultant Sound Space Design: Bob Essert
Façade Sample Construction King Glass Engineering
Group
Theatre Consultant Anne Minors Performance Consultants
Cost Consultant Gardiner & Theobald: Gary Faulkner
Total Area 62,770 m²

Bee'ah Headquarters [234–37]
Sharjah, UAE, 2014–
Client Bee'ah

Status Design stage
Design Zaha Hadid with Patrik Schumacher
Director Charles Walker
Project Director Tariq Khayyat
Project Architect (Construction Phase) Sara Sheikh
Akbari
Project Team John Simpson, Gerry Cruz, Drew Merkle,
Maria Chaparro, Matthew Le Grice
ZHA Project Architect (Design Phase) Kutbuddin
Nadiadi
Project Team (Design Phase) Gerry Cruz, Drew Merkle,
Vivian Pashiali, Matthew Le Grice, Alia Zayani, Alessandra
Lazzoni, Dennis Brezina, Yuxi Fu, Xiaosheng Li, Edward
Luckmann, Eleni Mente, Kwanphil Cho, Mu Ren, Harry Ibbs,
Mostafa El Sayed, Suryansh Chandra, Thomas Jensen,
Alexandra Fisher, Spyridon Kaprinis, John Randle, Bechara
Malkoun, Reda Kessanti, Eider Fernandez-Eibar, Carolina
López-Blanco, Matthew Johnston, Sabrina Sayed, Zohra
Rougab, Carl Khourey, Anas Younes, Lauren Barclay, Mubarak
Al Fahim
Structure/Façade Buro Happold (London)
MEP Atelier Ten (London)
Cost Gardiner & Theobald (London)
Landscape Francis Landscape (Beirut)
Local Architect Bin Dalmouk
Renders MIR
Site Area 90,000 m²
Floor Area 7,000 m²
Height 18m

Port House [238–41]
Antwerp, Belgium, 2009–16
Client Port of Antwerp
Design Zaha Hadid with Patrik Schumacher
Project Director Joris Pauwels
Project Architect Jinmi Lee
Project Team Florian Goscheff, Monica Noguero, Kristof
Crolla, Naomi Fritz, Sandra Riess, Muriel Boselli, Susanne
Lettau
Competition Team Kristof Crolla, Sebastien Delagrange,
Paulo Flores, Jimena Araiza, Sofia Daniilidou, Andres
Schenker, Evan Erlebacher, Lulu Aldihani
Executive Architect and Cost Consultant Bureau
Bouwtechniek
Structural Engineers Studieburo Mouton Bvba
Services Engineers Ingenium Nv
Acoustic Engineers Daidalos Peutz
Restoration Consultant Origin
Fire Protection FPC
Principal Contractors Interbuild, Groven+ (façade), Victor
Buyck Steel Construction (steel)
Total Floor Area 20,800 m² (12,800 m² above grade)
Site Area 16,400 m²

Library & Learning Centre [242–45]
Vienna, Austria, 2008–13
Client University of Economics Vienna
Design Zaha Hadid with Patrik Schumacher
Project Architect Cornelius Schlotthauer
Project Team Construction Enrico Kleinke, Markus
Planteu, Vincenco Cocomero, Peter Irmscher, Katharina
Jacobi, Constanze Stinnes, Peter Hornung, Frédéric
Beaupère, Mirjam Matthiessen, Marc-Philipp Nieberg,
Tom Finke, Kristoph Nowak, Susanne Lettau, Jahann Shah
Beyzavi, Florian Goscheff, Daniela Nenadic, Judith Wahle,
Rassul Wassa, Julian Breinersdorfer, Nastasja Schlaf,

Muhammed Patat, Elisabeth Dirnbacher
Structural Engineers Vasko und Partner Ingenieure
M&E Engineers Vasko und Partner Ingenieure
Façade Engineers ARUP Deutschland GmbH
Lighting Engineers Arup Berlin
Fire Protection HHP West, Bielefeld
Site Supervision Ingenos Gobiet ZT GmbH, IC Consulenten
Ziviltechniker GmbH
Project Team Competition Cornelius Schlotthauer,
Marc-Philipp Nieberg, Enrico Kleinke, Kristoph Nowak, Stefan
Rinnebach, Romy Heiland, Richard Baumgartner
Area 28,000 m²

Burnham Pavilion [246]
Chicago, Illinois, USA, 2009
Client Burnham Plan Centennial
Design Zaha Hadid with Patrik Schumacher
Project Architects Jens Borstelmann, Thomas Vietzke
Project Team Teoman Ayas, Evan Erlebacher
Local Architect Thomas Roszak
Structural Engineers Rockey Structures
Fabricator Fabric Images
Lighting & Electrical Tracey Dear
Film Installation Thomas Gray, The Gray Circle
Sound Design Lou Mallozzi, Experimental Sound Studio
Area 120 m²

Wangjing Soho [247]
Beijing, China, 2009–14
Client Soho China Ltd
Design Zaha Hadid with Patrik Schumacher
Project Director Satoshi Ohashi
Project Associate Armando Solano
Project Team Yang Jingwen, Christoph Klemmt, Shu
Hashimoto, Yung-Chieh Huang, Rita Lee, Samson Lee, Feng
Lin, Seungho Yeo, Di Ding, Xuexin Duan, Chaoxiong Huang,
Ed Gaskin, Bianca Cheung, Chao-Ching Wang, John Klein,
Ho-Ping Hsia, Yu Du, Sally Harris, Oliver Malm, Rashiq
Muhamadali, Matthew Richardson
Competition Team Satoshi Ohashi, Christiano Ceccato,
Inanc Eray, Ceyhun Baskin, Chikara Inamura, Michael Grau,
Hoda Nobakhati, Yevgeniya Pozigun, Michal Treder
Structural Consultant Adams Kara Taylor UK (competition),
CCDI Beijing (SD), (DD), (CD)
Façade Consultant Arup Facade HK (SD), Inhabitat Beijing
(DD)
MEP, VT, Fire Safety, Sustainability Consultant Hoare
Lea UK (competition), Arup Engineers (SD)
Site Area 115,393 m²
Gross Floor Area 521,265 m² (392,265 m² above grade,
129,000 m² below grade)
Footprint Area 21,000 m²

King Abdullah Petroleum Studies & Research Center
[248–49]
Riyadh, Saudi Arabia, 2009–16
Client Saudi Aramco
Design Zaha Hadid with Patrik Schumacher
Project Directors Lars Teichmann, Charles Walker
Design Director DaeWha Kang
Project Leaders Fabian Hecker (research centre);
Michael Powers (conference centre); Brian Dale,
Henning Hansen (library); Fulvio Wirz (musalla/IT centre);
Elizabeth Bishop (façades/2D documentation);
Saleem A. Jalil, Maria Rodero (masterplan); Lisamarie
Ambia, Judith Wahle (interiors); Bozana Komljenovic (2D

documentation); John Randle (specifications); John Szlachta
(3D documentation coordinator)
Construction Leads John Simpson (site associate),
Alejandro Diaz Fernandez, Brian Dale (interiors), Elizabeth
Bishop, Michal Wojtkiewicz (façades and canopies), Monika
Bilska, Malgorzata Kowalczyk (services coordination), Henning
Hansen, Ayca Vural Cutts, Michael Powers (structure), Ayca
Vural Cutts, Sara Criscenti (external landscape)
Project Team Adrian Krezlik, Alexander Palacio, Amdad
Chowdhury, Amit Gupta, Anas Younes, Andres Arias Madrid,
Annarita Papeschi, Aritz Moriones, Ayca Vural Cutts, Britta
Knobel, Camiel Weijenberg, Carine Posner, Claire Cahill,
Claudia Dorner, DaChun Lin, Daniel Fiser, Daniel Toumine,
David Doody, David Seeland, Deniz Manisali, Elizabeth
Keenan, Evan Erlebacher, Fernanda Mugnaini, Garin
O'Aivazian, Giorgio Radojkovic, Inês Fontoura, Jaimie-Lee
Haggerty, Javier Rueda, Jeremy Tymms, Julian Jones, Jwalant
Mahadevwala, Lauren Barclay, Lauren Mishkind, Malgorzata
Kowalczyk, Mariagrazia Lanza, Melike Altinisik, Michael
Grau, Michael McNamara, Michal Wojtkiewicz, Mimi Halova,
Mohammad Ali Mirzaei, Mohammed Reshdan, Monika Bilska,
Muriel Boselli, MyungHo Lee, Nahed Jawad, Natacha Viveiros,
Navvab Taylor, Neil Vyas, Nicola McConnell, Pedro Sanchez,
Prashanth Sridharan, Roxana Rakhshani, Saahil Parikh, Sara
Criscenti, Sara Saleh, Seda Zirek, Shaju Nanukuttan, Shaun
Farrell, Sophie Davison, Sophie Le Bienvenu, Stefan Brabetz,
Stella Dourtme, Steve Rea, Suryansh Chandra, Talenia Phua
Gajardo, Theodor Wender, Yu Du
Competition Design Team Lisamarie Ambia, Monika Bilska,
Martin Krcha, Maren Klasing, Kelly Lee, Hannes Schafelner,
Judith Schafelner, Ebru Simsek, Judith Wahle, Hee Seung
Lee, Clara Martins, Anat Stern, Daniel Fiser, Thomas Sonder,
Kristina Simkeviciute, Talenia Phua Gajardo, Erhan Patat,
Dawna Houchin, Jwalant Mahadevwala
Engineering Arup
Interior Woods Bagot
Landscape Gross.Max
Lighting Office for Visual Interaction
Catering and Kitchen Eastern Quay and GWP
Exhibition Design Event
Branding & Signage Elmwood and Bright 3D
Library Consulting Tribal
Cost/Design Project Management Davis Langdon
Area 66,000 m²

Galaxy Soho [250–51]
Beijing, China, 2009–12
Client Soho China Ltd
Design Zaha Hadid with Patrik Schumacher
Project Director Satoshi Ohashi
Associate Cristiano Ceccato
Project Architect Yoshi Uchiyama
Project Team Kelly Lee, Rita Lee, Eugene Leung, Lillie Liu,
Rolando Rodriguez-Leal, Seung-ho Yeo. DD Phase: Dorian
Bybee, Michael Grau, Shu Hashimoto, Shao-Wei Huang,
Chikara Inamura, Lydia Kim, Christoph Klemmt, Yasuko
Kobayashi, Raymond Lau, Wang Lin, Yereem Park, Tao Wen,
Stephan Wurster. SD Phase: Samer Chamoun, Michael Hill,
Tom Wuenschmann, Shuojiong Zhang
Competition Team DaeWha Kang (Lead Designer), Monika
Bilska, Elizabeth Bishop, Diogo Brito, Brian Dale, Kent Gould,
Jwalant Mahadevwala, Michael Powers, Vignesh Ramaraju
Local Design BIAD Beijing Institute of Architectural Design
Lighting Lightdesign
Contractor China Construction First Division Group
Construction & Development Co, Ltd

Plot Area 46,965 m²
Total Floor Area 332,857 m²
Above Ground 4 towers, 15 floors (12 office floors and
3 retail floors)
Max. Height 67m
Materials, Exterior 3mm aluminium exterior cladding,
insulated glass, stone
Materials, Interiors Glass, terrazzo, GRG, tile stainless steel,
gypsum board painted
Structure Concrete Construction (8.4m spans)
Floor-to-Floor Heights Retail floors 5.4m, office floors
3.5m
Landscape Stone, glass, stainless steel
Exterior Furniture Stone, FRP

Sky Soho [252–55]
Shanghai, China, 2010–14
Client Soho China Ltd
Design Zaha Hadid with Patrik Schumacher
Project Director Manuela Gatto
Associate Consultant Satoshi Ohashi
Project Architects Edgar Payan (phases SD, DD, CD), Yoshi
Uchiyama (construction administration)
Lead Façades Alberto Barba, Maria Rodero (design stages),
Kaloyan Erevinov (construction supervision)
Lead Interiors Claudia Glass Dorner (schematic design
stages), Mei-Ling Lin (construction supervision)
Lead Landscape Samson Lee
Project Team Arturo Revilla, Muriel Boselli, Chao-Chin
Wang, Ai Sato, Michael Harris, Dennis Brezina, Claudia Doner,
Mei-Ling Lin, Osbert So, Pierandrea Angius, Diego Perez
Espitia, Kaloyan Erevinov, Laurence Dudeney, Albert Ferrer,
Leonid Krykhtin, Mu Ren, Kwanphil Cho, Evgeniya Yatsyuk,
Lauren Barclay, Henning Hansen, Ben Kikkawa, Nicholette
Chan, Michael Grau, Sarah Thurow, Adrian Krezlik, Chiwai
Chan, Gordana Jakimovska, Ed Gaskin, Andrea D'imperio,
Samson Lee, Shaowen Deng, Will Chen, Joei Kung, Maren
Klasing, Carlos Parraga-Botero
Competition Team Ergin Birinci, Maria Tsiorni, Michael
Rissbacher, Seda Zirek, Spyridon Kaprinis, Xiaosheng Li
Local Design Institute Siadr – Shanghai Institute of
Architectural Design & Research Ltd
Façade Consultant Thornton Tomasetti
Lighting Lightdesign
Structural Engineering Siadr – Shanghai Institute of
Architectural Design & Research Ltd
Mechanical Engineering Parsons Brinckerhoff
Sustainability Consultant Aecom
Gross Floor Area 342,500 m²
Site Area 86,000 m²

Grand Theatre de Rabat [256]
Rabat, Morocco, 2010–
Client Agence pour l'Aménagement de la Vallée du
Bouregreg
Design Zaha Hadid with Patrik Schumacher
Project Director Nils-Peter Fischer
Project Team Martin Krcha, Yevgeniya Pozigun, Erwan
Gallou, Michail Desyllas, Duarte Reino, Katharina Hieger,
Joshua Noad, Thanh Dao
Local Architect Cabinet Omar Alaoui (Morocco)
Structural Engineer Adams Kara Taylor (London)
MEP Engineer Max Fordham (London)
Acoustics & Theatre Artec Consultant (New York)
Façade Ncwtccnic (London)
Lighting Office for Visual Interaction Inc (New York)

Cost Consultant Donnell Consultants Incorporated (Florida)
Acoustics & Theatre Arup (New York)
Kitchen IR2A (Rabat)
Landscaping PROAP
Local MEP and Structural Consultant Omnium (Rabat)
Fire Consultant Casavigilance (Rabat)
Site Area Approx. 55,000 m²
Gross Floor Area Approx. 25,425 m²

BBK Headquarters [257]
Bilbao, Spain, 2010–
Client BBK (Bilbao Bizkaia Kutxa)
Design Zaha Hadid with Patrik Schumacher
Project Director Manuela Gatto
Technical Associate Dillon Lin
Project Team Teoman N. Ayas, Muriel Boselli,
Maren Klasing, Edgar Payan, Arturo Revilla, Ai Sato,
Camiel Weijenberg, Seda Zirek
Engineering Consultant Arup Madrid
Gross Floor Area 25,000 m²

One Thousand Museum [257]
Miami, Florida, USA, 2012–
Client 1000 Biscayne Tower, LLC
Design Zaha Hadid with Patrik Schumacher
Project Director Chris Lépine
Project Team Alessio Constantino, Martin Pfleger, Oliver
Bray, Theodor Wender, Irena Predalic, Celina Auterio, Carlota
Boyer
Competition Team Sam Saffarian, Eva Tiedemann,
Brandon Gehrke, Cynthia Du, Grace Chung, Aurora Santan,
Olga Yatsyuk
Local Architect O'Donnell Dannwolf Partners
Structural Engineer DeSimone
MEP Engineer HNGS Consulting Engineers
Civil Engineer Terra Civil Engineering
Landscape Enea Garden Design
Fire Protection SLS Consulting Inc
Vertical Transportation Lerch Bates Inc
Wind Tunnel Consultant RWDI
Gross Floor Area 84,637 m²

Tea and Coffee Set [262]
1995–96
Client Sawaya & Moroni
Design Zaha Hadid
Design Team Maha Kutay, Anne Save de Beaurecueil
Material Stainless steel

Tea and Coffee Piazza [263]
2003
Client Alessi
Design Zaha Hadid with Patrik Schumacher
Design Team Woody Yao, Thomas Vietzke

Z-Scape [264]
2000
Client Sawaya & Moroni
Design Zaha Hadid
Design Team Caroline Voet, Woody Yao, Chris Dopheide,
Eddie Can

Iceberg [265]
2003
Client Sawaya & Moroni

Design Zaha Hadid with Patrik Schumacher
Design Team Thomas Vietzke, Woody Yao

Ice Storm [266–67]
2003
Client Österreichisches Museum für Angewandte Kunst
Design Zaha Hadid with Patrik Schumacher
Project Architects Thomas Vietzke, Woody Yao

Belu Bench [268]
2005
Client Kenny Schachter
Design Zaha Hadid with Patrik Schumacher
Project Designer Saffet Kaya Bekiroglu
Project Team Maha Kutay, Tarek Shamma, Melissa Woolford

Zaha Hadid Bowls 60, 70 and Metacrylic [268]
2007
Client Sawaya & Moroni
Design Zaha Hadid with Patrik Schumacher
Lead Designer Saffet Kaya Bekiroglu
Design Team Maha Kutay, Melissa Woolford, Tarek
Shamma
Size (Bowl 60) 600mm (width) × 275mm (depth) ×
130mm (height)
Size (Bowl 70) 700mm (width) × 325mm (depth) ×
130mm (height)
Size (Metacrylic) 700mm (width) × 325mm (depth) ×
130mm (height)

Aqua Table [269]
2005
Client Established & Sons
Design Zaha Hadid with Patrik Schumacher
Project Designer Saffet Kaya Bekiroglu
Design Team Tarek Shamma
Size 420cm × 148.5cm × 72cm

Flow [269]
2006–7
Client Serralunga
Design Zaha Hadid with Patrik Schumacher
Lead Designers Michele Pasca di Magliano, Viviana
R. Muscettola

Z-Car I and II [270]
2005–8
Client Kenny Schachter
Design Zaha Hadid with Patrik Schumacher
Project Designer Jens Borstelmann
Design Team David Seeland
Size 3.68m (length) × 1.7m (width) × 1.4m (height);
wheelbase: 2.45m

Z-Island [271]
2005–6
Client DuPont Corian
Design Zaha Hadid with Patrik Schumacher
Project Architect Thomas Vietzke
Design Team Georgios Maillis, Maurice Martel, Katharina
Neuhaus, Ariane Stracke
Manufacturer Hasenkopf
Size Exhibition space: 214 m²; main island: 4.5m (length) ×
0.8m (width) × 1.8m (height); second island: 1.2m × 1.6m ×
0.9m; wall panels: 100 pieces at 0.6m × 0.6m

The Seamless Collection [272]
2006
Client Established & Sons; Phillips de Pury & Company
Design Zaha Hadid with Patrik Schumacher
Design Team Saffet Kaya Bekiroglu, Melodie Leung,
Helen Lee, Alvin Huang, Hannes Schafelner

Dune Formations [273]
2007
Client David Gill Galleries
Design Zaha Hadid with Patrik Schumacher
Design Team Michele Pasca di Magliano, Viviana
R. Muscettola
Materials Aluminium, resin
Size 24m × 13m

Crater Table [274]
2007
Client David Gill Galleries
Design Zaha Hadid with Patrik Schumacher
Project Designer Saffet Kaya Bekiroglu
Design Team Chikara Inamura, Chrysostomos
Tsimourdagkas

Moon System [274]
2007
Client B&B Italia
Design Zaha Hadid with Patrik Schumacher
Design Lead Viviana R. Muscettola
Design Team Michele Pasca di Magliano

Mesa Table [275]
2007
Client Vitra
Design Zaha Hadid with Patrik Schumacher
Project Designer Saffet Kaya Bekiroglu
Project Team Chikara Inamura, Melike Altinisik

Zaha Hadid Chandelier [276]
2008
Client Swarovski Crystal Palace
Design Zaha Hadid with Patrik Schumacher
Project Designers Saffet Kaya Bekiroglu, Kevin McClellan
Project Team Jaime Bartolomé, Simon Koumjian, Amit
Gupta
Engineering Consultant Arup AGU: Tristan Simmonds
Fabrication LDDE Vertriebs GmbH; Stainless Steel Solutions;
Sheetfabs Ltd
Materials Swarovski crystal, aluminium, SS cabling, copper
wire, microprinted LEDs
Size 6m (height) × 2.25m (width) × 10.5m (length)

Swarm Chandelier [276]
2006
Client Established & Sons
Design Zaha Hadid with Patrik Schumacher
Project Architect Saffet Kaya Bekiroglu
Manufacturer Established & Sons
Material Crystal

Vortexx Chandelier [277]
2005
Client Sawaya & Moroni
Design Zaha Hadid with Patrik Schumacher
Design Team Thomas Vietzke

Partners Sawaya & Moroni; Zumtobel Illuminazione s.r.l.
Material Fibreglass, car paint, acrylic, LED
Size 1.8m (diameter)

Crevasse Vase [278]
2005–8
Client Alessi Spa
Design Zaha Hadid with Patrik Schumacher
Design Team Woody Yao, Thomas Vietzke
Manufacturer Alessi Spa
Material Silver-plated stainless steel

WMF Cutlery [278]
2007
Client WMF
Design Zaha Hadid with Patrik Schumacher
Project Designer Jens Borstelmann
Material Mirror-polished stainless steel

Series ZH Door Handles [279]
2007
Client Valli & Valli
Design Zaha Hadid with Woody Yao
Material Nikrall Zamak alloy UNI 3717

Icone Bag [280]
2006
Client Louis Vuitton
Design Zaha Hadid with Patrik Schumacher
Project Designer Ana M. Cajiao
Design Team Muthahar Khan

Melissa Shoe [280]
2008
Client Melissa/Grendene S/A
Design Zaha Hadid with Patrik Schumacher
Lead Designer Ana M. Cajiao
Design Team Maria Araya, Muthahar Khan

Lamellae Collection [281]
2016
Client Georg Jensen
Design Zaha Hadid with Patrik Schumacher
Design Team Maha Kutay, Woody Yao, Weilong Xei
Materials Various, including silver, gold, diamonds, rhodium plating
Size Bangle 19mm (height), 15.2–18.5cm (circumference, small–large); double ring 28.5mm; long bangle 9mm (width), 14.5–17.1cm (circumference, S/M–M/L); long ring 73mm × 25mm; ring I 41mm × 40mm; ring II 57mm × 37.5mm; twin ring 73mm × 47.5mm; twisted bangle 13cm (length), 17–18.5cm (S/M–M/L)

Lotus, Venice Biennale [282]
Venice, Italy, 2008
Client La Biennale di Venezia
Design Zaha Hadid with Patrik Schumacher
Design Team Melodie Leung, Gerhild Orthacker
Materials Glass-reinforced plastic and polyurethane with high-gloss lacquer paint finish, foam mattress, wood, printed fabric, synthetic rubber, and stretch fabric
Size Closed: 5.7m (length) × 5.7m (width) × 2.6m (height); Open: 10.2m (length) × 6.1m (width) × 2.6m (height)

Home Bar [283]
London, UK, 2008
Client Home House Ltd
Design Zaha Hadid with Patrik Schumacher
Design Team Maha Kutay, Melissa Woolford, Woody Yao, Susanne Berggen, Sophie Le Bienvenue, Susu Xu, Gabriela Jimenez
Materials Fibreglass, resin, fabric
Total Area 158 m²

Aura [283]
Venice, Italy, 2008
Client Fondazione La Malcontenta
Design Zaha Hadid with Patrik Schumacher
Design Team Fulvio Wirz, Mariagrazia Lanza
Lighting Designer Zumtobel Illuminazione s.r.l.
Manufacturer Idee & Design GmbH; The Art Factory
Core Material PU-Foam RG100 and Polystyrene EPS 20 milled parts; coated with PU-SB1
Installation Details Aura-L and Aura-S: lacquered fibreglass with embedded steel frame
Size 6m × 3m × 2.45m

Cirrus [284]
Cincinnati, Ohio, 2008
Client Lois & Richard Rosenthal Center for Contemporary Art
Design Zaha Hadid with Patrik Schumacher
Design Team Melodie Leung, Gerhild Orthacker
Materials Laminate by Formica®, colour Black (909-90) in polished finish stained medium-density fibreboard
Size 1.8m (diameter)

Seoul Desk and Table [284]
2008
Client NY Projects
Design Zaha Hadid with Patrik Schumacher
Designer Daniel Widrig
Size 422cm × 125cm × 72cm

Stuart Weitzman Boutiques [285]
Milan, Hong Kong, Rome, 2013–14
Client Stuart Weitzman
Design Zaha Hadid with Patrik Schumacher
Milan:
Project Architect Paola Cattarin
Design Team Alessio Costantino, Maren Klasing, Jorge Mendes-Caceres, Vincenzo Barilari, Zetta Kotsioni
Local Executive Architects Milano Layout, Marco Claudi, Sara Acconcia
Structural Engineer Bruni Salesi
Lighting Pollice Illuminazione
Contractor Tecnolegno Allestimenti, Claudio Radice
Hong Kong:
Project Architect Paola Cattarin
Design Team Alessio Costantino, Maren Klasing, Jorge Mendes-Caceres, Vincenzo Barilari, Zetta Kotsioni, Hinki Kuong
Local Executive Architects CW Tang
Client Project Manager Wong Chi Lap
Lighting Twinsen Ho
Contractor Vitus Man
Rome:
Project Architect Paola Cattarin
Design Team Jorge Mendes-Caceres, Vincenzo Barilari, Zetta Kotsioni, Soungmin Yu, Kyle Dunnington
Local Executive Architects Milano Layout, Marco Claudi,

Sara Acconcia
Structural Engineer Ing. Bruno Zeuli
Lighting Pollice Illuminazione
Craftsmen Me Cubo, Marco Marelli
Contractor Tecnolegno Allestimenti srl, Claudio Radice

Table, Shelf and Henry Moore Exhibition Design [286]
2008
Client Hauser & Wirth
Design Zaha Hadid with Patrik Schumacher
Project Team Woody Yao, Dylan Baker-Rice
Material Aluminium
Finish Mirror Finish
Dimensions:
Length 6.42m
Width 2.18m
Height 1.04m

Scoop Sofa [286]
2008
Client Sawaya & Moroni and ROVE LLP
Design Zaha Hadid with Patrik Schumacher
Design Team Saffet Kaya Bekiroglu, Melodie Leung, Maha Kutay, Dylan Baker-Rice, Filipa Gomes
Materials Glass reinforced plastic (GRP), with pearlized lacquered paint finish
Dimensions:
Length 3.90 m
Depth 1.41 m
Height 0.83 m

Kloris [287]
2008
Outdoor seating
Client Julian Treger and Kenny Schachter/Rover Gallery
Design Zaha Hadid with Patrik Schumacher
Design Team Melodie Leung, Tom Wuenschmann, Yael Brosilovski
Materials Glass reinforced plastic (GRP), with high-gloss lacquer finish in chrome and gradations of green, steel base plates
Dimensions 6500 × 5100 × 80 mm

Glace Collection [287]
2009
Client Swarovski
Design Zaha Hadid with Patrik Schumacher
Design Team Swati Sharma, Maria Araya
Dimensions:
Necklace 220 × 140 mm
Cuff 1 105 × 50 mm
Cuff 2 110 × 50 mm
Ring 1 45 × 49 mm
Ring 2 70 × 35 mm
Pendant 150 × 110 mm
Materials Coloured resin and Swarovski crystals in jet, opal, crystal, padparadscha and black diamond

J. S. Bach Music Hall [288–89]
Manchester, UK, 2009
Client Manchester International Festival
Design Zaha Hadid with Patrik Schumacher
Design Team Melodie Leung, Gerhild Orthacker
Acoustic Consultant Sandy Brown Associates
Tensile Structural Engineer Tony Hogg Design Ltd

Fabricator Base Structures
Fabric Trapeze Plus Lycra (approximately 7,000 sq ft)
Lighting DBN Lighting Limited
Size 17m × 25m

Avilion Triflow Taps [290]
2009
Client Avilion Triflow
Design Zaha Hadid with Patrik Schumacher
Project Architects Woody Yao, Dylan Baker-Rice, Maha Kutay, Melissa Woolford
Materials Chrome-plated brass-finish chrome, mirror-image finish
Dimensions:
Kitchen Length 43cm, width 27cm, height 34cm
Bath Length 40cm, width 23cm, height 20cm

Skein Sleeve Bracelet [290]
2009
Client Sayegh Jeweller
Design Zaha Hadid with Patrik Schumacher
Design Team Maha Kutay, Melissa Woolford, Michael Grau, Hussam Chakouf

Genesy Lamp [291]
2009
Client Artemide
Design Zaha Hadid with Patrik Schumacher
Project Architect Alessio Costantino
Material Expanded Polyurethane lacquered
Finish Gloss
Dimensions:
Height 195cm
Length 120cm
Width 59cm

Tide [291]
2010
Client Magis
Design Zaha Hadid with Patrik Schumacher
Design Team Ludovico Lombardi, Viviana Muscettola, Michele Pasca di Magliano
Finish Gloss
Dimensions:
Free-standing Module S Width 450mm; depth 450mm; height 450mm
Free-standing Module L Width 450mm; depth 450mm; height 1,350mm
Wall Module S Width 450mm; depth 275mm; height 450mm
Wall Module L Width 1,350mm; depth 275mm; height 450mm
Material Liquid wood

Zaha Hadid: Architects & Suprematism [292]
Zurich, Switzerland, 2010
Client Galerie Gmurzynska
Design Zaha Hadid with Patrik Schumacher
Project Director Woody Yao
Project Architect Melodie Leung
Project Team Maha Kutay, Manon Janssens, Filipa Gomes, Aram Gimbot
Artist Consultant Antonio De Campos
Gallery Directors Krystyna Gmurzynska, Mathias Rastorfer
Area 230 m²

Zaha Hadid: Palazzo della Ragione Padova [293]
Padua, Italy, 2009–10
Client Fondazione Barbara Cappochin
Design Zaha Hadid with Patrik Schumacher
Exhibition Team Viviana Muscettola, Michele Pasca di Magliano, Woody Yao, Elif Erdine
Installation Coordination Manon Janssens, Woody Yao, Filipa Gomez, Shirley Hottier
Main Contractor Idee & Design
Lighting Design I-Guzzini

Roca London Gallery [293]
London, UK, 2009–11
Client Roca
Design Zaha Hadid with Patrik Schumacher
Design Team Melodie Leung, Gerhild Orthacker
Project Directors Woody Yao, Maha Kutay
Project Architect Margarita Yordanova Valova
Design Development Gerhild Orthacker, Hannes Schafelner, Jimena Araiza, Mireia Sala Font, Erhan Patat, Yuxi Fu, Michal Treder, Torsten Broeder
Concept Design Dylan Baker-Rice, Melissa Woolford, Matthew Donkersley, Maria Araya
Structural and Façade Engineering Buro Happold
MEP and Acoustics Consultant Max Fordham Consulting Engineers
Lighting Design Isometrix Lighting + Design
AV Consultant Sono
Cost Manager Betlinski
Construction Manager Empty, S.L.
Area 1,100 m²

Z-Chair [294]
2011
Client Sawaya & Moroni
Design Zaha Hadid with Patrik Schumacher
Design Team Fulvio Wirz, Mariagrazia Lanza, Maha Kutay, Woody Yao
Dimensions:
Length 920mm
Height 880mm
Depth 610mm
Materials Polished stainless steel

Art Borders by Zaha Hadid [295]
2010
Client Marburg Wallcoverings
Design Zaha Hadid with Patrik Schumacher
Project Leader Melodie Leung
Project Team Filipa Gomes, Danilo Arsic, Russel Palmer, Salvatore Lillini, Maha Kutay, Woody Yao
Marburg Art Director Dieter Langer

Zaha Hadid: Fluidity & Design [296]
Muharraq, Bahrain, 2010
Client Shaikh Ebrahim bin Mohammed Al Khalifa Centre for Culture and Research
Design Zaha Hadid with Patrik Schumacher
Project Team Elke Frotscher, Woody Yao, Filipa Gomes, Manon Janssens, Melodie Leung, Maha Kutay
Artist Consultant Antonio De Campos

Zaha Hadid: Une Architecture [296]
Paris, France, 2011
Client Institut du Monde Arabe

Design Zaha Hadid with Patrik Schumacher
Exhibition Team Thomas Vietzke, Manon Janssens, Woody Yao, Jens Borstelmann, Sofia Daniilidou, Torsten Broeder, Tiago Correia, Danilo Arsic, Victor Orive, Mostafa El Sayed, Christoph Wunderlich, Martin Krcha, Niki Berry, Claudia Fruianu, Daniel Widrig, Filipa Gomes
Artist Consultant Antonio De Campos
Production AIA Production (APC+AIA): Renaud Sabari and Alexandra Cohen
Visual Identity Yorgo Tloup
Video Projections Cadmos
Production Coordination Emmanuel Lemercier de L'Ecluse
Pavilion Installation:
Artistic Supervision Zaha Hadid Architects: Thomas Vietzke, Jens Borstelmann
Client's Assistant AIA Productions
Project Management Elioth Iosis and ENIA
Building Viry (Fayat Group); Satelec (Fayat Group); Extenzo
Gross Floor Area 700 m² (29m × 45m)
Exhibition space 500 m²

Zaha Hadid: Form in Motion [297]
Philadelphia, Pennsylvania, USA, 2011–12
Client Philadelphia Museum of Art
Design Zaha Hadid with Patrik Schumacher
Project Director Woody Yao
Exhibition Design Team Jimena Araiza, Filipa Gomes
Exhibition Coordinators Manon Janssens, Maha Kutay
Area 395 m²

Zaha Hadid: Parametric Tower Research [297]
Cologne, Germany, 2012
Client AIT ArchitekturSalons
Design Zaha Hadid with Patrik Schumacher
Exhibition Team Thomas Vietzke, Manon Janssens, Woody Yao, Jens Borstelmann, Sofia Daniilidou, Torsten Broeder, Anna Roeder
Artist Consultant Antonio De Campos
Area 300 m²

Twirl [298]
2011
Client Lea Ceramiche and Interni
Design Zaha Hadid with Patrik Schumacher
Project Director Woody Yao
Project Architect Johannes Schafelner
Team Yuxi Fu, Manon Janssens, Maha Kutay, Danilo Arsic, Filipa Gomes
Area 800 m²

Floating Staircase [298]
London, UK, 2012
Design Zaha Hadid with Patrik Schumacher
Design Lead Melodie Leung
Design Team Garin O'Aivazian, Bear Shen
Structural Consultant Adams Kara Taylor: Christian Tygoer
Fabrication Il Cantiere
Structural Engineer C&E Ingeniere: Raphaël Fabbri
Steelwork and Installation Artistic Engineering
Size 8.8m (length) × 2.5m (width) × 3.2m (height)

Arum Installation and Exhibition [299]
Venice, Italy, 2012
Client Venice Architecture Biennale
Design Zaha Hadid with Patrik Schumacher

Exhibition Design Woody Yao, Margarita Valova
Installation Design and Presentation Shajay Bhooshan, Saman Saffarian, Suryansh Chandra, Mostafa El Sayed
Structural Engineering Buro Happold: Rasti Bartek
Material & Fabrication Technology RoboFOLD: Gregory Epps
Coordinator Manon Janssens
Collaborators Studio Hadid, Universität für angewandte Kunst: Jens Mehlan, Robert Neumayr, Johann Traupmann, Christian Kronaus, Mascha Veech, Mario Gasser, Susanne John; The BLOCK Research Group, Institute of Technology in Architecture, ETH Zurich: Philippe Block, Matthias Rippmann; Faculty of Architecture, ETH Zurich: Toni Kotnik; Centro de Investigaciones y Estudios de Posgrado, Faculty of Architecture, UNAM, Mexico: Juan Ignacio del Cueto Ruiz-Funes
With the support of Permasteelisa Spa ARTE & Partners
Size 2.8m × 2.8m (base); 10m × 7.8m (top); 5.8m (height)

Citco Tau Vases and Quad Tables [300]
Milan, Italy, 2015
Client Citco Italia
Design Zaha Hadid with Patrik Schumacher
Design Team Woody Yao, Maha Kutay, Sara Saleh, Filipa Gomes, Niran Buyukkoz
Material Marble
Tau Vases Bardiglio Nuvolato (extra small & extra large), Statuario (small), Bianco Covelano (medium), Bianco Carrara (large)
Quad Tables Statuario (small 1), Nero Marquina (small 2), Silver Wave (medium), Nero Assoluto (extra large & console)
Dimensions:
Tau Vases extra small (34 x 34 x 20 cm), small (43 x 43 x 20 cm), medium (40 x 40 x 34 cm), large (40 x 40 x 48 cm), extra large (50 x 50 x 74 cm)
Quad Tables small 1 (60 x 60 x 45 cm), small 2 (60 x 60 x 45 cm), medium (90 x 90 x 35 cm), extra large (150 x 150 x 27 cm), console (160 x 45 x 90 cm)

Liquid Glacial Dining & Coffee Table [301]
2012
Client David Gill Galleries
Design Zaha Hadid with Patrik Schumacher
Design Team Fulvio Wirz, Mariagrazia Lanza, Maha Kutay, Woody Yao
Project Director Woody Yao
Project Architect Maha Kutay
Dining Table:
Dimensions Section 1 Length 2,515mm, Depth 1,402mm, Height 750mm; Section 2 Length 2,827mm, Depth 1,405mm, Height 750mm
Material Polished Plexiglas Clear
Limited Edition 8 (+ 2 Artist Proofs + 2 Prototypes)
Coffee Table:
Dimensions Section 1 Length 2,500mm, Depth 870mm, Height 400mm
Material Polished Plexiglas Clear
Limited Edition 8 (+2 Artist Proofs + 2 Prototypes)

Zaha Hadid Retrospective [302–3]
'Zaha Hadid at the State Hermitage Museum', Nicolaevsky Hall (Winter Palace), State Hermitage Museum, St Petersburg, Russia, 27 June – 27 September 2015
Exhibition Design Zaha Hadid with Patrik Schumacher
Project Directors Woody Yao, Maha Kutay

Exhibition Coordinator Manon Janssens
Design Team Johanna Huang, Daria Zolotareva, Filipa Gomes, Olga Yatsyuk, Margarita Valova, Zahra Yassine, Jessika Green
Video Installation Henry Virgin
The State Hermitage Museum Dr Mikhail Piotrovsky (General Director), Ksenia Malich (Exhibition Curator), Dr Dimitri Ozerkov (Director of the Contemporary Art Department), Geraldine Norman (Advisor to the Director), Vitaly Korolev, Boris Kuziakin